WITHDRAWN

1989
NLT
973.0992 c.1
BLODGETT.
 AT HOME WITH THE PRESIDENTS.

1988 29.95 3-89

Alameda Free Library
Alameda, California P

D1442125

WITHDRAWN

At Home with the Presidents

Opposite page: William McKinley
relaxes on his front porch in Marion, Ohio.
Contents page: Mount Vernon, George Washington's Virginia
plantation on the banks of the Potomac River.

First Published in 1988 by
The Overlook Press
Lewis Hollow Road
Woodstock, New York 12498

Copyright 1988 by Bonnie Blodgett and D. J. Tice
All rights reserved. No part of this publication may be reproduced
or transmitted in any form or by any means, electronic or mechanical,
including photocopy, recording, or any information storage and retrieval
system now known or to be invented without permission in writing from
the publisher, except by a reviewer who wishes to quote
brief passages in connection with a review written for
inclusion in a magazine, newspaper, or broadcast.

Library of Congress Cataloging-in-Publication Data

Blodgett, Bonnie.
At Home with the Presidents.

Includes index.
I. Presidents—United States—Homes and haunts.
I. Tice, D. J. II. Title.
E176.1.B66 1988 973'.09'92 88-5339
ISBN 0-87951-281-4

Designed by Barbara Koster
Printed in Hong Kong by South China Printing Company

At Home with the Presidents

BONNIE BLODGETT AND D. J. TICE

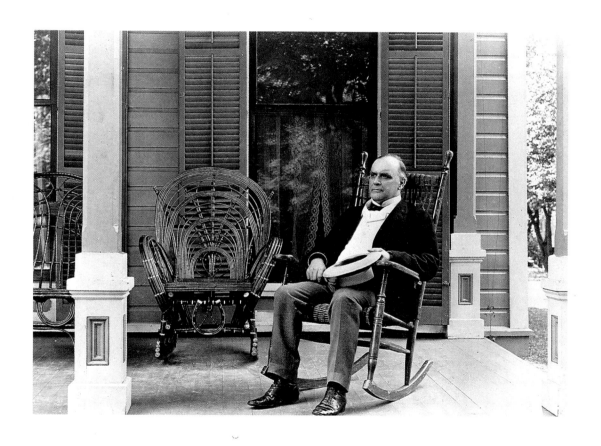

THE OVERLOOK PRESS • WOODSTOCK, NEW YORK

C. 1
ALAMEDA FREE LIBRARY

973.0992
BLODGETT

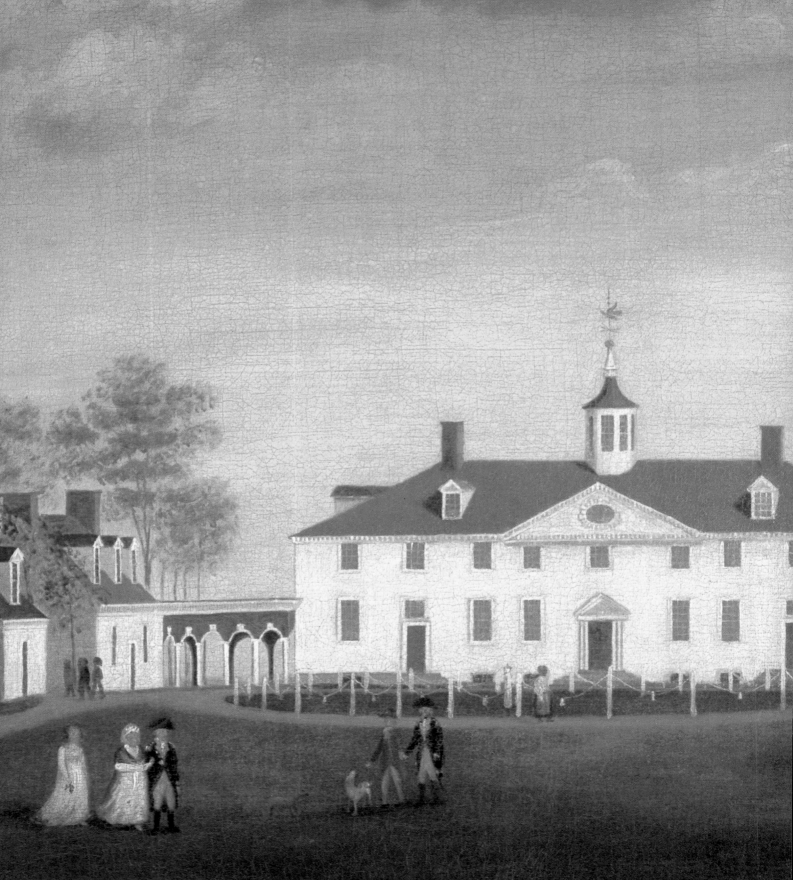

CONTENTS

FOREWORD

BY CLEMENT CONGER

Curator of the State Department

Curator of the White House, 1968-1986

At Home with the Presidents is a unique book, an extraordinarily detailed account of the private lives of America's presidents before and after they occupied the White House.

The majority of American presidents lived in the White House just four years and some fewer than that. George Washington never did pass beneath its celebrated portico, though he did lend a hand in the design. Several presidents were forced to move out during renovations. Only one managed more than the traditional eight-year tenancy, FDR. Yet though their stays were brief, each man made the White House his home for the whole of his tenure in the nation's highest office. And each left something of himself there.

My own acquaintance with the White House spans more than fifty years. As a young bachelor in the Thirties, I was frequently invited as "an extra man" to dinners and dances given by Roosevelt's daughter, Anna, whose future husband happened to be my associate in the newspaper business. Family parties during the Roosevelt era were always informal affairs, in sharp contrast to the official entertainments. Perhaps the most remarkable of the latter was the state visit of King George and Queen Mary of England in 1939, which I covered as a reporter and remember vividly. It was hellishly hot, and the White House was not air-conditioned. While Washington wilted, the royal guests appeared absolutely impervious to the blistering temperatures. A memento of that visit, Princess Elizabeth's gift of a painted looking glass, now hangs in the Queen's Bedroom in the private quarters.

Lovely Margaret Truman, only child of Harry and Bess, captivated Washington society during her father's tenure. Years later, while she was hard at work on her mystery novel, *Murder in the White House*, I received a call from Margaret asking me to refresh her memory. How did one go from her parents' bedroom to the Yellow Oval Drawing Room on the second floor in the private quarters? Were there inside connecting doors or did one have to go into the corridor and come in farther down the central hall? Both are possible, I replied, my curiosity very much aroused.

The start of my own official White House "residency" came in 1955, when as Deputy Chief of Protocol in charge of government entertainment I arranged American tours for high-level foreign dignitaries. The itinerary often included some state function at the White House, given by President and Mrs. Eisenhower. I held that post until 1961, when the Eisenhowers vacated the premises and the glamorous Kennedy entourage moved in.

Mrs. Eisenhower had begun to assemble the first White House collection of American antiques late in her husband's administration. Mrs. Kennedy enthusiastically embraced the project, completing the restoration Mrs. Eisenhower had launched of the Diplomatic Reception Rooms on the ground floor. The National Society of Interior Designers assisted her and happily paid the bills. (Federal funds have never been appropriated to such projects.) Perhaps Mrs. Kennedy's most famous contribution was an antique French wallpaper called "Scenic America," first printed 1829; an 1834 printing of this paper was discovered in a house in Maryland, removed overnight by workmen who had no idea how to perform such a delicate assignment, and brought to its new home riddled with holes. Unfazed, Mrs. Kennedy commissioned artists to fill them in, a task that is still repeated every three or four years, to repair moisture damage caused

by the wallpaper's unfortunate location adjacent to a well-used door.

Mrs. Kennedy's remarkable program of restoration suffered a single minor defect—it was the work of a confirmed Francophile. Her successor as First Lady had no wish to change any of it, however, and focused instead on beautifying America's great outdoors. Mrs. Johnson did acquire several important paintings including a handsome portrait of James Madison which had once belonged to President Monroe. But the White House itself was crying out for attention when Richard Nixon moved in.

I, in a sense, moved in with the Nixons. By now I had taken a position as Curator of the State Department, though I still helped plan state functions at the White House on weekends, evenings, and holidays. In other words, I had enough to do without taking on a major restoration of the White House as well. The Nixons, however, were adamant. After a whirlwind morning tour of the State Department Reception Rooms, the president pronounced them far superior to those in the White House. Will you "come over and help us out?" he inquired. By mid-afternoon I learned that I would indeed "come over." My papers were packed; I was Curator of the White House, like it or not. From February 1970 to May 1986 I shuttled back and forth between two jobs and two offices (on only one paycheck)!

I had made clear my reservations to the Secretary of State, William Rogers: this was a job for someone with graduate degrees in the decorative or the fine arts, not a fund-raiser and acquisitionist. I requested permission to hire the late Edward Vason Jones, the great Georgia restoration architect whose particular love was nineteenth century art. Permission granted. Meanwhile, Mrs. Nixon had made clear that she intended to make the White House the most beautiful home in America, restoring it to mint early-nineteenth-century condition. She took me on a three-hour inspection of every room on every floor. It was exhausting and discouraging. Every room was down at the heel, furniture was in poor condition, there were many bare walls where fine paintings should hang, and the draperies and upholsteries were badly worn.

One of our first projects was to locate missing portraits of First Ladies. We were eventually able to track down seven; seven are still unaccounted for. I found a painting of Mrs. John Quincy Adams quite by chance in the home of an Adams descendant in Devon, Massachusetts. Naturally I persuaded its owner, a Mr. John Quincy Adams, to donate it (in return for a substantial tax deduction) to the White House. The Nixons were so thrilled they threw a party for 200 members of the illustrious Adams clan.

Together, Mrs. Nixon, Edward Jones, and I raised several million dollars and refurbished twenty-seven rooms. It was a tremendous undertaking. We maintained rigid standards, accepting only the finest examples of American furniture. We built on an already strong foundation of excellent American paintings, which had been begun by the late James Fosburgh for the Kennedys. The Fords, the Carters, and the Reagans have continued the program.

I have continued too, though not as actively since the Nixons left office. President and Mrs. Carter gave me free rein to go about my business—and amazed me with the depth of their knowledge of American art and antiques. They explained that when Jimmy was governor of Georgia they spent considerable time exploring art museums and poring over art books in bookstores in Atlanta. Living in Plains made them appreciate museums and galleries all the more. The day after his inaugural I asked the president what he would like to put up on the walls of his study, now in rather sad condition with only nail holes where Jerry Ford's collection of political photos and cartoons had been. The president told me to use my judgment, revealing only that he was partial to "bright, sunny things." I fetched two fine American impressionist works from the White House collection and amassed a larger collection donated from several museums and private collectors.

Within a month the White House was home to some thirty-five paintings worth millions. "Where would you like them hung?" I asked Mrs. Carter, adding that perhaps I

should lean them against the walls where I thought they should hang. Jimmy had only one change: his vote for the finest of the collection, a Harnett still life called "Cincinnati Inquirer, 1888," would go in the West Sitting Hall (the family sitting room), where guests could enjoy it too. Later Dr. Armand Hammer, president of Occidental Petroleum Company, hearing of the president's fondness for that painting, arranged to buy it from its owner for $400,000 and presented it to the White House.

In January of 1981, Mrs. Carter presided over the last meeting of the Committee for the Preservation of the White House. It was disbanded during the Reagan administration. Even before the Reagan inaugural, Mrs. Reagan had set her decorator, Ted Graber, to work renovating the private quarters. She raised a million dollars for the project. Sadly, little of her enthusiasm for interior design has been channeled toward improving the White House permanent collection, which now consists of 115 American paintings, about 40 pieces of American furniture, and some 60 decorative objects on loan to the White House. It is my hope that future administrations will renew our work in this area, and establish a program for the continual replacement of materials for draperies and upholsteries as they wear out from use or age.

As much as the White House has to say about our presidents—and for one who has been closely associated with it for fifty years the building fairly quakes with memories of those presidents I knew—we musn't forget how brief was each man's residency, how much more a monument the White House is than a home. For a richer understanding of how our presidents came to live in this splendid mansion, one must travel beyond the boundaries of the nation's capital and into the nation itself, into the cities, towns, and villages they grew up in, the farms and ranches and businesses they worked for, and finally into their homes.

This book takes you there, offering fascinating portraits of the presidents "at home," as children growing up, as ambitious young men making their way in the world, as powerful leaders, and as former leaders looking back on what they had achieved—and what they had become.

Washington
February 1988

PART ONE

Lords of the Manor

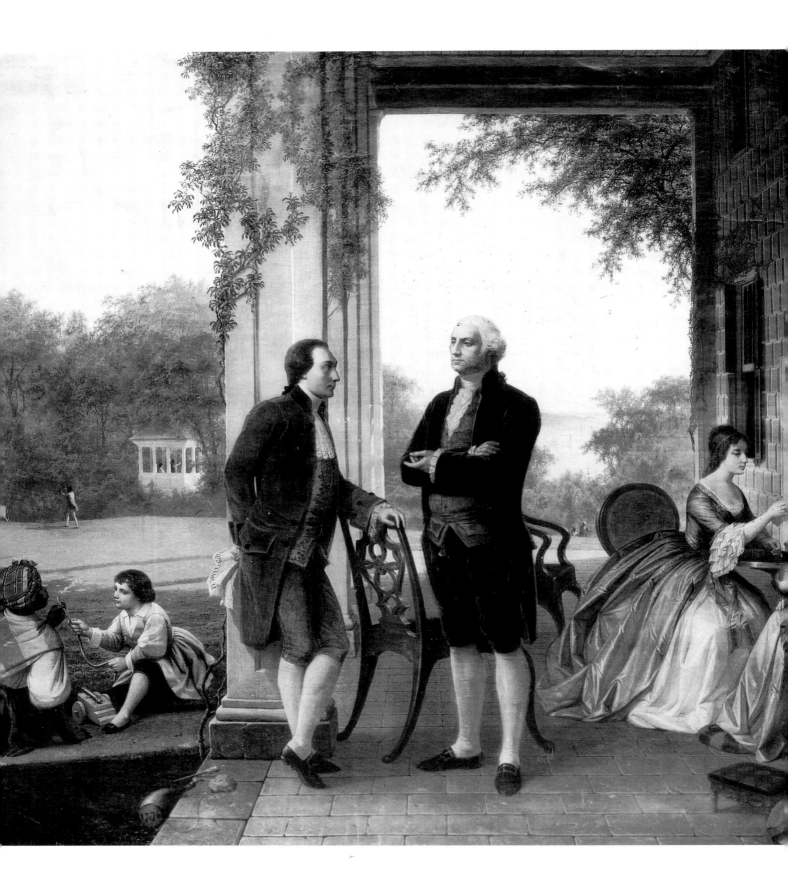

George Washington

"IF A MAN SHOULD BE SO UNFORTUNATE as to have married a wife of capricious disposition, let him take her to America, and keep her there three or four years in a country-place, at some distance from a town, and afterwards bring her back to England; if she do not then act with propriety, he may be sure there is no remedy."

So, in 1800, wrote Richard Parkinson, an English agriculturalist who had arrived in Virginia in 1798, brimming with curiosity and great expectations. He had come to the New World at the urging of retired president George Washington, who had offered the Englishman a chance to let one of the five separate farms that made up his beloved Mount Vernon plantation.

Parkinson liked Washington's house ("a very decent mansion...prettily situated") and his mules, but that was all he liked. He found Mount Vernon's soil poor and depleted ("like a yellow-washed wall"); its oats and wheat, stunted and of "a very light and bad quality"; its sheep, cattle, and hogs, scrawny and sickly; the one fellow farm manager he met, ignorant ("no judge of animals—a better judge of...whiskey"); and its black slaves, numerous and idle. Over dinner Parkinson informed his host that he had changed his mind about renting the parcel, and was "compelled to treat [Washington] with a great deal of frankness." The general, he reported, was "not well pleased."

Parkinson's judgment of Mount Vernon, like his vision of America as a reformatory for ill-mannered wives, was too harsh. But his reaction reminds us that early American life was primitive, even for the upper classes. The splendid colonial mansions of which Mount Vernon's is an example were among the many overcompensations of a wilderness aristocracy.

Whatever its shortcomings, Mount Vernon was Washington's greatest delight. Master at the estate for nearly half a century, he lived there full-time for barely half those years. Yet no matter where he was, or what his distractions, he never lost touch with the smallest detail of the plantation's affairs.

On September 30, 1776, the general wrote home to his cousin Lund Washington, who was managing a major remodeling at Mount Vernon. Washington was miserable. He had just lost the battle of Long Island, was about to lose the whole of New York,

Washington was born at Pope's Creek Plantation in Virginia's Westmoreland County. But even as a boy he treasured the river view at another family estate, Mount Vernon. On the grand piazza he built on Mount Vernon's river side (overleaf), Washington entertained the great figures of his generation, including Lafayette.

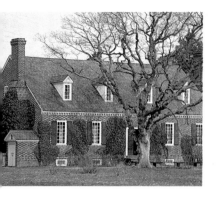

and was in command of a poorly fed, poorly clothed, poorly trained mob that passed for a Continental Army. "....In confidence I tell you that I never was in such an unhappy and divided state since I was born...," Washington moaned. Then abruptly he turned into a fussy, fretting homeowner: "With respect to the chimney, I would not have you for the sake of a little work spoil the look of the fireplaces.... The chimney in the new room should be exactly in the middle of it—the doors and everything else to be exactly answerable and uniform.... You ought surely to have a window in the gable end of the new cellar (either under the Venetian window, or one on each side of it)...."

Lund put the cellar pane under the "Venetian" window as his cousin retreated to Pennsylvania and prepared for his victory at the Battle of Trenton.

The tract of land along the upper Potomac River that would become Mount Vernon was granted to John Washington, the original family emigrant, in 1674. It passed eventually to his grandson Augustine, who became a prosperous planter, owner of thousands of Virginia acres. In the 1730s Augustine settled briefly on the Potomac land and built a simple, one and one-half story house on a hill that rose sharply from the river's edge, commanding a fine view of the waterway and the lower hills beyond. After several years the family moved permanently to a smaller farm near Fredricksburg, and Augustine set aside the Potomac estate, known then as Little Hunting Creek Plantation, as the inheritance of his eldest son, Lawrence. His third son, George, was to inherit the Fredericksburg farm and a few smaller tracts.

George was eleven when his father died in 1743. He spent most of his adolescence with Lawrence, at the estate the elder half-brother had renamed after British Admiral Edward Vernon, under whom Lawrence had served. George loved and admired Lawrence, and was never really close to his mother, who stayed on at the Fredericksburg farm. But part of the attraction was Mount Vernon itself. All his life Washington treasured that spectacular view of the Potomac spreading mightily below the brow of the hill, by turns wind-whipped and still as pond water—visited now by a squabbling flock of geese circling high above the river but below the house, now by a great sailing ship.

Lawrence Washington died in 1752, an event that must have triggered an awkward mixture of feelings for George. Lawrence's widow had no desire to remain at Mount Vernon, so the plantation was his. Already, with his earnings as a teenage surveyor, he had added enormously to his land holdings, indulging a land hunger that was exceptional even in eighteenth century Virginia. At his death Washington owned more than 60,000 acres, 8,000 at Mount Vernon.

From the first Washington managed his estate from a distance. He was off to frontier military service and the French and Indian War, where he made his reputation as a leader and a fighting man. In 1758 he secured his first real wealth and an incentive to spruce up his home when on leave he courted and won a young widow, Martha Dandridge Custis. With her came two small children and a fortune worth at least $100,000. The marriage would prove to be warm and loyal, if never especially passionate. The fortune would, through Washington's shrewd land purchases, make him one one of richest men in America, on paper.

From 1759 until 1775, Washington enjoyed his longest uninterrupted residence at Mount Vernon and the most carefree interlude of his life. In anticipation of his bride's arrival he launched the first major improvement of his property, raising the house his father had built to two and one-half stories. Yet the home to which he brought Martha in April, 1759, remained a simple one. Probably its greatest charm was the pine-paneled central passage, crossing the full width of house. Its west door opened onto a tree-lined lawn running down to the main gate; its east door, onto a narrower lawn giving way to the glistening river below.

Throughout the 1760s, Martha Washington applied herself mainly to improving the decoration of her home, while her husband, now a member of the Virginia House of Burgesses, turned his energies to the management of his farms. All the while they planned for the project that would transform their pleasant country home into a gracious mansion. Two large wings were to be added to the central structure. The northern addition would house a two-story banquet hall, known to the Washingtons as the "new room." The southern wing would become a private suite for the couple.

Washington eagerly looked forward to managing the remodeling, but as it turned out he would manage it by proxy, from Valley Forge, Harlem Heights, and Yorktown. One May morning in 1775 he gave some instructions to the workmen who had just started framing up in his new library, then mounted his horse and rode for Philadelphia and the Second Continental Congress. Save for two brief visits on his way to and from Yorktown, Washington would not return to inspect the carpenters' handiwork for eight years.

Throughout the war Washington's cousin Lund wrote the general of his fears that the British would sack defenseless Mount Vernon. Lund promised brave deeds should a British warship appear on the Potomac, but when one finally did, in the spring of 1781, he took more practical action, receiving the officers cordially (even serving refreshments), providing ample provisions from the plantation's stores, and standing placidly by as twenty slaves were stolen. Washington exploded in an angry and uncharitable letter. "It would have been a less painful circumstance to me," he wrote,

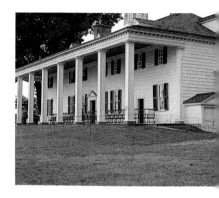

The pine-paneled central passage was Mount Vernon's principal charm after Washington's first remodeling. The piazza and Palladian window later became its defining features.

"to have heard...they had burnt my House, and laid the Plantation in ruins."

He probably felt differently when he finally came home to his still-beautiful estate, just in time for Christmas, 1783. Never again, Washington thought, would he have cause to fret over Mount Vernon from afar. To Lafayette he wrote: "At length...I am become a private citizen on the banks of the Potomac and under the shadow of my own Vine and my own Fig-tree....I am not only retired from all public employments, but I am retiring within myself....Envious of none, I am determined to be pleased with all....I will move gently down the stream of life, until I sleep with my Fathers."

The stream held turbulence for him yet, but for a time he did move gently. He had returned to a home that bore little resemblance to the one he left behind. Below the new master bedroom now stood Washington's nearly completed library, spacious and bright with two large southern windows.

Washington was never a great reader, never a philosopher or in any sense an intellectual. Jefferson left the polite testimony that Washington's "was a great and powerful mind, without being of the very first order." In short, Washington probably wrote more words in his library than he read, for there he handled his voluminous correspondence, usually early in the morning after coming down to shave and wash at the dressing table he kept in the library. From there, too, at dawn, he would send messages to those slaves and workmen not yet at their posts, messages "expressive of my sorrow for their indispositions," as he explained to a friend.

However much Washington enjoyed his hours alone in his library in those happy years after the Revolution, it was on the opposite, north end of his house, in the "new room," that the real transformation had been worked. Even without its whimsical applied-plaster decorations and the exquisite marble mantelpiece—these were added as the 1780s progressed—the room must have been stunning, with its soaring, two-story ceiling, its great length (like the central corridor, it crossed the full width of the house), and its regal Palladian window.

Curiously, the ubiquitous, three-paned "Palladian" window was one feature of Georgian architecture that was not at all, strictly speaking, Palladian. The design predates Andrea Palladio, a sixteenth-century Italian architect whose ideas otherwise dominated eighteenth-century architecture. Simply put, Palladio fused Renaissance flamboyance and classical harmony. His designs, whether for country villas, cathedrals, or opera houses, emphasized strict symmetry and absolute balance in all the parts of a structure. Those architectural values inspired Americans of Washington's generation, who found in them tangible expression of the Enlightenment faith in moderation and reason. Like most colonial structures, Mount Vernon was too much

a piecemeal effort to strictly reflect any architectural style, but Washington, who largely designed Mount Vernon, strove for classical balance.

The new room's splendid mantelpiece, carved with pastoral scenes, came to Washington as a gift from an admiring Englishman, Samuel Vaughan, who had emigrated to America after the Revolution. In accepting it Washington observed that it was "too elegant and costly by far" for his "republican style of living." But he had to know that his mansion no longer reflected such a style. On its east front, the river side, it now sported a grand "piazza," a columned porch running the full length of the house, rising to the roof line.

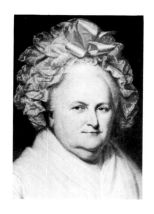

The present-day visitor to Mount Vernon, crowded onto the piazza with a mob of fellow pilgrims, is tempted to conjure up images of serenity and stillness—perhaps George and Martha Washington lounging there, just the two of them, at twilight. In fact the mob scene is closer to the life they lived there. So overwhelming was the stream of visitors to Mount Vernon, even in these years before the presidency, that Washington likened the estate to "a well-resorted tavern." In 1785 Washington kept track of his overnight guests; the total for that year alone was 423.

Washington gained his first real wealth by marrying Martha Custis, a rich young widow, in 1758. Their forty-year union was happy and serene, if not especially passionate.

Even apart from visitors, to properly envision Mount Vernon in the mid-1780s is to imagine not a quiet homestead but a teeming, chaotic small town. Washington never had children of his own, but Martha's son and daughter grew up at Mount Vernon. Washington's stepson, Jacky, had joined the general on the Yorktown campaign, and died during the siege of camp fever. Jacky's two children then joined the plantation household, which also included, at various times, nieces and nephews, aides of Washington's, his brother George Augustine and family, Lafayette's son, and many others. If loneliness still threatened, there were always the house servants—usually around ten—and several hundred other slaves and hired hands puttering about the place.

At Washington's death Mount Vernon was home to more than 300 slaves, an enormous number. The character of slavery at Mount Vernon was probably close to the Old South average—more humane than most of history's slave systems, but still cruel. The whip was by no means unknown at Mount Vernon, although the master insisted on moderation in its use: "Let Abram get his deserts," he once wrote "...but do not trust to Crow [one of the overseers] to give it to him;...he is swayed more by passion than by judgment."

Slavery was in truth the most "peculiar" of institutions, and the slave-master relationship, at Mount Vernon as elsewhere, riddled with contradictions. Washington was utterly contemptuous of his "people," finding them lazy, incompetent, and dishonest. Yet a slave named Davy was the manager of one of Mount Vernon's five

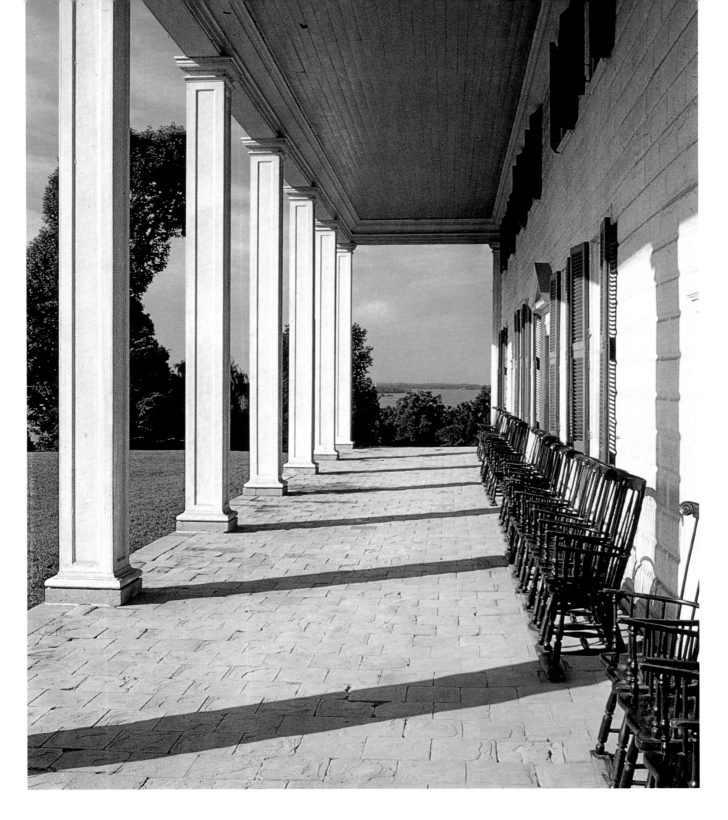

farms, and Washington thought him as trustworthy and competent as any white overseer he had ever employed—better than most. The slaves' feigned illnesses infuriated Washington, yet he was pained by their real infirmities and deaths. He often attended to them personally, especially those stricken with the dreaded smallpox,

as he had survived a bout with the killer in early manhood. He lectured his overseers incessantly about the need to avoid "familiarity" with the slaves, yet he had his own favorites, especially Billy Lee, his personal valet throughout the Revolution.

Washington often expressed distaste for slavery, but his complaints were mostly confined to its practical inefficiencies. His papers reveal no insightful discussion of its moral dimensions. ("I do not like even to think, much less talk of it," he once wrote.) On the other hand, Washington freed all of his slaves in his will, and had throughout his life generally refused to sell them, "as you would cattle at a market," with the result that his slave force was unusually inefficient. His 1786 census of his slaves shows that nearly one in five was too young, too old, or too sick to accomplish much useful work.

Like most of his aristocratic contemporaries, Washington thought agriculture the noblest and most elevating of human pursuits. "...[T]he life of a husbandman is the most delectable," he wrote. "It is honorable, it is amusing, and, with judicious management, it is profitable." Honorable and amusing agriculture may have been, but in fact it was never very profitable for Washington. He was, like most planters of his time, rich in land and slaves and chronically hard-pressed for cash. To cover the expenses of his trip to New York to assume the presidency, he borrowed money.

As Parkinson observed, agriculture at Mount Vernon was a primitive art, despite Washington's best efforts. He was an enthusiastic experimenter, forever testing new, imported plants in his greenhouse and botanical garden. He experimented with livestock, too. Along with sheep, hogs, and cattle, Washington kept deer at Mount Vernon, and he is credited with introducing the mule to America. One December afternoon in 1785, Royal Gift, a jackass sent to Washington by the King of Spain, was led onto the piazza at Mount Vernon to be inspected and measured by a wide-eyed general. Washington recognized the exotic beast's advantages as a draught animal, and soon had a barn full of the creatures, who so enchanted him that he toyed with the idea of using them to draw his presidental coach. Someone talked him out of this.

Washington struggled all his farming life to be rid of tobacco, a profitable crop for Virginia farmers, but one notoriously destructive of the soil and notoriously labor-intensive, worsening their dependence on slavery. He struggled, too, to enrich his impoverished soil. He once said that a good overseer must be "above all, Midas like, one who can convert everything he touches into manure." His favorite scheme for soil improvement was to incorporate into his fields mud from the bed of the Potomac. "Success to the mud!" became a familiar toast at Mount Vernon. But success, really, was never had.

Opposite: Mount Vernon's unique two-story piazza was a masterful piece of design, making exquisite use of the mansion's setting high above the Potomac. Its Palladian window, though exceptionally lovely, was a more common touch— an emblematic feature of colonial architecture.

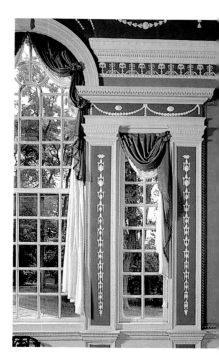

In addition to problems with slaves and soil, the incompetence of hired help was a constant aggravation for Washington. As often as not, the problem was liquor. In 1787 Washington drew up a contract for a new gardener, Philip Bater, which provided that Bater was to stay sober except as follows: he would be given "four dollars at Christmas, with which he may be drunk four days and four nights; two dollars at Easter to effect the same purpose; [and] two dollars at Whitsuntide to be drunk for two days..." Apart from these contractual binges and "a dram in the morning, and a drink of grog at dinner at noon," Bater was to keep a clear head.

Whatever his frustrations, the 1780s were golden years for Washington, filled not only with the delights of farming and a rich social life, but with other favorite amusements: fox hunting, cards (he enjoyed a bit of modest gambling), dances and the theater. He rode horseback every day of his life that he wasn't ill, and was an expert trainer. When still left with time on his hands, there were always the finishing touches still being applied to the mansion. It was completed in the fall of 1787, when the cupola was crowned with a weather vane in the shape of a dove.

It must have been something of a bittersweet occasion. The Constitutional Convention had been held that summer; Washington had served as chairman. He did not contribute much to the fierce debates, but he strongly supported the establishment of a more muscular federal government. Trouble was, the new Constitution called for a president of the United States, and there was no doubt in anyone's mind, least of all Washington's, who the first chief executive should and would be.

Washington loathed the idea of again leaving Mount Vernon to return to public life, or so he told anyone who would listen. "Every personal consideration conspires to rivet me...to retirement," he wrote to one friend. "....[M]y movements to the chair of Government," he told another, "will be accompanied by feelings not unlike those of a culprit who is going to the place of his execution."

A faint odor of overstatement hangs about letters such as these. It was fashionable in that day for prominent men to feign indifference toward high office. In a letter to Lafayette, Washington came close to admitting that he had protested too much. As he had not yet actually been made president, he feared that someone might aptly liken him to the proverbial fox "inveighing against the sourness of the Grapes, because he cannot reach them."

Still, it's true that Washington's eight-year presidency was something of an ordeal for him, especially the second term, which his entire Cabinet begged him to accept (it may have been the only thing Jefferson and Hamilton ever agreed about). He did not remain universally popular. A twenty-year conflict broke out between Britain and Revolutionary France in 1793, in effect the first world war, involving Russia,

Italy, Austria, Spain, Prussia, and ultimately America. Americans saw their political differences symbolized in that conflict: "conservatives" favored England, "liberals" sympathized with France. Washington insisted on neutrality, a slippery course, particularly as his own heart was with the English and his advisors were bitterly divided. The "spirit of party" that gripped the nation appalled him.

Though only sixty five when he left the presidency, Washington was not destined to enjoy a long retirement. Public duties threatened once more in 1798, when President Adams, fearing an outbreak of war with France, put Washington again in command of the American Army. But war did not come, and Washington returned to Mount Vernon for the last time, where his final years were marred by poor health, his own and Martha's.

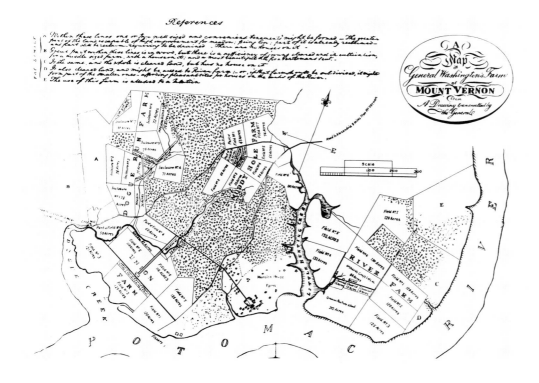

Washington's own map of his 8,000-acre plantation identifies its five "farms": Mansion House Farm, Union Farm, Dogue Run Farm, Muddy Hole Farm, and River Farm.

On December 12, 1799, Washington mounted a favorite horse and made his usual rounds of the plantation. The weather turned foul—snow, hail, and "a settled cold Rain," as Washington described it. By the next day he was ill, with a sore throat that steadily worsened. Still he went out that afternoon to mark some trees between the house and the river that he wanted cut down. Sometime after midnight he shook Martha awake, desperately ill now, fighting for breath. Doctors worked feverishly all day, bleeding him repeatedly. He died at around 10 p.m., December 14, 1799, in the upstairs bedroom of his mansion's south wing.

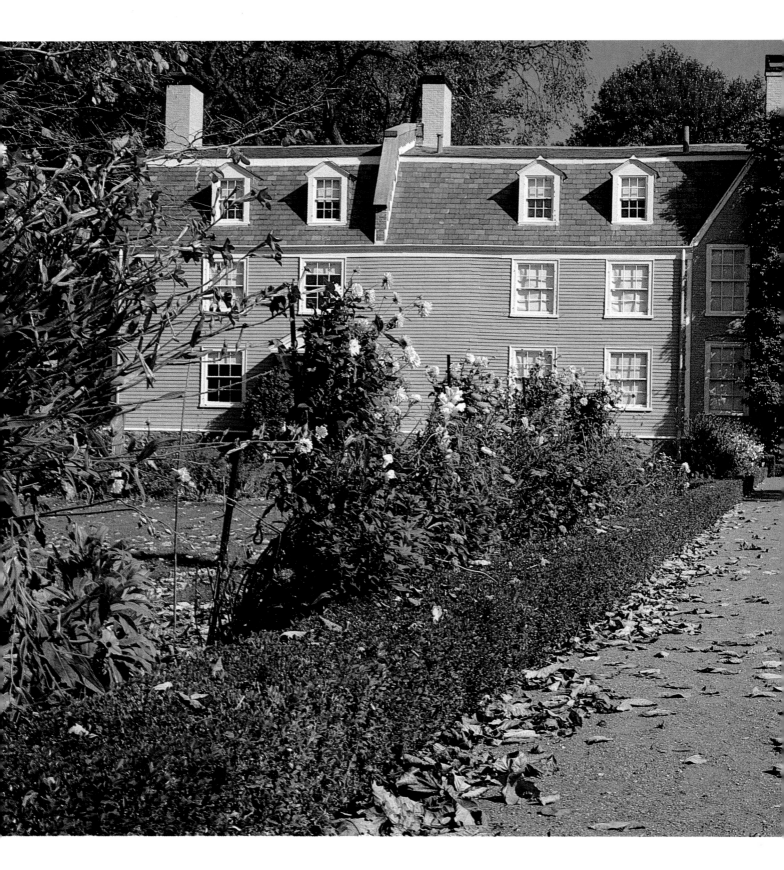

John Adams, John Quincy Adams

VERY LITTLE IS KNOWN, directly, about Deacon John Adams, but quite a lot can be confidently assumed. If the patriarch of America's greatest political dynasty bore any resemblance to his famous progeny, who were as much like one another as one New England autumn is like the next, he was a capable and intelligent man, perhaps a brilliant man. One can assume, too, that he was a realist, not to say a pessimist, fixed on a vision of life as serious business, and almost all business. And he was probably vain, thin-skinned, and combative.

Deacon John was a prominent, well-to-do farmer in Braintree, Massachusetts, a small rural community on the south shore of Boston Bay. He was descended from Puritans who had helped preserve the first perilous beachheads in the New World. In 1720, Deacon John purchased a homestead on the old Coast Road that ran from Boston to Plymouth and points south. It was a typical New England farm, standing at the foot of a wind-blown eminence known as Penn's Hill. To the west rose the low, lush Blue Hills, deep with lofty pine and with hardwood that blazed red and orange each fall. To the east, stony farm fields sloped rapidly away to the sea, whence came a chill, salty breeze, summer and winter. Colonial Massachusetts was, in every sense, a "new England." Kent and Sussex were crowded with near duplicates of Deacon John's sturdy "saltbox" house. It was covered in rough-hewn clapboard siding and adorned with a classical pediment over the doorway. On October 19, 1735, in an upstairs bedroom, the Deacon's wife delivered a son, who was named for his father.

John Adams grew up in a snug, cluttered home. The original structure had four rooms—two lower spaces dominated by a colossal stone fireplace and two bedrooms on the second floor. In all likelihood, its exterior was bare wood, as the practice of painting houses was not yet widespread. In time Deacon John expanded his home in typical fashion, by adding a "lean-to," a rear addition topped with a radically sloping roof. It nearly doubled the living space, but can't have changed the home's essential gloominess, relieved only by a few small, rectangular casement windows. All the same, it was everything a New England home of that time was expected to

21

Overleaf: John Adams
retired to the Old
House in Quincy,
Massachusetts, in 1802.
Built in 1731, the house
was enlarged and
remodeled during his
term as president. John
Quincy Adams inherited
the house upon his
father's death. His wife,
Louisa, was finally
persuaded to move from
their farm north of
Washington to Quincy
in 1830.

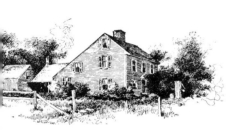

The family home in
Quincy, south of Boston.

be—stout, modest, durable. Young John Adams grew up convinced that the life of a rural yeoman was for him.

Deacon John had other plans. He wanted his son educated, in preparation for a career in the clergy. These were the days of the Great Awakening, a feverish Calvinist revival that swept through the thirteen colonies like a prairie fire, burning hottest, as have so many intellectual blazes, in and around Boston. As a teenager John Adams sat for hours by the family hearth listening to his father and other Braintree elders debate such heady issues as predestination and the perfectibility of man. By then a student at Harvard, John had come to love the life of the mind, but he found few charms in these theological disputes. He would make his career in the law.

A young colonial lawyer was of necessity a wanderer, travelling from town to town, on a "circuit," to try cases. John Adams's wandering would continue for forty years, and it began the same year that he became a homeowner. Deacon John died in 1761, leaving to young John the Braintree homestead, called Penn's Hill Farm. It then comprised about forty acres, a barn, and two nearly identical saltbox houses that literally stood within spitting distance of one another. The Deacon had purchased the second home, along with a few additional acres, around 1745.

With homestead and career in hand, John Adams set out in search of a wife. By 1764 he had courted and wed Abigail Smith, the daughter of a clergyman in nearby Weymouth. It was the best decision John Adams ever made. For more than fifty years Abigail Adams would ably manage his farms and finances, would raise his children, and would provide whatever sense of home and stability he knew during a long, nomadic, and often disappointing career in public service. Theirs was a great love, an uncannily fortunate match at a time when courtship was a brief and super-ficial ritual designed mainly to assess "suitability." John and Abigail thought alike and felt alike, sharing the same hopes and fears and biases. Self-educated and tough-minded, Abigail could and did challenge her husband intellectually; they were friends, almost colleagues, no less than lovers, yet their ardor seems never to have cooled. After the marriage John abandoned his swooning salutations, "Miss Adorable" and "My Diana," but fifty years later Abigail could write to her sister, "My first choice would be the same if I again had youth and opportunity to make it." It is a pleasing irony that these two decidedly unromantic figures—both were plain and portly, both moody and belligerent—should have lived as great a love story as American history has to offer.

Abigail is remembered today as an early, very early, proponent of women's rights. She shared John's passion for "the rights of man," but also wrote to him, "....by the way...Remember the Ladies, and be more generous...to them than your ancestors.

Do not put such unlimited power into the hands of the Husbands. Remember all men would be tyrants if they could." John's response, considering the date, was mild and respectful, but the time had not come for sexual equality. "I cannot but laugh," he wrote. "We have been told that our Struggle has loosened the bands of Government every where....but your Letter was the first Intimation that another Tribe more numerous than all the rest were grown discontented....in Practice you know We are the Subjects."

On July 11, 1767, in the second Penn's Hill cottage, Abigail gave birth to her second child, a son. He was named John Quincy Adams. A year later John Adams moved his little family to a house on Brattle Square in Boston. A desire to be closer to his burgeoning law practice entered into the decision, but so did a growing interest in the festering conflict between the colonies and Parliament, a conflict whose front lines lay in Boston. At the Brattle Square house, the Adamses were jarred awake each morning by the shriek and thud of British fifes and drums, as occupying troops drilled in the square across the street. Each evening, "Sons of Liberty" crowded the same square, armed with flutes and violins. Adams found their music "sweet," but as yet was unwilling to play along.

Over the next seven years, Adams fitfully moved his family back and forth between Penn's Hill Farm and various Boston houses, the moves corresponding to his changing moods—from outrage over British offenses, to discomfort with the radicalism of the Boston rabble, to simple weariness with politics. In 1770 he defended English officers and troops who had fired into an enraged, rock-throwing mob, in what has ever since been known as the "Boston Massacre," thanks to the efforts of colonial propagandists. Adams believed that the troops had been sorely provoked, and his argument prevailed in court (if not in the court of public opinion). Yet Adams was losing patience with efforts at compromise. In 1774 he left Braintree for Philadelphia and the First Continental Congress, as convinced as any delegate that revolution was inevitable. He would do little more than visit his home for the next quarter century.

The letters that passed between John and Abigail during the early years of the revolution form one of the most vivid eyewitness accounts in American history. John described for Abigail momentous events in Philadelphia—the decision to raise an army, to appoint George Washington Commander-in-Chief, to declare American independence. Abigail described a vicious shooting war that engulfed Penn's Hill Farm. "Our House has been upon this alarm in the same Scene of confusion that it was upon the first—Soldiers coming in for lodging, for Breakfast, for Supper, for Drink.... Sometimes refugees from Boston tired and fatigued, seek an asylum for a Day or Night, a week—you can hardly imagine how we live." Eight-year-old John

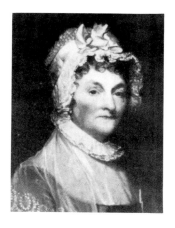

John Adams married Abigail Smith, the independent-minded daughter of a clergyman, in 1764. They were well-matched, and their marriage endured many long separations.

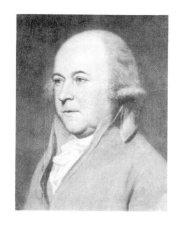

23

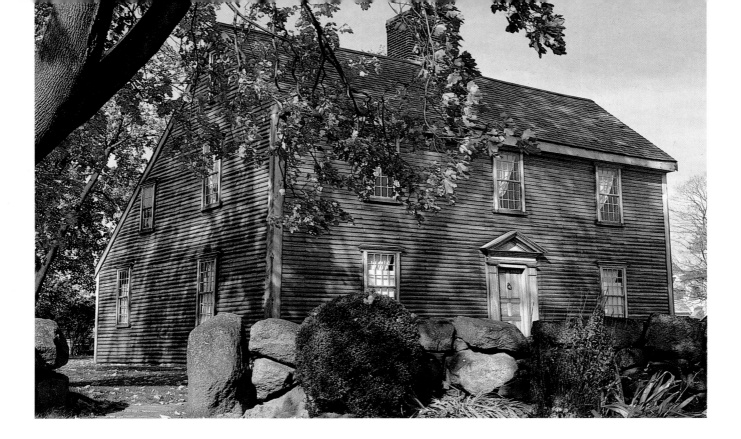

The Adamses owned Penn's Hill Farm, where both John and John Quincy Adams grew up, until 1787, the year they bought the Old House.

Quincy could hardly imagine what minutemen were doing when he found them one day in his mother's kitchen, cooking the family's pewter dishes over a roaring fire. "Bullet soup," he was told.

"The Day; perhaps the decisive Day is come," Abigail wrote on June 18, 1775. "....Charlestown is laid in ashes. The battle began upon our entrenchments upon Bunkers Hill...Saturday morning about 3 o'clock and has not ceased yet and tis now 3 o'clock Sabbeth afternoon.... How many have fallen we know not—the constant roar of the cannon is so distressing that we can not Eat, Drink or Sleep." Distressing, yes, yet strangely captivating. The night before Abigail had taken her young son by the hand and led him to the peak of Penn's Hill, behind the house, there to watch the glare and smoke of history, like a volcano erupting in the distance. Eight months later, from the same spot, they watched "the largest Fleet ever seen in America. You may count upwards of 100 & 70 Sail. They look like a Forest." The British were abandoning Boston, and the Braintree Tories, Abigail noted, "look a little crest fallen." But then, lest her husband conclude that all was well at home: "As to all your own private affairs, I generally avoid mentioning them to you."

John Adams was never again to be the master of Penn's Hill Farm. No sooner had he resigned from Congress than he was dispatched to Europe to negotiate, first for an alliance with France, then for loans from Holland, finally for peace with England. John Quincy, but not his mother, went along. At one stretch, John and Abigail did not set eyes on one another for more than four and a half years, and it was almost

more than even an independent woman could stand. "[T]he unbounded confidence I have in your attachment to me...has soothed the solitary hour," she wrote, but "....a cruel world too often injures my feelings by wondering how a person possessed of domestic attachments can sacrifice them by absenting himself *for years*." In 1784, Abigail at last joined her husband in London.

Four years of gracious European living spoiled the Adamses. They acquired not only refined tastes, but a houseful of elegant furnishings from Holland, France, and England. By the time they resolved to return to Braintree (now renamed Quincy), it was clear that Penn's Hill Farm would no longer do. In 1787, through the agency of a friend, Adams purchased a new farm not far from Penn's Hill, a farm whose two and one-half story, gabled house he and Abigail remembered as the loveliest in their community. From London Abigail issued detailed instructions for its renovation. John, for his part, was ready to return to a life of farming. He had taken a vow, he wrote Jefferson, "to retire to my little turnip yard and never again quit it."

Neither was quite so content when they got to their new home. John frantically applied himself to farming—buying livestock, fertilizing his thin, dry soil with sea-weed. But nothing could disguise his restlessness in the "turnip yard," his hunger for public office. Abigail felt worse. Europe had transformed her standards more than she knew, and her new home looked to her "like a wren's house." To her daughter she wrote despairingly, "Be sure you wear no feathers and let [your husband] come without heels to his shoes, or he will not be able to walk upright."

They had certainly returned to something less than a mansion, though not to a house without charms. Built in 1731, it was tall and very narrow, and indeed its ceilings were uncomfortably low, especially by eighteenth century standards. Apart from bedrooms the house contained only a slender entryway, a very decent dining room, and a magnificent sitting room paneled in solid mahogany. Abigail found this room disagreeably dark, and ordered the whole painted white (her grandson, Charles Francis Adams, restored the panelling in the mid-nineteenth century). It was by no means an uncomfortable or unfashionable home (the style was Georgian, though decidedly of the modest New England variety), but Abigail could dream only of the day that she would double its size. That day would not arrive, as it happened, for another decade.

John Adams became the first vice president of the United States in 1789, and its second president in 1796. Yet the greatest successes of his public career, as theorist of the revolution and as a tenacious diplomat, were behind him. Adams was a conservative; he loved liberty but thought it strong medicine, healthful only in measured doses. A political if not a religious Puritan, he basically distrusted men; the poor, if

given the chance, would oppress the rich as viciously as they had ever been oppressed themselves. He had no passion for "equality," as he believed a truly free society would always produce a "natural aristocracy." Deserved or not, he got a reputation as a "monarchist," an unsavory reputation in the America of the 1790s.

Adams's personality compounded his problem. Lacking the thick skin and the superficial charm essential to politics, he became little more than an appendage in the Washington administration, and his foolish fretting over protocol and titles moved wits in Congress to bestow a title upon him: "His Rotundity." As president he was caught in the crossfire between extreme Federalists such as Alexander Hamilton and Republicans such as Thomas Jefferson. Withdrawing from the brink of war with France in 1799, Adams did a service to his country, but by the same act split his party and ensured his own defeat at Jefferson's hands in 1800. He left office embittered and saddened, not only by the turn his public life had taken, but by private tragedy as well.

Just weeks before the end of his father's presidency, Charles Adams, John's second son, had died penniless and miserable at age thirty, from complications of alcoholism. For a quarter century John Adams had been a public man, and largely an absentee father. He scarcely knew his sons, and they knew little of him beyond his demands, his exhortations to be dutiful, industrious, and virtuous. Charles had instead descended into vice and despair, and even John Quincy, always his father's favorite and often his companion, had become a morose recluse. "When we turn into books he will visit us," his aunt had once playfully complained, but there was painful truth in her jest. As a young lawyer in Boston, John Quincy had learned the uses of both liquor and prostitutes, and it may have been only his appointment (by Washington) to the European diplomatic corps that saved him from his brother's fate.

Still, though he could not have known it as he slunk back to Quincy in the spring of 1801, the happiest period of John Adams's life still lay before him. He was to be blessed with another quarter century of life, most of it in good health and most of it in Abigail's company. At last he was a farmer, his first wish, and he threw himself into that vocation as though he had never done, nor thought of doing, anything else. Grandchildren crowded around, living with their grandparents for years at a time. With them the former president was indulgent and affectionate, as he had never been with his own children. Even old friendships that had been shattered by political pressures, most importantly his friendship with Jefferson, were restored. The two old revolutionaries exchanged scores of letters, most of them bristling with political ideas, despite their mutual declarations that they were through for good with that distasteful business.

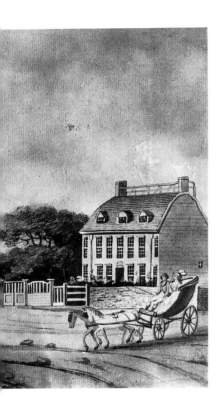

The Old House at Quincy as it looked when the Adamses lived there.

In the last years of the presidency, Abigail had transformed the Old House (this was what Adams usually called his Quincy farm, though at times he called it "Peacefield," "Stony Field," and, satirizing Jefferson, "Montizillo"). She had added a great east wing, gabled like the original structure. It provided a new, more-spacious entryway and a lovely drawing room that she called the "long room." Big and bright, with French doors and tall, slender windows, the room quite consciously redressed the Old House's darkness and its confining division into many small rooms. On the second floor, above the long room, stood another ample space, a study with a fine marble fireplace where both Adamses wrote hundreds of letters.

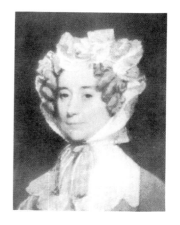

Despite the improvements, the Old House could still disappoint a woman accustomed to the palaces and villas of the Old World. In the fall of 1801, John Quincy returned from Europe with a bride, the former Louisa Catherine Johnson. The daughter of an American merchant, Louisa had grown up in England and France, and she was dumbfounded by the coarseness of life in her "native" land. The smallness and drabness of the Adams house was only part of it. Everything from the roads to the clothes appalled her. "Had I stepped into Noah's Ark," she wrote, "I do not think I could have been more utterly astonished."

In many ways, John Quincy Adams was an exaggerated version of his father. "Oh! that I should have a home!" the father had once written. "But this . . . has never been permitted me. Rolling, rolling, rolling into the bosom of mother earth." But John Quincy was the truly homeless one, the real rolling stone. After a brief stint in the Senate, and in an awful country house five miles from Washington, he accepted a teaching post at Harvard and bought a house in Boston. But the family had barely settled in when he was appointed the first U.S. minister to Russia and he and Louisa, leaving their sons behind at the Old House, set off for St. Petersburg and years of migrating from one wretched, vermin-ridden tenement to another.

When John Quincy Adams brought his bride, Louisa Catherine Johnson, home to America in 1801 she was astonished by the coarseness of life in her new land.

In 1814 John Quincy was dispatched to Ghent, in Belgium, where he negotiated an end to the War of 1812 (again like his father, he was most successful as a diplomat), and from there to Paris. Long-suffering Louisa was then sent the extraordinary instruction to travel overland from St. Petersburg to the French capital, finding some way around the inconvenient obstacle of Napoleon's retreating army. She found a way. At last John Quincy sent for his sons—it had been seven years—and moved his family once again, to London, where he accepted the ambassadorial post. It lasted only until 1817, when the Adamses set sail once again for America, where John Quincy would become secretary of state.

It was not until 1820, when he was fifty-three, that John Quincy Adams acquired something like a permanent home—a fine, three-story townhouse on Washington's

F Street. Formerly the home of James and Dolley Madison when Madison had been secretary of state, the F Street house was among the most elegant in Washington, yet John Quincy set about improving it, adding a coach house and stable and a ballroom nearly thirty feet long and equally wide. The house was purchased less as a personal asset than as a political one, a place to entertain in style. John Quincy was running for president.

America was not yet a true popular democracy in the 1820s. The suffrage was expanding, but by and large the keys to the White House still rested in the hands of a political elite, an elite that savvy politicians courted as breathlessly as lovers. John Quincy, like his father, had all the easy charm of a pit bull, but Louisa was a seasoned master of the social graces. The 1824 presidential campaign was largely waged, and won, in the Adams ballroom.

On January 8, 1824, the Adamses staged a glittering, 900-guest ball to celebrate the tenth anniversary of the Battle of New Orleans. The guest of honor was General Andrew Jackson, the hero of New Orleans and John Quincy's most formidable opponent in the presidential race. The party was a brilliant stroke, demonstrating less the frontier general's worthiness than the graciousness and patriotism of John Quincy Adams. Eight rooms of the F Street house were opened, their doors removed. Everywhere hung laurel wreaths adorned with roses; candles and oil lamps flickered. There was dinner, then dancing, then toasts and responses. Louisa kept the guileless guest of honor by her side all evening. "[E]very body who was any body was there," one newspaper reported, although in fact President Monroe stayed home, preferring to rise above the political fray.

Jackson bested Adams by a narrow margin in that fall's election, but failed to win a majority in the four-way race. The choice was thrown to the House of Representatives, and there, naturally enough, Adams prevailed. The circumstances left many embittered, and John Quincy's presidency became as difficult as his father's. In 1828 he became only the second president (and the second Adams) to fail in a re-election bid, losing to Jackson decisively.

In Quincy, meantime, life was winding down. Abigail succumbed to a stroke in 1818. John Adams lived on to welcome Lafayette to the Old House during the Marquis's grand American tour of 1824, to exchange grandsons with Jefferson, and to see John Quincy elected president. He did not survive to witness his son's defeat. He died at the Old House on July 4, 1826, the fiftieth anniversary of the Declaration of Independence. Jefferson died the same afternoon, at Monticello.

John Quincy was to inherit the Old House and its surrounding 103 acres, on condition that he reimburse the estate for part of the property's value. Louisa, frightened

by the financial burden and feeling little attachment to the Old House, insisted that the farm be sold. "I cannot endure the thought," John Quincy replied. The Old House was the only real home he had ever known; his roots, shallow as they were, were imbedded in the flinty New England soil. John Quincy and Louisa quarreled angrily over the Old House. After leaving the White House, they rented a farm just north of Washington, as Louisa steadfastly refused to move to Quincy.

Another, far more wrenching family tragedy followed John Quincy's acquisition of the Old House. John Quincy's son George, like his brother Charles, had borne the brunt of paternal criticism. John Quincy's stern demands and long absences had alarmed even John Adams, who knew the wages of such behavior. In the months directly following the old man's death, John Quincy, with George in tow, surveyed the Old House land, took inventories, tried to put the estate in order. Bitter arguments and recriminations erupted. George finally quit the work in a lather and fled to his disheveled hermit's rooms in Boston, where he descended ever more rapidly into drunkenness, debauchery, and finally madness. In April, 1829, en route to his parents' Washington farm (John Quincy, at last recognizing his son's distress, had pleaded with him to come), George jumped to his death from a steamboat in Long Island Sound.

John Quincy was not yet through tracing his father's steps. Like the elder Adams, he was to emerge from the depths of his greatest despair with a new mellowness, and with the opportunity to enjoy it. In 1830 Louisa was at last persuaded to take possession of the Old House, and over the next decade the younger Adamses launched major improvements to the property. They planted scores of trees, creating a shady, sloping lawn behind the house. They added a west ell overlooking the garden and a northern passageway on the second floor. They made plans for a free-standing, fireproof stone library to house the two presidents' 14,000-volume collection. It was completed, just north of the garden, by their son Charles Francis Adams, who later became a congressman and the third Adams to serve as minister to England.

The Adamses lived only part time at the Old House in their later years. They continued to reside as well at their gracious F Street home in Washington, for in 1831 John Quincy was elected to the House of Representatives, where he served, doggedly as always, for his final seventeen years. He became one of the first great Congressional critics of slavery, defending the right of any American to petition Congress on any subject, including the South's peculiar institution.

On February 21, 1848, John Quincy Adams suffered a stroke and collapsed on the floor of the House. Perhaps fittingly, he never made it home. He died two days later in the Speaker's chamber.

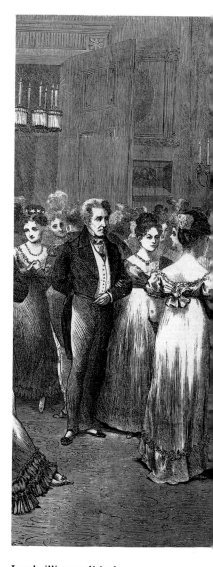

In a brilliant political stroke, John Quincy Adams threw a glittering party at his Washington home to honor Jackson, his rival for the presidency.

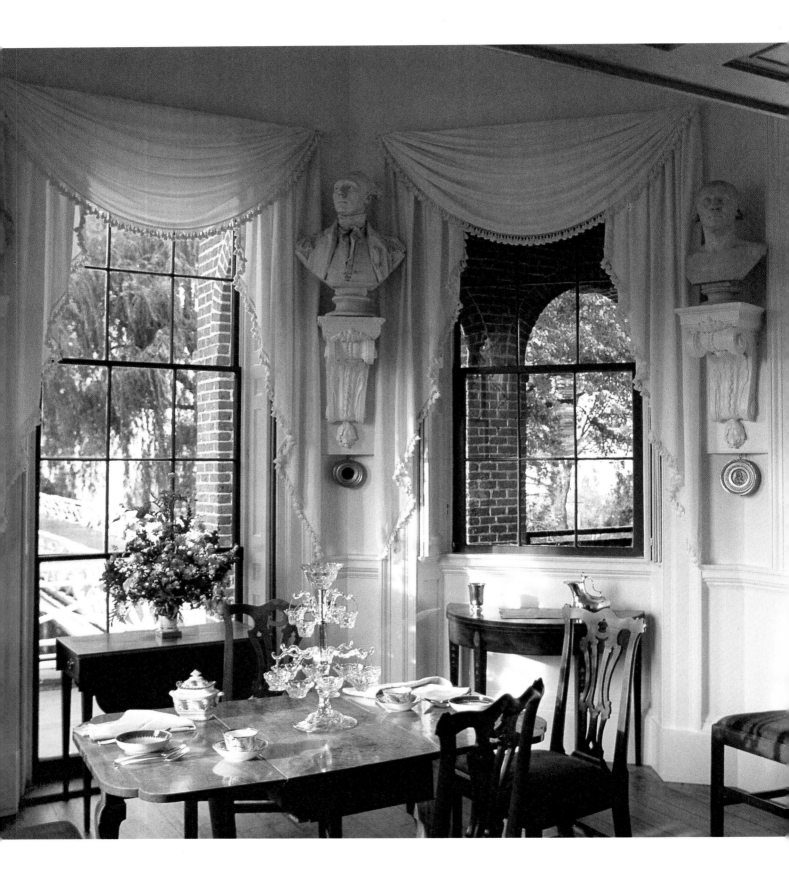

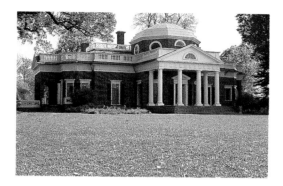

Thomas Jefferson

THOMAS JEFFERSON'S EPITAPH, which he wrote for himself, doesn't bother to mention that he was twice elected president of the United States. Nor does it cite his service as vice president, secretary of state, minister to France, member of Congress, or governor of Virginia. It's not every resume that can survive such omissions, but Jefferson was confident. On his tombstone he wanted "the following inscription, and not a word more: Here was buried Thomas Jefferson, Author of the Declaration of American Independence, Of the Statute of Virginia for Religious Freedom, and Father of the University of Virginia."

The epitaph is quintessential Jefferson: self-consciously artful and modest. Jefferson had an acute sense of his place in history, and he knew that an obelisk listing all of his achievements would merely numb future visitors to his gravesite. But a master-piece of understatement, *that* would intrigue them and set them to thinking.

It doesn't matter which feature of Jefferson's life you examine, the result is the same: astonishment, bordering on disbelief, at the man's inexhaustible energy, curiosity, and genius. He was not America's greatest president, but he was by far the most versatile. Among many other things, Jefferson was an accomplished lawyer, agron-omist, inventor, linguist, philosopher, naturalist, archaeologist, musician, essayist, and architect, and at one time or another he proclaimed each of those pursuits his

"supreme delight" or "the favorite passion of my soul." Only politics, to which he devoted four decades, seems never to have struck him as the worthiest vocation known to man. "Nature intended me for the tranquil pursuits of science...," he wrote. Only "the enormities of the times in which I have lived have forced me... to commit myself on the boisterous ocean of political passions."

More than any other president, Jefferson is best understood through his private rather than his political enthusiasms. Scientist, artist, philosopher, he never let public life deter him from those loftier interests. As Minister to France he spent endless hours studying the architecture and gardens of Paris, and sending seeds home to his experimental plots. "The greatest service which can be rendered any country," he claimed, "is to add a useful plant to its culture." As president he had Mastodon bones, shipped from the Lewis and Clark expedition, scattered about a White House ballroom, and could be found scurrying about on all fours, studying the treasure with boyish glee.

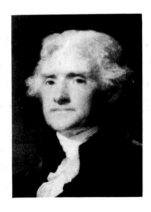

America's da Vinci, Jefferson was a genius whose "essay in Architecture," Monticello, may never be exceeded for elegance and quirkiness. The sun-washed tea room (overleaf), its faceted walls adorned with busts of the famous, was Jefferson's favorite space in the mansion.

The center of Thomas Jefferson's world was Monticello, his plantation at the summit of a prominent peak amid the undulating foothills of the Blue Ridge Mountains. He called it "my essay in Architecture," but it was also his observatory, his museum of natural history and oddball gadgets, his agricultural laboratory, and his model of perfection. Never was a man more determined to put his notions of virtue, beauty, and progress (to Jefferson all more or less the same thing) into action. Very little that was of interest or value to him went without expression on his "little mountain."

He chose the site of his home early on; it stood just across the Rivanna River from his father's plantation, Shadwell, in central Virginia's Albemarle County. One day in the 1750s, Jefferson and his best boyhood friend, Dabney Caar, hiked their favorite hill and found a spreading oak near the summit. There they took a vow, solemn as only the vows of youth can be. They would both be buried at this spot. In 1773, Dabney Caar, by then Jefferson's brother-in-law, became the first person laid to rest in the Monticello graveyard, which serves Jefferson's family to this day.

Jefferson loved the lush Virginia hill country as nothing else in life. Nature was not exactly God in Jefferson's thinking, but it was close enough, and he was convinced that North America was the crown of creation. "Europe is a first idea," he wrote, "a crude production, before the maker knew his trade, or had made up his mind as to what he wanted." The craft had been perfected at Monticello. "[W]here has nature spread so rich a mantle under the eye? mountains, forests, rocks, rivers. With what majesty do we there ride above the storms! How sublime to look down into the workhouse of nature, to see her clouds, hail, snow, rain, thunder, all fabricated at

our feet! And the glorious Sun, when rising as if out of a distant water, just gilding the tops of the mountains, and giving life to all nature!"

In the eighteenth century, building a mansion at the peak of a steep, 867-foot hill was no simple matter. In 1768, Jefferson, then twenty-five and already a rich man by inheritance, ordered the summit of Monticello cleared and leveled, and contracted for 100,000 bricks to be fired on the site. The project became more urgent two years later when Shadwell burned to the ground. Jefferson, his attention riveted on his mountaintop, mourned mostly for his books and refused, then and later, to be hurried with his masterpiece. "Architecture is my delight," he wrote, "and putting up and pulling down, one of my favorite amusements." He kept putting up and pulling down at Monticello for more than forty years, complaining as late as 1799, "It seems as if I should never get it inhabitable."

Jefferson's wife, Martha, never saw the finished product. When she arrived at Monticello in the winter of 1772, she moved with her husband into the south pavilion, a tiny brick cottage where, Jefferson reported, one room served, "like the cobbler's . . . for parlour, for kitchen, and hall. I may add, for bedchamber and study, too." The marriage, by Jefferson's account, was one of "unchequered happiness," and we have no basis to doubt him since he destroyed all the letters the relationship produced. Certainly, though, there were interludes of sorrow. Of six children, only two daughters survived infancy. The crushing blow fell in September, 1782, when Martha died after another difficult childbirth, plunging her husband into "a stupor that rendered me as dead to the world as she" He never remarried.

Altogether, the early 1780s were Jefferson's nadir. The heady philosophical combats of the early revolution had given way to the barbarism of real war. As military governor of Virginia from 1779 to 1781, for the first and last time in his life, Jefferson was a failure. He could not bring himself to seize the reins of command and rule by fiat. Shortly after he stepped aside in favor of a military man, the war came to Monticello itself, when word arrived one June morning that a troop of British cavalry was charging up the little mountain. Jefferson hustled his family into a carriage, leapt to his horse, and galloped into the forest, narrowly eluding capture and likely the gallows. So fragile was Jefferson's ego at the time that he dignified jests about his flight with an angry response. "These closet heroes, forsooth, would have disdained the shelter of a wood . . . against a legion of armed enemies." The British spared Monticello, although other Jefferson properties were torched.

From 1784 through 1789, Monticello was closed, as Jefferson was in Paris serving as American minister. Much about France shocked him—the poverty and corruption, the loose morals. But he could not help loving the sensuous, philosophical French

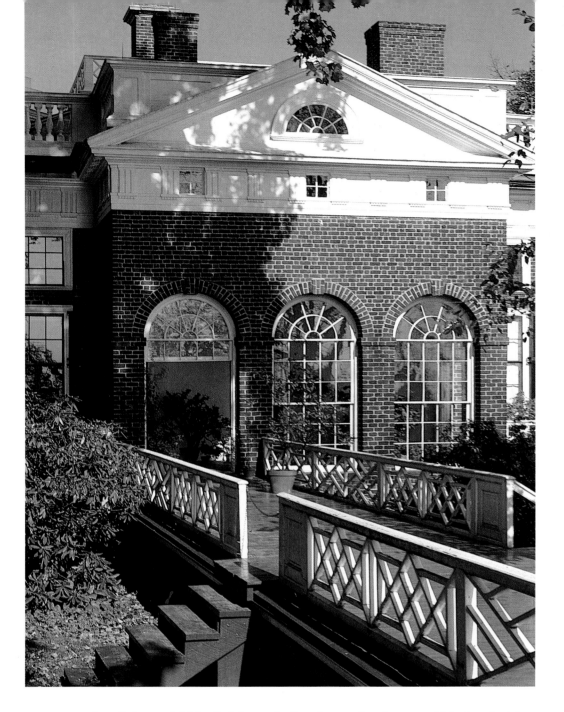

Like the tea room, Jefferson's private suite opened onto an L-shaped terrace, under which were tucked the plantation's "dependencies": stables, ice house, workshops, etc.

any more than John and Abigail Adams, in London at the time, could help admiring the cool, pragmatic English. As Jefferson's spirits lifted, good-natured quarrels ensued among the Americans over the merits of their respective posts. "I fancy it must be the quantity of animal foods eaten by the English which renders their character insusceptible of civilization," Jefferson wrote to Abigail. "[I]t is in their kitchens and not in their churches that their reformation must be worked."

Above all, it was French architecture that enchanted Jefferson. He had left behind at Monticello a formal, classical house along strict Palladian lines, with matching columned porticoes front and back, porticoes that he envisioned raising to two full

stories. In France he found a more flexible and idiosyncratic classicism, and liked it. "Here I am, Madam," he wrote to a friend while touring southern France, "gazing whole hours at the Maison Quareé, like a lover at his mistress." If his correspondent thought a man's falling in love with a house "without precedent," she was wrong. "[I]t is not without precedent in my own history. While in Paris I was violently smitten with the Hôtel de Salm." The Hôtel de Salm was an elegant townhouse with an unusual feature: a dome.

Jefferson had barely touched American soil when he received a message from George Washington, insisting that he become the nation's first secretary of state. He accepted, committing himself to the second great philosophical struggle of his life. His adversary would be Treasury secretary Alexander Hamilton, and it is only a slight exaggeration to reduce the early history of American democracy to the collision of these two colossal intellects. They disagreed over just about everything, but at bottom their dispute was about the nation they expected, and wanted, America to become. Hamilton envisioned a populous commercial and manufacturing giant, and sought a powerful, centralized government to nurture it. Jefferson dreamed of a loose association of widely scattered farmers, who could look after their own affairs.

It is not accidental, of course, that Monticello was a farm — 5,000 acres' worth— or that Jefferson was among the most inventive agronomists of his age. (Nor was it coincidence that Hamilton was a New Yorker, closely allied with the city's merchants and financiers.) At Monticello Jefferson experimented with literally thousands of plants and varieties, among them many kinds of grapes, upland rice (which he hoped might replace the unhealthy "wet" rice industry of the deep south), and olive trees. He invented a plough that stood unchallenged for decades as having a mouldboard of minimum resistance, and as with his other inventions, he refused to patent it. Together with his son-in-law, he introduced contour plowing to American agriculture.

The step from private passion to political conviction was a short one for Jefferson. His aesthetic likes and dislikes corresponded neatly in his mind to virtue and vice. "No occupation is so delightful to me as the culture of the earth," he wrote, "and no culture comparable to that of the garden." So Americans must stay on the land. "Those who labor in the earth are the chosen people of God," he argued in *Notes on Virginia*, "....the proportion which the aggregate of the other classes of citizens bears in any state to that of its husbandmen is the proportion of its unsound to its healthy parts....let us never wish to see our citizens occupied at a workbench....let our workshops remain in Europe."

The political currents of the 1790s and early 1800s ran strongly in Jefferson's favor, and in the end he crushed Hamilton and the political movement he embodied. But

the tide of history ran differently. Even within Jefferson's lifetime, Hamilton's America was emerging.

Jefferson's architecture—at the Virginia state capitol in Richmond, at the core campus of the University of Virginia, and at Monticello—has triumphed in the test of time. His home may never be excelled for sheer elegance, exuberance, and quirkiness. On his return from France, Jefferson unroofed his house, demolished its second story, and virtually began anew. He stuck with his classicism, modeling the decor of each "public" room after a particular classical order (Doric, Ionic, etc.), and copying the design for his dome, the first on an American home, from the Roman temple of Vesta. But otherwise he had an entirely new plan.

Jefferson's aim was to expand from eight rooms to twenty-one, and make his house appear smaller in the process. He installed skylights, fourteen in all, to eliminate the need for upper-story windows (there are a few, at floor level). Then he designed second- and third-story bedrooms to slip under a sharply sloped roof and obscured them further with two "widow's walk" railings. Monticello is a three-story home that looks for all the world like one story, after the Parisian style.

Also from the Parisians, Jefferson adopted a distaste for grand staircases. Monticello's are twenty-four inches wide and go virtually unnoticed. He relished the feeling of formal, uncluttered space. Most of Monticello's bedrooms have alcove or recessed beds, making even small chambers suitable as sitting rooms. Throughout the house are tall, many-paned windows that rise from the floor and are triple-sashed, so that they can be opened as doorways. Many of the smaller rooms are octagons or partial octagons, a shape that intrigued Jefferson and whose facets create added interest and a sense of greater space. The dining room houses two dumbwaiters and a revolving

Even family members were barred from Jefferson's private four-room suite in Monticello's south wing. Here the philosopher-president kept his enormous library, which he estimated at 9,000 to 10,000 volumes, including "all that is chiefly valuable in science and literature..." (Jefferson thought a volume called *The History of Cold Bathing* valuable; he began each morning by washing his feet in cold water.) In 1814, after the British had burned the Capitol in Washington and with it Congress's embryonic library, Jefferson sold some 6,000 books to the government, the beginning of today's Library of Congress.

Jefferson had himself invented a "copy-press" for making duplicates of letters, but around 1805 he came upon a strange contraption called the "polygraph," which connected two pens with wires so that one would crudely trace a letter as the other was used to write it. Jefferson thought it "the finest invention of the present age," and it found its way to his Monticello suite. Jefferson complained bitterly about "the

persecution of letters." He counted 1,267 he had answered in 1820, and asked John Adams, "Is this life? At best it is the life of a mill-horse." Adams would probably have preferred the life of a mill-horse to a life without letters; he wrote three to Jefferson's one throughout their long correspondence.

Jefferson, at any rate, loved gadgets for their own sake. Monticello's entrance hall features his calendar clock, which through a system of weights indicates the day of the week along with the time of day. All seven days would not fit on the wall, so Jefferson cut a hole in the floor to let Friday and Saturday register in the basement. The entrance hall also housed Jefferson's collection of Indian relics and natural-history artifacts, one of the best in America at the time. The parlor is surrounded by "automatic" French doors — open one and its opposite number is swung open by gears beneath the floor. It's hard to see much practical use in such contrivances, but Jefferson was no slave to utility. Monticello's octagon dome, complete with porthole windows that open on a spindle, was built solely for its architectural interest. It was used mostly as a storeroom.

Jefferson wanted Monticello's grounds to be formal and park-like. Unlike Washington, he would not abide the chaos of plantation life swirling about his mansion—not within sight, at least. He had the farm's "dependencies" (stables, ice house, smoke house, etc.) cut into the slopes rising toward the west lawn and the oval "roundabout" walk lined with flower beds. Then he built an L-shaped terrace off each end of the house, the terraces' floors serving as the dependencies' roofs, rendering the business part of the plantation invisible from the mansion. An under-ground tunnel emerged from the mansion's basement and led to each row of dependencies; along the tunnel lay the kitchen, rum cellar, and wine cellar, linked to the dining room by dumbwaiters.

It's hard to imagine a home more vividly capturing its owner's personality. Subtle, ingenious, and scrupulously lovely, Monticello can strike a modern visitor as faintly arid and cold. It is perhaps too obviously an "essay in architecture," a work of art, and one strains to imagine it as a home. There are too few accidents, too few compromises; Monticello's oddities are as calculated as its proportions. But that was Jefferson, prophet of perfectibility—nothing he ever saw seemed too good to be true.

It may have been the elusiveness of perfection in politics that made Jefferson disdain the profession. As president he bent principle to necessity with the best of them. In many respects, of course, he applied his ideals rigidly: he cut government's budget, virtually scuttled the American Navy, repealed the repressive Alien and Sedition Acts, and discarded the "monarchical" trappings of Washington and Adams. But Jefferson's most important presidential acts were expedient compromises. A

lifelong Francophile and Anglophobe, he became ready, when Napoleon took possession of Louisiana, to "marry [America] to the British fleet." When the Emperor surprised him by offering to sell Louisiana, he jumped at the deal, although he had always been the strictest of strict constructionists and was quite certain that the Constitution gave neither the president nor Congress authority to make such a purchase. The nation would have to overlook such "metaphysical subtleties."

Jefferson left office in 1809, a popular, even a revered man. He was happy to go. "Within a few days I retire to my family, my books and farms," he wrote just prior to Madison's inauguration, "and having gained the harbor myself, I shall look on my friends still buffeted by the storm with anxiety indeed, but not with envy. Never did a prisoner released from his chains feel such relief as I shall...."

Jefferson's final seventeen years were by and large happy ones. Monticello at last was completed and he was there to enjoy it. Incredibly, he lamented to a friend that his creation was "so subordinated to the law of convenience." He never left Virginia again, but as the years passed he spent more and more time tinkering at Poplar Forest, a small estate about 100 miles from Monticello. It was almost as though his little mountain, its architecture and landscape perfected, could no longer satisfy his creative yearnings. Soon he turned to the founding, and the architectural design, of the University of Virginia, "the last act of usefulness I can render."

When his wife died, Jefferson had been left with two young daughters (one died during his presidency). He had raised them mostly from a distance, but with evident devotion, and had provided for them a more substantial education than was customary for women at the time. The reason he gave was that he calculated at "about" fourteen to one, "the chance that in marriage [they] will draw a blockhead," and thus be responsible for the education of their own children. One of the delights of Jefferson's autumn was supervising his grandchildren's education himself. He kidded Abigail Adams that he was ahead of his friends in the production of progeny. "I have ten and one-half grandchildren, and two and three-fourths great-grandchildren, and these fractions will ere long become units."

Two mounting tragedies darkened Jefferson's last years. One was his deteriorating financial condition. A lavish lifestyle, inadequate salaries in public life, and an agricultural depression entered into the disaster, as did imprudent generosity. By the final year of his life Jefferson was plainly bankrupt and desperately sought permission to sell some of his lands by lottery. He held on to Monticello long enough to die there, but he died perhaps $100,000 in debt. His heirs were soon forced to liquidate the property.

Before his death Jefferson had stayed abreast of public affairs. In 1820 he heard

his famous "fire-bell in the night.... I considered it at once as the knell of the union." The alarm was the Missouri Compromise, which divided America permanently between free states and slave states. All his life Jefferson had remained confident that the slavery question would somehow be peacefully resolved, but "a geographical line...once conceived and held up to the angry passions of men will never be obliterated; and every new irritation will mark it deeper and deeper...." He was right, of course, but by then he could only suggest that slavery be allowed to expand.

For nearly 200 years Jefferson's reputation has been clouded by the rumor that he sexually used the slave women at Monticello, in particular one Sally Hemmings. The story was first spread in 1802 by James Callendar, a "journalist" to whom Jefferson had given money and support when he was poisoning the reputations of Federalists, but who later turned on his benefactor when denied a political job. Most recently, in 1974, the story was resurrected in Fawn Brodie's *Thomas Jefferson: An Intimate History*. There has never been anything but circumstantial evidence to support the charge, along with the simple fact that many slaveowners succumbed to the temptation of the slave quarters. It is certainly possible that Jefferson was among them, but it is by no means certain. Abigail Adams, who did not believe the story, should have had the last word. "When such vipers [as Callendar] are let loose upon society," she scolded Jefferson, "...all respect for character is lost."

Jefferson was one of America's largest slaveowners; he built his mountaintop mansion with chattel labor. While that saps some of the sweetness from his ringing defenses of liberty, there appears to be comfort in his equally ringing condemnations of slavery. "The whole commerce between master and slave is a perpetual exercise of...the most unremitting despotism.... Indeed I tremble for my country when I reflect that God is just; that his justice cannot sleep forever." The Old South, of course, was crowded with guilty consciences, and though Jefferson was more eloquent than most in venting his, eloquence came to him like breathing. Like most Americans of his time, Jefferson simply could not imagine welcoming free blacks into American society.

Jefferson was too optimistic a man to let private or public troubles drive him to despair. Amid the fields and gardens of Monticello he felt himself in paradise, as wonder struck as a child. "But though an old man," he assured a friend in 1811, "I am but a young gardener." Years later he replied to John Adams: "You ask if I would agree to live...over again? To which I say, yea. I think with you that it is a good world, on the whole; that it has been framed on a principle of benevolence, and more pleasure than pain dealt out to us.... I steer my bark with Hope in the head, leaving Fear astern. My hopes, indeed, sometimes fail; but not oftener than the forebodings of the gloomy."

James Madison, James Monroe

THE 1790s WERE A SPLENDID time to be young and beautiful and in Philadelphia—the gay, chaotic capital of the fledgling United States. Dolley Payne Todd, a twenty six-year-old Quaker widow, couldn't help enjoying herself. Bright, cheerful, raven-haired, and shapely, she was perhaps the most eligible young woman in town. "Gentlemen would station themselves where they could see her pass," a friend reported, and later warned Dolley to "hide thy face, there are so many staring at thee." In May, 1794, a gentleman who had done some of the staring decided to make his intentions plain. Dolley scrawled a breathless note to her friend: "Thou must come to me. Aaron Burr says that the great little Madison has asked...to see me this evening."

At age forty-three, James Madison had decided to settle down. He would wait months for an answer to his proposal. A Quaker, widowed less than one year, Dolley could not expect to marry a wealthy politician, a non-Quaker and a slaveholder, without being denounced and expelled by her sect. She cherished her faith's close-knit community, its confidence in the "inner light," and its doctrine of sexual equality. But she had always chafed under Quaker asceticism, unable to see the harm in parties, high spirits, and stylish clothes. Her friendship with Aaron Burr, a stranger to self-denial, demonstrates her taste for lively company.

Madison, too, was supremely eligible, though many of his friends had written him off as a lifelong bachelor. He had rarely shown profound interest in the opposite sex, and still less in the comforts of domestic life. Heir to Montpelier, a magnificent, 5,000-acre plantation in Orange County, Virginia, he had taken charge of the farm's affairs only within the past several years—and only then, it seemed, because his younger brother had suddenly died. Intense, self-absorbed, ambitious, Madison had been the complete public man, driven by a private sense of destiny.

He had met his destiny, becoming "the great little Madison," at the Constitutional Convention of 1787. Madison was convinced that American democracy was doomed unless a stronger central government was established. He arrived at the Federal

Convention—ostensibly called to improve commercial relations among the states—armed with a blueprint for a new national government. After months of debate, Madison's "Virginia Plan" emerged, slightly altered, as the Constitution of the United States. During the ratification battle that followed, Madison joined Alexander Hamilton and John Jay in writing *The Federalist Papers*, the most important defense of American political theory ever written.

It's not likely that Dolley Todd understood Madison's achievement in detail. But he was a famous man, if not an especially dashing one. Short (five feet six) and balding, with a long fleshy face and intense gray-blue eyes, Madison was shy and formal in society, but warm, talkative, and funny among friends. In September, 1794, the much-admired Mrs. Todd became Dolley Madison.

If Madison knew of his bride's ambivalence, he probably understood. During his years of wandering he had been tormented by indecision over his birthright, Montpelier. He feared and hated slavery, and recoiled at the thought of becoming a master. He thrived on the energy of Richmond, Williamsburg, New York, and Philadelphia. His friend Thomas Jefferson, knowing Madison's divided mind, had for years urged him to buy land near Monticello. But something had always caused him to hesitate, some visceral sense that Montpelier was home.

Montpelier had been founded in 1729 by Madison's grandfather Ambrose, on what was then the fringe of the wilderness. Ambrose owned considerable tracts further east, but here in the Piedmont lay some of Virginia's finest country—gentle folds of rich, red earth, deep with virgin forests of oak and hickory. In the near distance loomed the beautifully mysterious horizon of the Blue Ridge Mountains—sometimes faint as mist, sometimes close, craggy, and forbidding. When Madison was growing up at Montpelier in the 1750s, Indian attack was still a real threat, and the large family (James was the eldest of twelve children) lived in a rugged, utilitarian cabin as the mansion house was laboriously constructed on a nearby hill.

By 1797, when James and Dolley finally settled at Montpelier, the plantation was one of the most beautiful in America. The mansion was nicely placed on a breezy slope, facing a broad lawn that dropped away to the Rapidan River, behind which rose the Blue Ridge. It was a large rectangular house of two and one half stories, comfortable and simple. James and Dolley immediately began to add elegant touches. They had already ordered a large shipment of French furniture through James Monroe, American Minister to France—most of it abandoned by aristocrats who had fled the French Revolution. Now they added French doors, fine hardwood flooring, and elegant hardware. Madison took special interest in transforming Montpelier's front porch into a formal Doric portico and covering the mansion's brick exterior with a

Overleaf: At a round desk in the rounded "Treaty Room" in the Octagon House in Washington, D.C., Madison signed the Treaty of Ghent, which ended the War of 1812 and marked the zenith of his presidency. Its nadir, the torching of the White House during that war, had forced him to use the Octagon House as a temporary executive mansion.

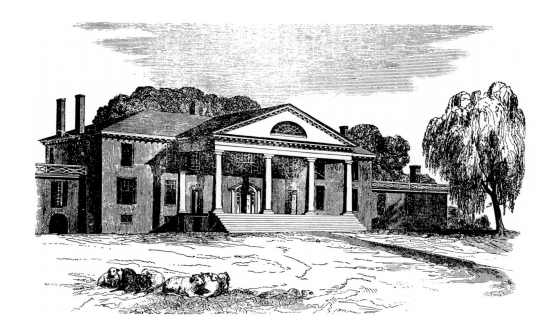

Restlessness and guilt over slavery made Madison ambivalent about Montpelier, the 5,000-acre family plantation in Orange County, Virginia. But once settled there in 1797, he became America's best farmer, in Jefferson's judgment, and certainly one of its happiest.

thick coat of limestone plaster. Around 1809, Madison had matching one-story wings added to either end of the house, making it about eighty feet long and forty wide.

Montpelier was not, in Madison's day, an architectural showpiece like Monticello, but its decoration was handsome and lavish. Mrs. Samuel Smith, an admiring visitor, found "airy apartments—windows opening to the ground, hung with light silken drapery, French furniture, light fancy chairs, gay carpets." The central drawing room had small comfortable sofas upholstered in red and a great Persian rug. It became known as the "Hall of Notables" for the many portraits and busts of American heroes: Franklin, Washington, Lafayette, Adams, Jefferson, and Madison himself. It "had more the appearance of a museum of the arts than of a drawing-room," said Mrs. Smith. The Madisons had a passion for patriotic symbols; the formal flower garden was laid out as a horseshoe, mimicking the chamber of the House of Representatives.

Madison's durable mother Nelly lived on at Montpelier until her death, at age 98, in 1829. She maintained an entirely separate household in the mansion's south wing. Devoted to her daughter-in-law, Nelly told Mrs. Smith, "She is *my* mother now, and tenderly cares for all my wants." Dolley Madison's good nature is the stuff of legend. Freed from Quaker restraints, she proceeded to set a standard for stylish entertaining that every First Lady since has been hard pressed to match.

Dolley had style. Though she would often putter about Montpelier or the White House all day in a gray, straight-cut Quaker dress, by night she unfailingly appeared in the latest and most daring fashions, being especially fond of turbans and de'colletage.

Breathtakingly beautiful and good natured, Dolley Madison probably was, as James called her, "the greatest blessing" of his life.

The alluring (mostly French) styles that so enchanted Dolley's generation appalled Abigail Adams when she first saw them in the 1790s—"too scant upon the body and too full upon the Bosom....they look like Nursing Mothers." Some observers, of course, took a different view. After attending a White House reception, Washington Irving rather insolently reported, "Mrs. Madison is a fine, portly, buxom dame."

She was also, by every account, genuinely warm and generous. She had "a smile and a pleasant word for everybody," Irving allowed, and another observer credited her with "the happiest of all dispositions—a wish to please and a willingness to be pleased." The Madisons' marriage, though it never produced children, proved almost ridiculously happy. James called Dolley, simply, "the greatest blessing of my life." Throughout his crisis-wracked presidency he retreated to his wife several times each day. In her presence, he said, he could count on enjoying "a bright story and a good laugh...as refreshing as a long walk." At Montpelier, on rainy days, the Madisons took their exercise by racing one another across the mansion's portico.

Mrs. Samuel Smith left a record of Montpelier hospitality in her diary: "We were met at the door by Mr. Madison who led us into the dining room where some gentlemen were still smoking segars and drinking wine. Mrs. Madison enter'd the moment afterwards...saying with a smile, I will take you out of this smoke....She took me thro' the tea room to her chamber which opens from it....She loosened my riding habit, took off my bonnet, and we threw ourselves on her bed....No restraint, no ceremony. Hospitality is the presiding genius of this house, and Mrs. Madison is kindness personified."

The dominant event of James Madison's presidency was the War of 1812, a war that probably should not have been fought. The cause was American outrage over Britain's blockade of Napoleon's Europe and the resulting harassment of American shipping. The United States was in no position to challenge Great Britain, but Madison saw war as the only means to defend American honor. Despite some surprising successes at sea, the overmatched, poorly led American forces took a steady thumping.

American honor dipped to something like an all-time low in August, 1814, when a British army marched virtually unopposed into Washington, D.C., and proceeded to torch what English newspapers still liked to call "the proud seat of that nest of traitors" (for the most part only public buildings, the White House and Capitol among them, were burned). Dolley Madison, left to make her own escape, stopped on her way out of the White House to cut the famous Gilbert Stuart portrait of Washington from its frame, saving it from the flames.

The British attack on Washington had one purpose—to humiliate and dishearten America. Madison, though a poor strategist, understood psychology. He ordered

the government back to its smoldering capital three days after the British attack, insisting that officials endure whatever makeshift housing and meeting space could be arranged. He and Dolley moved into the Octagon House, an elegant townhouse built in 1800 by Colonel John Tayloe. A peculiar home, designed to fit the seventy-degree angle formed by New York Avenue and 18th Street, it was not an octagon at all but a hexagon with a rounded front. Yet it was big and bright, and served handsomely as a temporary president's mansion. There James Madison lived out his darkest and most joyful days.

In February, 1815, Madison received at the Octagon two glorious pieces of news. First came word of Andrew Jackson's crushing victory in the Battle of New Orleans. A week later, a satisfactory peace treaty arrived from negotiators meeting in Belgium. Jackson's battle, fought weeks after the treaty was signed, had nothing whatever to do with the war's outcome, but few Americans were disposed to dwell on such details. It certainly appeared that America had won a "second war of independence." In the closing years of his presidency, Madison became, for the first time, almost as popular as his wife.

During his twenty-year retirement at Montpelier, Madison shared the struggle of many of the planters of his generation: the struggle for financial survival. Unlike many, Madison survived, despite a stepson's "strange and distressing career" as a gambler and speculator. Over the years, Madison spent at least $40,000 to keep Payne Todd out of debtor's prison. The cancerous slavery problem was another shadow on Madison's last years. His guilt and dread on the subject never lessened, but he was no better able than most Southerners to face the issue squarely.

Still, James Madison enjoyed an idyllic retirement, if any president did. He was on the whole quite satisfied with the way American history was proceeding, and with Dolley he remained, to the end, as blissful as a newlywed. A visitor to Montpelier in the late 1820s found the old man "very hale and hearty—the expression of his face is full of good humour." Another guest thought that the aging Madisons, home at last on the farm James had almost abandoned, "looked like Adam and Eve in Paradise."

In the last year of Madison's presidency, the ubiquitous Aaron Burr wrote to his son-in-law complaining of what he called the "Virginia junto," which had held the presidency for twenty four of the Constitution's first twenty eight years and seemed to "consider the United States as their property." The presidential candidate the Virginians were putting forward that year, Burr thought, was scarcely fit to vote. "Naturally dull and stupid; extremely illiterate; indecisive to a degree that would be

incredible to one who did not know him; pusillanimous, and of course hypocritical; [he] has no opinion on any subject and will always be under the government of the worst men."

James Monroe, the last member of the "Virginia Dynasty" and the object of Burr's unreasoning scorn, was in fact a new kind of a president. Washington, Adams, Jefferson, and Madison were, by any measure, colorful and exceptional men — natural leaders, as Adams might have put it. Monroe, though far from stupid or illiterate, was undeniably dull as stone. In a long and varied public career he had proved himself capable and honest, but never brilliant, and it was true that he owed his prominence largely to his friendship with brighter lights—mainly Jefferson and Madison, doubtless the "worst men" Burr had in mind. Monroe, in short, was the first ordinary man to reach the presidency. He was also the first ordinary man to prove a success in that office.

Monroe was born in 1759, the son of a "gentleman carpenter." His boyhood home was a two-story wood frame house surrounded by unbroken forest. Its large first-floor chamber served as living room, kitchen, and dining room in one. Closer to a woodshed than a mansion, the home stood in Westmoreland County in Virginia's Northern Neck, amid the manorial estates of the Carters, the Lees, and the Harrisons. Painfully aware that he did not belong to the first rank of society, Monroe developed a tender sensitivity to perceived insults that would cause him grief in later life.

Monroe's father was affluent enough to send his son to the College of William and Mary in Williamsburg. On his father's death Monroe's expenses were assumed by his prominent and modestly wealthy uncle Judge Joseph Jones. At eighteen Monroe abandoned his schooling and rushed off to join Washington's army in New York. He served bravely at Trenton, Monmouth, and other battles, but was hard pressed to make a name for himself in Washington's officer corps, crowded with the likes of Burr and Hamilton. Frustrated, Monroe left the army and took up the study of law in Virginia under the tutelage of Governor Jefferson. It was his most fortunate decision, but not because he ever became much of a lawyer.

Monroe had sold his father's home and moved temporarily to a small family property in King Georges County. Unexpectedly, the citizens of that county promptly elected the young man to the Virginia House of Delegates, probably inspired by his war record and his connection to Jefferson. A year later, in 1784, they sent him to Congress. There Monroe, together with Madison, became an early champion of the "men of the western waters," the frontier settlers, opposing the selfish schemes of "flagitious" eastern statesmen. By 1786 Monroe was anxious to return to private life and get his legal career underway, partly because he planned to marry. New York society was

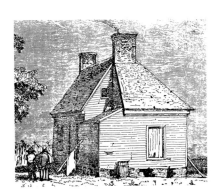

James Monroe, the son of a "gentleman carpenter," grew up in a plain wooden farmhouse in Virginia's Northern Neck, a region crowded with lavish estates.

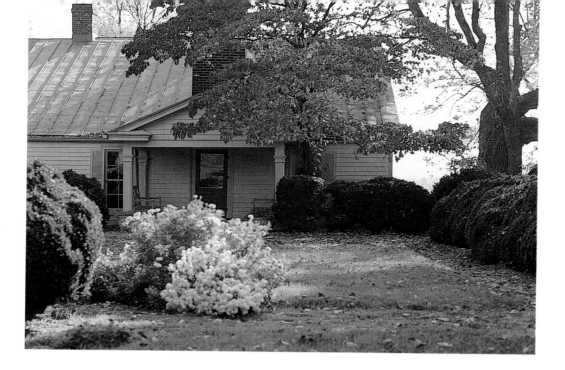

Highland, Monroe's "cabin-castle" near Monticello, was more cabin than castle. But its stunning setting in the Blue Ridge foothills and its proximity to Jefferson made it a happy home for Monroe, who saw several children born there.

dumbstruck that winter by the revelation that Elizabeth Kortright, a beautiful, snooty, much-sought-after young aristocrat, had become engaged to "a not very attractive Virginia Congressman," as one socialite put it.

Miss Kortright had better taste than her friends. Monroe was a tall, slim, vigorous young man with a narrow, bony face and sleepy blue eyes that had, said one observer, "more kindness than penetration." The kindness, though, was real. Virtually every surviving recollection of Monroe notes a mediocre intellect and a heart of gold. He "is not a brilliant man," wrote one colleague, "[but] he is a man of great good sense, of the most austere honor, the purest patriotism and the most universally admitted integrity." Jefferson, as usual, left the most famous assessment: "He is a man whose soul might be turned wrong side outwards without discovering a blemish."

In the winter of 1786-87, the newlyweds moved to Fredericksburg, and into the home of Monroe's uncle, Judge Jones. By spring Monroe wrote gloomily to Madison that neither his law practice nor Fredericksburg provided him with "materials to form a letter worthy of your attention." His restlessness was aggravated by a desire to establish his own homestead, and to establish it in Albemarle County, as near as possible to the mountaintop home of his mentor. "Believe me I have not relinquished the prospect of being your neighbor," he wrote to Jefferson. "...[T]o fix there and to have yourself in particular, with what friends we may collect around for society is my chief object, or rather the only one which promises to me...real and substantial pleasure." Jefferson, ever watchful over his supply of congenial company, encouraged the idea. "I wish to heaven you may continue in the disposition to fix...in Albemarle."

Jefferson needn't have worried. Monroe's disposition was fixed. In 1789 he purchased an 800-acre farm near Charlottesville, several miles from Monticello. The house was

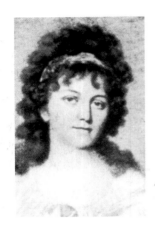

Elizabeth Kortright stunned New York high society with her decision to wed the mundane Monroe. But the sickly, somewhat ill-tempered First Lady found little cause for complaint during forty-four years of marriage.

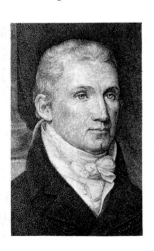

a small brick structure of vaguely Italian appearance. Monroe enlarged it and painted it white, and pressed a nearby building into service as a law office. Almost immediately he launched plans to move still closer to Monticello, to an adjoining parcel high in the verdant hills above Charlottesville, where he would build his "cabin-castle."

Highland, the name Monroe gave to his hill-country plantation (subsequent owners renamed it Ash Lawn), turned out to be more cabin than castle—a low, one-story wood-frame house with a sharply sloped roof. It contained no spacious ballroom, no decorative cornices, little sign of the self-conscious style so characteristic of the period's mansions. A miniature arched portico off the home's front was almost sad. Highland's setting, though, was striking, a broad rolling hollow ringed by forested peaks, on one of which sat Monticello, just visible from Highland's front door in winter. So plain and parsimonious is the house that still stands at Ash Lawn (it is the rear portion of the current mansion), that some historians have doubted that it can have been Monroe's home, speculating that the surviving structure was in fact an overseer's cottage. But the house seems too large and fine for that, and Monroe's decision to build a more gracious mansion after he became president suggests that he knew Highland left something to be desired.

Some of the incredulity about Highland stems from the fact that Jefferson had a hand in the home's design and construction. Monroe was in Paris when the work began, serving as minister for the Washington administration. It was an awkward and unpleasant assignment. By then a rabid pro-French Republican, Monroe had been appointed by Washington mainly to calm and deceive the French, who accurately suspected that America's "neutrality" was a thinly disguised pro-British policy. Monroe should have resigned, but instead held on until he was recalled in disgrace in 1797. He returned to Highland to write a bitter indictment of Washington's policy—but not before he had nearly been drawn into a duel with Alexander Hamilton.

Five years earlier, a Mr. and Mrs. Reynolds had approached Monroe, claiming to have proof that Treasury Secretary Hamilton was engaged in illegal financial dealings. Monroe and several other officials called on Hamilton and asked for his response. He shocked them with the story that he had, some time previous, conducted a torrid love affair with Mrs. Reynolds, and had been blackmailed by the couple ever since. Mr. Reynolds, himself under indictment, was hoping to obtain leniency by offering up the head of the Federalist leader.

About the time Monroe was relieved of his ministerial post, the whole sordid Reynolds story was published by professional character assassin James Callendar. Hamilton was convinced that Monroe had betrayed his confidence, and during a

heated confrontation that summer he blurted out, "I will meet you like a gentleman!" "I am ready," Monroe replied. "Get your pistols." Cooler heads stepped between the two men, and both backed away from the brink. (A few years later, the volcanic Hamilton would blunder into another fight. Aaron Burr shot him to death in a field outside New York City in July, 1804.)

Monroe was rapidly becoming one of America's first professional politicians, more from necessity than desire. His hope that the 3,500 acres at Highland would produce a handsome income quickly proved illusory. The farm, he wrote Madison, was "in the most miserable state that it could be," and while he knew that more effort was needed "to improve its natural deformities [and] make it yield what it is really capable of," he thought it would be "more agreeable...to apply the same labor to a more grateful soil."

Political opportunities sprouted more vigorously than his wheat and tobacco. By the end of Monroe's three-year term as governor of Virginia, Jefferson was president, and in 1803 he sent Monroe once again to Europe, where he took part in the successful negotiations for the Louisiana Purchase. In 1811 he became Madison's secretary of state.

Meantime, in 1806, Monroe's uncle Judge Jones had died, leaving to his favorite nephew substantial Virginia lands, the largest and finest portion in Loudon County northwest of Washington. A wood-frame cottage on that estate soon became the Monroes' primary home away from Washington. On the same land, in 1821, at the start of his second presidential term, Monroe at last built a mansion equal to his station—Oak Hill.

Jefferson again served as Monroe's architect, but this time his touch was evident. Built by James Hoban, architect and builder of the White House, Oak Hill was nothing if not flamboyant, fronted with a colossal portico sporting stuccoed Doric columns thirty feet tall. Though columned porticoes had long been a standard feature of plantation houses, Oak Hill's ostentatious edifice reflects the early stirrings of Greek Revivalism. The Greek War of Independence, which captured American imaginations and intensified an already healthy interest in classical architectural forms, began the same year ground was broken for Oak Hill. Inside, Monroe's new brick mansion was equally sumptuous, with dark, carved woodwork, sculpted marble mantelpieces, high ceilings, and spacious, formal rooms for entertaining.

James Monroe's presidency (1817-25) became known as the "era of good feeling," and though that overstates the nation's harmony, it's true that Monroe was popular. He enjoyed the luxury of governing without organized opposition, as the Federalist party was finished. His chief accomplishments were in foreign policy: negotiating

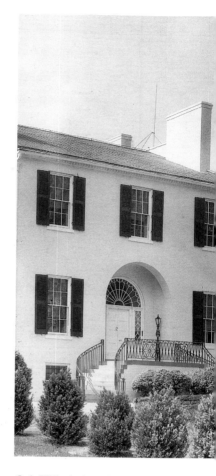

Oak Hill, designed by Jefferson, was Monroe's dream estate. Much changed in appearance (gone is the colossal Doric portico), the mansion was grand and costly, and contributed to Monroe's tragic bankruptcy.

the purchase of Florida, settling boundaries in the Pacific northwest and the southwest, recognizing the newly independent South American republics, and of course establishing the "Monroe Doctrine," by which America declared the Western Hemisphere off limits to European interference. He guided the nation successfully, if with plenty of bad feeling, through a severe recession in 1819. In 1820 he reluctantly signed the Missouri Compromise.

Though Monroe was at least as successful a president as Madison, Elizabeth Monroe had no luck at all filling Dolley's shoes. Stiff, class-conscious, and frequently ill, she lacked both the stamina and the inclination to try. She set strictly limited hours for White House entertaining, refused to pay "first calls" on foreign dignitaries, and left many social duties to her eldest daughter, Eliza, an "obstinate little firebrand" in John Quincy Adams's estimation. But whatever their social failings, the Monroes were a close and happy family. When he left Washington for Oak Hill in the spring of 1825, Monroe had every reason to look forward to a long, gracious retirement.

Instead his last years turned into a tragedy "at which the heart sickens," as Adams put it. Monroe's finances had never been good, and after the panic of 1819 and the enormous expense of building Oak Hill, they were nearly desperate. Monroe hoped to be restored by the settlement of his long-standing claims against the government. Like all public officials of his time, Monroe had paid his own expenses during his government career. In 1825 he submitted to Congress records of many thousands of dollars he had spent on his two diplomatic tours of Europe. Congress procrastinated, year after year, as Monroe's world fell apart. In 1825 he sold Highland and other tracts of Virginia land. The next year he sold land in Kentucky. In 1828, Lafayette—on whom Congress had casually bestowed a gift of $200,000—offered Monroe a loan. He declined. In 1829 the citizens of Albemarle County appealed to Congress on Monroe's behalf. Still nothing happened.

In September, 1830, Elizabeth Monroe died, and with her were buried her husband's hopes. Suddenly Oak Hill seemed a hollow prison. Two months later he moved to his last home, the New York City rowhouse of his youngest daughter and her husband. The following spring he offered Oak Hill for sale and wrote a painful farewell to James Madison: "It is very distressing to me to sell my property in Loudon, for besides parting with all I have in [Virginia], I indulged a hope, if I could retain it, that I might be able occasionally to visit it, and meet my friends....I deeply regret that there is no prospect of our ever meeting again...." Madison replied in kind: "The pain I feel...amounts to a pang which I cannot well express."

Monroe died on July 4, 1831, several months after Congress had at last granted a portion of his claims.

Be It Ever So Humble

Andrew Jackson, Martin Van Buren, William Henry Harrison

"WHAT? JACKSON UP FOR president? *Jackson? Andrew* Jackson? The Jackson that used to live in Salisbury?... Well, if Andrew Jackson can be president, anybody can!"

When the old woman from Salisbury, North Carolina, thought of Andrew Jackson, she remembered a coarse, uneducated ruffian, a cockfighter and a gambler, a hooligan so unsavory that her husband would not allow the man in their house. She remembered right, and "Old Hickory" hadn't changed much by 1828. America had. The suffrage had been greatly extended, and that year, for the first time, white male Americans would choose their own president. In what critics called "a raving howl of democracy," the people howled for Andrew Jackson. To hundreds of thousands of pioneers, yeoman farmers, and small merchants, he seemed a man very much like themselves, a man they could trust, above all a refreshing change from the bookish aristocrats who had dominated American politics for fifty years. Though far from poor by the time he became president, Jackson remained impeccably common to the end of his days. Exaggerating slightly, John Quincy Adams called him "a barbarian who...hardly could spell his own name." Tradition has it that Jackson refused to believe that the world was round.

Yet Andrew Jackson became a great and powerful president. He blew into Washington, as Daniel Webster put it, "like a tropical tornado," sweeping his opponents from the field and leaving behind a recreated presidency. During Jackson's administration, as never before, the president became the real chief of government—setting the national agenda, commanding action from Congress, taking his case to the people when thwarted. To the core of his soul Jackson was a fighter; the hostility of enemies was wind in his sails. "I was born for the storm," he said, "calm does not suit me."

To his critics Jackson was nothing less than a cold-blooded killer. They circulated a lurid handbill in 1828 showing eighteen coffins, representing the men Jackson had

personally slain or ordered executed. The number was perhaps too high, perhaps not, but no one denied that Jackson's life had been a seamless series of brawls. Thomas Hart Benton, who became one of Jackson's steadfast allies in Congress, admitted that as young men he and the president had dueled with guns and knives in downtown Nashville. "Yes," he said, "I had a fight with Jackson. A fellow was hardly in the fashion then who hadn't."

The exact location of Jackson's birthplace remains a source of dispute between North and South Carolina. Suffice it to say that he was born near the border between the two states, in the foothills of the Piedmont near the Catawba River. His father, a Scots-Irish immigrant, died a few weeks before Andy's birth, from injuries suffered while pulling a stump. He left his wife with three young sons, about 200 acres of scrubby, mostly uncleared wilderness, and a rude one-room log cabin set amid stunted pines and oaks near the lip of a deep ravine.

The Revolution finished off Jackson's family. His eldest brother died in battle in 1779. Later that year Andy, thirteen years old, and the middle brother enlisted in the cavalry. Captured within months, they were ordered to polish the boots of British officers. Both refused, and both were whacked on the head with a sword. (Jackson carried a scar for the rest of his life.) After a few months in prison the boys were released, both burning with smallpox. The older brother succumbed two days after arriving home. The next summer Jackson's mother traveled to Charleston to nurse prisoners of war, caught a fever, and died. Such horrors either crush a boy or make him mean. They did not crush Andrew Jackson.

Jackson went west in 1787, across the Smoky Mountains to what would become Tennessee. He had briefly studied law, and in Jonesboro he launched a lucrative practice. A year later he pressed further into the wilderness, over the Cumberland Plateau and down into the lush valley of the Cumberland River, where a huddle of tents, sod huts, and cabins had been dubbed "Nashville."

Appointed public prosecutor, Jackson took a room in a log blockhouse, or fort, that belonged to the widow of Nashville founder John Donelson. Also staying there was the Donelsons' daughter Rachel, a pretty and vivacious young woman who was on the lam from a cruel and jealous husband. By this time Jackson cut an unforgettable if not exactly handsome figure — tall and straight as a flagpole, with an almost

Overleaf: At its peak during Jackson's retirement, the Hermitage was as fine an estate as any president enjoyed. It vividly symbolized Jackson's self-propelled rise from his humble birthplace in the Carolina hill country.

comical, banana-shaped face that was scarred and pock-marked. Atop his head rose a thick, unruly tassel of dark red hair. He and Rachel enchanted one another from the start. They married in 1791, unaware that Rachel's divorce was still not final. Charges of bigamy and adultery would torment Rachel Jackson for the rest of her days. Her husband would kill over such accusations.

Financially, Jackson was thriving, often collecting his legal fees in land or slaves. In 1792 he bought a 330-acre farm, Poplar Grove, a fine spread with a great length of Cumberland river front and a simple wood-frame house, a mark of distinction on the frontier. Within a few years he bought a new plantation, again on the river, called Hunter's Hill, and there built a larger, fancier frame home sheathed with clapboard siding. On the same property he founded a general store, trading land, which he was accumulating rapidly, for merchandise purchased in Philadelphia and shipped down-river.

After serving one session in the House of Representatives and one in the Senate, Jackson was appointed a Superior Court Judge for Tennessee. He proved a hard-working, decisive jurist, if not a very scholarly one. He summed up his legal thinking in a sentence: "Do what is *right*; that is what the law always means." One day, while traveling his circuit, he ordered the Jonesboro sheriff to arrest a man named Bean who had mutilated an infant. The sheriff protested that Bean was so crazy and violent that no one dared approach him. Judge Jackson dared. He picked up a gun, stormed out of the courtroom, and returned forthwith, the cowed suspect in tow.

The charm of the Hermitage was the scale of its rooms. There were only eleven in the completed mansion, so the great front hallway often doubled as sleeping space. The mansion's false Corinthian front was Jackson's nod to Greek Revivalism.

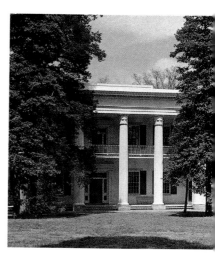

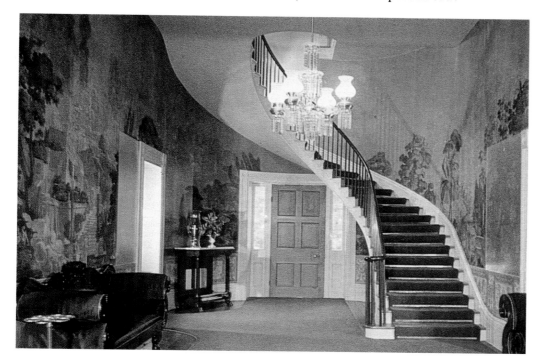

The "8th of January mantel" commemorated Jackson's reputation-making victory at the Battle of New Orleans. A veteran of the struggle worked on the mantel one day a year, the battle's anniversary, for twenty-four years.

Such escapades made Jackson a famous and a popular man in the West. A bloodless duel with the governor of Tennessee only enhanced his reputation. But when he killed a lawyer named Charles Dickinson in a duel in 1805, Jackson came in for severe criticism. Much more painful was the sudden collapse of his finances. He had accepted bank notes and other paper obligations in exchange for land, and had in turn incurred debts backed by that paper. When the notes proved worthless, Jackson was ruined. He sold Hunter's Hill, and at least 25,000 acres of land, and moved with Rachel to a 425-acre farm just south of Nashville. He was back in a log cabin, and his unending war against banks and paper money had begun. He called his new farm the Hermitage.

In fact, the log structure at the Hermitage was more than a cabin. It was a two-story blockhouse, thirty feet long and nearly as wide. On the ground floor was a single room, warmed by a great stone fireplace—parlor, kitchen, and dining room in one. James K. Polk remembered that a long wooden table, "capable of seating twelve to fourteen people comfortably," stood in the center and "was always set." Jackson built several additional log cabins nearby for guests. By frontier standards this initial establishment at the Hermitage was comfortable and even gracious. The Jacksons lived happily there for sixteen years, receiving scores of distinguished guests including President Monroe and Jefferson Davis, who recalled "a roomy log house. In front was a grove of fine forest trees, and behind were cotton and grain fields."

The natural setting of the Hermitage was, and still is, breathtaking—a misty blue-green meadow, rippled as a lake on a breezy day, dotted with low-spreading maples and oaks, with red cedar, hickory, sycamore, and spruce. Miles of rail and white board fence snake off in every direction, bordering fields and pastures that in Jackson's day were alive with thoroughbreds. Jackson loved blooded horses, and he established at the Hermitage one of the finest stables in America. His muscular bay stallion Truxton became the most famous race horse of the age, and earned his owner a fortune through purses, wagers, and stud fees. At Clover Bottom, three miles from the Hermitage, Jackson set up a new trading post, a boat yard, a tavern, and a racetrack—a kind of frontier mall and amusement park. On race days Clover Bottom swarmed with horsemen, gamblers, and spectators. The stakes were often huge, the bets often made in livestock. Two large pens stood near the track, one for wagered hogs and cattle, the other for wagered slaves.

These early years at the Hermitage were the Jacksons' happiest. Rachel was delighted to have her husband at home (he had resigned from the bench) and he adored his wife, regarding her almost as a saint. He wasn't alone. Intensely religious, somewhat puritanical, Rachel Jackson lived Christian charity, caring tenderly and tirelessly for

slaves, neighbors, and travelers. She brought home children like so many stray puppies; at least ten became full-time wards of the Jacksons for some period. She became known universally in the Nashville area as "Aunt Rachel."

What Rachel was not, as the years went by, was beautiful or sophisticated. After marrying Jackson she passed quickly through plump and pudgy and went on to obese. She smoked a pipe and sometimes cigars, was joyfully ignorant of the larger world, and spelled a good deal worse than her husband. An observer quoted in Burke Davis's *Old Hickory* left a vivid description of the happy Jacksons, blissfully out of place in high society, demonstrating a frontier dance at a gala New Orleans ball: "The general a long, haggard man, with limbs like a skeleton, and Madame le Ge'ne'rale, a short fat dumpling, bobbing opposite each other like half-drunken Indians, to the wild melody of 'Possum up de Gum Tree,' and endeavoring to make a spring into the air.... Very remarkable."

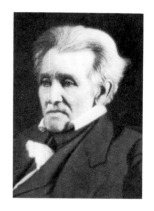

Rachel chose the location of the Hermitage mansion, just down-slope from the original log buildings. Construction began at the spot in 1819, even though nearly everyone else, Jackson included, thought the house would be better placed further up the hill. "Mrs. Jackson chose this spot," he said, "and she shall have her wish. I'm going to build this house for *her*." The house he built vividly symbolized his own self-orchestrated rise from backwoods orphan to gentleman farmer. It was a stout, squarish, red brick mansion in the Federal style, nothing less than a palace in middle Tennessee. With substantial remodeling and enlargements, it became as fine a home as any president retired to.

The great charm of the Hermitage was the scale of its rooms. The original structure had only eight chambers, the final version only eleven, so every interior space was panoramic. The central corridor, crossing the width of the house, was broad and long enough to serve as overflow guest space. A wide staircase rose from the right-hand wall and spiraled fluidly back on itself within view. To the left of the hallway were two colossal parlors divided by a sliding door. After dinner, gentlemen would gather in the front parlor for cigars and talk of farming or politics; ladies would retire to the back parlor. The great door would swing open for dancing.

Rachel Donelson wed Jackson while still technically married to another man, and charges of adultery haunted her for the rest of her life. A rough-hewn frontier woman, she was also sweet-tempered and generous, virtually a saint in her husband's eyes.

The Hermitage dining room was similarly huge and was the scene of almost constant entertaining. "I do not think the family ever sat down to a meal by themselves," remembered a granddaughter. Jackson was a convivial host, especially with ladies. He never sat at the table's head, but rather would plop himself down between two female guests and then move about throughout the meal, gossiping with everyone in turn. He had a casual, rough-hewn charm, was an eager conversationalist, and far from being ashamed of his frequent mispronunciations and grammatical errors,

he would, one guest recalled, put "emphasis on the error of speech, [giving] it a marked prominence in diction." In 1839 the dining room was fitted with the splendid "8th of January mantel," carved from solid hickory by a veteran of the Battle of New Orleans. He had worked on the piece one day a year—January 8th, the battle's anniversary—for twenty-four years.

In designing the Hermitage grounds, Jackson seems to have consciously mimicked Mount Vernon, laying out a guitar-shaped front lawn framed by a slender drive and parallel rows of cedar trees. He hired an Englishman to design a formal, one-acre garden, fragrant with magnolia and lilacs, roses and honeysuckle. A door from the first-floor master bedroom opened directly onto the garden, where Rachel invariably cut bouquets for departing guests.

Jackson became president in 1828 almost entirely on the strength of his military heroics. Between 1812 and 1820, he had conquered the Creek Indians at the Battle of Horseshoe Bend, the British at the Battle of New Orleans, and the Seminoles in Florida. A Jackson booster summed up the case for his election: "[He has] slain the Indians and flogged the British and...therefore is the wisest and greatest man in the nation."

The campaign became perhaps the nastiest in American history. Jackson was a murderer and adulterer, of course. He was also illiterate, his father was a black man, his mother a prostitute. Jackson forces gave as good as they got. John Quincy Adams had also lived in sin with his wife before marriage, had been a pimp for the czar while in Russia, and lived in regal splendor at taxpayer expense. The attacks on Adams's wife were too much for Jackson. "I never war against females," he wrote to his supporters, "and it is only the base and cowardly that do." It was also, all of it, quite beside the point. Jackson swept the South and West, carried New York and Pennsylvania, and won handily.

The victory cost him what he valued most. Try as he might, he could not protect Rachel from the scurrilous assaults on her that filled the nation's newspapers. She had always resented his public life and was terrified at the prospect of becoming First Lady, especially with her reputation in tatters. Her spirits and her health declined visibly as the campaign proceeded, and with victory in hand her comment was, "I had rather be a doorkeeper in the house of God than to live in that palace at Washington." She went to her God, suddenly, on December 22, 1828. Jackson refused to believe she was dead, ordering doctors to repeatedly bleed the corpse, then insisting that the table on which she was laid out be covered with blankets, so that when she awoke she wouldn't "lie so hard on it."

On Christmas Eve, in a chill, windswept drizzle, 10,000 Tennesseans converged

Jackson occupied the original Hermitage log cabin after falling into bankruptcy when several banks failed. Although it proved a fine home, and though his finances improved, Jackson never lost his hostility to banks. His war with the Bank of the United States was in part a personal vendetta.

on the Hermitage for Aunt Rachel's funeral. Pallbearers carried her coffin from the mansion to the southeast corner of the garden she had loved so well. The president-elect, quivering and weeping, proclaimed, "In the presence of this dear saint I can and do forgive my enemies." A columned and domed monument was built over the grave, where Jackson would be laid beside his wife in 1845. It is thought that Jackson wrote the inscription for the slab himself: "...Her face was fair, her person pleasing, her temper amiable, her heart kind....A being so gentle and so virtuous slander might wound but could not dishonor...."

Jackson had vowed to forgive his enemies, not to refrain from making new ones. From Inauguration Day, 1829, when thousands of common men turned a White House reception into a near riot, shattering china and glassware, until Jackson's departure eight years later, Washington was in a state of unrelieved turmoil. Amid constant, minor skirmishes, two epic battles preoccupied the country. The president wanted the Bank of the United States—the financial Goliath created by Hamilton—reformed or destroyed. When Congressional leaders balked, led by Speaker of the House Henry Clay, Jackson declared war. "The Bank, Mr. Van Buren, is trying to kill me," he told his chief lieutenant at a low moment. "But *I* will kill *it*." The Bank died. Jackson's second great struggle was with his first vice president, John C. Calhoun. Calhoun's native state, South Carolina, declared the high protective tariff of 1828—the "Tariff of Abomination"—null and void within its borders, and threatened to secede if the law was enforced. The underlying issue was growing North-South hostility over slavery. Though himself a Southerner, Jackson rejected the doctrine of nullification, declared talk of secession "treason," and issued an eloquent proclamation to the citizens of South Carolina: "You are deluded by men who are either deceived themselves or wish to deceive you....on their heads [will] be the dishonor,

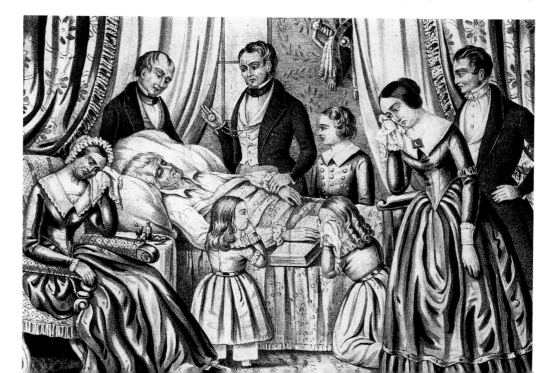

Jackson enjoyed just eight years of retirement. He died in 1845, as much admired and as much ridiculed as any president before or since.

but on yours may fall the punishment." The president ominously prepared for military action, but at the same time pushed a compromise Tariff through Congress, allowing South Carolina to back down while claiming victory. It was his finest moment.

Jackson retired to the Hermitage in 1837, as much loved and as much hated as any president before or since. He was himself well satisfied with his administration, except that hadn't found a way to hang Clay and Calhoun. Jackson had visited his plantation only four times in eight years—the journey from Nashville to Washington took three to four weeks in those days—but much had happened there. In 1831, Jackson commissioned a major remodeling of the mansion, adding one story wings on either end. The work was barely completed when, on October 13, 1834, sparks from the dining room chimney ignited the roof and wind-whipped flames engulfed the Hermitage. The second floor was a total loss. Jackson bore up with a religious fatalism worthy of Rachel: "The Lord's will be done," he wrote. "It was he that gave me the means to build it, and he has the right to destroy it, and blessed be his name....I will have it rebuilt. Was it not on the site selected by my dear departed wife I would build it higher up the Hill, but I will have it repaired."

In the wake of the fire, Jackson remodeled the house yet again. The upper floor was substantially enlarged, as were the windows throughout, and a flat roof replaced the former gabled one. Most dramatic, a false front was affixed to the southern side of the mansion—a grand, two-story Corinthian portico painted brilliant white, a flamboyant nod to the Greek Revival style then sweeping the country.

Death came to Jackson after just eight years in retirement. He kept a long-standing promise to Rachel in 1838, when he joined the little Presbyterian church he had helped to build for her on Hermitage land. According to family members, Jackson visited his wife's grave every day, at sunset, asking whoever accompanied him to wait at the garden gate.

On the face of it, Martin Van Buren seems an unlikely candidate to have become Andrew Jackson's political heir. Where Jackson was long and willow-switch lean, Van Buren was short and round, compact as a stump. Where Jackson embodied the raw frontier, Van Buren was an old-line Dutch New Yorker, a dandy in ruffled silk shirts and kid gloves. Where Jackson was impulsive and bellicose, Van Buren was a careful backstage manipulator, a genius at striding onto the field the moment the dust of battle had settled.

The two sensibilities were complementary, of course. "You will say I am on my old track," Van Buren told Jackson during the Nullification crisis, "— caution, caution, caution: but...I have always thought that considering our respective

temperaments, there was...no way...I could better render you...service." There were similarities, too. Van Buren and Jackson shared the old Jeffersonian political values—minimum government, states' rights, strict majority rule. But both were pragmatists at heart, knowing that ideology was a way of getting votes, not a way of governing. Both were widowers when they met, a fact of enormous significance to Jackson. Both, most important, valued discipline and organization. Watching Van Buren's political machine sweep one election after another, Jackson was reminded of well-drilled infantry. "If I were a politician," he said, "I'd be a New York politician."

Van Buren was born in 1782, in the village of Kinderhook, about 100 miles up the Hudson from New York City. The lower Hudson valley was then an insular Dutch enclave. The people spoke Dutch, lived by Dutch customs, attended Dutch Reformed churches, and married one another. It was a quiet society, cozy and timeless as the surrounding landscape of dense rolling woodlands, scored by gullies and hollows, a land where one's field of vision never extends very far. It was to Kinderhook that Washington Irving came to research his classic tales of goblins and enchantment. He wrote, in *The Legend of Sleepy Hollow*, of a "listless repose" about the region, a "drowsy, dreamy influence [that] seems to hang over the land, and to pervade the very atmosphere." In Kinderhook, perhaps, Irving found the model for Nicholas Vedder, the patriarch of Rip Van Winkle's village, who "took his seat from morning till night, just moving sufficiently to avoid the sun and keep in the shade of a large tree; so that neighbors could tell the hour by his movements as accurately as by a sun-dial."

Irving's stories also described the startling and, for many of the old Dutch, disturbing changes that overtook the Hudson valley in the years following the Revolution— the years of Van Buren's boyhood. New Englanders poured into the valley, the better to do business with the merchants of Manhattan. Shipping on the river doubled, then doubled again. Politics intruded, setting neighbor against neighbor. Ichabod Crane, the much-abused schoolmaster of Sleepy Hollow, was an interloper from Connecticut. When Rip Van Winkle returned from his twenty-year nap, he learned that his ill-tempered wife had died when she "broke a bloodvessel in a fit of passion at a New England peddler," and found everyone in town wanting to know "whether he was Federal or Democrat?" Rip might have been speaking for the whole community when he cried, "I'm not myself—I'm somebody else...I fell asleep on the mountain,...and everything's changed, and I'm changed...!"

Young Martin Van Buren watched everything change from the perfect vantage point of his father's tavern on the old post road between New York and Albany. The farm house/tavern was a plain clapboard building, long and low with a steep lean-to

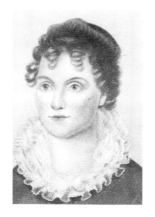

Martin Van Buren was, said John Quincy Adams, "the friend of all the world." But there was apparently little ardor in his twelve-year marriage to Hannah Hoes.

61

roof, and it was crowded to overflowing. Eight children and six slaves lived in it, in addition to the elder Van Burens and the paying guests. Martin delivered vegetables from his father's garden to buyers in Kinderhook, and as often served as bartender in the busy taproom, loud with the talk of local farmers and traveling politicians and businessmen.

In the smoky, raucous downstairs tavern, Martin Van Buren listened to political debates, learning how to argue one's case. He listened to old Dutch farmers wax nostalgic for the old days, and learned about the power of sentimentality and prejudice. He learned how to *listen*, how to read motivation, how to "look quite through the deeds of men," as a critic later admitted he could. He learned, most of all, to get along with everyone, following the lead of his father: "an unassuming amiable man who was never known to have an enemy." Martin Van Buren would make some enemies, but amazingly few. John Quincy Adams dubbed him *l'ami de tout le monde*, "the friend of all the world."

In politics, too, Van Buren took a cue from his father. The old Hudson valley was a bastion of conservative Federalism. Abraham Van Buren was a Jeffersonian, perhaps because he stood well down the line in the rigid social hierarchy of the old Dutch society. All his life Martin Van Buren resented and envied men of aristocratic bearing. He became a fussy, foppish dresser at least partly to feel more their equal. He saw political parties as, among other things, a way of diminishing aristocratic influence. He resolved to become a master back-room deal maker partly because it was the game aristocrats played to perfection. They soon met their match.

By the late 1820s, Van Buren was the most powerful man in New York State, chief of the "Albany Regency," a coalition of politicians, newspaper editors, and businessmen who had formed America's first political party (as we understand that term today). Van Buren was among the most perceptive early proponents of the "party system" of government, arguing that disciplined parties would provide a mechanism by which the will of the people could be put into action. The parties rose, as if spontaneously. The old Federalists became the Whigs, led by Adams, Clay, and Webster. The Jeffersonians became the Democrats, led by Van Buren, Calhoun, and Jackson.

Throughout his long climb to the top of byzantine New York politics, Van Buren had been in constant motion. For a short time he had owned a small salt-box house in Hudson, New York, but mostly he lived in rented homes and boarding houses. By 1807 a successful law practice and land speculations had made him financially secure, and that year he married Hannah Hoes, a Dutch woman he had known since childhood. She bore him four sons before dying of tuberculosis in 1819. If the marriage was passionate or of any great importance to Van Buren, he kept it to

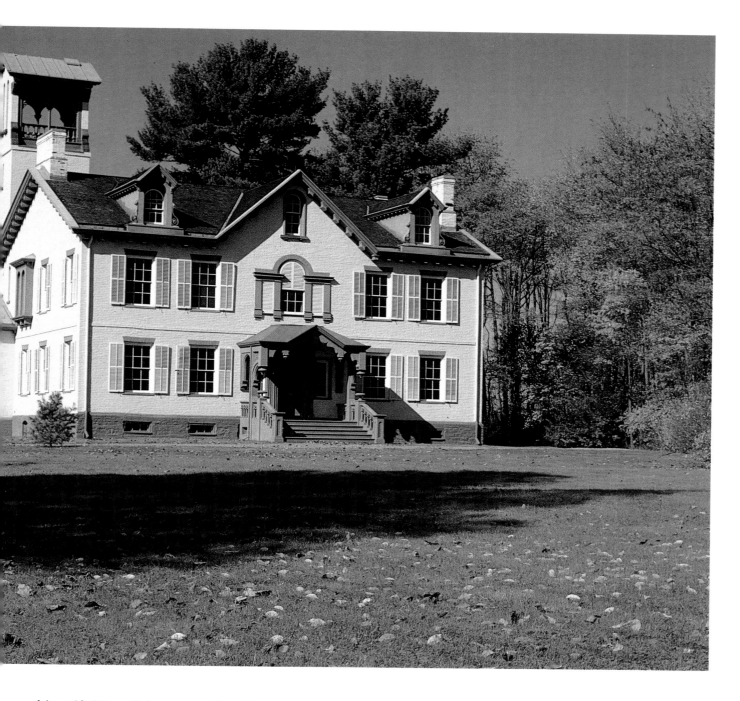

himself. Hannah is not mentioned in his autobiography. With his sons, though, he had warm rapport, even though, after Hannah's death, he kept them farmed out to friends and relatives, and never really made a home for his family.

In 1829, Van Buren became Jackson's secretary of state, his reward for having delivered New York to the "western" candidate. An unfair caricature of the Jackson years cast Van Buren as the sinister puppeteer, tugging at the strings of the thick-

Lindenwald was a stately Georgian mansion when Van Buren bought it. His son turned it into a fairy-tale castle, and Van Buren proclaimed himself "amused."

headed president. Yet it's true that "the little magician," as Van Buren came to be called, was one of the few men in America who knew how to handle Jackson. He shared the president's love of horses, and made a point of riding with his boss several times a week. On one such ride in 1831, when various disputes within the cabinet had reached a crisis, Van Buren suddenly announced his resignation, forcing the rest of the cabinet to follow suit. Jackson promptly appointed Van Buren Minister to England, but opponents in the Senate rejected the nomination. The more perceptive in Congress saw the beauty of the magician's maneuver. He had sacrificed high office for Jackson's sake, then put himself in a position to be humiliated by the president's enemies. He had become the "wronged friend." "Well," said one senator after the vote, "that makes Van Buren president of the United States."

So it did, in 1837. Old Hickory's chosen successor had not been in office two weeks when the bank panic struck. It was the worst depression in the young nation's history, caused in part by Jackson's anti-bank policies. Van Buren had no solution. He became preoccupied with establishing the Independent Treasury to hold government funds and with border trouble in Canada and Texas (Texas had rebelled against Mexico in 1836). As the election of 1840 approached, it seemed that the magician had run out of tricks.

The Whigs, on the other hand, had learned a few. "We have taught them how to conquer us," moaned one Democratic leader. The Whigs found themselves a westerner and a military hero, William Henry Harrison, but it was the Democrats themselves who handed the Whigs an invincible image. Thinking to insult Harrison, a Democrat

William Henry Harrison, the "log-cabin candidate," grew up at Berkeley, one of the most lavish plantations of tidewater Virginia. He and his wife, Anna, had lived in a log cabin for about one year.

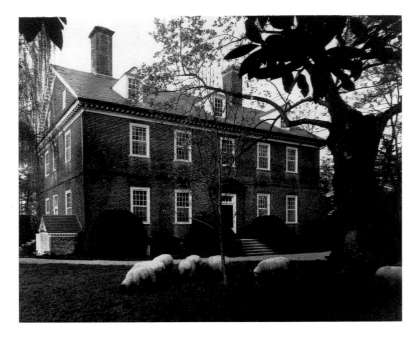

wrote, "Give him a barrel of hard cider, and settle a pension of two thousand a year on him, and my word for it, he will sit the remainder of his days in his log cabin...and study moral philosophy." Faster than a notch could be cut, Harrison became "The Log-Cabin Candidate."

Soon Whig headquarters around the country were housed in log cabins. Log cabin floats became a feature of every Harrison parade. The general's supporters distributed log-cabin buttons, log-cabin ribbons, log-cabin song books, log-cabin shaving soap, log-cabin whiskey. Horace Greeley published a pro-Harrison tabloid, *The Log Cabin*. Roles were reversed, but it was 1828 all over again: a man of the people, a simple plowman, against a conniving libertine, rushing about the glittering White House in a flutter of ruffles and bows. Whigs sang: *Let Van from his coolers of silver drink wine/ And lounge on his cushioned settee/ Our man on a buckeye bench can recline/ Content with hard cider is he.*

It was almost complete nonsense. William Henry Harrison was the son of Benjamin Harrison, signer of the Declaration. He was born at Berkeley, one of grandest plantations of tidewater Virginia, a stout brick mansion separated by acres of rose gardens and sculpted lawn from the mile-wide James River. Every president before Lincoln paid a call at Berkeley. The Harrisons, though, exhausted their lands and much of their fortune, and young William Henry, loath to become an impoverished Virginia aristocrat, joined the army and headed west.

For about one year, Harrison and his bride lived in a simple log cabin, at Fort Washington on the Ohio River. In 1797 they settled at North Bend, the last dramatic upward twist of the Ohio before it plunges southwest toward the Mississippi. There, too, they lived for a time in a log house, a massive log house with three rooms on the ground floor and several more upstairs. It was placed on a high bluff above the river, affording a panoramic view of the river, the virgin forest, and the Harrisons' 2,800-acre farm. Years later, after returning from Indiana, Harrison built the "Big House" at North Bend, incorporating the original log structure. He liked to open a closet door and show visitors a section of the original logs. The Big House was a long, rectangular wood farmhouse, roomy but not very fancy. A granddaughter remembered that the house was poorly designed, the rooms set side by side like prison cells, with no connecting hallway. The Harrisons entertained often, and a visitor recalled "an open table, to which every visitor was welcomed. The table was loaded with abundance, and with substantial good cheer, especially with the different kinds of game...His house strongly reminded me of...old English hospitality."

In 1800 Harrison was made governor of Indiana Territory. He moved to Vincennes on the Wabash River and there built Grouseland, a three-story brick mansion modeled

The parlor and dining room at Berkeley.

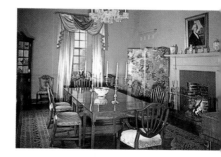

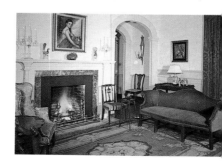

after Berkeley. Two long parlors stood opposite each other off a formal central hall, one made larger by deep bay windows. Silk-screened wallpaper, cherrywood banisters, French wool tablecloths, and thirteen oversized fireplaces added elegance to what was by far the largest and loveliest home on the northwest frontier. In the garden at Grouseland, Harrison held several unsuccessful parlays with Tecumseh, the fierce chief of the Shawnees who had allied himself with the British. In 1811, at the Battle of Tippecanoe, and in 1813, at the Battle of the Thames, General Harrison defeated the Indians and made his reputation. In 1814, the Harrisons returned to North Bend.

Van Buren's supporters tried to expose the facts, to point out that "the farmer of North Bend" was a blueblood who owned several mansions, while "King Mat" was a tavern keeper's son who had spent most of his adult life in rented quarters. It was no use. Probably most Americans knew that the log-cabin campaign was humbug. But they *liked* humbug. Harrison became the first presidential candidate to make campaign speeches, and his appearances attracted "acres of men," as was said at the time. At bottom, Harrison was not the issue. The people had simply had their fill of the depression, and of "Martin Van Ruin."

Van Buren took defeat gracefully and retired to Kinderhook. Several years earlier, he had purchased the old Van Ness mansion just southeast of the village. It gave him great pleasure to become master of an estate that had once belonged to Dutch "patroons"—the aristocrats who had so often snubbed his father. In summer, 1839, Van Buren and his son Smith dined at the just-purchased mansion. "We had a capital dinner of Fricassee and ham, washed down with champagne," Smith recalled. "We tried hard to get up a good name [for the place]; but it is very tough work. The present favorite is 'The Locusts,' of which there are a great number about." In the end Van Buren settled on "Lindenwald," after the many linden, or basswood, trees in the surrounding woods.

Lindenwald was a fertile farm of around 200 acres. The mansion stood about 100 yards off the road, fronted by a broad half-moon lawn, flat as a table and planted with lindens and maples and soaring white pines. The house was a typical Georgian structure of brick, square and big with a dominating Palladian window on the second floor. The central first-floor hallway was spacious, and made more so when Van Buren removed the stairway. It became eighteen feet wide and fifty feet long, and doubled as a banquet room.

Van Buren's real interest was in the farm. He set up a large garden and greenhouse where, a visitor said, "you could not think of a line that delights the eye, a fragrance that refreshes and purifies the soul, that were not displaying." He constructed two

artificial ponds and stocked them with pickerel, perch, and trout. His major crops were potatoes and hay. "My farming operations...have been very successful," he wrote proudly to Jackson. Later he added, "You have no idea of the interest I take in farming or the satisfaction I derive from it. The Whigs would hardly believe that a much larger portion of my time is taken up with [improving my] quantity and...quality of manure than in forming political plans."

There was time for politics, too. Van Buren made a serious run for the Democratic nomination in 1844, losing because he opposed the annexation of Texas. Slavery, now, was in the saddle, riding American politics hard. Van Buren had himself promised the Mexicans that no annexation would take place until all hope of reconciliation between Texas and Mexico had been exhausted. It seemed to him a sorry spectacle: America rushing to steal millions of acres from a helpless young nation, then filling the place with chattel slaves. In 1848 he bolted the Democratic Party and ran for president on the Free-Soil ticket, opposing any further expansion of slavery. He took about ten percent of the vote.

Retired for good, Van Buren asked Smith, his youngest boy, to move with his family to Lindenwald and keep an old man company. Smith agreed on condition that he be allowed to completely remodel the house in a more stylish fashion. He had secured the services of British architect Richard Upjohn, designer of New York's Trinity Church. At first Van Buren balked: "What curious creatures we are. Old Mr. Van Ness built as fine a home here...as any man could. [His son] disfigured everything....I succeed him and pulled down...any erection he had made....Now comes Smith and pulls down many things I had put up....What nonsense." Later, his humor improved and he decided that since Smith would make the changes anyway, once he was gone, he might as well see them. "We are to undergo a great Revolution here," he told his friends.

Upjohn's revolution turned Van Buren's stately mansion into a kind of fairy-tale castle, modeled loosely after Italian villas, almost rococo in the abundance of detail. A great central gable was added, framed by two dormers. A four-story bell tower rose from one corner of the house. Van Buren proclaimed himself "amused." More plainly pleasing were the additions of running water and a central heating system, one of the first in America.

Van Buren died in 1862. In his will he claimed that his "happiest years" had been those spent as "a farmer in my native town." A friend recalled that the ex-president "was very fond of reposing" under the trees that dotted his front lawn, "hearing the wind sigh and moan through their peculiar branches. He does not allow the birds to be molested, and they repay him in grateful song."

John Tyler, James K. Polk, Zachary Taylor

IN 1840, WHEN WHIGS WEREN'T RHAPSODIZING about log cabins and hard cider, they were chanting "Tippecanoe and Tyler, too!" Democrats jeered that there was "rhyme but no reason" in the catchy slogan, and they had a point. Whigs supported strong centralized government and Congressional supremacy. Democrats favored states' rights and a strong Jacksonian executive. Southern slaveowners were caught in the middle, detesting both the Whigs' centralization and the Democrats' imperial presidency. By the late 1830s, it was the Jacksonians they detested most, and many planters metamorphosed into curious creatures known as "states-rights Whigs." One of these was John Tyler, William Henry Harrison's running mate.

Tyler was nominated to balance the Whig ticket even though he opposed every centralizing policy the Whigs stood for. It hardly seemed to matter; the vice presidency was the weakest office in the land. After the inauguration Tyler returned to Williamsburg and his modest home on Francis Street. On April 5, 1841, a month and a day after the swearing in, he was awakened at 5 a.m. by a loud pounding on his door. Groggily, in nightshirt and cap, Tyler stumbled downstairs and learned stunning news: President Harrison was dead. John Tyler, not to mention the Whigs and the nation, was in trouble.

Tyler was well qualified for the presidency, better qualified than Harrison. He had served with distinction in both houses of the Virginia legislature, as Governor of Virginia, and in both houses of Congress. He was intelligent, honest, patriotic, and charming. He was also stubborn as rock, having twice resigned from Congress when he felt his principles compromised. "Whether I sink or swim on the tide of popular favor," he had said, "is a matter to me of inferior consideration." He meant this, and as president he sank.

Tyler was born in 1790, at Greenway, a 1,200-acre plantation on the James River in tidewater Virginia. His mother died when he was seven, and Tyler was raised by

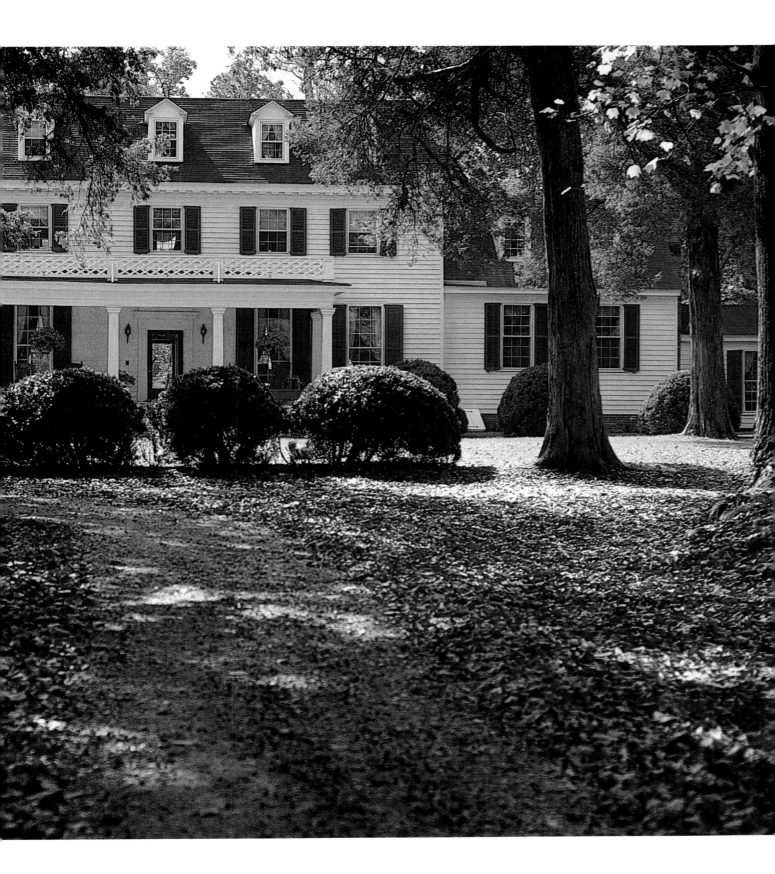

his father, a federal judge and one-time governor. From the judge Tyler learned his inflexible states' rights creed, and he also learned to enjoy the peaceful pleasures of plantation life — fine food and wine, elegant parties, hunting and fishing, books and conversation, music. Judge Tyler was a fiddler; at twilight he would straddle a chair on Greenway's front lawn and serenade a swirling throng of delighted children, white and black. Young John Tyler attended William and Mary, became a successful lawyer, and in 1813 married Letitia Christian, a lovely, wealthy, but painfully shy young aristocrat. The couple settled at Mons Sacer, the 500-acre portion of Greenway that Tyler inherited.

The retiring Letitia had no use for her husband's public life. Before his rise to the presidency she spent only one winter with him in Washington, remaining otherwise at various homes Tyler made for his family—Mons Sacer; Woodburn, an estate Tyler built in 1811; the Francis Street house in Williamsburg; and a 600-acre farm on the York River. In all these homes she was surrounded by devoted youngsters. "My children are my principle treasure," Tyler said, and he laid up quite a store of such fortune—fourteen children in all, seven by each of his marriages. In 1839 Letitia suffered a stroke and became an invalid. She was little more than a ghostly presence in the White House, emerging from her bedroom to appear in public only once before dying in the fall of 1842. "Nothing," wrote the president's daughter-in-law, "can exceed the loneliness of this large and gloomy mansion, hung with black, its walls echoing with sighs."

The gloom at the White House had more than one cause. Instantly dubbed "His Accidency," Tyler had found the presidency "a bed of thorns." Senate leader Henry Clay descended like a hawk on the administration, pushing through Congress two bills to re-establish the Bank of the United States. Tyler vetoed both, for which he was burned in effigy, threatened with impeachment and assassination, deserted by his Cabinet, and expelled from the Whig Party. Nothing moved him. He closed one heated exchange at the White House by saying, "Go you now then, Mr. Clay, to your end of the Avenue...and there perform your duty to the country as you shall think proper. So help me God, I shall do mine at his end of it, as *I* shall think proper." The government ground to a halt.

With Letitia gone and his administration wrecked, Tyler planned for his future. Late in the autumn of 1842 he purchased a dilapidated, 1,600-acre plantation on the James, less than two miles from Greenway. Founded in 1730, the estate rested in a thick lowland grove of oaks, its smooth, broad grounds sloping lazily down toward the river. The white wood-frame mansion, two and a half stories high and 90 feet long, was in need of repair, but Tyler was in need of more diversion than that. He

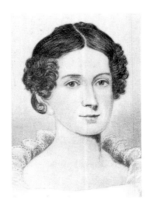

After the death of his frail, reclusive first wife, Letitia, John Tyler threw his emotional energies into the renovation of Sherwood Forest (overleaf), so named because Tyler thought himself, like Robin Hood, a noble outlaw.

plunged into an enormous remodeling project, deciding to connect the mansion to the free-standing kitchen and to build a matching wing on the other end. The completed house would stretch 300 feet, and is thought to be the longest frame house in America. Tyler christened his new home Sherwood Forest, as it would be the hideout of a righteous outlaw.

Tyler also searched for a new wife. In February, 1843, he met Julia Gardiner, the stunningly lovely daughter of one of New York's wealthiest families. Small and dark, like Letitia, Julia was high-spirited and vain. She struck Tyler as "the most beautiful woman of the age." Julia and her sister Margaret were husband hunting in Washington, and the hunting was good. Julia had rebuffed several distinguished suitors when she met the president, whose interest was instantaneous and unsubtle. Departing the White House one evening, as Margaret remembered in one of many family letters quoted in Robert Seager's *and Tyler too*, she offered her hand to Tyler, when "what does he do but give me a kiss!...He was proceeding to treat Julia in the same manner when she snatched away her hand and flew down the stairs, with the president after her, around tables and chairs until at last he caught her. It was truly amusing." But Tyler wasn't kidding. He pressed the chase until he married Julia Gardiner in June, 1844.

Tyler was fifty-four; his bride, twenty-three. The newlyweds were drunk with happiness. Julia's mother scolded the young First Lady in her letters: "You spend so much time in kissing, things of more importance are left undone." Tyler was an enthusiastic, mediocre poet, and wrote sugary sonnets to his new love. "I excuse all bad poetry when I am the subject," Julia said. The "lovely Lady Presidentress" captivated Washington. She surrounded herself with a court of sisters, cousins, and in-laws—the "vestal virgins"—and threw a series of glittering balls reminiscent of Dolley Madison's day. The grand finale crowded 3,000 people into the White House, moving Tyler to proclaim, "They cannot say now that I am a president without a *party.*"

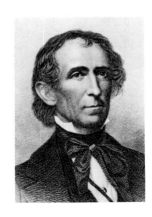

In 1844 Tyler married Julia Gardiner, thirty-one years his junior. The "lovely Lady Presidentress" bore him seven children (as had Letitia) and later battled tenaciously to save Sherwood Forest from the ravages of Civil War and Reconstruction.

In the spring of 1845 Julia took charge at Sherwood Forest, still very much in the making. The workmen, she assured her mother, were "amazed at my science and the president acknowledged I understood more about carpentry and architecture than he did, and he would leave all the arrangements...entirely to my taste." The house, she wrote, "outside and in is very elegant and quite becoming 'a president's Lady.' You will think it a sweet and lovely spot." Still, she allowed that "a new house I would have arranged...differently, of course."

Tyler's creation was and is a trifle odd. The central, two-and-a-half story section is flanked on each side by one-and-a-half story additions, then by long, low covered

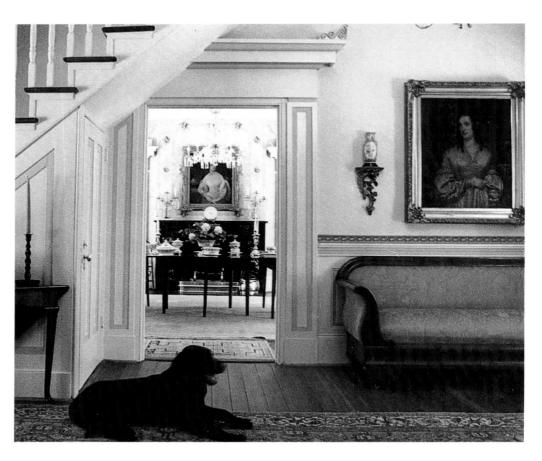

A peculiar creation, 300 feet long, Sherwood Forest was a typical plantation mansion on the inside, elegantly furnished and equipped with a striking entrance hall.

colonnades, with one-story sections punctuating each end. It looks like a small town that has been glued into one piece. Julia was charmed by the ballroom in the mansion's west wing, sixty-eight feet long with a soaring arched ceiling. The Tylers planted more than eighty varieties of trees in their grove and gardens, and the effect, as one approaches the mansion under the dense canopy, is of an overgrown woodland cottage.

For fifteen years, the Tylers lived the Old South myth. Sherwood Forest was a humane plantation, lacking whips and chains. "My plan is to *encourage* my hands," Tyler said. He followed his father's lead in fiddling by night for the plantation children. Each day Tyler rode about his fields, sometimes accompanied by Julia, always wearing a floppy Panama hat that his wife found hilarious atop his small head and slender, scarecrow frame. Children appeared in rapid succession, and Tyler eagerly took part in their nursing, rising each dawn to rock the youngest baby by the fire. Time and again Julia described the same sunset scene: she and the president sitting on the pillared back porch, he with his feet propped on the railing, ships slipping silently by far off on the river, the wind in the trees accompanied by the singing of the slaves as they returned from their day in the fields.

Tragedy stalked such romantic idylls. As John Tyler basked in his golden years at Sherwood Forest he watched the nation slide sickeningly toward civil war. Almost to the end, he clung to a moderate stance, urging Southerners to accept the territorial restriction of slavery as inevitable. It was the prospect of war, he said, that was "too horrible and revolting to be dwelt upon." Tyler headed a desperate Peace Convention in early 1861, but failing there finally voted for secession and took a seat in the Confederate House of Representatives. He died before Sherwood Forest was overrun, in January, 1862.

Julia fled the plantation later that year, but labored doggedly to save Sherwood Forest from a shifting cast of destroyers—the Union Army, emancipated slaves, and finally creditors. In 1868 her eldest son visited the estate and bitterly reported: "…gloom like the veil of the grave has settled upon the land….The house…is gradually rotting…. Deserted, tenantless, forsaken, the once beautiful home of our then happy family!" Julia would not be beaten. In 1874 she sold other family properties and moved back to Sherwood Forest, but the plantation was not fully secure until 1882, when Julia, along with other presidential widows, was granted a lifetime pension by Congress. That year she moved permanently to Richmond, no longer healthy enough for farm life, and she died there in 1889. Descendants of the Tylers live at Sherwood Forest to this day.

It's odd that James K. Polk should be among America's forgotten presidents. An earlier age would surely have remembered him as "James the Great" or "Polk the Conqueror." He was the warrior prophet of "Manifest Destiny," a high-minded phrase that at bottom meant that Americans wanted, and believed they deserved, a continental empire—and Lord help anyone who got in their way. Mexico and England stood in James Polk's way, but not for long. His acquisition of the entire Southwest and far West has earned him little latter-day acclaim, probably because it was a short-run catastrophe. Unwittingly, Polk triggered the final sequence of crises that tore the nation in half.

Polk was in every sense a disciple of Andrew Jackson, so much so that he came to be called "Young Hickory." He was born in 1795 in the same dry Piedmont foothills that had been the site of Jackson's boyhood home—on Sugar Creek near Pineville, North Carolina. There Sam and Jane Polk raised tobacco on 250 fertile acres. The log farm house stood two stories high and was connected by a covered passage to a separate kitchen building. It was a prosperous and peaceful farm that Polk's parents were reluctant to leave, despite the urging of friends and relatives who were stampeding across Appalachian passes like mustangs through an open gate. In 1806, when James

James K. Polk did more to expand American territory than any president save Jefferson. The table below, sporting thirty stars for the states of the union, stood in the president's retirement home in Nashville.

was eleven, his father succumbed to western fever and led his family to Tennessee.

They stopped in Maury County, south of Nashville, and carved a homestead out of the opaque wilderness in the valley of the Duck River. Six miles away, Polk's father helped other new settlers found and plan the town of Columbia. The land was rich, as advertised, and settlement was rapid. Through farming, surveying, and land speculations, Sam Polk thrived as never before. Yet it was a hard life in many ways, and young James, who had always been a sickly child, seemed to atrophy before his parents' eyes. In the fall of 1812 he underwent extraordinary abdominal surgery to remove a gallstone, without anesthetic. It saved his life, but his health would never be good.

In 1816 Polk's father quit farming and moved the family to Columbia, where he built a fine brick home. It was a modest two-story house in the Federal style, with a small double parlor on the first floor, four rooms upstairs, and a formal boxwood garden in back. In Columbia it was quite a showpiece, reflecting Sam Polk's growing wealth. James joined his father in land speculations and began to prosper himself. He was elected to the Tennessee legislature in 1823, and a year later he married and purchased a two-story home, with detached kitchen and smokehouse, directly across the street from his parents' place. But Polk would never be a homebody. He once told his wife, when she balked at the prospect of yet another political trip, "Why should you stay home? Just to take care of the house? Why, if the house burns down we can live without it." Yet Polk was tirelessly attentive to family affairs, which, as the eldest of ten children, he was often called upon to manage after his father's death in 1827. His younger brothers were ill-starred. Three died within nine months in 1831. In 1839 another died and a fifth went to prison after killing a man in a suspicious duel.

Polk also paid a great deal of attention to two large farms he owned but never lived on—the first in western Tennessee, the second in Mississippi. His overseer at both estates was Ephraim Beanland, whose letters suggest that Polk's were something less than model plantations. Beanland was ceaselessly plagued by slow harvests, runaway slaves, and sick livestock, and he was forever "corecting" his workers. Matters often got completely out of hand: "...Munday last I tooke aup Jack to corect him and he curste me very much and run alf...in runinge 2 hundred yards I caught him and I did not know that he had a stick in his hande and he broke it over my head...I stabed him [twice] with my knife and I brought him backe to the house and chainde him and I have him in chaines yet." Presumably Beanland had compensating virtues; he remained in Polk's employ for many years.

In 1844 Polk became America's first "dark horse" candidate for president. He had

been Andrew Jackson's floor leader in the House of Representatives, Speaker after 1835, governor of Tennessee in 1839, but then twice defeated in bids for re-election. Polk despised the Whig notion that the nation's leaders sometimes know better than the people. His guiding principle was that the majority should get what it wants, and in 1844 the majority wanted Texas and Oregon. "Let Texas be *re-annexed*," Polk proclaimed, pandering to the notion that Texas had been part of the Louisiana Purchase. On that battle cry and the slogan "Fifty-Four Forty or Fight!"—reflecting the parallel Americans thought suitable for a northwestern boundary—Polk was swept into office.

Polk reflected his constituents almost perfectly. Like them, he was consumed with land hunger—for himself and for his nation. He did not seek war, but neither did he recoil from it. "It is better to fight for the first inch of national territory than for the last," he said. He struck an honorable deal with the British on Oregon, settling for the forty-ninth parallel. When negotiations with Mexico collapsed, Polk sent troops into Texas, proclaiming to Congress that the enemy had "shed American blood on American soil." Within two years American forces were shedding Mexican blood in Mexico City, and had won Texas, the New Mexico Territory, and California, all for $15 million.

On the home front the Polk administration lacked fireworks. First Lady Sarah Childress Polk was a fervent Methodist who suffered no drinking, no dancing, and no card playing in the White House. En route to Washington she had silenced a band that tried to serenade the president-elect on Sunday. Yet she couldn't stop her husband from working on the Sabbath, or any other day. "I prefer to supervise the whole operations of the Government myself," he said, admitting that the task had rendered him "exceedingly wearied and almost prostrate." He was literally working himself to death.

Sarah spent her last year as First Lady supervising the remodeling of a gracious retirement home on Nashville's Union Street, the former home of Polk's law mentor. She filled its rooms with stylish rosewood and crimson brocade furniture, and added a splendid circular table of Egyptian marble bearing the seal of the United States and thirty stars for the states of the Union. On their way home in March, 1849, the Polks took a leisurely trip, visiting the president's boyhood farms and the family home in Columbia. They moved into the Nashville house when only "two or three rooms had been fitted up so we could occupy them." Polk threw himself into managing the home's completion, but didn't live to see it. He fell desperately ill on June 2 and died June 15, 1849. Sarah lived on in the Nashville house until 1891, when it was torn down to make way for the "Polk Apartments."

Sarah Childress Polk, a no-nonsense Methodist, could not stop her husband from working on the Sabbath. "Exceedingly wearied" when he left the White House, he died three months later. Sarah lived another forty-two years.

Though he spent many years at remote outposts such as Fort Snelling (below), Taylor thought of his Baton Rouge cottage as home. The letter, which accompanied the drawing opposite, reads: "Agreeably to your wish expressed in your letter of the 22nd ultimo, I herein enclose to you a sketch of my residence at this place. The sketch you will perceive is rude, but the best I can offer to you at this time. Indeed the building is rude in itself and scarcely worthy of being sketched. I hope however this may be suitable to your purposes. I am dear sir, with much respect and regard, your most obedient servant, Z. Taylor."

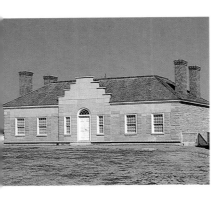

It was a misfortune for the country that the Whigs' old soldiers kept fading away. Zachary Taylor, among the least likely presidents, might be remembered today as a fine one had he not died in mid-term. A Southerner, owner of hundreds of slaves, Taylor was the last president before Lincoln to take an uncompromising stand against disunion and the expansion of slavery.

Taylor's father, Richard, was a hero of the Revolution. In 1783 he accepted a reward of 1,000 wilderness acres near the falls of the Ohio River and headed west, leaving his wife behind in Virginia to complete her third pregnancy. In November,

1784, at a cousin's estate called Montebello, Zachary Taylor was born. Eight months later he was taken to Springfield, the new family homestead near the frontier town of Louisville.

The settlement prospered rapidly, as the falls forced cargo vessels to stop there and unload their goods. By the 1790s Louisville was a small but wealthy town, sporting many fine homes, among which was the Taylors'. The first house at Springfield was a twelve-foot-square log cabin, quickly replaced by a large brick mansion in the style of Virginia plantation houses. A broad central hall crossed the width of the house and was flanked by double parlors and a spacious dining room. A second-

floor porch overlooked the gardens. There were 400 acres at Springfield, and Richard Taylor soon owned at least 10,000 acres across Kentucky. But despite the family's wealth and prominence, life on the frontier was perilous. Each night, in case of Indian attack, Richard Taylor loaded several rifles and left them at strategic spots around the house.

The army life, which would continue for four decades, began for Zachary Taylor in 1808. He was posted over the years to at least fifteen states, from Minnesota to Florida, Texas to Ohio. In 1810, while on leave in Louisville, he courted and wed Peggy Smith, a kind, self-reliant, and rather dull woman who bore five daughters and a son and patiently endured both long separations and the rigors of post life. The Taylors had one period of quiet domesticity, at the close of the War of 1812. They worked a farm Richard Taylor had given them, some 300 acres in what is now downtown Louisville, and probably lived at Springfield. Farming was altogether too quiet for Taylor, producing, he said, "nothing sufficiently interesting to trouble my friends by communicating with them on the subject." Within eleven months he was back in the army.

Already Taylor had earned a reputation as a cool and capable officer. In 1812, at

Fort Harrison in Indiana, his command had been attacked when he had only fifteen troopers not bedridden with fever. The fort was set on fire, and, as Taylor reported to William Henry Harrison, "…what from the raging of the fire, the yelling and howling of several hundred Indians, the cries of…women and children…and the desponding of so many of the men…, I can assure you that my feelings were very unpleasant." He got a grip on himself as well as the situation, and repulsed the attack. In time Taylor would earn the memorable nickname "Old Rough and Ready," bestowed because of his willingness to share his soldiers' hardships in the field. In fact Taylor was a notorious slob in the field, dressing more like a vagrant than a general. It is thought that Ulysses S. Grant modeled his famous disheveled appearance after Taylor.

From 1816 on, Taylor was an aggressive land speculator, especially in the rich cotton lands of the lower Mississippi. He bought his first cotton plantation while posted to Louisiana in the early 1820s, in Feliciana Parish just north of Baton Rouge. He and Peggy would always think of Baton Rouge as home, even though one of their longer residences was at the opposite end of the Mississippi valley, at various forts along the northwest frontier. Among them was Fort Snelling, near what is now St. Paul, a fort designed to overawe the local Indians. It loomed over the river valley from the summit of a sheer cliff, its thick stone walls rising smoothly from the rocky bank as if they were part of the natural landscape.

Old Rough and Ready saw no reason that he should lack the comforts of home at his wilderness posts. To Fort Snelling, as elsewhere, he brought a large shipment of heavy mahogany furniture, delicate china, and fine wine. The commandant's quarters at Snelling were impressive—a large stone house of eight rooms facing a sprawling parade ground. But life at frontier outposts was stupefyingly dull. There was little to do beyond struggling, usually unsuccessfully, to prevent white traders—"the greatest scoundrels the world ever knew," Taylor said—from exploiting the Indians. Taylor's daughters found the company of dozens of eligible young officers diverting. One married the post surgeon at Fort Snelling; another fell in love with Lieutenant Jefferson Davis, a match to which Taylor objected in vain. The daughter died of malaria shortly after settling at Davis's home near Vicksburg.

Back in Baton Rouge, Peggy Taylor declined to live in the commandant's quarters, choosing instead a small, run down cottage on the river bank. Formerly the home of Spanish commandants, it was a one-story, four-room wood house encircled by a wide veranda. Peggy liked its isolated location, its river view, and its spacious grounds, on which she planted a large kitchen garden. With the help of her slaves and some soldiers from the fort, she repaired and remodeled, and was soon delighted with the

results. It was the sort of home she had always wanted. At about the same time her husband bought for his retirement the sort of home he had always wanted, a 2,000-acre cotton plantation called Cypress Grove, near Rodney, Mississippi. Peggy stayed at her cottage when her husband was ordered to Texas.

In the spring and summer of 1846, Taylor scored three swift victories over the Mexican Army. In February, 1847, at Buena Vista, he confronted Santa Anna, who commanded some 17,000 men. Taylor's force numbered around 6,000, and Santa Anna demanded surrender. Ever the gentleman, Taylor responded: "In reply to your note of this date summoning me to surrender my forces at discretion, I beg leave to say that I decline acceding to your request." Cannons roared, and Taylor prevailed in the slaughter, inflicting 3,500 Mexican casualties against 700 American. He then went home, the most lauded hero since Jackson and overnight a serious contender for president.

Though he had Whiggish sensibilities, Taylor was no politician. He had never voted, and may have been the only president who truly did not desire the office. "Such an idea never entered my head," he said. "Nor is it likely to enter the head of any sane person." Taylor refused the notification of his nomination when it arrived at Baton Rouge postage due. On election day he told a reporter, "I did not vote for General Taylor; and my family, especially the old lady, is strongly opposed to his election." It wasn't enough; Taylor was inaugurated in March, 1849.

From the moment American troops crossed into Texas, the question of slavery in the new territories obsessed the nation. By the fall of 1849, when California sued for admission to the Union as a free state, civil war seemed imminent. Taylor called for admission, without concessions to the South. Into the fray stepped two aging warhorses, Daniel Webster and Henry Clay, who contrived the Compromise of 1850, a complicated affair that essentially admitted California in exchange for a stronger Fugitive Slave Law. Taylor opposed it as "a piece of political joinery" that conceded too much to the slave states. What might have come of the confrontation is hard to tell; Taylor fell suddenly ill and died at the White House on July 9, 1850.

"I will not pretend to believe that all wisdom...died with General Taylor," Abraham Lincoln said in his eulogy. But he praised the president for "a combination of negatives—absence of excitement and absence of fear," and for understanding that "the one great question of the day" could not forever be compromised. "How well," he added, "might the dying hero say at last, 'I have done my duty, I am ready to go.' " Peggy Taylor was ready, too, once her husband was gone. She returned to the deep South, moving into a small cottage in Pescagoula, Mississippi, and died there in August, 1852.

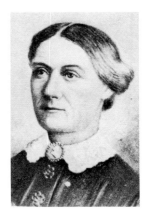

Before his own election as president, Taylor had never voted. He told reporters that his entire family opposed his candidacy—"especially the old lady," Peggy.

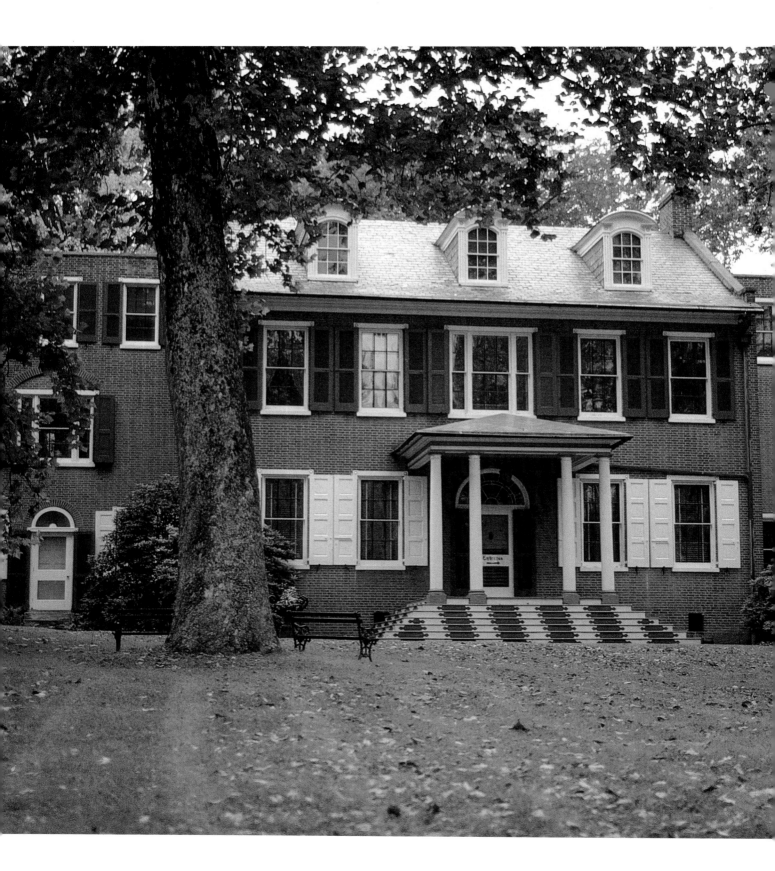

Millard Fillmore, Franklin Pierce, James Buchanan

IN THE 1850s, THE AMERICAN UNION shuddered and collapsed like a building being imploded. Understandably, the men who were in charge at the time have not been treated kindly by history. In their defense it can be said that Millard Fillmore, Franklin Pierce, and James Buchanan strained to appease the slave South because they thought it the only way to avert civil war.

They were the wrong men at the wrong time—cool, unimaginative rationalists adrift on a raging sea of emotion. Yet they failed because they tried to ignore the one plain fact in the situation: that slavery was dying in the civilized world and was doomed in America—one way or another, sooner or later. Great leaders might have prevented the war; the leaders America had could not.

In the spring of 1799 Nathaniel Fillmore and his brother Calvin stood in their flinty, stone-strewn farm fields near Bennington, Vermont, and listened to a land agent's rapturous tales of the rich black loam of western New York. They bought the salesman's story, and, sight unseen, a small farm in Locke township, in the Finger Lakes region of the Alleghenies. There, a year later, in a crowded one-room cabin, Millard Fillmore was born.

The thirteenth president later recalled that his family's farm was "high and cold" and "one of the poorest" in the region. He termed it "a blessing in disguise" that his father had been completely swindled, and lost the farm because of a faulty title several years later. The Fillmore clan moved to the village of Semipronius, rented a farm a mile west of Skaneateles Lake, and there built another crude cabin.

"I had...a great passion for hunting and fishing," Fillmore wrote in a memoir, "but my father was very unwilling to indulge it....Nevertheless, when I had any spare time I used to go down to the lake, and fish and swim in its limpid waters...." Spare time must have been scarce, as Millard became adept at the heavy labor of

wilderness agriculture. But his father had developed "a great distaste for farming." He apprenticed Millard to a succession of clothmakers.

The "library" at the Fillmore cabin consisted of "a Bible, hymn-book and almanac, and sometimes a little weekly paper." Fillmore was eighteen when he first laid his hands on a dictionary. "While attending the carding machines, I used to place the dictionary on the desk—by which I passed every two minutes...—and...I could have a moment...to look at a word....." In 1819 Nathaniel Fillmore moved his family again, to the village of Montville, where he rented a farm from Judge Walter Wood. He asked his landlord to take Millard on as a clerk, and one night at dinner Fillmore's mother broke the news that the old Quaker judge had agreed. It "was so sudden and unexpected," Fillmore recalled, "that, in spite of myself, I burst out crying, and had to leave the table, much mortified at my weakness."

Fillmore was admitted to the bar in 1823, after following his nomadic parents to the little town of East Aurora, just outside Buffalo. It was a fortunate move. The western terminus of the Erie Canal, Buffalo grew like a weed—ugly but vigorous. It had 4,000 people in 1820 and 40,000 in 1850. It was an ambitious, self-satisfied boom town, awash in civic improvement projects, in which Fillmore participated. As the years went by he became the undisputed first citizen of Buffalo. In the evenings he liked to hold forth on politics before impromptu gatherings on his front porch. He was honest, serious, vain, self-righteous, and very attractive, although most photographs, taken later in life, belie his good looks. Queen Victoria thought him the most handsome man she'd ever met.

Fillmore built his first home in East Aurora in 1826, the year he married Abigail Powers, a young woman who had been his tutor years before. The Fillmores shared a love of books. They collected a personal library of at least 4,000 volumes and later stocked the first permanent library at the White House. One night in 1830, Abigail wrote to her absent husband: "I have spent the day at home. Have felt more than usual lonely...Have finished studying the maps of ancient geography. O, that you could have been here to have studied with me!"

Overleaf: James Buchanan's palatial Wheatland, near Lancaster, Pennsylvania, was used in 1856 as a symbol of the candidate's solidity and moderation—in other words, his pro-South sensibilities.

The house on East Aurora's Main Street, just a few doors down from Fillmore's law office, was a two-story wood-frame cottage with a pillared and latticed front porch and a long one-story kitchen addition at the rear. The first floor sitting room and library were good-sized; upstairs the bedrooms were narrow and low ceilinged. Abigail laid out a large rose garden and an even larger herb garden just outside her kitchen door. A modest home by any standard, it was an impressive achievement for a young man of Fillmore's origins. In 1828, he was elected to the New York Assembly.

Fillmore was the quintessential Whig—moderately anti-slavery, strongly pro-Union, and in total sympathy with northern businessmen and their demands for roads, bridges, canals, and high tariffs. He was elected to Congress four times, but refused to let politics consume him. "[H]e is infinitely degraded," he said, "whose means of support depends on the wild caprice of the…multitude." Fillmore's didn't; by the mid-1840s his law practice was earning more than $100,000 a year, a phenomenal sum at the time.

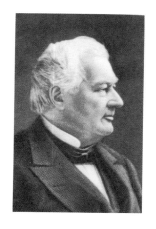

He had by then moved his family and his practice to Buffalo, where he continued to live simply, in a little house on Franklin Street near the center of town. It was a six-room clapboard structure of two stories, a kind of scaled-down Federal mansion with a long central corridor from which the rooms opened, upstairs and down. Abigail again applied her talents to the garden. Her husband encircled the property with a white picket fence, an inevitable adornment that in those days kept wandering pigs and cows out of one's yard.

In 1840 Fillmore summed up the turn American politics had taken, arguing that what the Whigs needed in its candidates was "a substance to which all can adhere, or at least that presents as few repellent qualities as possible." Eight years later, Fillmore seemed such a substance, and he became vice president. He presided over the Senate's ferocious debates on the Compromise of 1850, which President Taylor opposed. After Taylor's death, Fillmore reversed the policy.

Millard Fillmore married Abigail Powers, his former teacher, in 1826. They shared a love of books and of scholarly pursuits, and established the first permanent White House library.

"God knows that I detest slavery," Fillmore said, "…but we must endure it." He assumed that his support for the Fugitive Slave Act would bring down upon his head "vials of wrath," and he was right. The Act forced Northerners, as Lincoln later put it, "to arrest…slaves with greedy pleasure." In Boston, Philadelphia, and elsewhere, they rioted instead. Fillmore authorized the use of troops, admitting "no right of nullification, North or South." He sent troops south, as well, to intimidate radicals holding "secession" conventions. Gradually, the crisis passed, but the Compromise had killed the Whig party, now hopelessly split on slavery.

In his last months in Washington, Fillmore fretted about his home back in Buffalo. The little Franklin Street cottage was all very well, but hardly suitable for a former First Family. The trouble was less the house itself than the "disreputable" property next door. His concerns became irrelevant when Abigail Fillmore caught cold at Franklin Pierce's rain-soaked inaugural. She died of pneumonia three weeks later, and Fillmore decided that the Franklin Street house would suffice after all. "But it does not seem like home," he wrote later that spring. "The light of the house is gone."

Fillmore's spirits were slow to revive. To his friend Dorothea Dix, the crusader

for the insane, he revealed his pain: "I have done nothing...felt no desire to do any thing.... There is an aching void; a lonely solitude which none can appreciate but myself." Dix tried to cheer him with praise for his "comfortable dwelling. I like the good judgment which adopted it; and the good taste which furnished it, and most of all I like to think of you there with your children. May our gracious Lord spare them..." Her prayer was prescient. Fillmore's only daughter died a year later, plunging him still deeper into despair—"my dwelling, once so cheer[ful] and happy, is now dark and desolate."

Fillmore took a long tour of Europe in 1855. Meantime he maneuvered for the 1856 presidential nomination of the American, or "Know-Nothing," Party, an anti-Catholic, anti-immigrant group. Fillmore cared little for the nativist cause, but saw the Know-Nothings as a possible alternative to the Southern-dominated Democrats and the new anti-slavery Republicans. He warned audiences not to reopen "the bitter fountains of slavery agitation," insisting that the South would not tolerate a Republican victory. "We are treading upon the brink of a volcano," he said.

In 1858 Fillmore relieved his loneliness, and his concerns about the Franklin Street house, by marrying a wealthy widow from Albany, Caroline McIntosh. Together they bought the Hollister mansion on Buffalo's Niagara Square. It was a great, neo-Gothic palace of stone and brick, a riot of gables, parapets, false towers, and architectural detail. Caroline filled its many rooms with heavy Victorian furniture and with dozens of portraits and busts of her famous husband. The house became the social nerve center of Buffalo, as Fillmore continued to pour himself into civic projects and settled at last into happy retirement. "My own house is the most comfortable place I can find," he wrote to Dorothea Dix, "and my wife and library...the most charming society."

In February, 1861, Abraham Lincoln stopped in Buffalo en route to Washington and spent several days with the Fillmores. Fillmore supported the new president's war effort as best he could, but was soon decrying the conflict's duration and bloodiness, and what he termed Lincoln's "military despotism." Republican newspapers began by deploring Fillmore's "bad taste," and ended by accusing him of little less than treason. When, after Lincoln's assassination, Fillmore was slow to drape his house in appropriate symbols of mourning, some irate neighbors corrected the oversight, smearing his beautiful mansion with black ink.

As tempers cooled after the war Fillmore was restored to a position of honor in Buffalo. He lived on at Niagara Square, bragging that his life was "an earthly paradise," until March, 1874, when he died of a stroke.

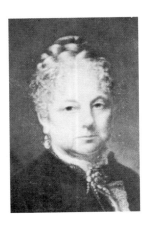

Fillmore's first home in East Aurora, New York, still stands. The Buffalo mansion where he died, which belonged to his second wife, Caroline, was demolished after serving for many years as a hotel.

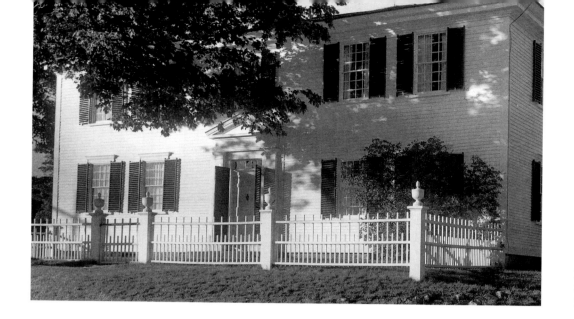

Franklin Pierce lived at his parents' home in Hillsborough, New Hampshire (left), until he was thirty-one. In 1842 he bought a similar house (below) in Concord, the only home he ever owned.

"There is a certain steadfastness...with regard to a man's own nature (when it is such a peculiar nature as that of Pierce) which seems to me more sacred and valuable than the faculty of adapting...to new ideas, however true they may turn out to be." So wrote novelist Nathaniel Hawthorne, Franklin Pierce's best friend. Another good friend, noting that Pierce had "no very remarkable talents," thought his career "an instance of what a man can do by trying." Pierce himself, on retiring from the presidency, was sure that his administration had been "one of positive good or positive evil," but didn't venture to say which.

According to legend, Pierce's father was one of those Massachusetts farmers who dropped his plow in the field when he heard the news of the battle of Lexington, and marched off to join Washington's army. After the war Benjamin Pierce moved to the pine-covered hills of Hillsborough County, New Hampshire, and bought a small farm on a branch of the Contoocook River. A devout fisherman, he had chosen the spot for its proximity to trout. Six weeks after the birth of Franklin, his fourth son, he moved the family out of its log cabin and into a massive, wood-frame house that had long been under construction.

Benjamin Pierce had quickly become one of New Hampshire's wealthiest and most respected citizens. His new home was elegant and big, with imported scenic wallpaper and hand-stenciled cornices. It had vast interior spaces, including a second-floor sitting room. The mansion was surrounded by lavish gardens, and directly in front lay an artificial fish pond, where the Pierce men enjoyed their avocation when they lacked the time or inclination to hike down to the stream.

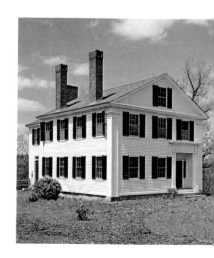

Franklin Pierce later described his mother as "affectionate and tender..., strong in many points and weak in some." Among her weak points were alcoholism and manic depression. Franklin was sent to the finest prep schools and later to Bowdoin College in Maine, where he made many friends with his vivacious personality, quick

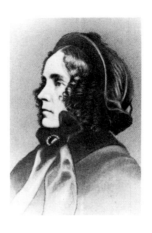

An anguished, brooding woman, Jane Pierce could do little to relieve her husband's own emotional storms. He fought a losing battle with alcoholism all his adult life.

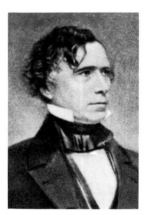

wit, and lean good looks. He graduated third in his class after ranking dead last at the end of his second year.

Pierce lived primarily at his parents' house until he was thirty-one. When he was admitted to the bar in 1827, his father built him a law office directly across the road from the mansion. That same year the elder Pierce was elected governor of New Hampshire, and it was in working on his father's behalf that Pierce first became involved in politics. He was himself made a state legislator in 1829, and was sent to Congress in 1833, an "unwavering and inflexible" proponent of states' rights.

Pierce married Jane Appleton in 1834 and bought his first house, in Hillsborough. Between trips to Washington and Mrs. Pierce's incessant visits to her relatives, the couple never really settled in this home. Fiercely religious, Jane Pierce loathed politics and her husband's public life. She was, as was said at the time, "delicate"—excruciatingly shy and morose. On her honeymoon she wrote to her father-in-law, "[We] have both generally been very well, and not very unhappy."

In the late 1830s, Pierce lived mostly in Washington boarding houses, while Jane often stayed with relatives. By then a Senator, Pierce partook freely of the capital's gay society, though his wife, when in town, often cramped his style. He wrote to his father of a party marked by "uncommon glee" that he had left at Jane's insistence. "Judging from the appearance of most of my friends," he said, "I believe I gain in the feelings of today what I lost by leaving early last night." But he didn't leave early very often.

In 1842 Pierce succumbed to his wife's pleas and resigned his Senate seat. They moved to Concord, New Hampshire's capital, and bought a two-and-a-half story, white frame house on Montgomery Street. It was a large home for so small a family. Three sons had been born, but one died in infancy. The new house was handsome, long and tall and unadorned in the typical New England fashion. Pierce, having sworn off liquor, became active in Concord's temperance movement. The city went dry in 1844, helping Pierce to solidify his leadership of the Democratic party in New Hampshire. A bold expansionist, he eagerly departed for the Mexican War in 1847, as a brigadier general.

When a second Pierce son died at the Montgomery Street house, it was enough for Jane to insist on a move. The property was sold while Pierce was in Mexico, and in the fall of 1848 he arranged to share a small Main Street cottage with some close friends. The Pierces would never again own their own home, even though they had purchased sixty acres nearby on which they planned eventually to build. The years at the Main Street cottage were Pierce's best. He doted on his one remaining son, Bennie, a spirited boy who would scamper downtown in the late afternoons to wait

outside his father's office and share the walk home.

Pierce was the ideal compromise candidate for the Democrats in 1852. He was a Northerner—a New Englander, no less—with impeccable pro-South credentials. An easy winner over the divided Whigs, Pierce was confidently preparing for his administration when, in January, 1853, he boarded a train with his family to travel to a friend's funeral. The train derailed, and there was one fatality—Bennie Pierce, hideously crushed before his parents' eyes. Jane concluded that God had taken the boy so as to leave his father undistracted, and Pierce, not knowing "how I shall be able to summon my manhood and gather my energies" limped into the White House a broken man.

Pierce honestly believed that the Compromise of 1850 had permanently settled the slavery question. He might have been right, had he and Senator Stephen A. Douglas not promptly unsettled it with the Kansas-Nebraska Act, probably the worst piece of legislation in American history. The Act repealed the Missouri Compromise and theoretically opened all unsettled American territory to slavery. Pierce was stunned by the ferocity of Northern reaction. Terror soon reigned in Kansas, where at least 200 died in warfare between "pro-slave" and "free-soil" settlers. By 1856, "anybody but Pierce" was the Democratic slogan, and that fall the citizens of Concord judged it "inexpedient" to welcome the president home, preferring to greet him with a "solemn, mournful silence."

Pierce was used to that. His wife had spent almost two solid years in the upstairs family quarters at the White House, writing letters to her dead son. "Everything in that mansion seems cold and cheerless," wrote one visitor. "I have seen hundreds of log cabins which seemed to contain more happiness." After leaving Washington the Pierces spent the better part of three years traveling in Europe and the Caribbean. In the summer of 1860 they went home to Concord, moving into a new house their friends had built at 52 South Main, where they would live for the rest of their lives.

The new three-story house, surrounded by a wrought-iron fence, was big and stylish, designed in the fashionable French mode. It was tall and fairly slender, with a Mansard roof, and sat high above street level. A wide central hallway led to a parlor, sitting room, and dining room on the first floor. One of the five bedrooms upstairs was set aside for Nathaniel Hawthorne, who often visited in those years and found that "something...seemed to have passed away out of [Pierce] without leaving a trace." Concord newspapers reported that no one in town would speak to Franklin Pierce, and while that was surely an exaggeration, the bitterness of neighbors was palpable in the war years. Pierce gave no quarter; he blamed Lincoln and other "abolitionists" for "all the woe...all the degradation, all the atrocity, all the desolation

and ruin." When Hawthorne died in 1864, Pierce was alone with him. But at the funeral, crowded with New England literati, the former president was denied the right to serve as a pallbearer.

Jane Pierce, too, was gone, having died a few months before Hawthorne. Pierce was alone when word of Lincoln's murder reached Concord. Despite his angry denunciations of the president, Pierce was stricken. He was lying prostrate on a sofa in his library when he was roused by the sound of a mob gathered outside his front door, apparently bent on mayhem. Standing in the shallow portico high above the sidewalk, he calmed the crowd with a speech decrying the assassination. But he refused to hang a draped flag from his door. "It is not necessary," he said, "for me to show my devotion to the Stars and Stripes."

The end of the war softened many hearts toward Pierce, but his scars were deep. In summer, 1865, he bought a lovely, two-story cottage at Little Boar's Head on the misty Hampshire coast, and afterwards spent less and less time in Concord. The coast cottage stood on high ground, near a sheer drop to a rocky, wave-battered beach. Pierce bought up nearly 100 acres of adjoining land and toyed with the idea of establishing a summer colony there. Nothing came of it. For four decades Pierce had fought a lonely battle with alcoholism, and in these last years he mostly gave up the fight. He fell ill at the cottage in the summer of 1869, and returned to Concord. He died in a front bedroom of the Main Street house on October 9.

New Hampshire could not bring itself to raise a monument to Pierce's memory for fifty years.

In 1844, James K. Polk asked Andrew Jackson to comment on his cabinet selections. Jackson was appalled by one of the choices: James Buchanan for secretary of state. "But general," Polk protested, "you yourself appointed him minister to Russia." "That I did," the old firebrand admitted. "It was as far as I could send him out of my sight. I'd have sent him to the North Pole if we'd kept a minister there!"

Despite having gotten on Old Hickory's nerves, James Buchanan's political career was marked by an exceptional talent for skirting controversy. The irony is that, when he finally became president, Buchanan inherited a nation on the brink of anarchy. He succeeded only in pushing it over the edge, becoming in the process the most angrily vilified of our chief executives. Thaddeus Stevens's assessment, that Buchanan was "a bloated mass of political putridity," was typical.

Like Pierce, Buchanan was a Northerner with Southern convictions—what abolitionists called a "doughface." He was a gracious, old-fashioned gentleman, generous and formal. Though not born into wealth, he had an aristocratic, paternalistic

temperament, and an almost religious fidelity to the Constitution. Disliking slavery but thinking it protected by the Constitution, he occasionally bought slaves in Washington and took them home to Pennsylvania, where he set them free.

In 1848, after serving Polk capably, Buchanan bought a twenty two-acre estate just outside his longtime home of Lancaster, Pennsylvania. Called Wheatland, reflecting the dominant agriculture of Lancaster County, the place had the feel of cotton country about it. A lithograph of Wheatland was widely circulated, especially in the South, during the 1856 campaign. After decades of log-cabin campaigns and candidates boasting of humble origins, whether they had them or not, it was suddenly an advantage to live in manorial splendor, to be an aristocrat of the old school—Jefferson reborn.

As it happens, James Buchanan had been born in a log cabin in 1791. It is thought that a larger family home had burned down shortly before his birth. The cabin stood at a place called Cove Gap, Pennsylvania, where Buchanan's father, an Irish immigrant, ran a general store. It was such rugged and unsettled country that the Buchanan children were fitted with cowbells when sent out to play, lest they stray too far. Within a few years the family moved to a 300-acre farm near Mercersberg, and then to Mercersberg itself, where a two-story brick house served as both home and trading post.

Buchanan credited his mother for "any little distinction which I may have acquired." Though poorly educated, she was a tireless and perceptive reader, always encouraging her children in intellectual pursuits. "She would argue with [us], and often gain the victory; ridicule [us] in any folly..., and enter into all [our] joys and sorrows....My father did everything he could to prevent her from laboring in her domestic concerns, but it was all in vain. I have often...sat in the kitchen with her and while she was at the wash-tub, have spent hours pleasantly and instructively conversing with her."

Distinctions came quickly to Buchanan. He was admitted to the bar in 1812, at age twenty one, and moved to Lancaster. In 1815 he bought a Lancaster tavern and pressed it into service as an office and home. That same year he was elected to the first of two terms in the Pennsylvania legislature, but he then abandoned politics, the better to court Anne Coleman, the beautiful daughter of a Lancaster millionaire. They became engaged, but in the fall of 1819 they quarreled and Miss Coleman renounced their plans. She died suddenly in December, prompting Buchanan to write a painful letter to her father, pleading for permission to attend in the funeral: "My prospects are all cut off," he wrote, "and I feel that my happiness is buried with her in the grave. It is now no time for explanation...." The letter was returned unopened, and the time for explanation never came. It is thought that Miss Coleman

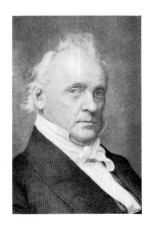

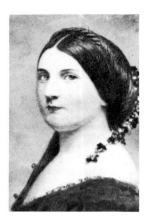

America's only bachelor president, Buchanan shared his home and much of his life with his niece Harriet Lane, who served as First Lady.

feared that her fiancee was interested only in her money. Years later, when he had plenty of his own, Buchanan bought the Coleman family's lovely home on King Street in Lancaster; it was from there that he moved to Wheatland. He never again had a serious romance. He was the only bachelor president, and probably a lifelong celibate.

The tragedy propelled Buchanan back into politics. He served ten years in the House and ten in the Senate; was Jackson's minister to Russia, Polk's secretary of state, and Pierce's minister to England. He was a supremely loyal and doctrinaire Democrat, an ardent expansionist, and a perennial presidential hopeful. But his time stubbornly refused to come. Wheatland was to be his compensation in retirement.

By the late 1840s, Lancaster was already an old and picturesque colonial town, a living stereotype with its red brick row houses, cobblestone streets, and brick sidewalks. The surrounding countryside was, as it still is, soft and verdant—an open, lumpy land of green and beige, of dense hilltop forests and sprawling fields of wheat and corn. Settled largely by farmers of German extraction, plus the Amish and Mennonites, it was the scene of conservative, self-sufficient agriculture.

Wheatland was a hobby farm at most, an island of opulence in this plain and practical country. Set amid a dense grove of maples and elms, the mansion was long and narrow, its square central section topped with a sloping slate roof and three French dormers, and flanked by two flat-roofed, three-story wings set slightly back from the facade. Three sided steps led to a small pillared portico over the front door, which opened onto a grand T-shaped hallway. The mansion's thirteen rooms were uniformly large and high-ceilinged. Rounded arches, extravagant plaster mouldings and cornices, and heavy wooden venetian blinds added to the palatial atmosphere. Throughout the house was pine woodwork painted to resemble oak, a common practice at the time. In Buchanan's library stood two enormous mahogany bookcases. Great crystal chandeliers hung in the hall and several of the public rooms. The fine fireplaces, some in carved marble, were closed off, as Buchanan had added an early coal furnace.

Buchanan lived at Wheatland with his housekeeper, Hetty Parker, who was with him nearly forty years, and with an adopted nephew and niece, James Buchanan Henry and Harriet Lane. He had taken charge of these children, seven and nine years old, respectively, when they were orphaned in the early 1840s. He raised them as his own, and they brought warmth and gaiety to what was otherwise a lonely life. He came to rely on Harriet as a kind of surrogate wife. She traveled with him to England in 1853 and was a great success at court. During his presidency she was his White House hostess and was treated officially as First Lady.

The mission to England, though not very successful in itself, made Buchanan president at last, when he was sixty-five years old. Having been abroad, he was the one prominent Democrat not soiled by the Kansas-Nebraska Act. His hands didn't stay clean for long. Two days after his inauguration, the Supreme Court handed down the Dred Scott decision, ruling that Congress had no authority to legislate on slavery, and that blacks could not be citizens and had no right to due process, no rights whatever. The North could not stomach it, especially when it was learned that Buchanan had privately urged the court to make such a ruling. Then, in Kansas, pro-slave settlers, outnumbered by free-soilers at least five to one, sued for admission as a slave state. Buchanan backed their request, and it was too much even for Stephen A. Douglas. The Democratic Party began to unravel. In October, 1859, John Brown's bloody raid on Harper's Ferry killed what was left of moderation in the South. And then the long-dreaded nightmare engulfed James Buchanan.

When the crisis struck after Lincoln's election, Buchanan assured Congress that secession was illegal, but added that the president had no authority to prevent it by force. It added up to doing nothing, and though Buchanan defended his policy as being designed to leave Lincoln's options open, few were impressed. On inauguration day Buchanan told the new president, "If you are as happy on entering the White House as I am on returning to Wheatland, you are a very happy man indeed."

Lancaster gave Buchanan a lavish welcome. He was escorted to his mansion by a company of militia and a large brass band that struck up "Home Sweet Home" as he stepped from the carriage. It was April; the estate was bursting with new life. But Buchanan's retirement was to be a trial. Militiamen stayed on guard for months, and so great was the fear of violence that Buchanan was a virtual prisoner at Wheatland, afraid even to go into Lancaster. He was subjected to a relentless barrage of cruel criticism, blamed both for the war and for not commencing it sooner.

Though he disapproved of emancipation, Buchanan gave Lincoln unwavering public support. He retired to his library in Wheatland's east wing, and there, on his felt-top desk, replied to his critics in a long apologia, *Mr. Buchanan's Administration on the Eve of the Rebellion*. It was an able defense from a seasoned lawyer, but it did little to quiet his accusers, and has done little to improve his historical standing.

Still, Buchanan felt vindicated, and he was happy at Wheatland, though less so after Harriet Lane was married in the mansion's first-floor parlor in 1866, and finally left him. "My evenings are rather solitary," he wrote to a friend. "Still, I resign myself in a philosophic and, I trust, Christian spirit to the privations inseparable from old age." His privations ended, in an upstairs bedroom at Wheatland, on June 1, 1868.

Abraham Lincoln

IN A SHADOWY WOOD IN CENTRAL KENTUCKY, at the top of steep, short hill, stands a columned Doric temple of marble and granite, reached by a broad, fifty-six-step staircase. Inside the hushed shrine rests a rude log cabin barely twelve feet square, bark still clinging to its squared logs, roof poles jutting unevenly from the peaks at either end. Now permanently entombed, it is a well-traveled hovel, having been displayed at fairs and expositions around the country in the early years of this century. Its striking shabbiness has survived dozens of dismantlings and reconstructions. It is indistinguishable from millions of log cabins built by American pioneers, yet this one has the mystical power of a saintly relic. It is, or at least is accepted as representing, the cabin in which Abraham Lincoln was born on February 12, 1809.

Lincoln himself, the flesh and blood man, is a little like his homely birthplace—obscured within a ponderous edifice of legend and adulation. Lincoln has come to represent American idealism itself, and to embody the defining democratic myth—that the well of greatness can be found along the humblest walks of life. It's easy to picture the jocular Lincoln making sport of his latter-day canonization, but it's not certain that he would want such a legend deflated. He once listened to a discussion of George Washington, the faultless idol of his own generation, in which it was argued that the general could not possibly have been as pure as people imagined. Lincoln agreed, but added, "Let us believe...it makes human nature better to believe that one human being was perfect; that human perfection is possible."

If Americans ever attributed perfection to Lincoln, they've gotten over it. It is common now to take note of his racial prejudice; his pragmatic purposes in freeing the slaves; his many blunders. But his story still does human nature no harm. With barely one year of formal education, he became as great a genius as American public life has known. As a craftsman of English he stands with the finest American writers, possessing, said one judge in whose court he argued, "a clearness of statement which was itself an argument." And when all the qualifications are accounted for, his insistence that some moral differences cannot be split still inspires. "Let us be diverted by none of these sophisticated contrivances," he told one audience, "...contrivances such as groping for some middle ground between the right and the wrong: it is as

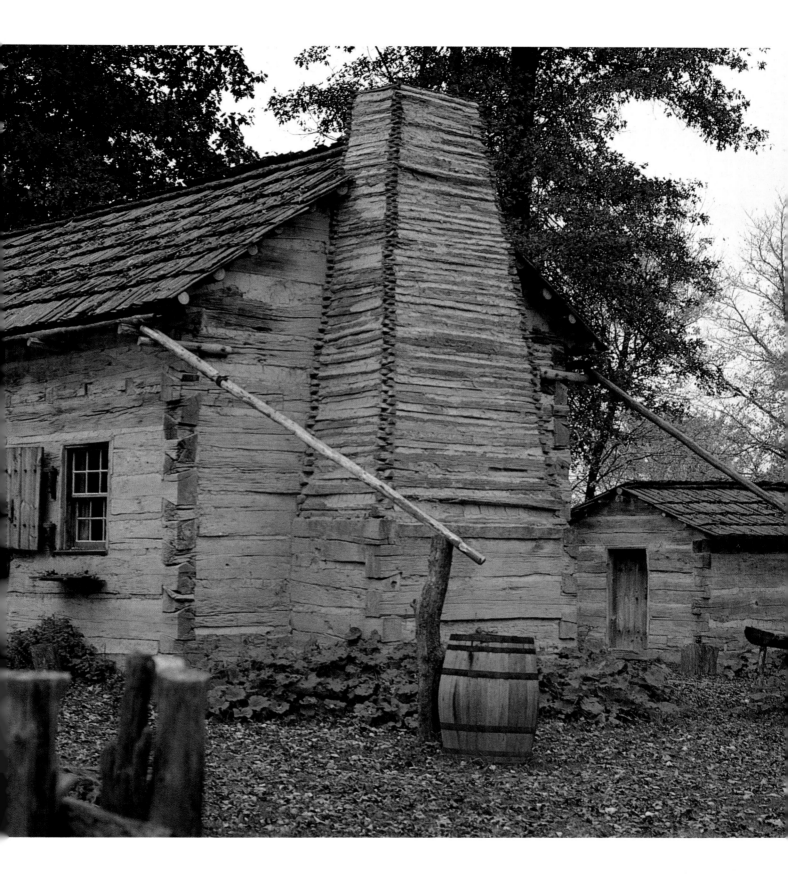

Like a saintly relic, the crude cabin in which Lincoln was born was enshrined within a granite monument in 1911. A replica of the Indiana farm where Lincoln spent most of his boyhood (overleaf) is exact down to the wooden gutters that collected rain water from the roof.

vain as the search for a man who should be neither a living man nor a dead man."

Lincoln's ancestors were English, originally Quakers. The first emigrant came to Massachusetts in 1637, and from there the progeny wandered—to New Jersey, Pennsylvania, Virginia. They were carpenters, blacksmiths, and farmers, and nothing has been found to alter Lincoln's own assessment that they were all "undistinguished families—second families, perhaps I should say." Lincoln's grandfather and namesake, Abraham, brought his wife and five children to Kentucky in 1782. Two years later he was gunned down in his field by a marauding Indian, who was proceeding to carry six-year-old Tom into the forest when an elder brother evened the score with a shot from the cabin window.

Tom Lincoln grew up to become a carpenter, cabinet maker, and half-hearted farmer. In 1806 he married Nancy Hanks and bought 350 acres on Nolin Creek near what is now Hodgenville, Kentucky. There he built the cabin destined for immortality beside the "Sinking Spring," a deep limestone depression that receives water bubbling up nearby. The soil was thin and dry, there was a problem with the title, and Abraham Lincoln was to have no memories of his birthplace. When he was two the family moved ten miles north to a 230-acre farm on Knob Creek, a homestead he remembered "very well."

"Our farm was composed of three fields which lay in the valley surrounded by high hills and deep gorges," Lincoln wrote in an autobiographical sketch. "Sometimes when there came a big rain in the hills the water would come down the gorges and spread over the farm. The [first] thing I remember...was one Saturday afternoon; the other boys planted the corn in what we called the 'the big field'—it contained seven acres—and I dropped the pumpkin seed. I dropped two seeds every other hill and every other row. The next Sunday morning there came a big rain in the hills; it did not rain a drop in the valley, but the water, coming down through the gorges, washed ground, corn, pumpkin seeds and all clear of the field."

Tom Lincoln was a decent man who provided adequately for his family and stayed out of debt. But by every account he was lazy. The cabin he built at Knob Creek, like the earlier one at Sinking Spring, was perhaps a bit rougher than it needed to be. Its packed dirt floor was never covered; the one window and one door remained mere holes in the wall; furniture was scarce and crude. Abraham's cousin Dennis Hanks, who lived with or near the family for many years, remembered that Nancy Lincoln was "turrible ashamed o' the way they lived" but "wasn't the pesterin' kind."

Lincoln, who had one elder sister, admitted to inheriting his father's distaste for

physical labor. "He taught me to work," he said, "but he never taught me to love it." But work he did, reporting that at around age eight "an ax was put in [my] hands...and from that till within [my] twenty-third year [I] was almost constantly handling that most useful instrument." Most important among the instrument's uses was the chopping of firewood for winter, a daunting task that began in earnest in summer and continued until a stack much larger than one's cabin had been stored. Even at that it was a losing battle. In a cabin such as the Lincoln's, a blazing midwinter fire in the hearth could not keep a glass of water from freezing on the mantel.

"It is a great folly," Lincoln said, "to try to make anything out of...my early life." The whole could be captured in one phrase: "the short and simple annals of the poor." Elsewhere he spoke of "pretty pinching times" and "stinted living," and termed the region of his boyhood "as unpoetical as any spot on earth." Yet it's possible to overstate the hardships of pioneer farming. There was no disgrace in the Lincolns' condition, and because they were isolated, they had little cause to feel envy or resentment. There was beauty in their surroundings, and privacy to the point of deprivation. And there was, for the Lincolns at least, no hunger. If Tom Lincoln was a poor farmer, he was a passionate hunter and fisherman. The splintery Lincoln table brimmed with venison, rabbit, trout, and turkey—so much so that salt pork and raw sliced potatoes were delicacies.

Abraham ate heartily, but didn't share his father's pleasure in the hunt. When he was eight, he remembered, "a flock of wild turkeys approached the...cabin, and...with a rifle gun, standing inside, [I] killed one of them. [I have] never since pulled a trigger on any [large] game." Like innumerable farm boys, he fell in love with a pig. "I played with him, and taught him tricks. We used to play hide-and-seek. I can see his little face now, peeking around the corner of the house...." The inevitable day for slaughtering came, and Abraham, after a desperate attempt to flee with his friend, could only "blubber" at the "awful tragedy." Dennis Hanks found "suthin' peculiarsome about Abe," not least his habit of lecturing his playmates about torturing animals, proclaiming that "an ant's life is as sweet to it as ours is to us." Lawyers who later rode the circuit with him recalled his falling hours behind to rescue every baby bird sundered from its nest.

There are too many such stories for all of them to be true, but Lincoln's compassion is not in doubt. As president he saved thousands of men from the gallows, making the Civil War unusual among "revolutions" for the rarity of executions.

In the summer of 1816, the Lincolns lashed their mobile possessions onto the backs of two horses and moved to southern Indiana—"partly on account of slavery," Lincoln wrote later, "but chiefly on account of the difficulty in land titles." Kentucky's

swelling slave population was unwelcome to a poor, slaveless farmer such as Tom Lincoln, who also seemed to have a special talent for buying disputed land. But in fact the "chief" reason for this move was probably simple wanderlust, the inexplicable pioneer restlessness that kept millions of Tom Lincolns endlessly chasing the horizon.

The rawness of the frontier to which the family trudged is captured in Lincoln's simple description: "We settled in an unbroken forest." What can that have meant to a man whose whole youth was spent in the wilderness? The new farm was founded on a slight rise of land near Little Pigeon Creek, and much of the first winter was spent under a lean-to shed, open to the weather on one side and warmed after a fashion by a perpetual bonfire just beyond the lip of the roof. "The clearing away of surplus wood was the great task ahead," Lincoln wrote. Some of that surplus went into yet another crude cabin, this one eighteen by twenty feet, with a shallow sleeping loft reached by a ladder of wooden pegs driven into the wall. A barn and several other log outbuildings followed, as did a lean-to woodshop that faced south. On merciless winter days, the shop, warmed only by the sun, was warmer than the cabin.

Lincoln adored his stepmother, Sarah, and credited her for his successes. His relationship with Tom Lincoln, his affable, lazy father, was troubled.

Two years after the family settled at Pigeon Creek, Nancy Lincoln died of "milk sickness," a poison ingested through the milk of a cow that had eaten snakeroot. She had long been a withdrawn and morose woman, but also a kind wife and mother, and her loss was an emotional blow to her family. As a practical matter, the loss of a pioneer wife's labor was a catastrophe that could not be endured. Within a year Tom Lincoln traveled alone to Kentucky, and with no-nonsense dispatch proposed to a widow he had known years before. They married the next day and departed for Indiana.

In his haste Tom may not have noticed that this time he'd landed "the pesterin' kind." Sarah Lincoln arrived at Pigeon Creek with three children from her previous marriage (making, with Dennis Hanks, a family of eight); a substantial store of furniture, bedding, kitchen utensils, and clothing; and no intention of being ashamed of how she lived. A plank floor appeared at the Lincoln cabin, then real windows and a real door, then chairs and beds. Sarah took her stepchildren in hand, and, as she put it, "made them look a little more human." It wasn't long, said Dennis Hanks, before "we felt as if we was gittin' along in the world."

For nine-year-old Abraham, the transformation at the homestead went far beyond these new physical comforts. His relationship with his father was difficult. Years later, when the old man lay fatally ill, Lincoln made lame excuses for attending neither the bedside nor the funeral. But he visited his stepmother faithfully, once

just before departing for the White House, and credited her for all he had become. Illiterate herself, Sarah noticed that her stepson was "diligent for knowledge," and that he had a phenomenal memory. He would come home from a church meeting, she said, climb a stump, and repeat the day's sermon word for word. Dennis Hanks thought his cousin obsessed with words. He would scrawl words anywhere—in the dirt, the snow, the fireplace soot, the dust on a table—and then just stare at them. He once showed his name to Dennis and marveled that such scratches could somehow represent a person. "'Peared to mean a heap to Abe," Dennis reported.

The teenager became stranger and stranger, developing the lifelong habit of reading aloud while lying flat on his back, his feet propped against a wall. He took to helping neighbors write their letters, and drove them to distraction with his insistence that they find just the right way of phrasing the information that they were all healthy and the corn was coming middling well. Tom Lincoln was puzzled and "pestered" by the whole business, but Sarah encouraged her stepson, who would one day become president almost entirely on the strength of his skill as a speaker and writer.

Even as a speaker, the backwoods never came out of Lincoln. All his life, chair was "cheer," there was "thar," getting was "gittin'." He spoke in a piercing, high-pitched voice that had carrying power but little charm. One observer called it "not positively disagreeable." At Gettysburg the audience heard something like this, in a shrill falsetto: "....It is ruther fur us toe be heer dedicated, toe the great task remaining befur us....that we heer highly resolve that these dade shall not have died in vain...and that government of the people, by the people, fur the people, shall not perish from the earth."

Beyond his odd "diligence for knowledge," Lincoln's life at Pigeon Creek isn't hard to picture. It was mostly work. Water was a problem on the farm, as all of Tom Lincoln's wells went dry and the nearest spring was a mile off. Father and son fashioned rain gutters out of slender poles, then extended them on a slant from the roof edge to wooden barrels. Another long, stiff pole rested against the stick and mud chimney, a frightening fire hazard that merely leaned against the house above the stone firebox. The pole was there to aid in swift demolition should the chimney catch a spark.

Lincoln grew tall (six feet four), with abnormally long arms and legs that would lead later enemies to invariably call him an "ape" or a "baboon." He became, by all accounts, physically strong, though one needn't believe stories that he could hoist a full whiskey barrel and drink from the bung (spitting out the whiskey afterwards, of course). By his mid-teens his famous taste for broad humor was full grown. He would have neighbor children walk in the mud, then he'd carry them into the cabin and lift them, upside down, to make tracks across his stepmother's ceiling. Such

absurdity never ceased to delight him. Even en route to Washington in the tense winter of 1860-61, he would call his short, plump wife up to a platform beside him and announce, "There, now you have the long and the short of it." When Lincoln told such jokes, no one laughed harder than he.

After thirteen years at the Pigeon Creek farm, Tom Lincoln felt a familiar urge. In March, 1830, the Lincolns boarded ox-drawn wagons and rolled toward Illinois, stopping in Sangamon County at the cusp of the great eastern forest and the prairie country that seemed to stretch from there to forever. The family's first prairie winter was a howler, more than enough to propel Tom Lincoln on another migration, this time to southern Illinois. Abraham, twenty two years old, struck out on his own, and soon landed in New Salem, Illinois, "like a piece of floating driftwood."

New Salem was one of those frontier towns that bloomed and wilted like wildflowers. It was young and optimistic during Lincoln's six years there, a cluster of low wood shacks on a forested bluff rising high above the river and the prairie. While there Lincoln caromed from one job to another—storekeeper, postmaster, surveyor, handyman. He got in and out of debt, made friends with his humor and generosity (he was very casual about postal regulations), and searched for a future.

He tried military life for ninety days in 1832, during an uprising led by Chief Black Hawk. Years later Congressman Lincoln rose on the House floor to describe the experience. It was 1848, and the Democrats were trying to counter Zachary Taylor's hero image by inflating the military career of their own candidate, Lewis Cass. "By the way, Mr. Speaker," Lincoln drawled, "did you know *I* am a military hero? Yes sir; in the days of the Black Hawk War I fought, bled, and came away.... If General Cass went in advance of me in picking huckleberries, I guess I surpassed him in charges upon the wild onions. If he saw any live, fighting Indians, it was more than I did; but I had a good many bloody struggles with the mosquitoes, and although I never fainted from loss of blood, I can truly say I was often hungry."

In New Salem Lincoln sometimes boarded with families who, needing income, made room in their crowded cabins for such drifters. At other times he bunked in the back rooms of the stores where he clerked, sharing with other men beds so narrow that "when one turned over the other had to do likewise." While briefly running his own store, he made his bed on the front counter. But despite his vagabond lifestyle, Lincoln's ambition was already pushing him hard. In 1832 he audaciously declared himself a candidate for the state legislature and lost. Two years later he won. A conventional Whig, he supported banks and government-financed improvements to roads and rivers. He lobbied hard, even ruthlessly, for moving the statehouse to Springfield, the seat of Sangamon County. He had meanwhile taken up the

study of law. In 1837 he was admitted to the bar and moved to the new state capital.

At first he was disappointed. "[L]iving in Springfield is a rather dull business after all," he wrote. "...I have been spoken to by but one woman since I've been here, and should not have been by her, if she could have avoided it." Women were on Lincoln's mind. His painful years of romance brought the dark, brooding side of his personality explosively to the surface. In Springfield Lincoln shared a room above a store with Joshua Speed, who thought that "I never saw so gloomy and melancholy a face in my life." Several years later, when Speed was himself tormented with melancholy as his wedding approached, Lincoln wrote him: "[I]t is the peculiar misfortune of both you and me, to dream dreams...far exceeding all that anything earthly can realize."

Lincoln had had his first romance in New Salem, with Anne Rutledge, a pretty young woman who was engaged to a man who had disappeared. The mythmakers have probably exaggerated the depth of this attachment, yet Anne's sudden death shattered Lincoln. His second failed courtship was more comic than tragic. Lincoln had met Mary Owens in 1833. Around the time he moved to Springfield, a mutual acquaintance suggested that Miss Owens might make a good wife, and arranged a reunion. The lady, Lincoln told a friend, had changed: "I knew she was over-size, but she now appeared a fair match for Falstaff....I could not...avoid thinking of my mother...from her want of teeth, weather-beaten appearance in general, and from a kind of notion...that nothing could have commenced at the size of infancy and reached her present bulk in less than thirty-five or forty years..." Lincoln dutifully went forward, "mustered my resolution and made the proposal direct; but, shocking to relate, she answered, 'No.'....I very unexpectedly found myself mortified almost beyond endurance."

This was not Lincoln's kindest moment. He was himself, as he said many times, "not much to look at." His skin was dark and coarse as canvas; his eye sockets were cavernous; the entire lower half of his face was slightly sunken. Many thought him plainly ugly. Even so, in 1839 he met and charmed Mary Todd, a schooled and sophisticated daughter of a distinguished Kentucky family. She was pretty (though chronically "over-size"), intelligent, and aggressive. Despite strong disapproval from her family, she accepted Lincoln's proposal in the fall of 1840.

Then something snapped in Lincoln. He broke off the engagement and collapsed emotionally. "I am now the most miserable man living," he wrote to his law partner. "If what I feel were equally distributed to the whole human family, there would not be one cheerful face on the earth....To remain as I am is impossible. I must die or be better, it seems to me." Gradually, he got better, and on November 4, 1842, he

Lincoln termed his marriage to Mary Todd "a matter of profound wonder." His bafflement with his stormy wife persisted throughout their twenty three-year marriage. After her husband's murder, Mary slid into madness.

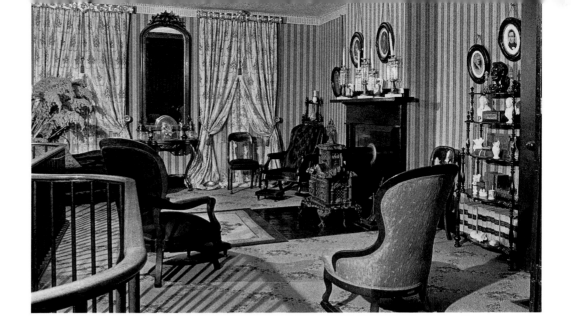

In the front parlor of his house on Springfield's Jackson Street, Lincoln learned of his nomination and, months later, informed Mary of his election.

married Mary Todd—"a matter," he said, "of profound wonder."

For a year the newlyweds took a room in the Globe Tavern, a large, raucous hotel in Springfield. The first of four sons was born there. They rented a cottage during the winter of 1843-44, and the following spring bought a one-and-one-half-story, wood frame house at the corner of Eighth and Jackson Streets, on the outskirts of the city. Designed in the fashionable Greek Revival style, it was one of the nicer houses in Springfield, with an oak frame and a good deal of walnut and hickory trimming. It stood on a standard city lot, at the back of which was a small barn and stable. Lincoln tended to the family's horse and cow himself, and chopped wood for the household in the back yard. Neighbors remembered him often splitting firewood late into the night, perhaps as much for therapy as for fuel.

The marriage was a stormy mixture of fire and ice. Mary Lincoln suffered chronic migraine headaches, and exploded in frequent fits of irrational anger. One story has her locking Lincoln out of the house, then dumping a pail of water on his head as he stood at the front door begging admission. Several times, it's said, she drove him from the premises with a broom, raining blows on his head. Insane tantrums were common, and Lincoln did his best to head them off. Workmen came to him one day, saying that Mrs. Lincoln had ordered the one shade tree in their yard cut down. They thought this unwise, but Lincoln said, "For God's sake cut it down, clean to the roots!" He was not blameless for the tensions. Mary had been raised an aristocrat, and could not tolerate Lincoln's willful refusal to learn even the simplest manners. He was perpetually late for dinner, and then would not dress as she wished or even try to use silverware correctly. Though they had a maid, Lincoln would answer the door himself in shirtsleeves, and if the callers asked for Mary he'd say something like, "Well, wait here. I'll trot her out."

For all their quarrels, the Lincolns cared deeply for one another. They understood

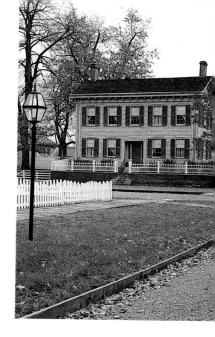

one another, or at least each understood what it was like to be driven by mysterious internal forces. When Lincoln was elected to Congress in 1846, Mary found that she could not tolerate Washington and went home with the boys to Kentucky, since the Springfield house had been leased. The letters that passed between husband and wife testify to her pride in him and to his good-humored acceptance of her difficult personality. "All with whom you were on decided good terms send their love to you," he wrote. "The others say nothing."

Neither Lincoln nor his wife was a gardener. Mary's sister planted a few flowers one spring in an attempt "to hide the nakedness" of the Eighth Street home, but they went untended. In 1850 Lincoln ordered a brick retaining wall built along the front of his lot. A few years later he had the improvements extended along the Jackson Street side, and added a brick sidewalk. In 1856, Mary received an inheritance and undertook a major enlargement of the house, turning the second floor, which was really just a four-foot attic, into a full second story with eleven foot ceilings. The completed house was comfortable, better than average for its time and place. Off the narrow entrance hall, to the right, was a casual family parlor. Opposite was a double formal parlor, the two sections separated by a folding door, and behind was a dining room about the size of the Sinking Spring cabin. In every room was a Franklin stove, and in most was a fireplace. The stoves were for heat, the fireplaces for show, as a room just did not seem natural without one. Brass cornices hung over the parlor windows. These were manufactured, mass-produced, and thus a rather exotic touch in those days when it was hand-made goods that were "run of the mill."

It was the unpretentious home of a shrewd and successful country lawyer. Lincoln handled all sorts of cases, from major lawsuits between railroads and steamship lines to squabbles over the ownership of a hog or a horse. His third and longest-lived partnership was with William Herndon, who later wrote the first great Lincoln biography. Herndon was a spirited young man with two passions: abolitionism and whiskey. Many wondered what Lincoln saw in him—Herndon and Mary loathed one another—but the partners were well matched. Both existed primarily above the shoulders, and their office was a notorious shambles. One young clerk claimed to have found weeds growing in the dirt in the corners.

Lincoln's skillful oratory served him well in the courtroom, where he was by no means above manipulating a jury's emotions. His ethics could be flexible. When a client of his jumped bail—a woman charged with killing her abusive husband— Lincoln was accused of encouraging her. He denied it, admitting only that she'd asked where she could find a good drink of water, and he'd observed, "There's some mighty good water in Tennessee."

The plain but substantial Lincoln home was the rowdy scene of sometimes hysterical fights between husband and wife, and the mischief of four spoiled sons. The youngest, Tad, dreamy and moody like his father, suffered from a deformed palate and a lisp.

ALAMEDA FREE LIBRARY

Lincoln was as happy in the early 1850s as he would ever be. He was respected in his profession and prosperous. He was an indulgent father to his three sons (one had died at the house in 1850), and the boys had become "brats" in Herndon's estimation. He was finally able to buy Mary some of the elegant clothing she loved, and their home became the site of occasional parties and dinners. He was, as much as he could be, at peace. But then, in 1854, the Kansas-Nebraska Act opened all new American territory to slavery, and Lincoln turned a corner, never to return.

Like millions of Northerners, Lincoln was angry, out of patience with Southern fears. In August, 1855, he wrote to Joshua Speed, who had moved to the South. "You say that sooner than yield your legal right to the slave…you would see the Union dissolved. I am not aware that any one is bidding you yield that right….I do oppose the *extension* of slavery…and I am under no obligations to the contrary. If for this you and I must differ, differ we must." He went on to discuss the confounding state of politics. With the Whigs dead and only the pro-Southern Democrats, the radical abolitionists, and the anti-Catholic Know-Nothings in the field, he could find no place for a man like himself. "Our progress in degeneracy seems to me pretty rapid," he wrote. "As a nation we began by declaring that 'all men are created equal.' We now practically read it 'all men are created equal, except negroes.' When the Know Nothings get control, it will read 'all men are created equal, except negroes and foreigners and Catholics.' When it comes to this, I shall prefer emigrating to some country where they make no pretense of loving liberty….where despotism can be taken pure, and without the base alloy of hypocrisy."

Lincoln's radicalization had begun, though he never thought of it that way. He thought of himself as a conservative; it was the determination to perpetuate the expansion of slavery that was fanatical and dangerous. But in 1858 he rose in the Springfield statehouse, the Republican candidate for Senator, and spoke words the South would never forget: "A house divided against itself cannot stand. I believe this government cannot endure permanently half slave and half free….It will become all one thing, or all the other." In the debates that followed with Stephen A. Douglas, Lincoln insisted that he had no intention of "interfering" with slavery where it already existed, but added, "You may have a…cancer upon your person, and not be able to cut it out lest you bleed to death; but surely it is no way to cure it, to engraft it and spread it over your whole body." Northerners heard the plainest good sense; Southerners heard that their way of life was "a cancer."

Throughout the presidential campaign of 1860, candidate Lincoln stayed home at the Eighth Street house. He still answered the door himself, still coatless as often as not. The house was overrun by delegations, reporters, office seekers. Springfield

was beside itself. Rowdy parades would march down Eighth Street and stop in front of the Lincoln home. The candidate would appear on his front step, say a few words of thanks, and almost invariably express his happiness that they had had this chance to see one another, especially as he was getting "the best of the bargain."

Lincoln stayed home at the Jackson Street house, often gaily festooned and overrun with well-wishers, throughout the 1860 campaign.

Early in the morning of November 7, 1860, Lincoln walked home alone from the telegraph office along familiar streets. He found Mary seated in the front parlor. What he had to tell her would not be news. Springfield shuddered with fireworks and cannon shots. "Mary, we're elected," Lincoln said, then plopped down full length on the sofa. The electoral college would make him president, but he knew it had been less an election than a declaration of war. He had carried barely forty percent of the popular vote, and in the entire South not one ballot had been cast for him—or so the official returns suggested.

Three months later Lincoln stood on the rear platform of the train that would take him to Washington, hatless in a cold rain. A crowd had gathered to see him off, and he stepped forward: "No one not in my situation," he said, "can appreciate my feelings of sadness at this parting. To this place, and the kindness of these people, I owe everything. Here I have lived a quarter of a century, and have passed from a young to an old man. Here my children have been born, and one is buried. I now leave, not knowing when, or whether ever, I may return, and with a task before me greater than that which rested upon Washington.... Trusting in Him, who can go with me, and remain with you, and be everywhere for good, let us confidently hope that all will yet be well. To His care commending you, as I hope in your prayers you will commend me, I bid you an affectionate farewell."

He never saw home again.

Andrew Johnson, Ulysses S. Grant

ON MARCH 4, 1865, ABRAHAM LINCOLN DELIVERED his second inaugural address, urging Americans to restore their war-torn union "with malice toward none, with charity for all." It didn't work out that way. Lincoln was murdered forty-one days later, and Reconstruction quickly degenerated into an orgy of malice and corruption, an ugly era presided over by two shining heroes of the Civil War. Andrew Johnson and Ulysses S. Grant had both lived their finest hours during their nation's darkest crisis. Neither was able to reproduce that greatness in the White House.

Andrew Johnson never forgot, or stopped talking about, the destitution of his boyhood, his years of battle with "the gaunt and haggard monster called hunger." It was the first of many fearsome battles. Johnson was brave, honest, and as pugnacious as a bull, especially toward the wealthy and high-born. He once wrote a friend condemning some "God forsaken, hell deserving, money loving, hypocritical, back biting, Sunday praying scoundrels," and then asked his correspondent to "give me some new-fangled oaths, that I can more effectually damn some of that brood."

Johnson was born in 1808, the third child of Jacob and Polly Johnson. Jacob was a landless porter and handyman at Casso's Inn, a popular hotel in Raleigh, North Carolina. He stood about as low in the Old South's social order as a white man could. The family lived in an employee cottage on the hotel grounds, a tiny, two-story wood-frame house with a gabled roof. The little building was attractive, almost stylish, from the outside—it stood in plain sight of the hotel guests—but within it was a rough, confining shack, with one cramped room on each floor. Jacob Johnson offered no complaint. He was a happy, easy-going fellow, fully resigned to his lot in life, and he was well liked by his "betters," who found nothing so charming as a pliable servant.

Andrew was three years old when Jacob Johnson died, of pneumonia and injuries incurred while saving several drunken "gentlemen" from drowning. Polly and her children were allowed to stay on at the Casso's Inn cottage, but were plunged into

crushing, humiliating poverty, daily made more galling by the proximity of swaggering wealth. Andrew did not attend a single day of school (he is the only president of whom this can be said), and instead became "a wild, harum-scarum boy," according to a neighbor, something of a leader among the rowdy, barefoot urchins of Raleigh. In 1822, Polly bound Andrew and his brother as apprentices to a tailor, determined that her sons would at least learn a trade. Two years later the boys ran off, and the tailor posted a ten-dollar reward for their capture. He described young Andrew Johnson as having "black hair, eyes, and habits."

The defiant teenager eventually relented and returned to Raleigh, prepared to serve out his time as an apprentice. His vindictive master refused to take him back, and also declined to cancel the apprenticeship, condemning Andrew to years as an unemployable fugitive, so long as he stayed in North Carolina. Eighteen years old and consumed with bitterness, Johnson led his family across the Appalachians and onto the frontier. All their possessions rode in a two-wheeled cart, drawn by a blind pony.

They stopped in the hill country of east Tennessee, in a little town called Greeneville, hard beside a churning stream that sliced down the eastern slope of a vast, darkly wooded valley. Squeezed between the Smoky, Bald, and Unaka Mountains on the east and the wide Cumberland Plateau on the west, the valley was in fact a range of lower hills, soft and lumpy as a featherbed. It was a region of small subsistence farms and market towns crowded with tradesman. A newspaper reported that Greeneville had "two taverns, four stores, three physicians, four lawyers, one Presbyterian and one Methodist church, one large brick courthouse, one stone jail, and a large spring of good limestone water." The Johnsons camped for a time beside a brook that bubbled out of this "Gum Spring." Some months later, Andrew opened a tailor shop.

In the spring of 1827, Johnson married Eliza McArdle, the orphaned daughter of a Greeneville cobbler. They rented a two-room cabin on the village's Main Street, a rough structure of "puncheon boards"—heavy timbers finished on one of four sides. Each room, front and back, measured twelve feet by twelve feet. The front room became Johnson's tailor shop; the back room was home, where in short order two of the couple's five children were born. Eliza was a quiet, strong-willed woman. Like her husband, she had had her fill of poverty. A happy difference between them was that Eliza had enjoyed a basic education, while Andrew remained virtually illiterate. Eliza shared her husband's long days in the front room of the Main Street cabin, reading to him as he sat cross-legged on his workbench, cutting and sewing. In the back room, in the evenings, she helped him with his reading and taught him to write

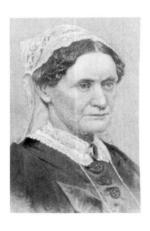

Eliza McArdle Johnson spent her evenings teaching her husband to read and write. By day, as he tailored, she read to him from newspapers and political speeches.

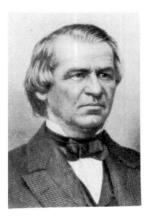

Overleaf: Ulysses Grant's home on Bouthillier Street in Galena, Illinois, a gift to the town's conquering hero.

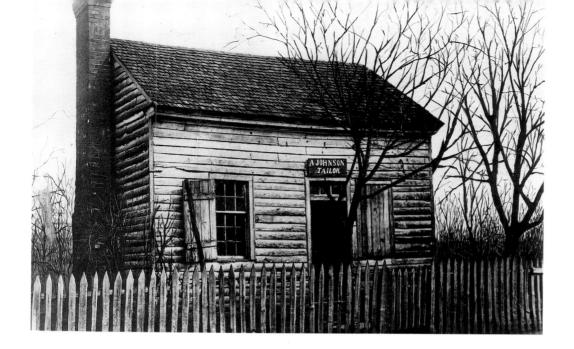

Johnson's tailor shop in Greeneville, Tennessee, became a debating hall for the hill country tradesmen whose support propelled his political career.

and cipher. He devoured knowledge like a starving man.

Johnson was a skillful tailor. His business thrived. In 1831 he was able to purchase a real home for his family on Greeneville's Water Street. It was a small, two-story, red-brick house with white trim and shutters. Along its south side ran a long wooden porch, and off the back was a one-story kitchen addition. It stood on an ample city lot, and presently Johnson bought a ramshackle one-room clapboard building and had it moved to the site. It became his new shop.

Johnson had made good his escape from poverty, but his fiery ambition called for much more. "Someday," he said, "I'll show the stuck-up aristocrats who is running the country!" Almost from the day it opened, his tailor shop became a free-form debating hall, a gathering place for young tradesmen eager to flex their new-found political muscle. As Andrew Jackson was leading the "common man" to power at the national level, Andrew Johnson was fomenting a similar rebellion in east Tennessee. The region's workmen and small farmers made him an alderman in 1828, mayor of Greenville in 1832, state representative in 1835, state senator in 1841, and a five-term Congressman beginning in 1843. In 1853 he won his first state-wide election, becoming Governor of Tennessee. Four years later he was sent to the United States Senate.

Johnson was, to say the least, a political maverick. "No man could count on what he would do," said fellow Tennessean Oliver Temple, "except that he was sure to do something unexpected, and very likely something disagreeable." He was a tireless, and to many tiresome, champion of the lower classes, as in his dogged support of the Homestead Act, anathema to Southern planters who feared the rapid settling of new free states. In an era not famous for political decorum, Johnson stood out as a ruthless debater, a master, Temple said, of "bitter harangues...plentifully

seasoned...and served steaming hot." He termed one opponent a "vandal," "coward," "devil," "hyena," and, for good measure, "a man of no character." His spiciest tirades were reserved for America's "upstart, swelled headed, iron heeled, bobtailed aristocracy...too lazy to work...and afraid to steal."

By the 1850s, Johnson was himself a modestly wealthy man, but he still considered himself a "plebian," and always would. In 1851 he bought a new, much larger home on Greeneville's Main Street, a property that appealed to him as a vivid symbol of his rise from poverty. Across the back of his new lot ran the gurgling stream beside which his destitute family had camped a quarter century before. The house was plain but substantial, a two-story brick structure in the Federal style. Its main section was rectangular and very narrow, and stood right on the street. A one-story ell reached out into the spacious back yard. Beyond it, between the house and the stream, was a large hedged garden and two great weeping willows. Eliza Johnson furnished her new home pleasantly but simply, with black haircloth sofas, lace curtains, a few overstuffed chairs, and grasscloth floor coverings. Johnson had traded his Water Street house in part payment for the new property, but he could not part with his tailor shop. He held on to the sagging shack all his life, leasing it out to other tradesmen. He insisted that the sign over the front door—A. Johnson, Tailor—be left in place.

Johnson called his new property "The Homestead." When there he liked to putter in the garden, his only regular diversion. He had few friends, and was devoted to his family. All was not well. His eldest sons became helpless alcoholics; both died in their early thirties. His youngest child, Andrew Jr., was never well, and died of tuberculosis at twenty-seven. Eliza, too, fell chronically ill in the early 1850s, and was soon an invalid.

Johnson had defied the South's political leaders on many scores, but he had never crossed them on the slavery question. He owned a handful of slaves himself, and was mostly exasperated at the issue's insinuation into every discussion. "If some member of this body was to introduce the Ten Commandments for consideration," he told the Senate in 1858, "somebody would find a Negro in them somewhere; the slavery agitation would come up." But when that agitation finally shook the nation apart, after Lincoln's election, Johnson startled Americans North and South by turning on secessionists with a withering blast. "How has Mr. Lincoln been elected...?" he cried. "By the vote of the American people....I voted against him; I spoke against him...but I still love my country....Let us talk about things by their right name! [Secession] is treason and nothing but treason...!" Before that chaotic winter was over, *The New York Times* had judged Andy Johnson "the greatest man of the age."

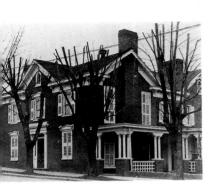

Johnson's first home in Greeneville (opposite page) was modest but marked his escape from crushing poverty. Confederates pressed the Homestead (above) into service as a military hospital. The Union army used it as a brothel during Johnson's presidency.

In Tennessee, he was hung and burned in effigy, and warned not to come home.

Johnson could not be intimidated. Braving the lynch mobs, holding several at bay with his pistol, he made a desperate whirlwind tour of his home state, pleading with Tennesseans to reject the Confederacy. It was no use, and in the end Johnson had to run for his life. He was declared an "alien enemy" of Tennessee, and across Greene-ville's Main Street a banner was strung: "Andrew Johnson, Traitor." His property was confiscated, the Homestead sacked and turned into a military hospital. His sons fled into the hills to join pro-Union resistance movements. Johnson returned to the Senate and threw his support behind Lincoln. "This government must not, cannot fail," he said. "Let it be baptized in fire...and bathed in a nation's blood."

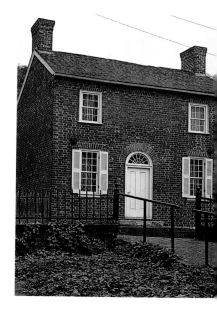

Nowhere did the blood flow more freely than in Tennessee. By the summer of 1862, federal forces had gained uneasy control, and Lincoln appointed Johnson Military Governor, sending him home to govern his neighbors as a virtual dictator. Proclaiming that "treason must be made odious," Johnson cracked down hard, jailing rebellious editors and preachers and confiscating property.

It was all but inevitable that the heroic Johnson would become Lincoln's running mate in 1864. When the incomprehensible happened at Ford's Theater, many "Radical Republicans" could shed only crocodile tears at the news that Lincoln was out and Johnson was in. Lincoln had made it very plain that he meant to be magnanimous in victory. Johnson, it seemed, was no such soft-hearted fool.

But Johnson again did something unexpected, and, to the radicals, something very disagreeable: he followed Lincoln's lenient line. As always, his view of events was filtered through the fierce class consciousness produced by his early home life. The war, he thought, was the fault of proud aristocrats who had led the humble people of the South off a cliff. It was the South's poor whites, not its blacks, that concerned him. He would insist that Southerners abolish slavery, but he would not compel "equal rights" for Southern blacks. If racial equality was the issue, he said, "recon-struction may as well begin in Ohio as in Virginia." Johnson felt the pain of military occupation directly. The Homestead in Greeneville had passed from the Confederate to the Union army, but was receiving no better treatment. At one point during his presidency, Johnson's home was used as a brothel.

For once Johnson had picked a fight he couldn't win. His confrontation with Congress became bitter, then venomous, and finally hysterical. Four separate attempts were made to impeach him, always on absurdly trumped up charges. The last try succeeded, in 1868, but the Senate acquitted Johnson by one vote. He served out his term as little more than a figurehead, and went home to Greeneville in 1869.

Johnson's volatile stock had risen in the South as it fell in the North. For his

homecoming, a new banner fluttered above Greeneville's Main Street: "Andrew Johnson, Patriot." He busied himself with a thorough overhaul of the battered Homestead. Fresh paint and wallpaper covered graffiti and other scars left by two armies. A second story was added to the rear of the house, as was a broad, two-level porch overlooking the garden. Brick walkways were laid around the house, stretching back into the sunny yard. Visitors almost invariably found the former president in his garden, and no visit was complete until he taken his guests on a stroll up the street to his famous tailor shop.

But quiet retirement held no joy for Johnson. Greeneville, he wrote, was "lifeless as a graveyard." He needed the noise and drama of battle as he needed air, and above all he yearned to win once more. "I would rather have the vindication of my State," he wrote, "than to be the monarch of the grandest empire on earth. For this I live." In 1875, Tennessee returned him to the Senate. It was, one Republican newspaper conceded, "the most magnificent personal triumph which the history of American politics can show."

It was Johnson's last fight. He lived long enough to make a grand entrance onto the Senate floor, and to deliver one final scalding speech, denouncing military rule in the South. That summer, back in Tennessee, he succumbed to a stroke. He was buried in the hills above Greeneville, according to his own characteristic instructions. His shroud is a flag of the United States; his pillow, a copy of the Constitution.

Ulysses S. Grant loathed the sight of blood. All his life he drove chefs to despair, insisting that meat be charred beyond recognition. He did not hunt, he did not swear, and he did not enjoy dirty jokes, not even Lincoln's. Rough treatment of animals infuriated him. Yet this sensitive, even squeamish man scored his great success in life by waging war with terrible ferocity. There was always something of the artist in the moody, erratic Grant, but he discovered the creative life only in his final months. Above all he was a puzzle. "Grant's whole character," wrote William Tecumseh Sherman, "was a mystery even to himself—a combination of strength and weakness not paralleled."

Grant's delicacy must have come to him naturally, since his childhood was hardly designed to produce it. His father, Jesse, was a tanner and leather merchant, and his place of business was just across the street from Grant's boyhood home in Georgetown, Ohio. At the tannery sat stockpiles of raw, reeking hides, tatters of flesh still clinging to them. Jesse soaked the skins in acid and scraped them, turning them into supple sheets of leather. "I detested the trade," Grant wrote in his memoirs. Jesse found other chores for the boy.

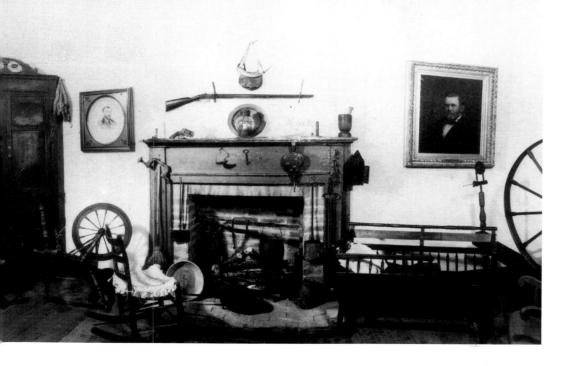

Grant's birthplace was a drafty cabin on the banks of the Ohio River.

Grant had been born, in 1822, at the little trading community of Point Pleasant, where Jesse had rented a two-room frame house on a high bank of the Ohio River. It was a glorious spot, but a cramped and drafty home, and the family moved to Georgetown when Ulysses was not yet two. On Cross Street Jesse built a house that looked like a bigger improvement than it was. It was a stout, two-story structure of brick, but little more than a cabin, with one room on each floor. Its charm was that it looked more like the home of a successful businessman, which, in time, was what Jesse Grant became. He was soon able to double the size of his house, adding a fine parlor and more bedrooms for his growing family. Grant could not remember ever being in less than "comfortable circumstances."

He did recall other sorts of discomfort. "Boys enjoy the misery of their companions," Grant wrote, "at least village boys in that day did." Ulysses was a fat target for boyish cruelty—timid, self-conscious, persistently naive. His father sent him to buy a horse one day, telling him to offer twenty dollars and go as high as twenty-five if need be. Ulysses revealed the whole of his instructions to the trader, and, as he put it, "it would not take a Connecticut man to guess the price finally agreed upon." All of Grant's business deals were like that. Among the shrewder boys in Georgetown, young Ulysses found friends but no intimates. He turned for affection, as have many tender youths, to animals. He had an uncanny gift with horses.

"I have no recollection of ever being punished at home," Grant wrote, "either by scolding or by the rod." That sketches either a perfect home or a neglectful one, and the elder Grants were less than perfect. Ulysses's mother, Hannah, was a cold, reclusive woman. It's said that when Grant came to visit after the Civil War, the most beloved American hero since Washington, Hannah stared at him without a smile, muttered,

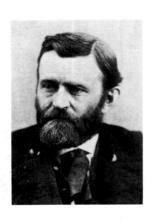

Grant married Julia Dent in 1848, and for twelve years failed at everything he tried. Bankrupted again after his presidency, he won a heroic battle to complete his memoirs, which earned for his widow some $500,000.

"Well, Ulysses, you've become a great man, haven't you?" and turned abruptly back to her business. Jesse, too, was impatient with his eldest son, but did give some thought to his future. There was a place for soft young men with ability but no direction: West Point.

Grant was a middling cadet in every way, excelling only in mathematics and drawing. "A military life had no charms for me," he wrote. Yet war itself, which Grant soon experienced in Mexico, did have charms. He disapproved of the Mexican War, calling it "one of the most unjust ever waged by a stronger against a weaker nation." But the experience of combat, its exquisitely simple drama, stirred something in him that nothing else touched. "I have known a few men," he wrote, "who were always aching for a fight when no enemy was near, [and] were as good as their word when the battle did come. But the number of such men is few." Ulysses Grant was one of those few.

At the end of the Mexican War, in 1848, Grant married Julia Dent, whom he had met before the war while posted in St. Louis. Julia was proud, intelligent, and ambitious, but not lovely. She was severely cross-eyed and heavy-set, a match in height and weight for the handsome young officer who called on her. She was just what Grant needed—a boss—and the marriage proved a happy one.

For several years the Grants lived in officers' quarters, first in Sackett's Harbor, New York, and later in Detroit. The first of four children was born in 1850, and with his family near Grant rather liked the languid life of the peacetime army. But in 1852 he was assigned to new duty on the raw Pacific coast, and he went alone. First at Fort Vancouver in Washington, and later at Fort Humboldt in northern California, boredom and loneliness consumed him. He had learned to drink in Mexico, but not to do it well. Never a continuous drinker, Grant, when he did drink, almost always got boiled. In 1854, having swilled himself into disrepute and despair, he resigned his commission and went home to his wife.

Grant was thirty-two years old, and as adrift as a teenager. He decided to become a farmer, the inevitable recourse in those days for American failures. On land near St. Louis owned by his in-laws he founded "Hardscrabble," building with his own hands a big, brawny log house. "I worked very hard," Grant wrote, "never losing a day because of bad weather, and accomplished the object in a moderate way." Two stories high, his creation was long and sturdily constructed of heavy squared timbers, with coarse hand-hewn siding as a decorative touch around the doorways. There were two oversized rooms on the first floor, each with wide, multi-paned windows. It was a solid, roomy house, but it had no more style than a woodshed. Grant's farming, meanwhile, was a financial disaster. Soon he was cutting firewood off his

land and peddling it on St. Louis street corners. The Grants abandoned Hardscrabble in 1858. After failing again, in the St. Louis real estate business, Ulysses led his family to Galena, Illinois, where his father owned a leather-goods store.

Galena in 1860 was a hearty, bustling trade center of 14,000 people, a more important city than Chicago. The town was wedged into the narrow valley of the Galena River, a few miles east of the Mississippi. On its crowded west side Galena rose against the steep valley wall like a pueblo village, each street fifteen or twenty feet higher than the street before. The Grants rented a slender brick cottage, reached from the city's business district by a wooden staircase of 200 steps. For months Grant descended those stairs every morning, to clerk in a store run by two younger brothers. He made no special impression on his neighbors, but when the Civil War began and a town meeting was called to raise volunteers, Grant was elected chairman. He was the only West Point man in town. "I never went into our leather store after that meeting," he wrote.

Quite a few presidents have emerged from humbler origins than Ulysses Grant, but none enjoyed so abrupt and exhilarating a rise to fame. In the spring of 1861, Grant was the soul of mediocrity. He had failed at everything he'd tried, and owed a job he didn't like to the charity of relatives. Four years later he was among the most powerful men on earth, supreme commander of the greatest army ever assembled, heir apparent to the presidency. He did it, of course, by winning battles, early and often—battles won less through brilliant tactics than through sheer fury and fearlessness. Grant was always on the move, always on the attack, and though he apologized in his memoirs for two especially pointless bloodbaths, he never flinched at the knowledge that war was about killing. Critics called him "the Butcher" and urged Lincoln to dismiss him. "I can't lose this man," the president replied. "He fights."

No American was ever more popular than Ulysses Grant in the summer of 1865. His welcome home in Galena was that little city's grandest day. The town was an obstacle course of arches, banners, and delirious crowds. Grant had kiddingly told a reporter that after the war he wanted to go home to Galena and see to it that a decent sidewalk was built. The job was done when he got home, and a banner read: "General, Here Is Your Sidewalk." A massive arch spanned Main Street; atop it stood three dozen of Galena's loveliest ladies, all in white. "Hail To The Chief Who In Triumph Advances" read the sign at their feet. The parade crossed the river to the stylish east side of town. There, on Bouthillier Street, stood a pretty brick house in the "Italianate Bracketed" style, a gift to Grant from Galena's finest. It was plentifully furnished and well designed, with a long parlor crossing the house in front,

A sea of neighbors who had scarcely noticed Grant before the war hailed "The Chief Who In Triumph Advances" when he returned to Galena in 1865.

and an even larger library that faced the hill sloping down toward the river.

The Bouthillier Street house was one of three Grant received at the close of war. Later, wealthy friends would provide several more. But Grant was never again to feel truly at home, or truly in command, even of himself. As he was about to become a political pawn, manipulated by forces he only vaguely understood, so he would spend the rest of his life in fine homes chosen and paid for by others. He always felt faintly ill at ease with these arrangements, like a person wearing rented clothes. But he never rebelled.

Julia adored the gift house where the family spent most of the late 1860s, a beautiful Washington townhouse on I Street. It was as big and elegant as any in the city, with double drawing rooms, cascading chandeliers, and a vast, high-ceilinged library. When Grant was elected president in 1868, he made arrangements to sell the house, but Julia would not hear of it. "Very well," cried the president-elect, "I will send word...that my *wife* will not *let me* sell the house!" "You may do so," Julia said.

Grant's handling of the presidency wasn't all bad, but it wasn't good. He settled a dangerous dispute with England over that country's aid to the Confederacy. Otherwise, good intentions led nowhere. Grant followed the radical line on Reconstruction, trying to enforce equality for Southern blacks. Whether he pushed too hard or not hard enough will be debated forever, but there is no dispute about where the effort led—to corruption and violence, and finally back to white supremacy. Meanwhile, tawdry scandals soiled the administration. More than 300 government officers, including Grant's personal secretary, were implicated in the "Whiskey Ring," a conspiracy to skim tax revenues. Grant's secretary of war was caught for taking bribes. And there was a good deal more. Grant was, said one observer, "a perfect child in financial matters," and no match for industrial America in its unruly adolescence.

The Grants had spent their presidential summers at Long Branch, a sleepy community on high ground above the Jersey shore. Their red brick "cottage" was small but extravagantly designed, with nine dormers, a two-story porch that encircled the house, a wealth of iron railings, and a large "widow's walk" on the roof. The president, especially, loved the place, and his vacations there grew longer and longer.

In 1877, at the end of Grant's second term, Ulysses and Julia had nothing special to do and nowhere special to go, so they went almost everywhere. For more than two years they wandered, crossing Europe several times and visiting Russia, Egypt, India, China, and Japan. Everywhere they were toasted by royalty, cheered by crushing throngs. They returned at the end of 1879, as rootless as ever. "I have no home," Grant wrote, "but must establish one. I do not know where."

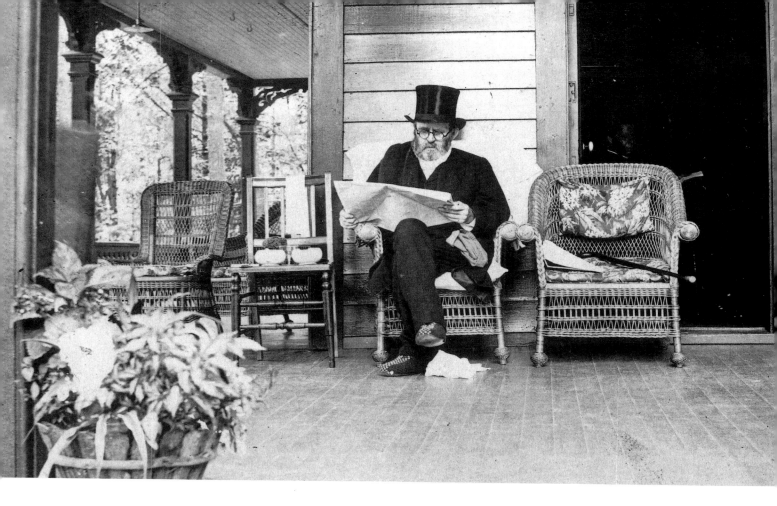

He established himself in New York, after some months in Galena, from where Grant conducted a half-hearted bid for a third presidential term. Once more wealthy friends provided Grant with a home, raising the money for him to buy a four-level brownstone just off Fifth Avenue, at 3 East Sixty-sixth Street. The house was plain but big, a honeycomb of bedrooms. Two first-floor parlors stood beneath a spacious second-floor library that faced the street and had a view of Central Park.

Grant's second son, Ulysses, Jr., had formed a Wall Street partnership with a dashing young man named Ferdinand Ward. The retired president, who had recently failed yet again in a Mexican railroad scheme, now invested his prestige, and a great deal of money, in Grant & Ward. Happily he went down to his Wall Street office day after day, signing documents he didn't read or didn't understand. Ward was the brains of the outfit, and the outfit was thriving.

Ward was also a thief. He worked every kind of swindle stock manipulators had invented, and in the end there was scarcely a legitimate transaction in Grant & Ward's portfolio. Ward and another partner went to jail, but the courts and the public accepted the explanation that Grant had long since proved himself a financial illiterate, and that his son was probably no different. Spared prosecution, Grant's humiliation was nonetheless complete. So was his bankruptcy. That summer he began to

Four days before his death from cancer, Grant took the air on his porch at Mount McGregor. His valet is barely visible in the doorway.

feel pain in his throat that was soon diagnosed as terminal cancer. He could fall no farther.

Grant had one fight left in him. In the fall of 1884, he sat down at his desk in the second floor study on Sixty-sixth Street, and wrote, "My family is American...." He had decided to write his memoirs, as publishers had been pressing him to do. He hoped that royalties on the book would relieve his family's poverty, if he could live long enough to finish it. But it wasn't just that. He found the work "congenial," and he found, to his surprise, that he was good at it. He could describe things: "I saw an open field...so covered with dead that it would have been possible to walk across the clearing, in any direction, stepping on dead bodies, without a foot touching the ground." It was going to be a good book, and it became his obsession. "This is my great interest in life," he said, "to see my work done."

In the spring of 1885, Grant accepted an invitation to spend the summer at Mount McGregor, in the foothills of the Adirondacks above Saratoga Springs. The invitation was both kind and shrewd. Grant's illness was common knowledge, and his poignant presence was sure to produce voluminous publicity for the growing resort area. But at least the mountain cottage was everything he had been promised. It was a two-story wood-frame house, big enough for family, servants, guests, and doctors, newly redecorated in brilliant colors. Around three sides ran a broad veranda, freshened by cool breezes, and beyond the little wood that surrounded the house the land dropped rapidly away, leaving a stirring view of receding forest and looming sky. Grant came to love that porch; he sat there hour after hour, often in a top hat and always with a scarf wrapped around his tortured throat. He didn't mind the tourists who strolled by in a steady stream. He often waved to them, or tipped his hat. Distinguished visitors came by the dozens, including several Confederate generals, to sit beside him on the porch and remember better, or at least younger, days.

Sometimes slumped in a large wicker chair on the porch, more often at a heavy table in the cottage's drawing room, Grant worked on his book—"as many hours a day as a person should devote to such work," he said. It was a grueling struggle to concentrate, sometimes through waves of searing pain, sometimes through a fog of cocaine and morphine. He asked his son to finish the work should he die before it was done, and to put off his burial until it was finished. But chapter by chapter the book went together, and on July 14, 1885, Grant set down his pen. Nine days later he was gone.

Published by Samuel Clemens, *The Personal Memoirs of U. S. Grant* became a sensation, earning nearly half a million dollars for Julia Grant. It is widely ranked among the finest military memoirs ever written.

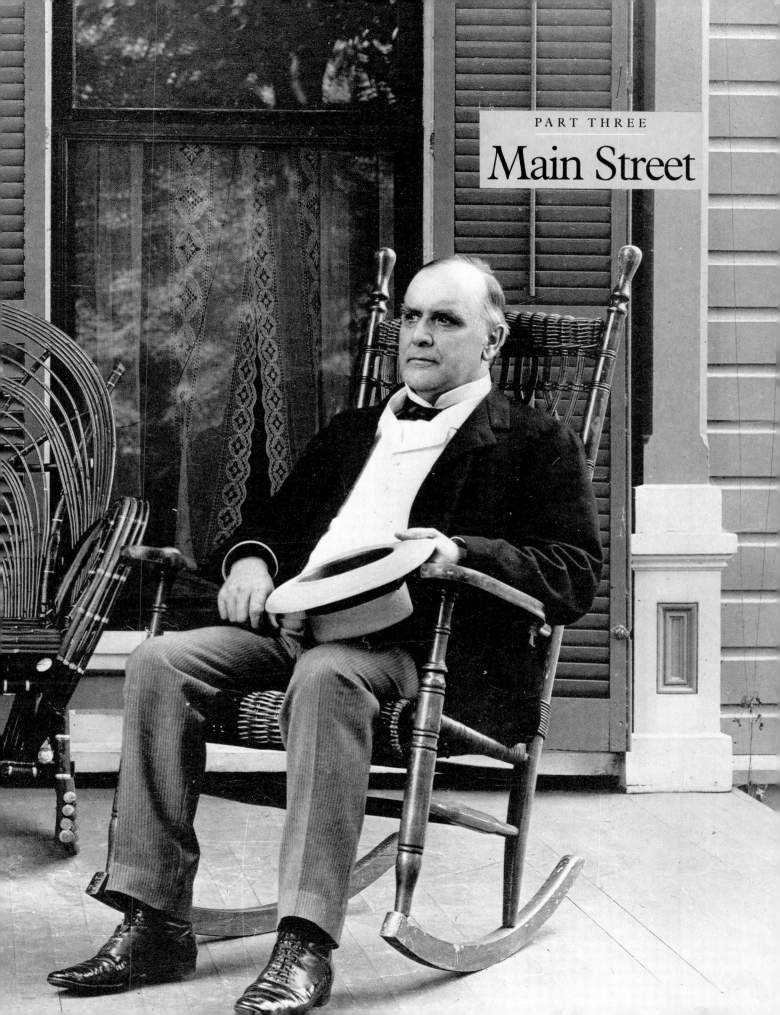

Rutherford B. Hayes, James A. Garfield, Chester A. Arthur

EVERY AMERICAN SCHOOLCHILD KNOWS how General Custer met his fate one hot June day in 1876. But most contemporary Americans would be hard put to recall a detail about Rutherford B. Hayes, nominated for president that same month. The presidents of the late nineteenth century have slipped into the shadows of time. Thomas Wolfe called them "the lost Americans: their gravely vacant, bewhiskered faces mixed, melted, swam together....Which had the whiskers, which the burnsides: which was which?"

Americans have long been pleased to believe that their presidents are "average" citizens. In the late nineteenth century, an era of breathtaking economic growth, the notion of what was "average" changed. Pioneer origins still didn't hurt, but it was more important for a man to seem a prosperous member of the middle class, a man from Main Street.

"I am one of the sunniest fellows in the world," chirped twenty-four-year-old Rutherford B. Hayes to his diary. He never had cause to change that self-assessment. Talented and lucky, Hayes was blessed with a stubbornly mild disposition. Shortly before his death the former lawyer, general, congressman, governor, and president assured a friend that his happy marriage was "the most interesting fact of my life."

Hayes's father left Vermont in 1817. He lead his family to the wilds of central Ohio and quickly established a thriving farm and general store in the village of Delaware on the Olentangy River. In the summer of 1822 he caught typhoid fever and died, leaving his wife, Sophia, with two young children and a third on the way. Rutherford Hayes was born three months after his father's death.

The family was far from destitute. They lived in a narrow brick house with a long, rough wooden addition off the rear. It was a plain but comfortable home, over-large for the little clan that included Sophia's brother Sardis Birchard. A lifelong bachelor, and in time a wealthy one, Sardis generously aided his sister, becoming a devoted

Overleaf: A reunion of Hayes's 23rd Ohio Volunteers at Spiegel Grove in the summer of 1877. Right: Hayes takes dinner with his children and friends at Spiegel Grove in March, 1892.

surrogate father to her children.

Life at the Delaware home was enriched for young Rutherford by frequent visits to the nearby farm with his sister, Fanny. The two were inseparable, bound by a fierce, almost excessive affection. "She loved me as an only sister loves a brother whom she imagines almost perfect," Hayes wrote after Fanny's death in 1856. "I loved her as an only brother loves a sister who *is* perfect."

With the financial aid of his uncle, Hayes enjoyed a fine education and became an avid amateur scholar. In 1850 he settled into bachelor's quarters in Cincinnati and struggled to launch a legal practice. He earned sudden fame in 1852 with his defense of Nancy Farrar, a deranged young murderess. Hayes pled her not guilty by reason of insanity, a very flimsy defense at the time, and won on appeal.

Hayes's mother and sister, meantime, were shopping for a bride for Rutherford. He met Lucy Webb—a "frank," "joyous," and "tolerably good-looking" girl, Fanny thought—in 1847, and married her in 1852. A year later he bought his first home, a small, three-story townhouse on Sixth Street in central Cincinnati. It was a good house, though at first the Hayeses found its walls home to some "beasts" and had to apply "purification" measures. Soon they had to enlarge the property, since they were embarked, as Hayes put it, on a booming "boy business" (of eight children, seven were boys). Hayes's legal business, too, was thriving, so much so that he was able to offer free representation to the runaway slaves who poured through Cincinnati in the tense 1850s. At least once, the Hayeses went farther, spiriting away a black infant abandoned by night on their front steps.

The world's sunniest fellow had met his match in Lucy, from whom, he told his diary, came "a glorious flow of friendly feeling and cheerfulness." Lucy was a college

graduate, the first among First Ladies. She shared her husband's reforming impulse, leading movements for better prisons, asylums, and orphanages, and exceeded his zeal for temperance. Her total White House ban on alcohol would earn her the nickname "Lemonade Lucy."

The Civil War was a somber interlude, but for Rutherford Hayes, as for many of his generation, it was also a stirring crusade that nothing in later life could match. From one battlefield he wrote, "I am much happier in this business than I could be fretting away in the old office near the courthouse. *It is living.*" He found Congress, to which he was elected in 1864, less stimulating, just a dressed up way of "being an errand boy to one hundred fifty thousand people." He jumped at the chance to run for governor of Ohio in 1867, and found the office "the pleasantest...I ever had," as there was "not too much hard work, plenty of time to read, good society, etc." Ohio's first three-term governor, Hayes was popular, though his reform programs and support for black rights had only mixed success. A greater frustration was his uphill struggle to alter his family's living arrangements—a series of rented homes near the capitol in Columbus. Hayes was eager to take possession of Uncle Sardis's rustic paradise; his wife was not.

Sardis Birchard had started buying tracts of land in northwestern Ohio in the 1830s. From the first he was enchanted with one twenty-five-acre plot near a village later named Fremont—an unusually lush stretch of forest, cool and dark under a tangle of oaks, pines, and elms. An old Indian trail snaked through the low-lying wood, where after each rain tiny pools of water sparkled in the filtered sunlight. Sardis named it Spiegel Grove ("Spiegel" is German for "mirror"), and resolved to build a home there that would one day pass to his nephew. In 1859 he started construction on a two-and-one-half-story, gabled brick house with a wide veranda around three sides. "It is just such a house as I would prefer to live in," Rutherford wrote that same year. "...I suspect [Lucy] will prefer it to a city home, after she once gets settled there."

It took nearly a quarter century to get her settled there. Lucy liked city life, and disliked the idea of living with her in-laws. But in 1873 Hayes's "years of vagabondizing" ended and he began a rapturous love affair with his personal enchanted forest. In every season the grove moved him to eloquence. In autumn "the 'twin oaks,' with all their leaves still perfect, were of a deep dark crimson. The maples...seemed to ray out golden and rosy glory." In winter "the snow lodged on the trees...as it fell in the still air, until now the grove has a beautiful white, feathery powder covering it." Yet the place was "never so homelike as in...hot weather. The grove, green and fresh, and the house, airy, cool, spacious."

Rutherford Hayes married "Lemonade Lucy" Webb, an ardent temperance advocate, in 1852. Their happy marriage was troubled only by Lucy's twenty five-year refusal to abandon city life for Spiegel Grove.

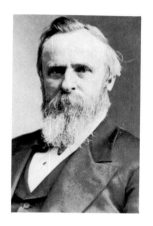

Sardis's original house at Spiegel Grove had seemed to Rutherford "large and very handsome. Not too large." Over the years he more than doubled its size. He added a drawing room thirty-six feet long that opened onto a library of the same dimensions. He raised the house to three full stories and topped it with a greenhouse cupola, from which one could look straight down to the grand first-floor hallway. A three-story bay window adorned the south end. Hayes had always wanted "a veranda with a house attached," and the porch at Spiegel Grove grew to eighty feet in length, providing a panorama of lawn and wood and abundant space for rainy-day exercise.

During the 1876 presidential campaign, Hayes's supporters made much of the "exceedingly plain house" he was renting in Columbus during legislative sessions, and had little to say about Spiegel Grove. Hayes had intentionally sought a modest place in Columbus—but less for political reasons than to spare Lucy any temptation to linger there. Hayes was not exactly elected president. Democrat Samuel Tilden prevailed narrowly in both popular and electoral votes, but Republican leaders challenged the results. A special Electoral Commission awarded the presidency to Hayes amid anguished cries of foul play. A shot was fired through the dining-room window of the Columbus house.

In time Hayes's gentle manner and personal integrity calmed the country. He dismayed Republicans, proclaiming that "He serves his party best who serves his country best," and then governing as if he believed this. He ended military Reconstruction in the South, lashed out at corruption in the civil service, and dealt firmly and carefully with the violent nationwide railroad strike of 1877. Satisfied that the 1880 election of James Garfield, another Republican, had vindicated his administration, Hayes happily unloaded presidential burdens—"the responsibility, the embarrassments, the heartbreaking sufferings [one] can't relieve, the...danger of scandals...among those [one is] compelled to trust"—and returned to his "obscure and happy home in the pleasant grove at Fremont."

In their last years the Hayeses remodeled their house yet again and lavished attention on Spiegel Grove's grounds and gardens. They redesigned their driveways so as to be out of sight of people sitting on the veranda. They judiciously cut down trees to open broader views. They took to naming favorite specimens after friends and famous guests: the "McKinley Oaks," the "Garfield Maple," the "General Sherman Elm."

If Hayes foresaw that his would be a humble place in history, he didn't let it cloud his sunny temperament. During his retirement he proudly proclaimed, "The two happiest people in the country are here in Spiegel Grove."

James Abram Garfield was the last president to grow up in a log cabin—a potent

political symbol that his supporters exploited with gusto. In private, Garfield himself detected few blessings in his humble childhood. "I lament sorely that I was born to poverty," he wrote to a friend, describing his youth as a "chaos" that prepared him only for "fight [and] storm.... In the little great things of life...how sadly weak and inferior I feel. Let us never praise poverty."

The last presidential log cabin stood in northeastern Ohio, wedged between two shimmering streams on the crest of a hill above the Chagrin River. There, in 1829, Abram Garfield had hacked a farm out of dense forest, a looming wilderness that would teach his son "what Tennyson meant by 'wooded walls.'" When Abram Garfield died in 1833, eighteen months after the birth of his fourth and most famous child, his wife, Eliza, rejected the usual recourse of the frontier widow—to sell her property and split up her family. Laboring in the fields beside her children, she managed to wrest a living from thirty fertile acres.

Eliza was as cheerful and affectionate as she was indomitable. Her home was happy, almost by decree. But away from home young James writhed under "the ridicule and sport of boys that had fathers, and enjoyed the luxuries of life." In 1842 Eliza remarried, only to desert her new husband a year later, inviting divorce, scandal, and inflamed ridicule for her youngest son. James grew into a fearful, dreamy young man who "never was still...always uneasy," as his mother remembered it. At sixteen, enchanted with fantasies of the sea, Garfield wandered to Cleveland and found work as a canal driver. He managed to make it a dangerous if not romantic job, tumbling into the water no less than fourteen times in six weeks.

The "chaos" of Garfield's childhood gave way to emotional chaos in early adulthood— what Garfield would call "years of darkness." At nineteen he found religion, accepting baptism from the Disciples of Christ, a stern, world-denying Christian sect that his parents had joined years before. Not long after that, he discovered sin. Women liked the brilliant, moody Garfield. While studying at the Disciples' college, the "Eclectic Institute," he enjoyed the affections of several women but backed away from marriage— an ungentlemanly course at the time. He became formally engaged to Lucretia Rudolph, but again delayed, disturbed that the quiet, cerebral young woman inspired no "delirium of passion." Continuing his education at Williams College in Massachusetts, Garfield found delirium in the arms of yet another hopeful lover. In 1858, still bewildered by his "strange wild heart," Garfield reluctantly married Lucretia.

The troubled couple spent their first years together in a boarding house in Hiram, Ohio, the dusty village the Disciples had founded to serve as home to the Eclectic Institute. Garfield became president of the Institute in 1857 and two years later was elected to the state Senate. Converted to the antislavery cause, he eagerly accepted

During his youthful "years of darkness" Garfield toyed with the affections of many young women. He found intellectual rapport but no passion in Lucretia Rudolph, whom he reluctantly married in 1858. In time, the marriage proved successful.

a commission in the army with the outbreak of Civil War. He served coolly and successfully under fire, and found his first real peace of mind through the cathartic drama of battle. Home on leave in 1862, he finally learned to love his wife.

A real marriage called for a real home, and Garfield wasted no time. On his orders Lucretia rented a two-story frame house in Hiram just across the road from the Eclectic campus. It had a large and lovely yard, shaded by fruit trees, but Lucretia thought the house too small and too run-down. Her husband felt differently. Gripped by a sudden passion for homemaking, he impulsively bought the Hiram house and launched a major remodeling. Though he would own the property for less than a decade, the Hiram home was always "the old house" for Garfield, somehow representing a bridge between his stormy youth and his new incarnation as a contented family man. He threw himself into that new role with characteristic fervor. "It is every year more sweet," he wrote, "to lose myself in the sweet circle that has gathered round my hearthstone. The triumph of love could not be more complete."

Lucretia still saw room for improvement. A wartime trip to New York had produced another adventure in "lawless passion," as Lucretia put it when she learned of Garfield's brief affair with a Mrs. Calhoun. He promised that it was his last indiscretion, and kept his word. In 1864, Lucretia brought another marital flaw to her husband's attention. "We sat in our little parlor," Garfield recalled, "[and] she slipped into my hand a little memorandum which she had made. This was the result of it. We had been married four years and three quarters and we had lived together just twenty weeks. . . . I then resolved that I would never again go to Washington . . . without her."

Garfield's seventeen-year career in the House of Representatives had begun in 1863. His Ohio Congressional district was safely Republican, and by 1869 Garfield felt sufficiently confident of his political longevity to build a home in Washington for his wife and five children. He chose a lot at 13th and I Street, commanding a view of Franklin Square, and ordered construction of a plain but spacious three-story brick house. "I go every day," he wrote to Lucretia, "to the little spot of earth where we are planting a home. . . . and felt how sweet it would be when all our little darlings should be happy and safe sheltered under its roof. . ."

Garfield apparently used up all his passion—though not all his self doubt—in private life. As a politician he was cautious and somewhat indecisive, with "the backbone of an angle-worm," in Ulysses Grant's unkind assessment. He was a powerful speaker, but had little taste for personal combat or rigid ideology. While voting with the radicals on Reconstruction, he was, he said, determined to be "a radical and not a fool . . . , a matter of no small difficulty." Despite charges that he had accepted bribes during the Grant-era orgy of corruption, Garfield was popular and prominent

by the late 1870s, and at least some Republican leaders were thinking of him in presidential terms.

Garfield's mind was elsewhere. As the years had passed he had tired of politics, which, he said, "fossilized" a man. He felt unmoored, having sold the Hiram house in 1872, and thereafter spending his summers as a mere tourist in the region of his youth. On a visit to Ohio in 1876, he stood on a hillside and thought, as he remembered it, "Here is my love of a farm revived in me...I must get a place where my boys can learn to work, and where I can...touch the earth and get some strength from it." On that impulse he bought a one-hundred-sixty-acre farm in Mentor, not far from Cleveland.

During the presidential campaign of 1880 friendly reporters christened the Mentor farm "Lawnfield," and the Garfields later adopted the name. Such a gracious title hardly suited the place when Garfield bought it. It was a shabby, neglected farm, with a sagging, one-and-a-half story frame house hard beside a reeking pigsty and several slowly collapsing barns. The fields were by turns swampy and stony, yet the very rawness of the property seemed to appeal to Garfield. "The general state of chaos," he said, "opens before us a fine field for work and contrivance."

The farm became yet another outlet for Garfield's enormous emotional energy. He virtually rebuilt the house, turning it into a rambling, three-story Victorian mansion bristling with dormers and gables. He attached a spacious library addition which despite its size could not confine the former academician's thousands of volumes. He drained the swamps, moved the barns, and planted broad fields of oats and hay. He was still a congressman, but when in Washington he admitted to daydreaming about his newest love. "Every day," he wrote, "I try to imagine what is going on at the farm: how high the corn is...what progress is being made with the horse barn...whether the brush are taken out of the orchard..." Almost proudly Garfield confessed to a friend, "I have never been able to anything moderately."

By 1880, Garfield's immoderate labors had produced such a lovely country estate at Lawnfield that a campaign biographer felt obliged to explain it: "[O]nly within a few years past, has [Garfield] been able to live...in a style suitable even for a family so quiet and simple." Such careful image maintenance was crucial in the presidential campaign of 1880, a campaign almost barren of real issues.

Senator Roscoe Conkling, the flamboyant and ill-tempered "boss" of the New York Republicans, believed that Garfield had promised to restore the patronage Rutherford Hayes had stripped from the machine. Garfield thought otherwise, and prevailed in a venomous battle over confirmation of his appointments, destroying Conkling's career in the process. It was a considerable achievement, but Garfield

Garfield with his daughter Molly, whose childhood death shattered him.

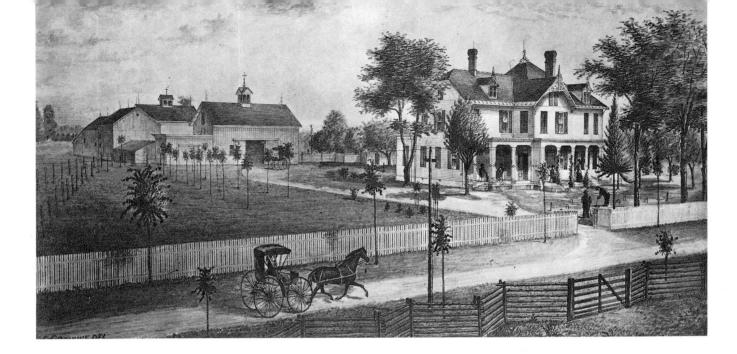

In the years just preceding his election as president, Garfield transformed a seedy farm near Mentor, Ohio, into a gracious estate. Reporters christened it Lawnfield.

was to enjoy no others. By the late spring of 1881, the new president was a marked man.

Charles J. Guiteau has almost always been referred to as a "disgruntled office seeker." Blaming Garfield's assassination on the spoils system made powerful propaganda for civil-service reformers. But Guiteau's failure to secure a government job was the least of his problems. God, he thought, had chosen him to "remove" the president, a "political necessity" that the public would eventually come to understand. He bought a fancy, bone-handled revolver, since he wanted the divine instrument to appear handsome when it went on display. On the morning of July 2, 1881, he walked up behind Garfield at the Baltimore and Potomac Railway Station and fired two point-blank shots.

"I am a dead man," Garfield told doctors who hovered over him on the floor of the depot. He was right, though he was to linger at the edge of death for eighty days. In September doctors moved him from the White House to a cottage at Elberon, on the Jersey shore. There, perhaps as he was sensing the end, Garfield's disjointed thoughts turned to his home. "He longed to be at...Lawnfield," a reporter confided, "...to have some of Aunt Alpha's indian bread again, and pick wintergreens on the hill....He longed to be in Ohio, 'on the old sod' once more."

Around midnight on September 19, 1881, a pack of New York newspaper reporters circled a stylish row house on Lexington Avenue. Word had reached the city that James Garfield was dead at last, and the reporters were hoping for a statement from the master of the house—the new president of the United States. The doorman informed them that there would be no appearance. Chester A. Arthur was "sitting alone in his room sobbing like a child."

That was the image Arthur had been presenting to the public ever since Garfield's shooting—the image of a humble, broken-hearted American, overwhelmed with grief and awed by the immense responsibilities that were about to be his. The public was suspicious. This was, after all, "Chet" Arthur, the corrupt and calculating master spoilsman of New York, a man who had made a career out of underhanded power grabs. One newspaper judged Arthur "about the last man who would be considered eligible [to be president]."

Arthur's unlikely journey to the White House began in Fairfield, Vermont, where he was born in October, 1829, the fifth child and first son of William and Malvina Arthur. William, a Scots-Irish immigrant, was a roof-rattling Baptist preacher and an angry abolitionist, a combination that kept both him and his parishioners restless. Chester's birthplace was a temporary log-cabin parsonage, but before he was one the family moved into a plain frame house with a single first-floor room and a sleeping loft above. He was not quite three when the family wandered to a new parish; not quite five when they moved again; not quite seven when they changed towns a third time. Chester was to know eight different boyhood homes, each a humble parsonage in a Vermont or upstate-New York village.

Many years later Arthur would rebuff a reporter with the famous line, "I may be president of the United States, but my personal life is nobody's damned business." He proved that he meant this by ordering all his private papers burned a day before his death, with the intended result that Chester Arthur's private affairs, including his childhood, are as obscure as a small-town mayor's. It's clear, though, that Reverend William's parish-hopping condemned his large family to a hard life. Chester found relief in dreams of fancier things and more glamorous adventures. Confronted with a new social challenge every few years, the boy mastered the arts of superficial

Chester Arthur's birthplace in Fairfield, Vermont, photographed in 1880.

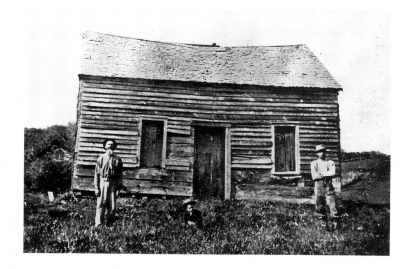

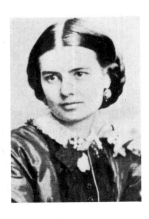

The quintessential machine politician, Arthur preferred the late-night company of his cronies to the company of his wife, Ellen. She died just months before his nomination for vice president.

charm, becoming, as he would always remain, a witty, cheerful, likeable fellow.

There was never much question about where Arthur would make his own home. New York City, sprawling even in those antebellum years like a refugee camp, was fast becoming the social and financial capital of the country, bursting with glamour, power, and money. Arthur arrived there in 1853, took up bachelor's rooms and a position with an abolitionist law firm, and began to do what he did best—make the right friends. He worked on several controversial defenses of fugitive slaves and the rights of free negroes, and grew ever more obsessed with slavery. In 1856, along with another wide-eyed young lawyer, he departed for Kansas Territory, where the slavery dispute had become a shooting war. It took the idealists only a few months to decide that intellectual combat was more to their liking, and Arthur was back in New York when the state's Republican Party began to coalesce in 1857.

The golden age of machine politics was dawning in New York, and Chester Arthur was made for machine politics. He was socially graceful and blindly loyal; he had a talent for organization and detail; he could take orders from abrasive tyrants and pass them along with gentleness and style.

In October, 1859, he became a family man, marrying Ellen Herndon, a beautiful, gifted daughter of Virginia aristocrats who, like her husband, relished gracious living and ached with ambition. Yet the marriage was to be troubled, largely because Arthur preferred the late-night company of his political cronies to the company of his wife—to almost everything else in life. His days rarely began before noon or ended before two a.m. He ate and drank prodigiously, but mostly he loved long walks and political discussions in the dead of night.

The Civil War, too, had wounded the relationship. Before the war, the Arthurs had lived with Ellen's mother in lower Manhattan, an arrangement that became impossible when, after Fort Sumter, Arthur advanced quickly as a quartermaster in the New York militia, equipping and dispatching the troops who were descending on the Herndons' native Virginia.

When the war ended in 1865, Arthur bought a home, a four-story brownstone at 123 Lexington Avenue. The formal entrance to the row house was on the second floor; off it were several large parlors, where the Arthurs entertained frequently and stylishly. Arthur set up an office for himself on the basement level and carefully stocked a handsome library, mostly for show.

By 1871, Chester Arthur was the trusted chief lieutenant of Republican czar Roscoe Conkling, and that year harvested the choicest plum in the entire American spoils system when President Grant appointed Arthur Collector of the Port of New York. Arthur served for eight years, and was perhaps less flagrantly corrupt than his prede-

cessors. But reform was in the air. In 1877 President Hayes launched an investigation of Arthur and the customhouse, found the Collector guilty of "gross abuses," and fired him after a prolonged battle with Senator Conkling.

When Arthur was first appointed Collector, a friend remembered, "there was no happier woman in the country" than Ellen Arthur. She delighted in her husband's prominence and prosperity, which allowed her to keep five Irish-immigrant servants at the Lexington Avenue house and to pamper the two children, a son and a daughter, who survived infancy. But her resentment of Arthur's neglect only worsened. One account has it that the marriage was on the brink of collapse when Ellen Arthur suddenly died of pneumonia in January, 1880. Arthur, as usual, was away on political business, and though he rushed home on a milk train to Lexington Avenue, he never saw Ellen conscious again.

Even Arthur himself was startled by his nomination for vice president later that year—"a greater honor," he said, "than I ever dreamed of attaining." The honor was Garfield's peace offering to Roscoe Conkling and the New York machine. Arthur managed the ticket's campaign in New York with his usual skill, and at a celebratory dinner after the victory he as much as admitted that he'd been up to his usual tricks. "I don't think we had better go into the minute secrets of the campaign," he said, "...because I see the reporters are present, taking it all down."

But if the presidency ever changed any man, it changed Chester A. Arthur. As president he broke with Conkling, refusing to aid the political machine he had done so much to build. "He has done less for us than Garfield, or even Hayes," groaned one old ally. Arthur launched the rebuilding of the American navy, and, in the neatest irony of all, supported the first substantive reform of civil service.

But while Arthur was surprisingly successful as president, he did not enjoy the job, except for the social side of it. He refused to move into the White House until it was redecorated in the fashionable *art nouveau* style, and once he did the mansion became the site of the kind of glittering entertaining it had not seen in decades. By day Arthur generally found the presidency wearisome. "Great questions of public policy bore him," wrote one reporter, adding that the president seemed "sluggish" and "indolent." Part of the trouble was Arthur's failing health. Though few knew it, Arthur was slowly dying of Bright's disease, a painful, progressive kidney ailment.

Arthur toyed with the idea of pursuing renomination in 1884, but he knew that he was in no condition, physically or politically, to manage it. He returned to New York and the rowhouse on Lexington Avenue, where he swiftly declined, guarding his privacy and denying reports of his serious condition to the very end. He died in November, 1886.

Reporters swarmed around Arthur's Lexington Avenue home on the night Garfield died. The ruthless boss, they were told, was too distraught to speak with them.

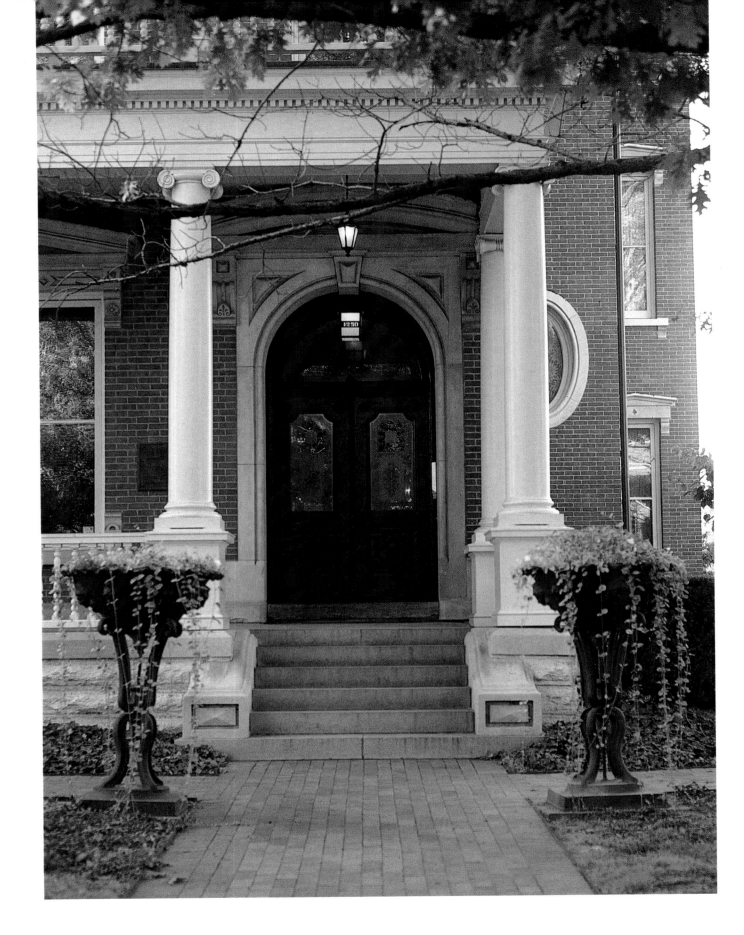

Grover Cleveland, Benjamin Harrison

GROVER CLEVELAND WAS HIS FATHER'S SON. In 1847, as abolitionism swept upstate New York like a virulent flu, Reverend Richard Falley Cleveland wrote to a relative, "I am not much taken with the new-growth reforms of the present day, and am more disposed to make the best of the old and well-tried expedients. Still, I hope for the world's reformation, and I trust I may even be ready, according to the measure of my ability and opportunity, to promote it." The modesty and the devotion to duty, not to mention the conservative Democratic politics, passed undiluted to the Reverend's son—a militant promoter of old-fashioned reform who became his party's only president between Buchanan and Wilson.

Reverend Cleveland was a kind, diligent man with too few outstanding talents and too many offspring. Stephen Grover, the fifth of nine children, was born in March, 1837, at the rather extravagant, gabled Presbyterian manse in Caldwell, New Jersey. A year later Richard moved his swelling brood to Fayetteville, New York, a scruffy, fast-growing village near Syracuse where the preacher's salary was larger and the parsonage less stylish. It was a slender, ungainly house of three stories, the first sheathed in stone and the upper floors covered with clapboard siding. The Reverend and his wife painstakingly planted a fine, fragrant flower garden behind the house. They had decided to settle down, finding Fayetteville pleasant, prosperous, and marked, Richard wrote, by "pleasing indications of the spirit's presence.... Our drunkards are nearly all reformed."

The Clevelands' was a joyful home, though a strict and pious one. Grover's religious fervor would cool with time, but he never forgot the lesson, as he put it while president, "of how solemn a thing it is to live, and feel the pressures of the duties which life...imposes." When one's duty was done there was room for good humor. Reverend Cleveland could only chuckle and shrug when parishioners complained of his son's late-night pranks. "If some of the old householders were here," President Cleveland admitted on a visit to Fayetteville, "I could tell them who it was that used to take off their front gates." A less mischievous diversion for the boy was fishing, a

From a shallow portico (later replaced by a full porch) over the oak and leaded-glass door of his North Delaware Street house in Indianapolis, Benjamin Harrison blasted Grover Cleveland in the presidential campaign of 1888.

fiery passion Cleveland indulged all his life. Informed that the first president had been an angler, Cleveland wrote, "I am much pleased to learn that the only element of [Washington's] greatness heretofore unnoticed...is thus supplied."

In 1851, Reverend Cleveland took a job with the American Home Missionary Society and moved his family to Clinton, New York, a pretty town perched among hills overlooking the Oriskany and Mohawk Rivers. Money remained scarce, and soon Grover was sent back to Fayetteville to fend for himself as a store clerk. For nearly two years he lived in a bare, stoveless room above McVicar's General Store. "We fairly froze," his roommate remembered. Back in Clinton, Cleveland later mused, "our family circle entire..., for the last time, met around the family alter and thanked God that our household was unbroken by death or separation. We never met together in any other house...and Death followed closely our departure." Two weeks after accepting a new ministry in Holland Patent, Richard Cleveland died of a burst ulcer.

After a dreary year working and living at New York City's Institution for the Blind, seventeen-year-old Grover struck out for the West, bound for Cleveland, Ohio, for no better reason than that the town's name appealed to him. He stopped en route in Buffalo, New York, where an uncle persuaded him to pause for a time. Buffalo was then a raw, rowdy boom town, thriving on the Great Lakes-Erie Canal trade, teeming with prostitutes, sailors, and merchants—altogether a fertile field for a bright young lawyer, which was what Cleveland now hoped to become. The city's legal community, he was often reminded, had produced a president, Millard Fillmore. Who knew what a hard-working young man could accomplish?

Cleveland was determined to find out. Rarely did his work day end before midnight. "I think he was insensible to physical requirements," a friend theorized, but he had to know that Cleveland's requirements for food and drink were considerable. Friendly reporters liked to say that Cleveland had "a tendency toward corpulency" or "a well-fed look." In truth he was huge, rotund as a bear, with "skin [hanging] on his cheeks in thick, unhealthy-looking folds," as a less generous observer saw him. In off hours Cleveland could be found in one of Buffalo's saloons, drinking, singing, and frequently brawling—pleasures he persisted in even as governor, and, on fishing trips, as president.

Throughout his almost thirty years in Buffalo, Cleveland lived in rented rooms, first in a series of "second-class hotels" with which he was "not very much pleased," and later in the "Weed Block" in downtown Buffalo, a dubious improvement. The Weed Block was a ponderous, unadorned pile of whitewashed brick, housing shops on the first floor and offices and apartments on the floors above. Inside and out, it had all the charm of a pillbox. The intensely cerebral preacher's son was as indif-

ferent as a mole to his physical surroundings, unless he was in the midst of nature, whose beauties, he often said, "are too good for human beings." The time and money others might have invested in making a home, Cleveland poured into building a communal fishing lodge on an island in the Niagara River. The hours other bachelors might have devoted to courting, Cleveland spent fawning as a surrogate uncle over Francis Folsom, the infant daughter of a close friend. Grown women left him cold, so far as his neighbors could tell.

They were wrong. Around 1871, the year Cleveland was installed as sheriff of Erie County, an attractive, troubled widow moved to Buffalo. More than friendly with several young men, Maria Halpin bore a son in 1874, naming Grover Cleveland as the father. He accepted her verdict and while declining marriage supported mother and child financially. When Mrs. Halpin's alcoholism worsened, he sued to have the boy removed from her custody. Eventually he arranged for the child's adoption. The episode, of course, was to haunt Cleveland politically. It inspired from him one of the memorable directives in the history of American electioneering: "Tell the truth."

Cleveland became mayor of Buffalo in 1881, elected by a coalition of Democrats, reform Republicans, and saloon buddies. His dizzying rise, in three years, from that modest post to the White House was fueled by his eccentric habit of calling things by their proper names. "This is a time for plain speech," wrote Mayor Cleveland to his city council, vetoing an appropriation as "the culmination of a bare-faced, impudent, shameless scheme to betray the interests of the people," the product of "low, cheap cunning...and the mock heroism of brazen effrontery." Cleveland talked that way throughout his career, to men of both parties, and to the delight of millions sickened by routine corruption. After two years as governor of New York, years of pitched battle with Tammany Hall, the Democratic machine in New York City, Cleveland was nominated for president in 1884 on the slogan, "We love him for the enemies he has made."

Though he apparently didn't know it, Cleveland had made enemies even among the clergy of Buffalo, who leaked exaggerated versions of the Maria Halpin story and unleashed a nationwide chorus of vilification. Cleveland was a "libertine," a "betrayer of women," a "man of shameless and profligate life." Cleveland's supporters, forbidden to deny the affair, responded with a bluntness worthy of their leader. "If every man...who has broken the [Sixth] Commandment voted for Cleveland," one cried, "he would be elected by a [vast] majority." Cleveland won, but very narrowly, and proved himself a thin-skinned warrior by forever refusing to forgive Buffalo's treachery. "I have no home at my home," he wrote a friend. Years later he termed his residence of three decades, "the place I hate above all others."

Francis ("Frankie") Cleveland, twenty-eight years younger than her husband, was the daughter of Grover's closest friend. Decades before their White House wedding, he had changed her diapers and rocked her to sleep.

Cleveland extracted one last blessing from Buffalo—"something better," he said, "than the presidency for life." 'Frankie' Folsom, the little girl whose diapers the bachelor lawyer had changed, became Mrs. Grover Cleveland in a White House ceremony in 1886. She was twenty-one; he was forty-nine. Contrary to cruel and persistent rumors that "the beast of Buffalo" abused his wife, the marriage was warm and loyal, with Cleveland, in private matters, happily dominated by his girlish bride.

He had purchased his first home in anticipation of the marriage, a presidential retreat on Georgetown Heights about three miles from the White House. Variously called "Oak View" or "Red Top," it was a squat stone house, and even after Cleveland enlarged it, wrapping a double-tiered porch around two sides and painting the flat roof apple red, it had, as a house, no particular charm. But the location was fine—the very spot, people said, from which Washington and L'Enfant had chosen the site of the federal capital. "The house," reported *The New York World*, "is on such...an eminence that all of Washington is disclosed....[It] lay like a phantom city, seemingly only a little way below us. The slight mist that had arisen veiled its lights and structures, except that the moon, exactly at its full, poured its radiance upon that grand [capitol] dome....and touched with such less profusion the outlines of the Capitol itself that the dome seemed as though hung in the sky."

With childlike pleasure the Clevelands established at Oak View a working hobby farm, securing, Cleveland wrote, "two old horses, a cow without horns that gives twelve quarts of milk a day, and some hens. I am thinking about a pig, but can't quite settle on one yet." Also counted among the livestock were at least three dogs, some pet foxes, and numerous caged birds belonging to the First Lady. Oak View became, in Cleveland's eyes, "one of the handsomest places in the United States." Certainly, its value soared. Cleveland sold Oak View at a profit of nearly $100,000.

Cleveland's unique presidential history—elected, rejected, elected again—shows how much more attractive reform was in principle than in practice. In his first term, Cleveland issued more than 400 vetoes, three times as many as all the presidents before him combined. He blocked excessive military pensions, enforced civil service reform, supported the first regulatory agency (the Interstate Commerce Commission), and called for dramatic reductions in the tariff—offending veterans, spoilsmen, railroads, and manufacturers. Republican Benjamin Harrison ousted him in 1888, largely on the tariff question.

Francis Cleveland left the White House in a huff, turning on the staff and assuring them, "We'll be back, four years from today." Her husband, meantime, was "overwhelmed with offers of houses to live in." He settled on a Manhattan rowhouse at 816 Madison Avenue, where he "entered the real world" in 1891 with the birth of

the first of five children. He was fifty-four. The Madison Avenue house was a four-story brownstone, spacious and subdued within, its rooms darkened by oak and mahogany woodwork. The exterior had the exuberant look of a neo-Gothic castle, with round-arched, multi-paned windows, and a square protruding tower crowned with a triangular peak. The family later moved to another townhouse at 12 West Fifty-first Street. Delighted, or so he claimed, with his quiet new life, Cleveland practiced some law, played cribbage and billiards, and plotted fishing expeditions.

One such outing led Cleveland to Buzzard's Bay, on the underside of Cape Cod. There he purchased a summer home that was his idea of paradise—a plain but comfortable wilderness cottage, overlooking a harbor boiling with bluefish and sea bass. What neighbors there were were old friends or rough-hewn men of the sea, the sort of company he had always preferred. Beneath a broad-brimmed hat Cleveland worked the waters of Buzzard's Bay like a man possessed, eight or twelve hours at a crack. On the small, breezy porches of Gray Gables, as the Clevelands called their hideaway, he cavorted as a boy with his new daughter, Ruth, and later her siblings. Ruth's death from diphtheria at age twelve finally broke the spell the place cast over Cleveland. He sold it and never returned.

Cleveland made good his wife's prediction in 1892, turning the tables on Harrison. In his second term he found whole new classes of citizens to outrage. Imperialists resented his refusing to annex Hawaii; laborers decried his breaking the Pullman strike; the wealthy recoiled from his support of an income tax; the poor loathed his defense of the gold standard. He left office widely criticized and openly repudiated by Democrats, who had "wandered off," he moaned, "after strange gods"—gods named Bryan and Silver. Cleveland spent his last year in public life quietly working for his own party's defeat.

Some months before retirement, Cleveland gave a speech in Princeton, New Jersey. Presently he wrote to a friend there, "Somehow for the last few days the idea has entered our minds that we might be very comfortable...at Princeton.... I would like to buy a house...having plenty of room and a fair share, at least, of the conveniences of modern existence...; and in this house I want to be free from all sorts of social and other exactions that might interfere with the lazy rest I crave."

Princeton had much to recommend it. Convenient to New York, it preserved a serene, small-town rusticity, yet its venerable university gave it sophistication and architectural beauty that few small towns could equal. Not insignificantly, it was a bastion of solid Presbyterian thinking, and Richard Cleveland's alma mater. Within weeks Cleveland had purchased a home in Princeton and named it Westland. "A grove of pines surrounds [the house]," wrote the *New York Tribune*, "and pretty

lawns stretch away on all sides, with well-kept driveways and walks. The house is of Colonial architecture, with the usual white pillars in front, and is two and a half stories high. It is built of brick and stone, with cream stucco finish. The avenue is one of the most aristocratic in the village, being lined with handsome houses occupied by members of the University faculty." Westland was as handsome and as big as any, and Cleveland enlarged it, adding a billiards room and a spacious study. He bought a tiny farm just outside town—yet another sporting lodge, where he could rest and refresh himself while hunting or fishing in the countryside.

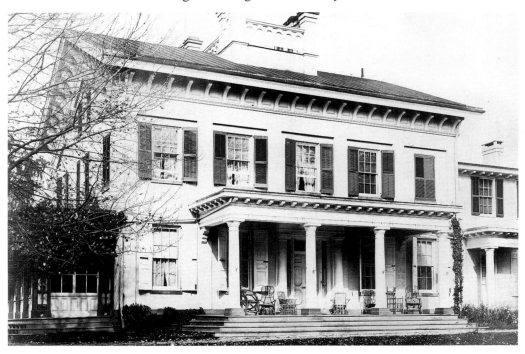

Westland was Cleveland's retirement home in Princeton, New Jersey, where he became a hero and living icon to university students.

Princeton welcomed the former president heartily. Students adopted him as a living icon—the toughened old veteran of political wars, a symbol of practical morality and courage. Cleveland, understandably, enjoyed the role, and appeared eagerly at debates, dinners, football games, and on his front porch, where admiring students would stop by for a few words of wisdom. He was "seldom seen walking through the streets," the *Tribune* reported, but "every university youth is quick to recognize his carriage as it bowls along." Most often as the years passed, Cleveland was found lounging on Westland's portico, an aging father watching toddlers frolic on the lawn. He was sixty-six when his last child was born.

"Lazy rest" was not really Cleveland's style. He took to writing articles—sometimes about politics and sometimes about fishing—for *The Saturday Evening Post*, *The Atlantic*, *Century*, and other magazines. He became a trustee of Princeton University,

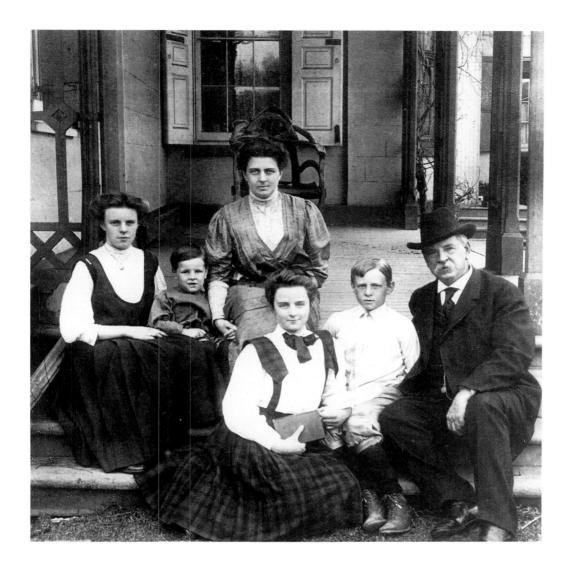

Cleveland and family on Westland's porch. "Frankie" is in the center at the rear.

and sometimes clashed with Woodrow Wilson, though the two generally admired one another. He served as a consultant to the corruption-ridden Equitable Life Assurance Society. And he kept up with politics, denouncing the Spanish-American War. When jingoistic publisher William Randolph Hearst invited prominent Americans, Cleveland included, to vent their rage about the sinking of the *Maine*, the old fire flashed from Cleveland's pen: "I decline to allow my sorrow...to be perverted into an advertising scheme for the *New York Journal*."

Cleveland lived to see history revised in his favor, to hear people agree that he'd been right as president more often than not. He died in April, 1908, with the attributed last words (perhaps too good to be true): "I have tried so hard to do right!"

At a wild and beautiful place called North Bend, where the broad Ohio River

meets the Big Miami, there once stood a farm that shares a distinction with the Adams houses in Quincy, Massachusetts. They were the only private estates to serve as home to two American presidents.

On August 20, 1833, in the Big House at North Bend, General William Henry Harrison was blessed with a grandson. Seven years later William Henry defeated incumbent President Martin Van Buren, in a campaign touting the "log-cabin" simplicity of the general's home life. Fifty-five years later, the grandson, Benjamin Harrison, ousted incumbent Grover Cleveland, and again the rugged ways of North Bend seemed somehow relevant to many voters. One Harrison supporter thought the candidate worthy because his grandfather had "killed and scalped more Injins, drank more hard cider, and lived and died in more log cabins" than any man in American history.

There was one flaw with this kind of logic: the Harrison place at North Bend was a stunning, 2,800-acre farm, the Big House a lavish, sixteen-room mansion. When Benjamin was born, John Scott Harrison, William Henry's son and Benjamin's father, was busy constructing a home of his own a few miles west of the Big House. It stood on a slender, 600-acre strip of land, almost a peninsula, squeezed between the Ohio on the south and the Big Miami on the north. Where the rivers met, John Scott's land ended. He called his section of the estate The Point.

It was a lovely spot, but an ill-chosen farm, subject to frequent catastrophic flooding. John Scott was an inept farmer, perpetually on the brink of ruin, or, at any rate, complaining that he was. But his family lived well, in a handsome two-story house of brick whose cavernous dining room looked out on the Ohio. Benjamin and the other grandchildren enjoyed the run of the whole estate, and spent many hours at the rambling Big House. Tutors called to see to their schooling. Discipline was firm and wide-ranging. Benjamin was warned against the evils not just of smoking, drinking, and dancing, but also of cucumbers and novels. The reading of fiction, he declared as a schoolboy, "weakens the mind and if carried to excess will ultimately destroy it."

No one ever accused Harrison of being a romantic. "I was born to be a drudge," he once confided, and elsewhere confessed to being "a poor pleasure seeker." He was the sort of man who, when dragged to the symphony, brought along a weighty legal volume to help pass the time. People called him "the human iceberg," and his political bandwagon, "the Harrison ice-cart." Yet he sensed his limitation, and in private affairs vicariously enjoyed the imaginative, emotional life. At college he became, by his own reckoning, "a pious moonlight dude" as he breathlessly courted Caroline Scott, a free-spirited, artistic woman whose delicate, almost impressionistic painting

found its way onto dishes, tapestries, and canvas. As First Lady she established the White House collection of presidential china.

The Harrisons' engagement was a long one, so long that Benjamin convinced himself that his betrothed might drop dead out of sheer anxiety to land her hero. "The question," he wrote a friend, "is narrowed down to this: Shall I marry Carrie now...or...let her hasten to an early grave?" He had another motive for getting on with his life. He was living with a sister in smoky Cincinnati, and he despised the place with its "abominable compound of coal dust and mother earth....it almost blinds you." He married Caroline in 1853 and headed west, toward a younger, smaller, and, he hoped, cleaner community: Indianapolis.

Indianapolis was one of those American cities that sprouted like a mushroom— suddenly, out of nowhere, and seemingly for no reason. Dead in the center of Indiana, on the banks of the unimportant White River, the town had fewer than 4,000 people in the mid-1840s. When Harrison got there a decade later the population was pushing 16,000 and growing daily. Railroads linking Chicago to the South had built the city, and the Harrisons found it much to their liking. It was healthy, innocent, and vigorous, loud with the clatter of hammers and saws. Even the Civil War didn't stop its growth. Returning from the battlefields, Harrison "found himself a stranger in his native town, lost in a labyrinth of new and eloquent buildings."

In college Harrison had resolved the question of "whether a Christian could be a lawyer." In Indianapolis his practice thrived. He was dedicated, thorough, and a fierce battler in court—"the best cross-examiner in the state," thought one colleague. His name didn't hurt, as Indiana was the site of his grandfather's triumphs at Tippe-canoe and the Thames. The Harrisons' first Indianapolis home was a sagging, three-room shack on Vermont Street. They soon moved up to a two-story, wood-frame house on New Jersey Street, with a long, carpeted front porch. The quarters were cramped, as two children had been born and Harrison was housing a brother and a nephew. Early in 1862 he bought a bigger, finer house on Alabama Street, an old-fashioned affair with a radically sloped roof, a dormer jutting off the second-floor front, and a pillared half-circle portico.

Harrison had by then gotten interested in politics, "a drug," said his father (who served two terms in Congress), "which should never be found in a gentleman's parlor." Especially distasteful to John Scott was the derivative Benjamin was hooked on—Republican, anti-slavery politics. Elected state supreme court reporter, Harrison stayed out of the Civil War until the summer of 1862, after which he served in Tennessee and throughout Sherman's Georgia campaign. He rose to the rank of brigadier-general, seeing more personal combat than any war-hero president save

Benjamin Harrison's first wife, Caroline, was an artistic woman who launched the White House collection of presidential china.

Grant—a good deal more than his grandfather. For the rest of his life he would stubbornly "wave the bloody shirt," condemning his Democratic foes as traitors with the blood of Union soldiers on their hands. He would also be an unyielding champion of indiscriminate pensions for disabled veterans, even when they resulted in government largesse to men injured in the act of desertion.

Throughout the war Harrison wrote to his wife of his longing to return to "the temple of my heart, at home," and of his resolve to become "a more domestic and sociable man" when he got there. He plunged as single-mindedly as ever into law and politics, but in 1867 he bought a large, 150-foot-wide lot on Indianapolis's North Delaware Street. Seven years later he built his temple.

It was, and still is, a magnificent home, a sixteen-room, red brick mansion in the boxy Italianate style, dripping with conspicuous signs of the wealth. In the grand drawing room to the left of the entrance hall hung one of many cascading crystal chandeliers. Also hanging there were "puddle drapes," several feet too long for the soaring windows—evidence that the owner could afford more than enough fabric. Across the hall the vast dining room, with seating for twenty, was made to feel bigger by a glittering diamond-dust mirror. Harrison's dark, plush library was fitted with a gigantic walnut bookcase. Upstairs a winding hallway led to spacious chambers furnished with massive beds and oversized headboards of mixed inlaid woods. In the sitting room the general, an exercise enthusiast, kept a rowing machine and wooden weight-lifting set.

In his later years Harrison remodeled his home, adding electricity and central heating. A wide, two-story, L-shaped veranda replaced a shallow portico shading the oak and leaded-glass door. Apart from Caroline's abundant artwork, the North Delaware Street house was in every way an outstanding example of conventional Victorian qualities—and thus a vivid witness to the man who built it.

Harrison remarked, when talk of a presidential nomination grew loud, that his "public life [had] been brief and inconspicuous." He had twice run for governor of Indiana and lost, had refused a spot in Garfield's cabinet, and in 1881 had been sent to the Senate, where he served capably but without flair, as "the soldiers' legislator." Defeated in a bid for re-election, he admitted that he'd earned a reputation for "almost getting there." Yet he received the Republican presidential nod when the party was still chafing from its first defeat in a quarter century. He ran a quiet campaign entirely from his house. On the night of his nomination, a souvenir-hungry mob removed his picket fence board by board.

As president Harrison did just what he'd promised, but he couldn't seem to inspire people. Theodore Roosevelt unkindly judged him "a cold-blooded, narrow-minded,

After Caroline's death during the 1892 campaign, Harrison married Caroline's niece, Mary Dimmick.

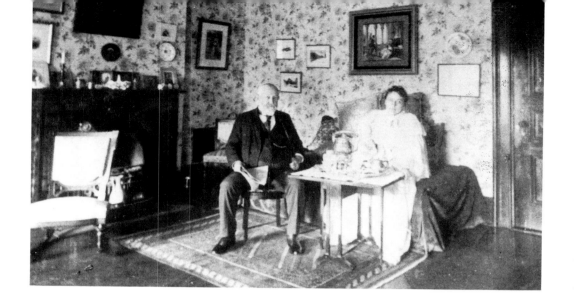

Benjamin and Mary take breakfast in an upstairs sitting room on North Delaware Street. Harrison's children objected to the match. He ignored and partially disinherited them.

prejudiced, obstinate, timid old psalm-singing Indianapolis politician." Too many others thought much the same thing.

In 1890, a group of wealthy friends presented the president with a twenty-room "cottage" at Cape May Point, New Jersey, fueling a brief, abusive controversy until it was learned that Harrison had refused to accept the house as a gift and had already repaid the $10,000 price. The country was more charitable when Caroline Harrison, long in poor health, died in the last weeks of the 1892 campaign. All electioneering ceased, but the result was already certain.

Harrison returned to Indianapolis in the spring of 1893, claiming that defeat had "no sting...after the heavy blow the death of my wife dealt me." He found his house "needing the labor of almost every known trade," and quickly applied it. The widower's life was "a very lonely one," and after waiting what he thought a decent interval— three years—Harrison remarried. His bride was a widowed niece of Caroline's, Mary Dimmick, twenty-five years her husband's junior. Harrison's children angrily objected, but he was undeterred. "A home life is essential to me," he wrote to his son. "I am sure [my children] will not wish me to live the years that remain to me in solitude." When it became clear that such was their wish, he partially disinherited them. A third child was born to Harrison, sixty-six years old, in 1897.

In his final years Harrison spent long, carefree summer vacations supervising construction of a mountain retreat in upstate New York's Adirondacks. He called the place "Berkeley Lodge," after his family's ancestral Virginia plantation.

Benjamin Harrison was like Grover Cleveland in that he "never regarded life as a joke," as a friend said. The two were alike, as well, in being the last of their kind— the last in a generation of presidents shaped by the Civil War and its issues, and somewhat perplexed by the nation it produced. A new sort of president was about to take the stage when Harrison died quietly, in his own bed at the North Delaware Street house, on March 13, 1901.

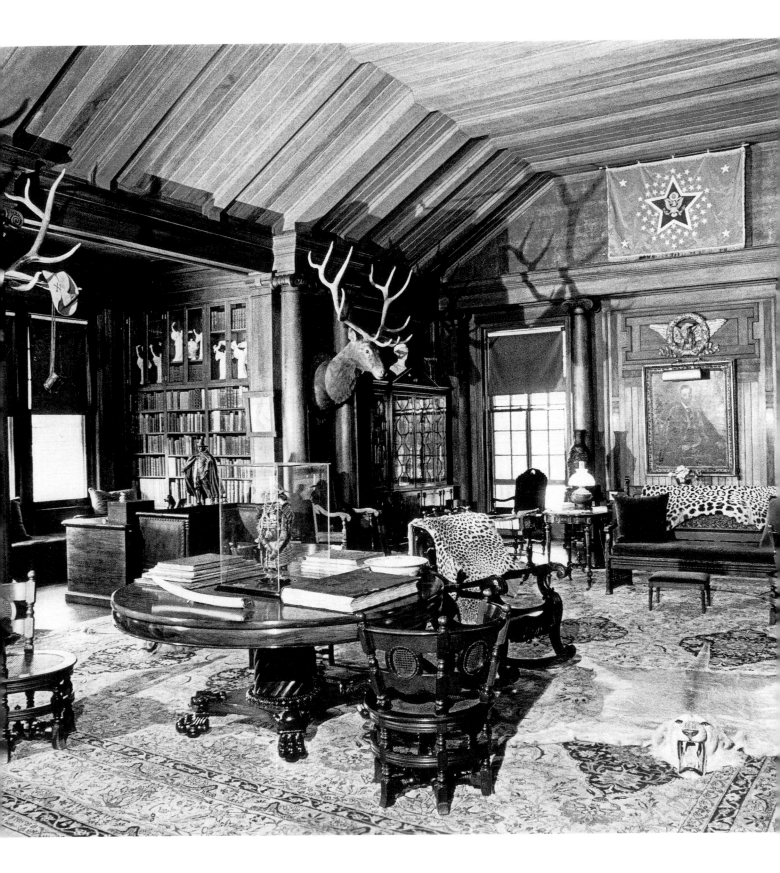

William McKinley, Theodore Roosevelt

IN 1898 PRESIDENT WILLIAM MCKINLEY declared war on Spain, unwittingly (for McKinley was no visionary) ending forever America's indifference to the course of international affairs. "Isolation is no longer possible or desirable," McKinley told visitors at the Pan-American Exposition at Buffalo, New York, in 1901. "The period of exclusiveness is past."

McKinley was a beloved but undistinguished president. More original thinkers than he, such as William Allen White, the influential Kansas newspaperman and friend of many presidents, spoke eloquently of America's responsibility to cultivate democratic principles in foreign soil. The notion of "manifest destiny," as White called it, enthralled the likes of Theodore Roosevelt, McKinley's second-in-command. It deeply bothered McKinley himself.

On the one hand, the war with Spain was immensely popular, and McKinley was a careful, even a crafty politician. Senator Joseph Cannon once said that the president "kept his ear so close to the ground he could hear the grasshoppers." On the other hand, the war had been tragically ill-conceived. Given a choice the Spanish almost certainly would have surrendered their claim to Cuba, whose sporadic bids for independence finally ignited the conflict. Roosevelt's "splendid little war" need never have been fought—and while President McKinley knew it, he seemed powerless to prevent it.

McKinley was by nature more of an isolationist than an empire-builder. He was, in fact, a homebody. As governor of Ohio and Republican nominee for president in 1896, he preached the gospel of protectionism and sound money from his own front porch. The candidate could afford to stay home. While his opponent, the populist Democrat William Jennings Bryan, dashed about the country like a starving jack rabbit, racking up more campaign miles than any presidential candidate before him, McKinley supporters were shattering all previous spending records. Cleveland industrialist Marcus A. Hanna, having paid McKinley's way to the governor's mansion, dug deep into his own pockets to secure the Republican presidential nomination;

Overleaf: The spirit of
Theodore Roosevelt lives
in the magnificent North
Room of his Long Island
estate, Sagamore Hill.

now he pestered his fellows in commerce and industry until they had coughed up $16 million to get McKinley elected.

Hanna was frankly terrified by the prospect of Bryan in the White House. This Democratic firebrand had no conception of the opportunities of the new industrial age, Hanna believed, but saw only its immediate injustices, which he sought to redress through a regression to agrarian values. What's worse, in his infatuation with silver, Bryan had failed to grasp the vital link between stable currency and the gold standard. Those masses of common men he claimed as his constituency must be told the truth about silver: that abandoning gold would make dollars so plentiful as to be finally worthless. To Hanna, William Jennings Bryan was a dangerous megalomaniac; William McKinley was, as Hanna gravely proclaimed, "a saint."

Farmers and foundrymen, lawyers and doctors, college students and Civil War veterans—Hanna organized them into manageable "delegations," decorated them with "Sound Money" buttons, bow ties, caps and placards, and, with the help of low "excursion" fares arranged by his friends in the railroad business, shipped them by train to Canton. They were greeted at the station and led through town to the corner of Eighth and Market, where a brass band struck up the McKinley theme song ("The Honest Little Dollar's Come To Stay"). They came bearing gifts of candy, clothing, and flowers. One pilgrim presented the candidate with three eagles: "McKinley," "Protection," and "Republican." A delegation from the West offered a strip of jointed tin, sixty feet long, engraved with the names of the Republican candidates. Other tokens included a gavel carved from a log that was taken from a cabin Lincoln had lived in, a finely polished tree stump, and the largest plate of

Delegations of
Republicans from across
the nation made the
pilgrimage to Canton,
Ohio, to hear their
candidate speak about
"sound money."

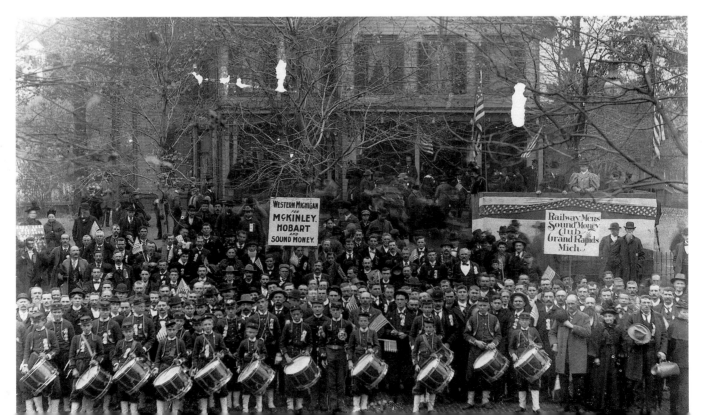

galvanized iron ever rolled in the United States. The children chanted, "Governor McKinley, he's our man/If we can't vote for him our papas can," as the candidate climbed aboard a kitchen chair to say a few words about sound money.

McKinley entertained 750,000 people from thirty states at his home in Canton, while prominent Republicans who were willing to travel, Theodore Roosevelt among them, set out after Bryan to throw cold water on the Democrat's scorching oratory. In contrast to his peripatetic opponent, McKinley was the picture of presidential dignity. Never mind that his legs were a bit short, his handshake pulpy, his delivery unctuous, and his message mundane. There was in his countenance—the dark, unwavering stare; the flat, unfurrowed brow; the Roman nose—something imperial, even Napoleanic.

About that nose a newspaper columnist had observed, "He does not like to be told that it looks like the nose of Napolean. It is a watchful nose, and it watches out for McKinley."

Had the candidate lived in a mansion like Theodore Roosevelt's Sagamore Hill, surrounded by servants and acres of prime real estate, Hanna surely never would have underwritten such a campaign. But Canton, Ohio, offered a vivid rebuttal to Bryan's argument that McKinley was merely a puppet of wealthy businessmen. The pretty white house at the corner of Eighth and Market hardly seemed that of an opportunist. Trimmed in dainty "Victorian lace" curlicues and ringed by a picket fence, McKinley's modest, two-story home was like his economic policy—safe and sound.

The house had been a wedding gift from his wife's parents. The famous porch ran along the two sides facing the street, and widened before the front door, which was flanked by tall shuttered windows. Here McKinley liked to relax in a high-backed wooden rocker, while his wife, Ida, sat beside him in a rattan chair, knitting. She was another reason why the candidate refused to move off the front porch. Ida McKinley grew up in Canton, the daughter of a wealthy and socially prominent businessman (her husband was the seventh child of an ironworker in Niles, Ohio). She was pretty and well-connected, and he loved her. At first they were blissfully happy, but when her second child died in infancy, Ida went into a deep depression and developed the symptoms of epilepsy. Utterly dependent on her husband, she passed her time knitting slippers and is said to have made more than a thousand pairs. McKinley suffered his wife's bizarre behavior without complaint. The nation was deeply impressed.

Rather than subject Ida to the mayhem of Republican nominating conventions, McKinley listened to them by telephone in his study. In 1896 he should have gone.

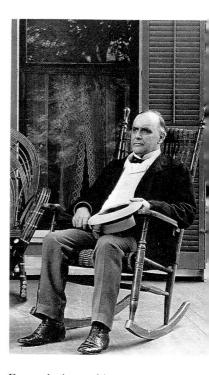

Even relaxing on his front porch, McKinley cut an impressive figure.

Ida McKinley gave birth to two children and lost each of them, one in childbirth, the other at age four. The deaths left her ill and shattered. She never recovered.

Pandemonium broke out in Canton when Ohio's forty-six votes clinched the nomination. Cannon blasts and firecrackers mustered a mob of well-wishers, who stormed the McKinley house, tearing down the picket fence and trampling the grass, crushing rosebushes, shrubs, and petunia beds. A friend who had been sitting with McKinley fled out the back door in a panic, shouting over his shoulder, "You have my sympathy!" The nominee kept his composure; he knew what to do. Grabbing a kitchen chair he strode out onto the front porch and quieted the crowd with a few words about sound money. Then he vanished into the house, reappearing seconds later to address the celebrants swarming into the back yard. By midnight he had shaken hands with half the population of Canton.

On September 5, 1901, having just completed his remarks to the Pan-American Exposition in Buffalo and taken his place in the receiving line, William McKinley grasped the bandaged hand of his assassin. Two shots rang out. The president slumped to the floor. "Don't let them hurt him," he gasped as secret servicemen converged upon his deranged assailant. Then: "My wife, be careful how you tell her." McKinley died nine days later, chanting the words to his favorite hymn, "Nearer, my God, to Thee."

McKinley's body was transported overland from Buffalo to Canton for burial. Ida moved back to the corner of Eighth and Market. The president had sold the house when they went to Washington, leased it for the celebration of their silver wedding anniversary, and then bought it back again two years before his death for $14,500, adding an octagonal gazebo. It was to have been the president's retirement home but instead the house was dismantled to make room for a hospital. The Depression stalled plans to rebuild it elsewhere in Canton, and by the time the project could be resumed much of the house had been destroyed by vandals.

Vice President Roosevelt was perched on a mountaintop in the Adirondacks when a forest ranger brought news of McKinley's death. Teddy's friends must have been amused, imagining the scene. Mark Hanna was not. Roosevelt's heroic assault of Kettle Hill had made the Rough Rider a national idol. With him on the ballot in 1900, McKinley could campaign wherever he liked—in his front parlor or the stable out back—and still be assured of reelection. Still, Hanna had opposed the Roosevelt nomination. "Don't any of you realize there's only one life between this madman and the presidency?" he thundered as the nominating committee drifted inexorably toward a McKinley-Roosevelt ticket.

It is hard to imagine an odder couple than William McKinley and Theodore

Roosevelt. The president was sedentary and malleable, his vice president renowned for his explosive energy and monstrous ego. Willful, bombastic, dogged, unpredictable, incorruptible, flamboyant, and fiercely independent, Roosevelt was also, much to Hanna's chagrin, confoundingly lovable. His round, open face was a blank canvas upon which teeth and spectacles, moods and motives were painted in primary colors. He was absolutely guileless, endearingly vulnerable, enchantingly romantic, and, at the close of the Spanish American War, the most famous man in America.

Like McKinley, Roosevelt believed that he had a special gift for sensing the popular will. But where McKinley was the calculating politician, deftly adjusting his course to the prevailing winds of public opinion, Roosevelt was hot-tempered and headstrong. If his world view didn't quite mesh with reality, well, he would work on reality. In 1896, the vast majority of Americans wanted peace. Roosevelt, then assistant secretary of the Navy, wanted war, and when it came insisted on taking up arms himself. His intensity proved irresistible. Inspired by Roosevelt's breathtaking example, the country embraced its manifest destiny. On the home front, meanwhile, Teddy had long since launched another crusade, siding with working men, small businessmen, and the wilderness against the abuses of men like Mark Hanna.

As president he called his reforms the Square Deal. He was the most progressive president since Lincoln.

Sagamore Hill is the spitting image of Theodore Roosevelt. His spirit still lives in the rambling, twenty-three-room, wood and brick mansion he built in 1884 on a Long Island peninsula overlooking Oyster Bay. Cove Neck, as the spit of land was called, had been a summer retreat for seven generations of Roosevelts.

One of America's oldest and most socially prominent families, the Roosevelts were descended from a Dutch merchant who settled in New Amsterdam (now Manhattan) in the 1640s. As a boy "Teedie" spent three seasons of the year in the city. He was born in a four-story brownstone row house on East Twenty-eighth Street. The house had a lovely garden in back and a noisy furnace in the basement that Theodore Senior, ("the best man I ever knew," Roosevelt often said of him) blamed for his son's asthma. Teedie divided his time among the gymnasium, where he contended daily with his maddeningly frail physique; his bedroom, where he conducted his experiments in natural history until the laundress threatened to quit ("How can I do the wash with a snapping turtle tied to the sink?"); and the library, where he curled up in a favorite chair and taught himself to read.

Small and delicate like Roosevelt himself, the chair had soft red-velvet upholstery and matching tassels. "I was nervous and timid," Theodore said years later. "Yet

from reading of the people I admired,—ranging from the soldiers of Valley Forge, and Morgan's riflemen, to the heroes of my favorite stories—and from hearing of the feats performed by my Southern forefathers and kinsfolk, and from knowing my father, I felt a great admiration for men who were fearless and could hold their own in the world, and I had a great desire to be like them."

In 1874, when Roosevelt was seventeen, the family moved to a grand mansion on West Fifty-seventh Street. Designed by Russell Sturgis, then the most fashionable of New York architects, the house was a mighty fortress filled with treasures—sumptuous Oriental rugs, rare antiques, dark ornamental woodwork. In a letter to his wife, Mittie, Theodore Senior called the house "another landmark reached on my life's journey....one abiding-place for the rest of our days." Young Theodore had his father's reverence for heroic exploits and the trappings of a manly life—elaborate riding habits, great yawning fireplaces, hunting trophies of truly monumental proportions. From his mother came the quick sense of humor and expensive tastes. Theodore Senior was as proud of Mittie's taste as he was of her beauty. Knowing how she detested anything artificial, he cheerfully ordered workmen to remove a "beautifully finished" plaster ceiling at the new house and replace it with oak beams.

To Teddy the most important floor was the garret, which housed his Museum of Natural History. Finally his immense collection of specimens would have a proper home. The gym occupied the top floor. Here Theodore (and his siblings—their father considered all five children "sickly") resumed his furious quest for fitness. By the time he entered Harvard he was strong, if still alarmingly slender.

No sooner had the family settled into their new house in town than they were packing their bags for Oyster Bay. Theodore Senior had rented a plantation-style mansion that would become the family's permanent summer residence. Before Tranquillity, as the graceful Long Island estate was called, there had been four summers at Loantaka, a country house in Madison, New Jersey. At Berrytown-on-Hudson, New York, Teddy had started his extraordinary diary. He revelled in these summer interludes.

Theodore Senior knew Tranquillity would appeal to his wife. Born and raised in Georgia, she had been so upset by her husband's Union sympathies during the Civil War that he finally agreed to send a surrogate soldier to do his fighting for him. (Some believe that young Theodore's pugilism grew out of humiliation and guilt over his father's failure to take up arms.)

He died in February of 1878, the first stunning tragedy of Teddy's life. "Oh Father, my Father," he wrote in his diary, "no words can tell how I miss your counsel and advice!" Devastated, Theodore began to see less of his family, more and more of a

Theodore had intended to name his Oyster Bay estate Leeholm, after his first wife. But Alice Lee Roosevelt died in childbirth on the very same day Theodore lost his mother.

lovely young woman from Boston named Alice Lee. For Teddy it was love at first sight. After a grueling two-year courtship (Alice's passionate suitor seems to have been driven temporarily mad from the pain of unrequited love), Miss Lee finally consented to become Mrs. Theodore Roosevelt.

Roosevelt graduated from Harvard in the spring of 1880 and that summer Alice accompanied him to Oyster Bay. For ten golden days the young lovers scoured the peninsula for traces of Theodore's not-so-distant youth. He told her how he and his cousins romped through these lush forests, how the neighbors laughed that the place should be called Tranquillity when it housed such a boisterous mob. He told her how the crisp, pure air of Long Island had been a tonic for his asthma, indeed a panacea for all ills including lovesickness—he had escaped to Oyster Bay during the worst of it with her. Finally, he took his betrothed to a hill overlooking the sea where he had spent hours sketching birds and recording their calls. This was his favorite place in the world, he said. He resolved then and there to claim it for his own, to build a huge mansion and to name it after Alice.

The newlyweds spent their honeymoon at Tranquillity. Theodore purchased the prized hilltop, and sixty surrounding acres, for $10,000. Then he entered law school, moving in with his parents at 6 Fifty-seventh Street. His days were filled with classes and study, his nights with lavish parties, the scant time in between with political meetings at the local Republican Party headquarters a few blocks away. Roosevelt won election to the New York State Assembly in 1881. He would serve three terms.

Alice joined her husband in Albany in October 1882 and set up housekeeping in a small, attractive brownstone on W. Fifty-ninth Street. After a hard day at the state capitol, Theodore enthused to his diary: "I can imagine nothing more happy in life than an evening spent in my cosy little sitting room, before a bright fire of soft coal, my books all around me, and playing backgammon with my own dainty mistress." In the spring of 1883 Alice became pregnant. The baby was due the following February. Theodore abruptly turned his attention from politics to family, and to the house at Oyster Bay.

He was determined that Leeholm, as he called it, would be magnificent—muscular, broad-shouldered, and big. What the house looked like from the outside was of no consequence to Roosevelt, or so he claimed. His architects, the New York firm of Lamb and Rich, "put on the outside cover with but little help from me," he wrote to the editor of *Country Life in America* in 1915. "I had to live inside and not outside the house, and while I should have liked to express myself in both, as I had to choose, I chose the former." That was just as well, for Leeholm was no beauty. Roosevelt's only absolute requirement was that the house have an ample outdoor porch, properly

Roosevelt's Manhattan birthplace later housed his first museum of natural history—until the laundress complained that she couldn't do wash with a snapping turtle tied to the sink.

situated: "I wished a big piazza, very broad at the n.w. corner where we could sit in rocking chairs and look at the sunset."

As for the interior, Roosevelt made his views "perfectly definite." There would be "a library with a shallow bay window opening south, the parlor or drawing room occupying all the western end of the lower floor; as broad a hall as our space would permit; big fireplaces for logs; on the top floor the gun room occupying the western end so that north and west it look[ed] over the Sound and Bay."

In August 1983 he surveyed Leeholm and bought more land—but construction was delayed by a tragedy from which Roosevelt for a time believed he never would recover. On February 14, Alice died in childbirth at the Roosevelt's Fifty-seventh Street home; Roosevelt's mother, Mittie, died downstairs on the same day, just two hours earlier.

Within a week both the family mansion and the Albany townhouse were sold; Roosevelt could not bear to be reminded of his "sweet, pretty" Alice. "I think I should go mad if I were not employed," he confided to his cousin, Anna Roosevelt. He took on a crushing load, but the burden of grief was far heavier. "The light has gone out of my life forever," he wrote in his diary. He fled to the open plains of Dakota, where just before his marriage he had bought a piece of a cattle operation called the Maltese Cross Ranch.

Perhaps it was merely the passing of time that restored him, but Roosevelt seemed to thrive on the extreme rigor of the cowboy's life. In 1885 he returned to New York with his enthusiasm more or less intact, and several inches added to the circumference of his neck and forearms. He left behind a second cattle operation. The Elkhorn Ranch consisted of a herd of cattle and a hunting shack (the West was open range, not private property at that time). Roosevelt had replaced the shack with an eight-room "cabin" as opulent, in its way, as a Manhattan townhouse. Stuffed moose and buffalo heads shared the rough log walls with bookshelves (he later would produce books as zealously as he consumed them). Coonskin caps dangled from the rafters, hunting rifles collected in the corners. Roosevelt imagined himself in winter reading by the fire that burned constantly in the massive stone fireplace; in summer, rocking on the generous piazza. These same visions he carried with him back to New York— for he was finally able to contemplate life in the big house at Oyster Bay without its beloved namesake.

In June he viewed the house for the first time. "Manly" is how he wanted it, and manly it certainly was, though ungainly better describes the haphazard arrangement of steep, gabled roofs, dormer windows, and jutting porches that now sprawled across the grassy hilltop. Roosevelt's sister Bamie had tried to soften the forbidding

The Roosevelt children thrived in "just the proper mixture of freedom and control" at Sagamore Hill, according to their devoted father.

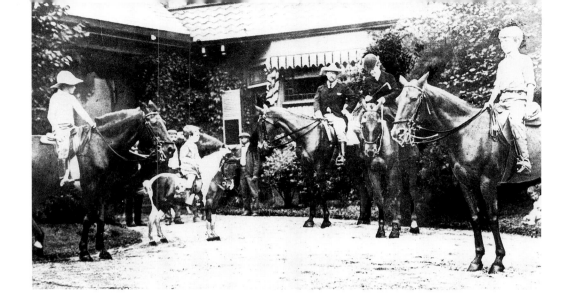

A skilled and fearless horseman, Theodore worked hard to instill in his children respect for nature and enthusiasm for outdoor sport.

first impression with vines and shrubs. But horticultural sleight-of-hand could not quiet the cacophony produced by mustard yellow shingles against green trim and crimson mortar between bright pink foundation stones. Happily, and no doubt much to Bamie's relief, Roosevelt pronounced himself "*delighted!*" with the house. He decided to name it after Sagamore Mohannis, the Indian chief who had given up this land to white settlers.

In December of 1886 Teddy married his childhood sweetheart, Edith Carow, and brought her to live at Sagamore Hill. She would bear five of his six children. His father's legacy had provided a tidy income of $8,000 a year. Roosevelt's Dakota properties set him back $85,000 (the Blizzard of 1887 would wipe out half of that), Sagamore Hill another $45,000. Roosevelt had spent most of his patrimony by the age of twenty-five. He was no businessman; just in time his yen for politics returned.

His battles against corruption as a civil service official won him the respect of influential Republicans, including Henry Cabot Lodge. Senator Lodge had arranged for Teddy to meet McKinley in Canton, when Roosevelt was between Bryan campaign stops. President McKinley gave him the Navy job partly as a reward for chasing the Democrat on his behalf. Roosevelt used the post to further the cause of war, then resigned to go fight it. After that he needed no introductions—he was elected governor of New York in 1899, and one year later McKinley chose him as his running mate. Teddy had served exactly four days when the assassination catapulted him into the White House.

Roosevelt pledged to carry out the McKinley program, but his presidential style and eventually his policies were his own. He believed in strength—a strong central government no less than a strong military. He deliberately fomented revolution in Panama in order to get the canal project underway. Yet he was also an effective peacemaker, winning a Nobel Prize for negotiating an end to the Russo-Japanese War, and always ready to defend any victim of the burgeoning business trusts.

Edith Carow Roosevelt, Theodore's childhood sweetheart and second wife, bore five of his six children.

An immensely popular president, Roosevelt departed for a year-long African safari at the end of his second term. The next year he spent on the European lecture circuit. Finally he could stay out of the action no longer. Convinced that William Howard Taft, his hand-picked successor, would fail to make good on his (Roosevelt's) campaign promises, the former president sought his party's nomination for a third term. He lost after a bitter fight, formed his own party, and ran for president on the Progressive (Bull Moose) ticket. A Democratic victory was assured. Woodrow Wilson became president in 1913, the first Democrat in the White House since Cleveland.

Throughout his turbulent but always astonishingly productive political career, Roosevelt traveled—mainly in pursuit of ever greater tests of his mental and physical toughness. Always he returned from his exploits to Sagamore Hill, weighted down with booty. President Roosevelt once confided to a reporter: "Fond as I am of the White House and much though I have appreciated these years in it, there isn't any place in the world like home—like Sagamore Hill, where things are our own, with our own associations." And in 1905 he wrote: "At Sagamore Hill we love a great many things—birds and trees, and books, and all things beautiful, and horses and rifles, and children and hard work and the joy of life."

Like his mother, Roosevelt especially loved elaborate woodwork and furnishings. Most of the first floor—the main entrance hall, the library, the formal dining room, the North Room—is panelled in rich dark wood. The heavy, masculine atmosphere—a cross between a hunting lodge in the Catskills and a men's club in London—is relieved on the first floor only by the gracious femininity of the drawing room, with its white lace curtains, tin ceiling, and plush upholstery. Even here Teddy could not be shut out altogether; the soft white rugs are polar bear. Upstairs, in the master bedroom, the Roosevelts shared a colossal bed of modern Gothic design, featuring a pair of giant spikes rising from the headboard. In the third floor Gun Room sits a chair made entirely of the horns of longhorn bulls.

Of Sagamore Hill's twenty-five rooms (including thirteen bedrooms), the North Room is the most muscular, the most broad-shouldered, the most irrepressibly Teddy. Added to the house in 1905, the room was designed by Roosevelt's friend C. Grant LaFarge as a suitably grand setting for presidential entertaining. It is a cavernous vault of a room, thirty by forty feet, with a sunken floor and beamed ceilings, a great book-lined bay at one end, and completely encased in Philippine and American woods: mahogany, black walnut, swamp cypress, and hazel. A huge ten-foot-wide fireplace with a carved mantel and a dark gray marble hearth dominates one wall, along with the massive head of a water buffalo. The fireplace is flanked by pillars,

one of four pairs set in the walls as if to support the ceiling.

Everywhere there are mementos of Roosevelt's legendary machismo: elephant tusks, a gift from the Emperor of Abyssinia; Samurai swords, from the emperor of Japan; a huge rug, from the Sultan of Turkey, over which are scattered leopard and buffalo skins; a set of elk horns, from the Elkhorn Ranch, from which are suspended the sword and hat Roosevelt wore with his Rough Riders. Here as everywhere in the house, hunting trophies abound—bighorn sheep, rhinoceros, wolf, antelope, moose, cougar—and at certain times of the day, especially at twilight, one can almost imagine these noble creatures roaming about among the armchairs and pedestal tables. To Roosevelt's oldest son and namesake, the North Room "always means evening, a great fire blazing in the hearth, its flickering light dancing on the flags in the gloom of the ceiling. Father, a book under one arm, poking it with a long iron trident. Mother, sitting sewing in a corner of the sofa by a lamp."

Life at Sagamore Hill was rarely so peaceful, however. With six children in residence, plus countless pets and servants, cousins and guests, the house never felt empty or cold, except on sub-zero days when even its good-sized fireplaces (four to a floor, each outfitted with a dumbwaiter to raise wood) and two hot-air furnaces fully stoked could not adequately heat it. Such weather inspired the family nickname for Sagamore Hill—"the bird cage." The more clatter and confusion the better, as far as Teddy was concerned. When the din became unbearable he could always retreat to the library or, in extreme cases, the Gun Room on the third floor.

"[At Sagamore Hill] I would say that there was just the proper mixture of freedom and control in the management of children. They were never allowed to be disobedient or to shirk lessons or work; and they were encouraged to have all the fun possible. They often went barefoot, especially during the many hours passed in various enthralling pursuits along and in the waters of the bay. They swam and they tramped, they boated, they coasted and skated in winter, they were intimate friends with the cows, chickens, pigs, and other livestock. . . ." When one of these "intimate friends" died, the entire family would troop to the small animal cemetery to pay their last respects, Theodore and Edith leading the mournful procession.

As a young man courting Alice Lee, Roosevelt was instructed by his doctor to enjoy life fully but not too strenuously, for he had a weak heart and would not likely live out the decade. The impatient youth headed West and pushed himself harder than ever, declaring to a friend that he would live to be sixty.

And so he did. Theodore Roosevelt died on January 6, 1919, in his monstrous spiked bed.

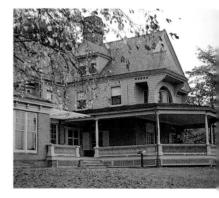

Roosevelt claimed that Sagamore Hill's architects "put on the outside cover with but little help from me."

William Howard Taft, Woodrow Wilson

THOUGH BOTH ENDED UP HIS BITTER enemy, the two men who followed Roosevelt to the White House—William Howard Taft and Woodrow Wilson—had once basked in Teddy's high esteem. In an era notable for blatant avarice and intrigue, the Republican Taft was a sturdy bastion of incorruptibility, the Democrat Wilson a stirring evangelist for truth and justice.

Taft's father grew up in Vermont, the son of a farmer who served as a state legislator and later as a judge. Well schooled in the virtues of honesty, hard work, temperance, and thrift, at sixteen Alphonso Taft had saved enough money teaching school to put himself through college, graduating from Yale in 1833, and then law school. Degree in hand, he surveyed the legal landscape. "The notorious selfishness...of the great mass of the men you find in New York," he wrote to his betrothed, Fanny Phelps, "[poses] a serious objection to settling there....After balancing every consideration which I have been able to bring to bear upon the case, I am disposed to locate [in Cincinnati]."

Taft's decision to marry Miss Phelps, the youngest daughter of a respected judge, was no more impetuous than his choice of a new home. He preferred Fanny's older sister Elisa. "As to Fanny, she is so young & her character so little formed, I don't think it worth while to take any trouble about her...If Elisa won't do I had better cast around for another, by and by I suppose. I would rather some one would do it for me. I have enough else to do." Elisa rejected him. Once settled on the pretty but frail Fanny, Alphonso lost no time in "forming" her character. His letters were filled with advice on matters ranging from spelling and punctuation to the wearing of corsets (he did not approve).

By 1841, he was ready to receive his young wife (Fanny's father had inspected Cincinnati and found it so to his liking that he moved there himself; the elder Tafts followed shortly from Vermont). Returning from their honeymoon, the newlyweds happened to catch a lecture by Charles Dickens. The eminent English author, too,

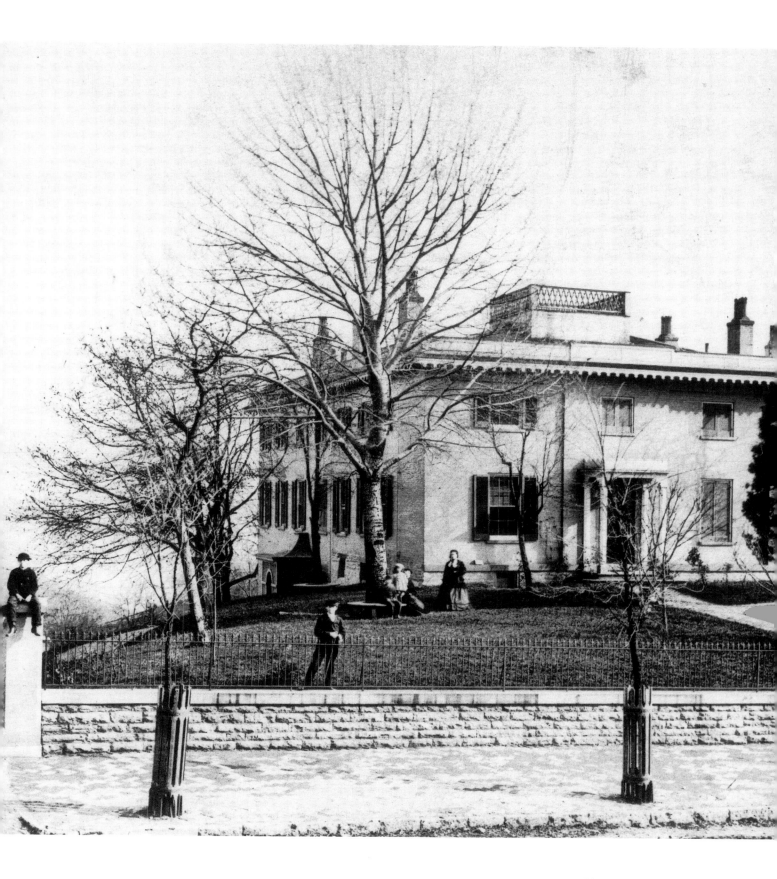

was enchanted by Cincinnati, "...with its clean houses of red and white, its well-paved roads and footways of bright tile," as well as the "neighboring suburb of Mount Auburn."

Ten years and five children later (two boys survived infancy), the Tafts moved into a handsome two-story home in that charming suburb. Alphonso paid $10,000 for the house in Mount Auburn, which offered excellent views and an escape from the heat and smog of the city. Fanny had fallen ill after the death of her last baby, and her husband hoped that the clean air would restore her. It did not. She died of "congestion of the lungs and of the brain" in 1852.

Within eighteen months the ever efficient Alphonso was remarried. This time he chose a more sophisticated woman, twenty-six-year-old Louise Torrey of Millbury, Massachusetts. Their first child died in infancy; William Howard came next, followed by two more boys and a daughter. The brick Federal house was big enough to hold them all, with room for a private apartment for Alphonso's parents. Square and stocky, with shuttered windows, a graceful pillared entrance, a widow's walk in the center of the roof, and Victorian scroll-trimmed eaves, the house presided over a large sloping yard filled with cats, dogs, children, horses, and a few cattle. Both Louise and her mother-in-law were avid gardeners, and soon flower beds ran along both sides of the front walk. Surrounded by farmland, the lot teemed with squirrels, possum, and fifty species of bird. "Mount Auburn is in its glory now," Louise wrote to her sister in 1852. "The country could not look more beautiful." Cincinnati proper, like most of the country's thriving industrial centers, was filthy. "The soft coal spreads such a dust that everything is black with it....I hardly dare make a call or enter a store without satisfying myself that I have not a large beauty spot on my nose or other part of my face....Everybody you meet has a similar ornament."

Along with the layers of coal dust came prosperity. Mount Auburn was home to about fifty families when Louise arrived; she was pleased to find her new acquaintances more worldly and fashionable than she had expected. Still, she missed the elegance of her childhood home, with its period furniture, silver, and fine china. Her parents shipped her piano, and Louise spent three hundred dollars of wedding gift money on a marble-topped parlor table, a Gothic chair upholstered with figured plush, and a whatnot table. Satisfied with the parlor, she turned her attention to her wardrobe; what could not be hastily purchased back East she sewed herself. "Mr. Taft," she wrote, seems "proud of me."

Louise's inventiveness and thrift proved lifelong assets. "Mr. Taft" never made more than a comfortable income. When he had a stone fence built around the property, Louise complained to her sister that she would have preferred wrought iron; the

Overleaf: William Howard Taft (standing behind fence) grew up in Mount Auburn, a suburb of Cincinnati. His boyhood friends called him "Lubber," though he preferred his other nickname, "Big Bill."

$300 could have been better spent on curtains and new carpeting. But the fence was durable and the children loved to sit on it, swinging their legs.

As Civil War loomed, Louise noted "a spirit of improvement going through the hill, to correspond with the sidewalks and fences." She planted trees and shrubs; ivy vines hung from baskets in the library, newly outfitted with cherrywood cabinets and gaslight reading lamps. A graduate of Mount Holyoke, the nation's first college for women, Louise in erudition was a match for her husband. In the evening after dinner they repaired to the library together, he to work on legal documents, she to read, often aloud from newspapers.

William Howard was born in 1857, in the first floor master bedroom. "He is very large for his age," Louise wrote to her sister two months later, "and grows fat every day." Unlike Roosevelt, whose drive toward the White House was fueled in part by a heroic triumph over childhood illness, the young Taft was "perfectly healthy"— and perfectly content. Never politically ambitious, his dream was to sit on the Supreme Court. But Roosevelt had other dreams for Will, and more potent even than his yearning to be a high court judge was Taft's need to fulfill the wishes of those he loved.

By 1870 Cincinnati was a bustling boom town of 200,000 people—and Will Taft a burly boy of thirteen who lived for baseball. Owing to his size, he proved better at attracting nicknames than circling bases. Friends called him "Lubber" or "Big Bill," the name he no doubt preferred, for it endured, as did an astonishing number of those early friendships. Affable and unassuming, with a quick sense of humor and contagious laugh, Taft led the "Mt. Auburn crowd" into battle against the rabble of Butchertown, on one side of the Mount Auburn ridge, and Tailortown, on the other.

As the suburb matured, Alphonso began warring with elderly neighbors over the installation of a rail line up the hill. His adversaries worried that the line would disturb the tranquillity of the village; Taft believed that progress was inevitable and desirable. Like William Howard, he was a sometimes unpredictable mixture of conservative instincts and progressive positions. His deep-rooted sense of civic duty drew him from private practice to the bench. Just as his son would years later, Alphonso served on the Ohio Superior Court for Cincinnati, as Secretary of War (and later Attorney General), and as a diplomat overseas. While in Washington the Tafts rented the Mount Auburn house. During this period a fire forced a drastic remodeling that added a third story and walk-out basement.

In 1908, William Allen White asked the future president how he managed to get so many important jobs at such a young age. The inelegant reply was vintage Taft. "I got my political pull, first, through my father's prominence: then through the fact

Taft's birthplace, now a National Historic Site, during its restoration.

Nellie Taft was probably more ambitious than her good-natured husband, and certainly more at ease in the White House.

that I was hail-fellow-well-met with all of the political people of the city convention-going type. I also worked in my ward and sometimes succeeded in deflating the regular gang candidate by hustling around among good people to get them out."

As Alphonso lay dying in 1891 William Howard worried that his own good fortune would expire with him. Hard-working with a memory to match his elephantine frame, even as a boy Will was haunted by visions of failure and terrified of disappointing his parents. While a student at Yale, he once tore his room apart in a rage when some friends refused to leave him alone to study. He graduated second in his class and enrolled in the University of Cincinnati Law School, living at home until the Mount Auburn house was rented. In 1886 he married Nellie Herron. His father-in-law, a prominent banker, gave the newlyweds a choice lot overlooking the Ohio River and financed construction of their three-story Italianate mansion. A graceless structure with redwood-shingled roof, scroll-trimmed porches, and colored-glass windows, the house nonetheless had breathtaking views of the valley and, from Will's library, the lush Keys forest.

He was employed as a collector of internal revenue, "a circumstance not of his seeking," Nellie wrote in her memoirs, when his restless spirit found "a pleasant harbor" on the Ohio Superior Court. In 1890 President Harrison, hearing of Taft's ambition to be appointed to the Supreme Court, and thinking him too young and inexperienced, offered him a slippery stepping stone instead: Solicitor General. Eager to move to Washington, Nellie urged him to take it. His brother Charles reminded him, "We boys are all trying to push along toward success if for no other reason than to convince Father in his ebbing days that he had not spent a life in vain." Taft dutifully "pushed along." Later an appointment to the circuit court sent him back to Ohio (much to Nellie's dismay), where he served until President McKinley asked him to set up a civil government in the Phillipines.

Will's assignment was to prepare the islands, now under martial law, for democracy. The transition would be in stages, the first a transfer of authority from the U.S. military presence, General Arthur MacArthur, to Taft's civil commission. Now a family of five, the Tafts were to live in the dilapidated but homey Arellano house in Malate, overlooking the ocean. While Nellie lingered in Japan with the children, Taft installed ceiling fans and daily rose at dawn to enjoy the cool sea breezes; in those precious hours he indulged his lifelong habit of writing his wife voluminous letters in which expressions of love and more mundane details, especially related to diet, outnumbered probing political insights by a wide margin. "I long for the time when you shall come," he wrote. "I cannot tell you how helpless I feel without you."

Desperately lonely, he finally resorted to bribes: "There will be…many interesting Filipino men to cultivate and entertain, beautiful furniture and interesting curios to collect."

In the impoverished Phillipines the parsimonious Mrs. Taft found that she could scarcely afford not to spend money. She indulged her every material whim without the slightest compunction. The family swiftly acquired a large retinue of servants, five carriages, including Nellie's victoria driven by matched black ponies, a steam launch, a pure white pony for their youngest child (and thirteen others for no one in particular), a monkey, an orangutan, and a pet deer. In 1901 Will was sworn in as governor. The Tafts moved into the Malacanan Palace after General MacArthur grudgingly moved out.

Situated on a bend in the Pasig River and shaded by palms, the palace was a vast, ceremonial barn of a building, full of fine porcelains and ferocious mosquitos. The living quarters Nellie decorated with plants and wicker, and on the walls she hung picturesque native gear—bolos, hats, spears, and so on (the style later earned the Taft White House the nickname "Malacanan Palace"). In the Phillipines Nellie learned the art of profitable entertaining. The Tafts wooed the Filipinos with a procession of lavish and often imaginative receptions, balls, and dinners, always accompanied by music. In 1903, when the Governor's work was finished, they said good-bye with a spectacular Venetian fete. Guests were conveyed to the palace in canoes, bancas, rafts and barges festooned with flowers. Twinkling light from Japanese lanterns and the music of mandolins and guitars greeted them at the landing, along with their host, convincingly gotten up as the Doge.

The "little brown people," Taft called the Filipinos; they worshipped their Governor, and he loved them in return—even though the spicy food and the tropical climate nearly killed him. So effective was he in this delicate assignment that "duty" was to dog him for the next several years. It drove him to Latin America to oversee completion of the Panama Canal, and then back to Washington and the war department. In 1909 he reluctantly accepted his party's nomination for president. As Teddy's hand-picked successor Taft easily defeated the Democratic candidate, Bryan, then sank into a miasma of despair and self-doubt from which he would not rise until Woodrow Wilson sprung him from his White House "prison."

Never in history had the White House seen such "pulling and hauling, intriguing, contention, bickering and strife" as during the Taft presidency, William Allen White wrote. Taft was "a hewer of wood, a man to whom work was his whisky, his cards, his revelry by night." But alas, he was no visionary. His sole inspiration and guide even as president was the Constitution, which he protected as zealously as Roosevelt

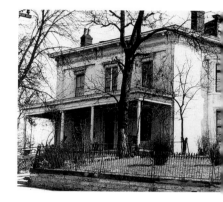

The Tafts sold the family home after Alphonso died.

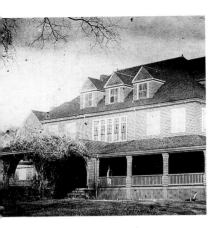

Taft's summer home in Beverly, Massachusetts, as it looked during his presidency.

had labored and schemed to preserve the virgin wilderness. As Taft took the conservative line with the business trusts, Roosevelt flew in the opposite direction. In the three-way campaign of 1912 the Rough Rider pulled no punches, calling Taft, among other things, a "flubdub," a "floppy-souled creature," a "puzzlewit," a "fathead," and a "man with brains of about three guinea-pig power." Taft kept silent as long as he could, then branded Roosevelt "a maniac" who presented "a great danger to the nation." Privately Taft mourned, calling the end of his friendship with Roosevelt "the greatest tragedy of my life."

Further aggravating Taft's "do-nothing" conservatism was his flagrant escapism. Rather than face the responsibilities of his office, especially when they forced him to cross or disappoint friends like Teddy, Taft traveled, ate (he was 350 pounds at his peak), golfed, and toured the countryside in the first presidential auto (Taft traded up from a Baker Electric to a Pierce Arrow, bought another and a White Steamer; Wilson, who blamed the horseless carriage for a host of national ills, retired the fleet). Taft stretched his annual retreats to the summer White House in Beverly, Massachusetts, well into autumn, spending most of the day on the golf course.

It was in far happier circumstances that the Tafts moved back to Washington in 1920. The ex-president was teaching law at Yale when President Harding granted his fondest wish. His children grown, the new chief justice looked for a home that would serve him well in retirement. He paid $75,000 for a white brick Georgian Revival townhouse equipped with a private elevator to the third floor library and within walking distance of the Supreme Court building, a pet project of Taft's while president. With the exception of a rustic cottage at Murray Bay, Quebec, this was the first house that the peripatetic Tafts actually owned. On his bedroom wall the Chief Justice hung a portrait of his younger brother, Horace (who braved his parent's disapproval to give up law for teaching), so that on waking he could see "that fine old kindly face smiling down on me a benediction."

Taft was a superbly efficient chief justice, just as he knew he would be. He gave up golf and paid strict attention to his diet. When he died of heart failure in 1930 he weighed just 250 pounds.

Propelled into office by the Republican split and a platform of sweeping reforms, Woodrow Wilson enjoyed popularity and success until the close of the Great War. Then dissension over America's proper role in world affairs shattered his dreams, then his presidency, and finally the man himself.

The son of a prominent Presbyterian minister, Dr. Joseph Ruggles Wilson, and for most of his life a teacher and scholar, Woodrow was portrayed by his more

flamboyantly virile opponents (notably the Rough Rider) as a frustrated preacher and ivory tower idealist more comfortable with women than men, perhaps even effeminate. Though their caricature bears traces of a likeness, his opponents underestimated him. Wilson was a complex and passionate man, and his death-defying fight for a League of Nations to ensure everlasting world peace every bit as courageous as Roosevelt's scramble up Kettle Hill. Not since Jefferson, whose name Wilson invoked more out of Democratic loyalty than genuine affinity, had a more scholarly or imaginative man attained the presidency.

Woodrow Wilson entered the White House after serving just one term in elective office, as governor of New Jersey, his interest in politics until then confined to teaching and writing. He published his first essay, on cabinet government, while a Princeton senior. The essay betrays Wilson's essential elitism; though a Democrat, he admired Hamilton and especially resonated to the writings of Edmund Burke. The Englishman believed that a habit of good conduct, more than constitutional structure, is the key to good government. A skilled debater and writer, Burke argued for prudence and expediency, both familiar Wilson themes. Woodrow's editor was a brilliant and like-minded Harvard instructor named Henry Cabot Lodge; decades later Senator Lodge would engineer Wilson's and the League of Nation's undoing.

His father's low-paying occupation as much as his Southern roots made a Democrat of Woodrow Wilson. He put off politics so long because he believed himself too poor. A deeply religious man who believed his work expressed God's will, he was impatient and stubborn when crossed, pettily vindictive in defeat. These qualities, too—along with his love of silliness and his literary bent—came from his father.

Woodrow's mother, Jessie Woodrow, also was reared in a Presbyterian manse, but neither the Woodrow nor the Wilson brand of religion was dogmatic. Indeed, the Wilson household was an intellectual oasis in Augusta, South Carolina, where Woodrow grew up. Under his father's tutelage, he became an eloquent speaker and disciplined literary stylist who ruthlessly pruned away any passages that lapsed into the florid rhetorical style then fashionable among politicians and preachers alike.

Though he briefly attended Davidson College, a small Presbyterian institution in North Carolina, Wilson never seriously contemplated the cleric's life. After graduation from Princeton and a fizzled experiment in legal practice, he enrolled in The Johns Hopkins University, set on an academic career. His first job was teaching young women at Bryn Mawr College outside of Philadelphia. He and and his wife Ellen, pregnant with their first child, rented a small frame cottage. Situated between the "Deanery," home of the Dean, and a house called the Greenery, the Wilsons called it the "Betweenery."

Ellen shelved her ambition to become an artist in order to marry Woodrow. It was a strong and loving, if at times tempestuous, partnership.

When Ellen Axson's mother and father (yet another Southern Presbyterian minister) died, leaving behind three children younger than Ellen, she knew the charming love nest would have to go. With her small inheritance she rented an eleven-room parsonage in the woods; shortly a brother and sister moved in. For the next twenty years the Wilsons' would be an extended family. Whenever Woodrow and Ellen took up residence in a new place, a shifting cast of temporarily displaced relatives moved with them.

Woodrow adored his wife, whom he believed more gifted than he. To constantly subject his work to her scrutiny, "with its *insight*," was ever humbling, he told her. "My defense is that you are a woman, and loyal beyond words!" Ellen was studying painting in New York when Woodrow proposed. She loved him passionately almost from the moment they met, and swiftly supplanted her career with his. Her artistic impulses found outlet in the decoration and later the design of their homes.

Exasperated by the Bryn Mawr students' "painful absenteeism of mind" (he marveled that the "incomparable" Ellen had been born female), Woodrow moved on to Wesleyan University. There he found the (male) students even worse prepared, a lack he attributed to "narrow circumstances" breeding "narrow thought." He lasted two years, joining the Princeton faculty in the fall of 1890.

A close-knit community of 600 students and forty-three professors, equidistant from New York and Philadelphia in a quaint village of 3,400 souls, Princeton was the ideal incubator for Woodrow's political views. He proved a versatile and entertaining lecturer, intent on capturing the "spirit" of an age, if occasionally at the expense of fact. Students packed his courses. His popularity bought him increasing influence in matters of policy. Wilson believed that if Princeton were purged of its snobbish pretensions and narrow Presbyterianism, it might one day become a truly great university. Without altogether realizing it, he was laying the groundwork for his appointment as Princeton's next president.

In 1891, Ellen and Woodrow paid $3,000 for a large wooded lot on Library Place (now Washington Road). Having lived in all manner of homes, hotels, and apartments over the past decade, and having raised three daughters and assorted surrogate children, the Wilsons were ready to put down roots. Library Place was their dream house. The untimely demise of her brother-in-law, George Howe, firmed Ellen's resolve that the house would be large—large enough to accommodate Woodrow's widowed sister, Annie, and her three children.

Ellen drew her inspiration for the eleven-room house from a book of architectural plans she found in the Princeton library. Edward Southwick Child of the New York firm of Child & de Goll reworked her drawings for a two-story, half-timbered Tudor house, and sent them out for bids. Wilson was outraged when the bids came in

higher than expected. What's more, he was offended that a Princeton trustee who had agreed to finance construction offered less than generous terms, and furious with himself for having miscalculated the interest payment. Wilson put the house on hold and steeled himself for his wife's disappointment. Her magnanimity—Ellen was dismayed that he feared she lacked "the sense and self-possession" to accept the postponement—only spurred him on to greater efforts to get Ellen her house. He tabled two scholarly works. Promising to write solely for money now, he cautioned his wife that she would not be well "served" in the long run if striving for material things should finally kill him.

Then a friend jubilantly announced that he had persuaded the tight-fisted trustee to improve the terms: "You may soon have a home in which you may live to end your days in Princeton for we could never spare you from the old town." Wilson was not so magnanimous as his wife. Displaying the prideful anger that would mar his stewardship of Princeton and later of the United States, he rejected the compromise and secured a $7,000 mortgage from the Mutual Insurance Company of New York.

Ellen had sacrificed a back staircase, a bay window in the sitting room, a terrace, and a wide overhang in the back of the house, but had saved the basic floor plan, including an overhanging upper story and full basement. The unfinished third floor was reserved for storage and future bedrooms. The house came in over budget, at almost $14,000, but Wilson overruled Ellen's argument that they again postpone construction. He put himself on the lecture circuit and contracted with *Harper's* magazine to write six essays on the life of George Washington.

Ground was broken in June 1895, sending Woodrow off to Baltimore to lecture at Johns Hopkins. Ellen kept him apprised of every detail. Apart from a "rather ugly

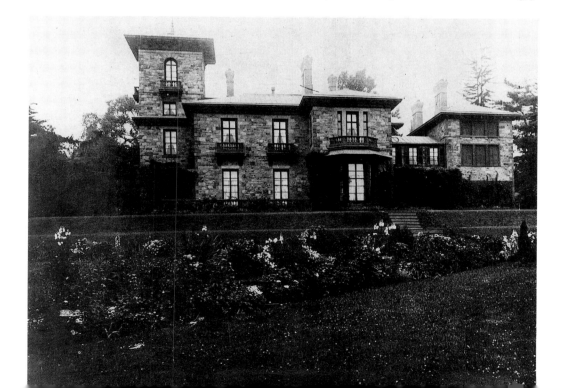

At Prospect, the Florentine mansion that housed Princeton University presidents, Ellen declared war on high Victorian decoration—and Woodrow declared Ellen's garden "one of the most beautiful" in town.

and queer-looking" staircase post, designed by Child, the house was "getting to look so elegant that it is hard to believe it is really ours," she enthused in February. It was harder still to believe that it would ever be finished, what with the delays: "The mill-man has...an appointment with the architect...to see about the storm doors. They haven't been made and the man doesn't understand about them. I regret to say that your window-seat is not made either." Construction costs climbed.

In March, Ellen hired ten burly movers and handed each a sketch showing the arrangement of furniture in every room. The move was accomplished in a single day. That evening Joseph Wilson, ill and irascible at nearly eighty, called the family together to dedicate the new house, which he had helped pay for and where he planned to die.

The old man was sitting in a barbershop on Nassau Street when he learned that his son would be Princeton's next president. He hurried home and and instructed Wilson's three daughters never to forget that "your father is the greatest man I have ever known."

Ellen mourned the loss of their "dear home and sweet, almost ideal life." But she was soon working full-time on plans to redecorate the president's mansion, Prospect. "I know so exactly what I want," she told her husband, "that if Mr. Holmes [a Philadelphia decorator] doesn't agree with me,—so much the worse for Mr. Holmes!"

The Florentine-style mansion stood on land donated to the college for its first building, which Prospect replaced in 1849. Designed by Philadelphia architect John Notman, it had housed Princeton presidents since 1878. Visitors passed through the porte cochere into a two-story vestibule, ringed by an iron and brass balustrade on the upstairs level. Sunlight filtered through a pale stained glass skylight set in a dome. French doors opened onto a back terrace from both the drawing and dining rooms, which shared the first floor with a large study for Woodrow, a cozy sitting room for Ellen, and a library. The third floor "tower," surrounded on three sides with windows, was Wilson's private sanctum.

Ellen vowed to erase every vestige of high Victoriana, which she loathed. She shopped for antiques in Boston, Philadelphia, and New York, purchasing a new dining table and chairs, and drawing room chairs covered in rose brocade. "I have one ambition about all this," she wrote. "I think that life can be made beautiful without being expensive." Ever resourceful, Ellen took to prospecting for treasures in the mansion's commodious basement. One day she struck gold—in a dank corner, veiled in shadows and spider webs, were stashed several lovely marble mantels and carved cornices. Banished to the basement during the reign of the Victorians, these

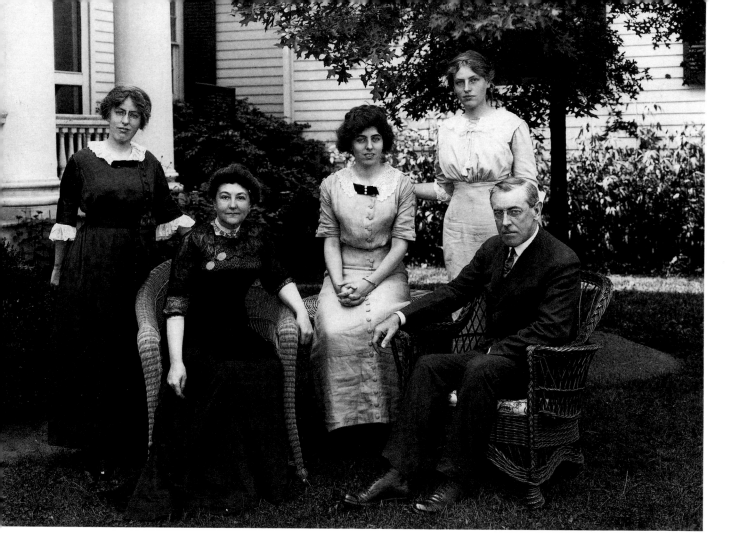

Ellen, Woodrow, and their three daughters at home.

were cleaned and restored to their former stations.

Next Ellen ventured into the garden. Here she eschewed formality, replacing a stiff geometric design with masses of white, pink and yellow tulips, daffodils, irises, peonies, and dahlias. Narrow paths led to a pool with a fountain, in the center of the garden. She selected a sunny spot for her roses and nearby erected a long pergola for rose vines. Purple wisteria climbed the iron grillwork along the small southern porch.

Woodrow pronounced the garden "one of the most beautiful" in Princeton. It sustained Ellen as the demands of family and her husband's position grew nearly insupportable. The Wilsons had not been in Prospect more than a month when their youngest daughter happened to pass by her parents' room on the way to bed. Through the half-opened door she saw Ellen crying, Woodrow stroking her hair. "I should never have brought you here, darling," he said. "We were so happy in our own home."

Wilson's turbulent tenure ended in his resignation after the trustees vetoed his proposals for a radical reorganization of campus housing. When Woodrow was elected

Wealthy friends bought a townhouse on S Street (opposite page) for Woodrow and Edith, his second wife. Here in the library (above), surrounded by his vast collection of books, the former president had hoped to write his magnum opus. It was not to be.

governor of New Jersey in 1910, rumors of a romantic attachment to a New York divorcee hit the newspapers. The affair cooled, and the customary flood of love letters between Woodrow and and his wife resumed, but Ellen never wholly forgave him. Through it all, she fretted over his chronic poor health, ignoring her own. Scarcely had the family settled into the governor's mansion than Woodrow was again on the campaign trail. In 1913 the Wilsons moved into the White House.

Ill and exhausted, Ellen confined her decoration to the living quarters, brightening the gloomy central passageway and completing renovation of several third floor bedrooms, a project begun by the Tafts. "Everything is going wonderfully well with us and we, in health, are all very well,—considering the heavy strain," she wrote a friend soon after the inauguration. Buoyed by economic prosperity and enthusiasm for his "New Freedom" reforms, Wilson enjoyed a productive first year in office. The honeymoon soon ended. As war raged in Europe, Wilson struggled to maintain neutrality but pressure mounted to join Britain against the Germans. The only alternative was to propose a peace settlement. Wilson's emissary to Berlin was coldly rebuffed.

Ellen did not live to see her husband send American troops abroad. She grew weaker and more distant. Just weeks before she died, in 1914, her doctor finally diagnosed her condition as Bright's disease.

Wilson was staggered by the loss of his devoted Ellen, mentally and physically. His health had never been robust; strokes had left him blind in one eye and perma-

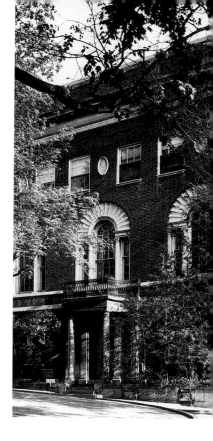

nently weakened his right hand and left side. As if by divine intervention (Wilson had no doubt that it was), the president met Edith Bolling Galt, the woman who would become his second wife. Instantly smitten, he wooed the stylish widow with a vengeance. Two days after the sinking of the *Lusitania* (the catastrophe did not divert him from his amorous attentions to Mrs. Galt), he wrote, "I need you as a boy needs his sweetheart and a strong man his helpmate and heart's comrade. Do not doubt the blessed fact. And when you have accepted that, God grant you may see your way to my side.... For I love *you*, not myself!"

They were married in December of 1915. Another disaster at sea cut their wedding trip short. Resigned to war with the Germans, Wilson took on both the pacifists and the war-mongers in the name of "preparedness." In Woodrow's, and now Edith's, bedroom, the double bed he and Ellen had shared was replaced by Lincoln's—eight feet long and canopied.

Wilson's marital bliss was short-lived. The next four years would see the White House turned into a bunker, as the president battled both his deteriorating health and the isolationist Lodge, who masterfully and maliciously dismantled the Wilson plan for world peace. Wilson refused to compromise. His blind obsession with the League turned first the Congress, then the country against the ailing president. Though his efforts would win him two Nobel Prizes, Wilson unwittingly set the stage for a conflagration more devastating even than "the war to end all wars," and delivered the White House to the Republicans.

Wilson's single remaining ambition was to write "The Philosophy of Government," the magnum opus shelved at Princeton. After looking at houses in New York and Philadelphia, the Wilsons chose to stay in Washington, near their good friends and the Library of Congress. Ten of those friends chipped in $10,000 apiece to buy them a red brick townhouse on S Street. There was ample room for an elevator and for Woodrow's thousands of books. From the simple first-floor entry rose a grand staircase, set off by a large Palladian window at the landing. Following Scottish custom, Woodrow presented Edith with a small piece of sod from the garden and a key to the front door. She found the Georgian Revival house "unpretentious, comfortable, dignified."

Here, until he died, Wilson received prominent visitors—including Georges Clemenceau and David Lloyd George. He spent mornings in his library, though sadly his magnum opus never advanced beyond the dedication to Edith. Later in the day he went for a drive, waving at well-wishers delighted to have a glimpse of a former president. The man who hated motor cars was now a touring enthusiast. Until his death in January 1923, his afternoon drives with Edith were Woodrow Wilson's greatest pleasure.

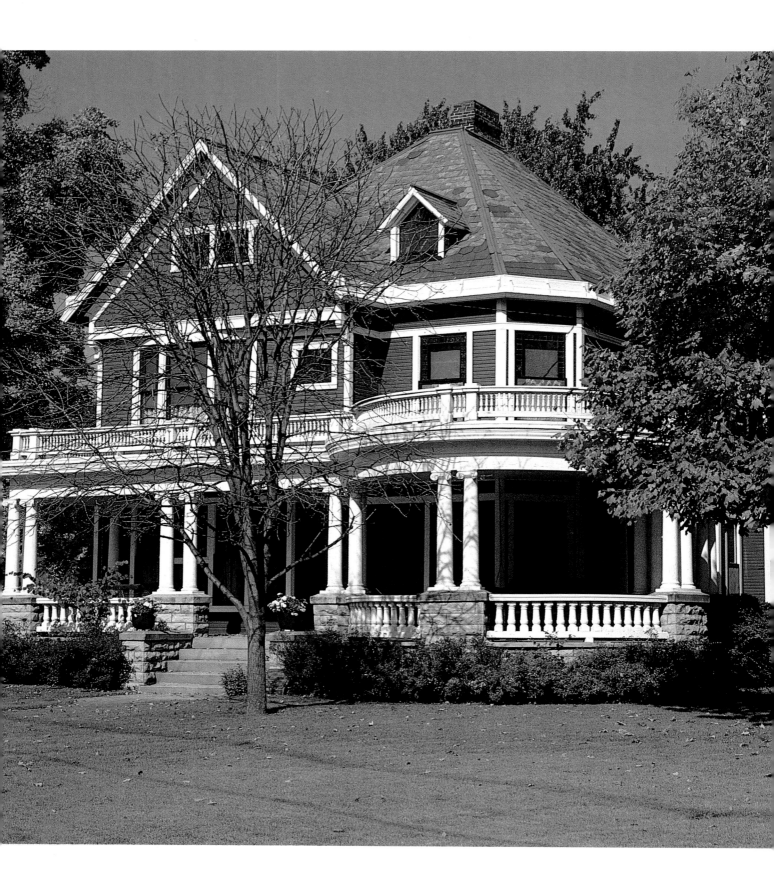

Warren G. Harding, Calvin Coolidge

WARREN G. HARDING HAD NOT SOUGHT the presidency, believing himself unfit. But destiny and the Republican machine singled him out. Flattered, he responded to the call, perhaps believing that destiny would tell him what to do next.

"The presidency is an easy job!" he happily informed his aides a few weeks after the inaugural. Yet within months Harding was deeply mired in issues crying out for a strong hand—and Judson Welliver, his personal secretary, was deeply worried. William Allen White recorded his portrayal of a floundering president:

"Jud, you have a college education, haven't you? I don't know what to do or where to turn in this taxation matter. Somewhere there must be a book that tells about it, where I could go to straighten it out in my mind. But I don't know where that book is, and maybe I couldn't read it if I found it!...My God, this is a hell of a place for a man like me to be...."

The president wouldn't find that book on taxation in his library back home in Marion, Ohio. Harding had stuffed the small alcove at the rear of his parlor with the collected works of Hawthorne, Bulwer-Lytton, Ruskin, and the Ancient Greeks from Herodotus to Homer, as well as multi-volume encyclopedias and fat historical tomes purchased from book salesmen who recognized a soft touch. In a tall mahogany bookcase with swinging doors and on portable shelves with leaded glass fronts, the president's books sat, impressive and undisturbed. Harding did not read books; he collected them.

He did read newspapers. Harding's principal achievement before entering politics was making a profitable enterprise out of the bankrupt Marion *Star*. It was a decent if not a brilliant newspaper under Harding's stewardship, and decidedly better than average after the publisher shifted the editorial responsibility to an experienced editor.

Harding often said that he chose politics because it was easier than newspaper work. A handsome man and an effective speaker, he rose swiftly from convention delegate to U.S. Senator to presidential candidate. America wants a "solid, mediocre"

Warren Harding and his wife, Florence, designed their home in Marion, Ohio. The front porch had to be enlarged after collapsing under the weight of well-wishers during his first Senate race. It served Harding well in the campaign of 1920.

man in the White House, one supporter explained, with "sound and careful judgment and good manners." America wanted whatever it believed that Woodrow Wilson was not. The Armistice had brought neither peace nor prosperity, but strikes, inflation, and price controls. America blamed the incumbent.

Harding preached the politics of harmony and compromise; appropriately, he became known among the Republican delegates who came to Chicago in 1920 as "the available man." He was the only man who could break the deadlock that froze the convention, in spite of a blistering heat wave. Having launched the immortal line about the president "made at 2 a.m. in a smoke-filled room," Harding's chief strategist Harry Daugherty ordered his charge not to move off his front porch for the duration of the campaign. Mrs. Harding was delighted.

Why he ever married Florence Kling is another of the mysteries that shroud the memory of Warren G. Harding. She was several years older than he, and no beauty. Edith Wilson described her as a painted crone who talked incessantly. She often boasted that she had "made" Warren Harding. No doubt she was a formidable pursuer; perhaps her father's wealth and prominence in Marion persuaded Harding not to resist. Amos Kling, for his part, never cared for the good-natured newspaper publisher. When Warren first announced his political ambitions, Kling tried to snuff them out with a smear campaign based on the preposterous yet durable rumor that his son-in-law was a black man.

Warren Gamaliel Harding was born on a farm in Blooming Grove, Ohio, in the final year of the Civil War. His father, Tryon, piled the family belongings aboard a hayrack and moved to nearby Caledonia when Warren was eight. The Hardings lived in a yellow-brown frame house with gingerbread trimmings. Tryon took up the practice of medicine. He was a restless man, a dreamer and a gambler, whose fortunes were prone to sudden swings. Warren's mother, Phoebe, turned to the church for solace and support. Tryon turned to his son, and as long as he lived Harding helped his father through financial crises.

When his parents moved a third time, Warren followed. He had just graduated from Iberia college. In the summer of 1882, he mounted a mule and rode to Marion, a small but thriving manufacturing town.

Warren and the Duchess, as he called Florence, were married in 1891, in the front hall of the Marion home they designed themselves. For all its Victorian bric-a-brac and scalloped shingles, the green clapboard structure tended to take after its mistress. Mounted on yellow stone blocks and shaded by maples, the house was somber outside, gloomy within. Sunlight, filtered through stained glass windows, cast an

amber glow over oak balustrades, arches, mouldings, bookcases, and furniture. Even the toilet seat was oak. A generously shaded lamp illuminated the front hall; upon its base a boy in colonial garb presented a nosegay to his beloved.

The original front porch collapsed under the weight of well-wishers on the eve of Harding's election to the Senate. Its replacement ran the full length of the house, supported by Ionic columns. A bulge at one corner formed a natural speaking platform. Here the candidate enjoyed the most relaxing presidential campaign since McKinley's. The McKinley flagpole was uprooted and shipped from Canton to Marion, for replanting in Harding's front yard. On Notification Day Marion's population swelled from 28,000 to 150,000. Civic pride burgeoned right along with it, as evidenced by the eagle-mounted pillars set twenty feet apart along both sides of the route from the Union Depot to the Harding home. The Marion Civic Association paid for the mile-long "Victory Way," the arches of flags at every intersection, the acres of bunting, and the blow-up Harding photographs in every window.

From his very ordinary front porch this very ordinary man spoke convincingly of "normalcy," and won a resounding victory over the Democrat James Cox. Borrowing once again from McKinley and Hanna, Harding and the indispensable Harry Daugherty, whom Harding appointed attorney general, set a course they called "safe and sound." The president surrounded himself with distinguished advisors, including Herbert Hoover, Andrew Mellon, and Charles Evans Hughes, and gave them full control over their departments. "Best Minds, Inc.," he called his cabinet. He presided over a strong economic rebound from the postwar recession, cut government expenditures almost in half, and created the Bureau of the Budget, under the Budget and Accounting Act of 1921. Beloved by business, Harding endeared himself to working men as well when he released Socialist leader Eugene V. Debs from prison on Christmas Eve in 1921. "I want him to eat Christmas dinner with his wife," the president said.

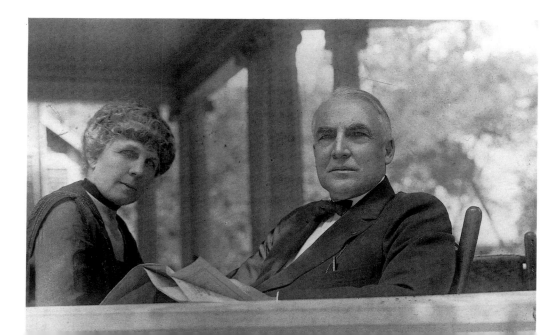

Harding always called his wife "the Duchess." Florence once said that she "made" Warren Harding.

Harding's enthusiasm for such simple pleasures was his most appealing trait. He loved rich food and strong whisky. Golf and gambling were his passions. On poker night at the White House, "the air [in Harding's White House study was] heavy with tobacco smoke," Alice Roosevelt Longworth wrote in her 1933 memoir *Crowded Hours*. "Trays with bottles containing every imaginable brand of whisky stood about, cards and poker chips ready at hand—a general atmosphere of waistcoat unbuttoned, feet on the desk and the spittoon alongside.... Harding was not a bad man. He was just a slob."

When he wasn't partying with his cronies, the president penned love poems to pretty women. One of these, a girl from back home whom Harding entertained regularly in the Oval Office, gave birth to his only child. He kept her silent with gifts of money and talk of marriage once he got out of this present fix. Another, miffed at Harding for supporting war with the Germans, whom she loved more than he, on the eve of Harding's nomination spilled the details of her dalliance to her husband, Harding's close friend and frequent traveling companion. The friend was bought off with a world cruise, but that did not prevent his wife from dropping by campaign headquarters from time to time. A mutual acquaintance described one such visit. Harding was sitting on the porch, his lover lurking behind a nearby maple. Suddenly "a feather duster came sailing out [of the Harding house]...then a wastebasket.... Next came a piano stool.... Not until then was there a retreat. She tossed him a kiss and left quietly.... Her face was especially attractive in contrast to that of Mrs. Harding."

In 1923, following shocking charges of graft within the administration, the resignation in disgrace of Veterans Bureau chief Charles Forbes, and the suicides of two subordinates, Harding admitted to William Allen White what he had himself suspected all along. The job was too much for him. It had become a nightmare. "I can take my enemies," he told White, "but my damn friends, my God-damned friends, White, they're the ones that keep me walking the floors nights." Paralyzed by indecision the president fled. The first order of business, he decided, was to win a second term.

He was spared the gory details of his fall from grace; Harding died on the campaign trail. Rumors of foul play, as usual, fogged the event. The president's personal physician blamed cerebral hemorrhage. Other doctors disagreed. The Duchess refused to allow an autopsy.

Before he left, Harding had written to his aunt that he had purchased the family homestead in Blooming Grove. "My one dream is to restore the old houses of your father and great-grandfather Harding. I think they can be restored as they were on the exterior and made modern on the interior, and be combined into a very attractive

group of farmhouses.... The addition of the Finney Farm was made in the hope of acquiring...ground along the road for a sufficient distance to provide a nine-hole golf course."

It was a humble ambition, for a president. Sadly, the "one dream" that sustained him during his darkest hours never came true.

"Father, you are still a notary?"
"Yes, Cal."
"Then I want you to administer the oath."

Vice President Roosevelt had been whisked from a mountain peak following McKinley's assassination in 1901. The Vermont homestead where Calvin Coolidge received the tragic news of Harding's death was almost as remote. In a daring bit of drama worthy of the Rough Rider, the vice president chose to take the oath of office in his father's house, the house he was born in. After the sordid oil-lease revelations of previous months, the notion of a president being sworn in by his father, in the light of a kerosene lamp, seemed innocent and touching—even inspiring.

Coolidge and his wife, Grace, had arrived in Plymouth Notch the day before: August 1, 1923. They planned a month-long respite from the heat of Washington, and from the press of social engagements, which Calvin loathed. Mindless chatter numbed his spirit and seemed to freeze his vocal cords as well, while the rich food had the opposite effect. He had always been a finicky eater; chronic indigestion raged ceaselessly in his innards.

Otherwise, he had no complaints. He had been in politics most of his life, waged dozens of campaigns, lost only twice. From city solicitor of Northampton, Massachusetts, he advanced to mayor, then to state representative, then to lieutenant governor. As governor he achieved national renown after refusing to be cowed when a police strike turned Boston into a war zone. "There is no right to strike against the public safety by anybody, anywhere, any time," he wrote to Samuel Gompers as riots, fires, and looting paralyzed the city. That celebrated sentence effectively ended the Boston Police Strike, and swept Calvin Coolidge into the race for the presidential nomination in 1920. It was a crowded field; he settled for second place on the Republican ticket.

After three years in Washington, Coolidge was plainly delighted to be back home in Plymouth Notch for a visit. While Grace busied herself raking leaves in the front yard, the vice president applied his father's sledgehammer to a maple tree that was splitting at the trunk. Then he was off to a neighboring farm to help put up hay for the winter.

In its heyday, the Notch boasted a church, a store, a schoolhouse, a cemetery, and seven farmhouses. Among these the Coolidge place was unremarkable: one-and-a-half stories, three bedrooms, a large kitchen, a parlor and a dining room, used only for special occasions. Amenities were simple and precious few: heat came from the wood-burning stove, light for reading from kerosene lamps, water from the hand-pump outside. There was no plumbing. Calvin's father, twice widowed, shared the house with his housekeeper and cook, Aurora Pierce. The elderly spinster was the only woman on earth who knew how to cook pies and stews to Calvin's liking. Aurora kept the old place spotless, and just as it was when Calvin was a boy. The clapboard gleamed with a fresh coat of whitewash. The geraniums, brilliant red and abundant, were the same geraniums that had come out of the basement every spring for thirteen years.

"Vermont is my birthright," Coolidge once said. "Here one gets close to nature, in the mountains, in the brooks, the waters of which hurry to the sea; in the lakes, shining like silver in their green setting; fields tilled, not by machinery, but by the brain and hand of man. My folks are happy and contented. They belong to themselves, live within their incomes, and fear no man."

Ordinarily, Calvin Coolidge did not wax poetic. Most people knew him as Silent Cal. Admirers saw exceptional character and sagacity in his reticence, and compared him to Lincoln. His critics thought him shallow, selfish, and unimaginative. He described himself as a simple man who liked to take the precise measure of people and events, and act accordingly. Among the old-fashioned virtues he prized, two stood at the top of the list: brevity and thrift. He was a hard worker, but a better manager. He squandered neither time nor money, except if he happened to pass a shop-window in which women's hats were displayed.

Calvin's own clothes were uniformly plain, though crisply tailored and always immaculate, but he had a weakness for hats of all kinds, especially women's picture hats, the more elaborate the better. Even after becoming president, he often accompanied his wife on shopping trips. Coolidge loved to see her in bright colors, fringes,

Calvin and his two sons pitch hay to Calvin's father, John, at the Coolidge home in Plymouth Notch.

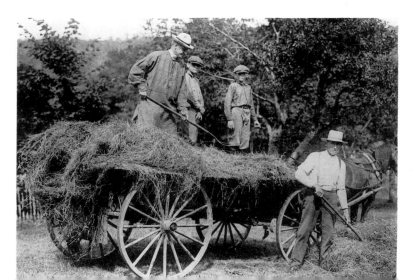

paillettes, buttons and bows. Once he brought home a black velvet gown with crimson streamers running from neck to hem. Grace called for the dressmaker. "What do you think of this that the president has sent up for me to see?" she asked. "It wouldn't be bad without these," the dressmaker replied, pinning the streamers out of sight. "Oh, but that's what he likes about it," the First Lady protested. "That is why it took his eye."

Coolidge confined his extravagance to his wife's wardrobe. He was otherwise a notorious tightwad. His penny-pinching might have driven Grace mad if it hadn't been such fun to tease him about it. The Coolidges returned early from their planned two-week honeymoon in Montreal when Calvin found the prospect of seven more days of pointless expenditure more than he could bear. "In accordance with the procedure commonly accepted as becoming a bride," Grace would sit in the bay window of their tiny house in Northampton waiting for her husband's return from work. One day he showed up toting a large leather bag. It contained a wedding gift, he told her. Another hat? Calvin upended the bag and out flowed a torrent of socks, all in need of repair. Grace hastily began to gather them up, whereupon her husband informed her that she needn't count them; he had managed to stuff fifty-two pairs into the bag, he said, and would bring the rest when she had finished with these.

Grace and Calvin were well-suited, though opposite in nearly every respect. She was gregarious and fun-loving, he moody and misanthropic. She loved sports, theater, and parties; he found all forms of entertainment a bore, and exercise a particular waste unless it accomplished some useful task. She was a casual, though never reluctant, housekeeper; he had a passion for order. They were bound together by humor. He knew his eccentricities, and was often the target of his own understated jests, delivered with such gravity that they often escaped everyone but Grace.

It was late evening when the Coolidge's chauffeur brought word to Plymouth Notch that President Harding was dead. The vice president had retired early. An enthusiastic sleeper, Coolidge was always in bed by ten. John ("the Colonel") Coolidge, on the other hand, never slept well. When he heard a car pull up outside he rose from his bed and went to the door. His voice trembled as he called upstairs to wake his son.

Calvin dressed carefully, then knelt with Grace to pray. Downstairs the small dining room was filling up with people, among them Congressman Porter Dale, a close friend. He urged Coolidge to take the oath at once. The Colonel, it seemed, was qualified to administer it. Calvin's father grabbed his mug from the bedroom shelf and vanished into the kitchen to shave, while the vice president huddled with his

Lovely, cheerful Grace Coolidge was her husband's alter ego. Never had Washington society basked in such a smile as hers.

stenographer in the parlor, dictating messages to Mrs. Harding and then to the American people. "Reports have reached me, which I fear are correct, that President Harding is gone. The world has lost a great and good man. I mourn his loss. He was my Chief and friend...."

Grace, weeping quietly, prepared the dining room for the swearing-in ceremony. It was the central room in the house and, at seventeen by fourteen feet, the largest. The staircase was at one end, opposite three bay windows and a door that opened onto the front porch. With its low ceiling and faded wallpaper of embossed gilt, now lit by two kerosene lamps, the room was properly formal and grave. For Calvin it was filled to overflowing with memories. He could still imagine his mother, a victim of tuberculosis when he was a boy, reclining on the horsehair settee. He carried a picture of her with him all his life. His sister had died in this room and then his stepmother. A red tablecloth covered the large dining table. A piano, a wood stove, and two high-backed rockers cast their shadows on the walls. The Colonel brought out the family Bible—it had belonged to Calvin's mother—and instructed his son to repeat after him the oath of office. Then he sent the president back to bed and retired to his own room, where he sat, untroubled by fatigue, until dawn.

Three challenges loomed large before Coolidge. Of these the oil scandal was the most urgent, and would dictate to a degree the success of the other two: his first presidential message to Congress, and his own candidacy in 1924. He moved quickly and without fanfare. The investigators did their work, and by the end of 1924 Coolidge had asked for and received the resignations of Daugherty and the others involved. His message to Congress was characteristically spare and to the point, a refreshing change from the baroque style of his predecessor; popular support for Coolidge swelled as editorials praised the new president. The economy was equally cooperative. At the Republican convention Coolidge asked for and received the nomination.

"The chief business of the American people is business," Coolidge once said. Throughout his presidency he held to that conviction. As the economy grew, evincing an insatiable appetite for credit, Coolidge kept his hands folded, his mouth closed. Silent Cal certainly had no inkling of the impending disaster, but just as his laissez-faire philosophy was credited during his presidency with unprecedented prosperity, so inevitably would it be blamed when "the gaudiest spending spree in history," as Scott Fitzgerald called the Twenties, came to a cataclysmic halt in 1929.

While Americans enjoyed their spree, the president applied to government a spending style that he personally preferred. "Economy is idealism in its most practical form," he said in his inaugural in 1924. He began at home, scrutinizing every bill that crossed the White House threshold. He once wrangled fiercely with the kitchen staff

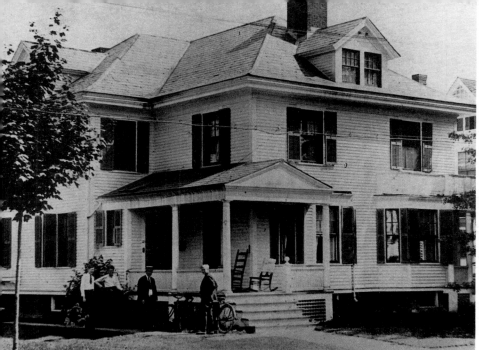

over the number of hams required to feed sixty guests. Mrs. Elizabeth Jaffray, house-keeper to several presidents, had ordered six. When Coolidge protested, she explained that the hams were small. He remained unconvinced: "Six hams still looks like an awful lot to me." The redoubtable Mrs. Jaffray was discharged two months later.

Coolidge relished these domestic entertainments; they amused him, and aroused his penchant for practical jokes. On one occasion his staff responded to a sudden din of alarms from the Oval Office, only to find it unoccupied, or so they thought until the president, unable to stifle a giggle, revealed his hiding place under his enormous desk.

The death of his son abruptly ended all frivolity. The boy had been playing tennis without socks, and a blister became infected, poisoning his blood. "When he went the power and the glory of the presidency went with him...I don't know why such a price was exacted for occupying the White House," Coolidge wrote in his *Autobiography*. The Colonel had died just weeks before. Both tragedies no doubt figured in Coolidge's decision to leave office after a single term. He made the announcement while vacationing in the Black Hills, handing reporters slips of paper on which were typed the words: "I do not choose to run for president in 1928."

Calvin and Grace retired first to the cozy duplex at 21 Massasoit Street where the boys, John and Calvin, had grown up. It was their second home in Northampton, rented when Grace became pregnant with John. Simple but charming in the classic New England style, the house had tall bay windows in front, and a small screened porch where Calvin loved to sit until the inevitable parade of curiosity-seekers drove him indoors. There were three bedrooms upstairs and a single bath; on the first floor a dining room, kitchen, and parlor furnished with a couch Grace's father had built

The Coolidge home on Massasoit Street in Northampton, Massachusetts. They retired to the cozy duplex in 1929. Calvin enjoyed the porch when tourists weren't gawking at him.

177

for them and Calvin's Morris chair. Watercolors hung on the walls, and over the mantelpiece a framed quotation:

A wise old owl sat on an oak,
The more he saw, the less he spoke;
The less he spoke, the more he heard.
Why can't we be like that old bird?

For their half of the duplex they paid $28 monthly the first year; by the time Calvin was elected governor the rent had climbed to $40. Though they never owned the house, 21 Massasoit Street was always home to Mrs. Coolidge. Throughout her husband's career in state politics—even after he became governor—he had lived in a hotel room during the week, commuting to Northampton on weekends.

By 1930, both Coolidges yearned for privacy and space. They found it in The Beeches. Built for Dr. Henry Noble MacCracken while he was a professor at Smith College, the estate sprawled over eight acres of land whose magnificent trees shielded the big shingled mansion from the road. Dr. MacCracken sold the house upon his appointment as president of Vassar College. It had tennis courts, a swimming pool, and, best of all, iron gates at the entrance flanked by stone pillars. Coolidge added a privacy fence.

To Calvin Coolidge, home never ceased to mean Plymouth Notch, and within two years of buying his country estate in Northampton, he was hard at work on plans to expand his father's house. There would be a large living room, a high porch to one side, windows all around, plumbing fixtures from Sears, Roebuck. "As he grows older I think he will turn more and more to these peaceful hills," Grace wrote. "It is in the Coolidge blood."

One month before his death the following winter, he confided to an old friend and newspaperman his profound unrest. The devastating economic depression mirrored the former president's own state of mind. "I feel I no longer fit in with these times," he said. "We are in a new era to which I do not belong, and it would not be possible for me to adjust myself to it." To Grace, too, he confessed his bewilderment. "I do not know what is going to become of us....If I had pursued other courses from those which I did follow results might have been different."

Aurora Pierce lived on at the Coolidge house in Plymouth Notch until her death in 1956. The Colonel's housekeeper had missed the famous swearing-in ceremony, being fast asleep at the time, but was greatly annoyed to read the newspaper account of it and to see her kerosene lamps described as "greasy." Old and worn they may have been, but Miss Pierce cleaned them herself every day.

In 1930 the Coolidges sought privacy and found it at the Beeches. Sadly, Calvin never did recover his peace of mind.

Mobile Homes

Herbert Hoover, Franklin Delano Roosevelt

ON FEBRUARY 10, 1899, LOU HENRY MARRIED Herbert Hoover and sailed with him to China. They settled in Tientsin, a city of half a million people sixty miles southeast of Peking. Summer came swift and steamy to the northern provinces. One particularly warm afternoon in June, Lou took her Chinese grammar book into the garden, spreading a blanket in the shade of the elegant blue-brick house she shared with her husband, a mining engineer, and an extended family of servants. Her eyes pored over the delicate characters. Her mind wandered.

There were fifteen servants in all, if one counted the gardener, the ricksha messenger boys, and the cook, who took his pay from whatever profits he could "squeeze" out of the daily food allowance. Lou would have enjoyed poking about in the market for exotic ingredients, but she bowed to local custom. The squeeze method was rampant in China and probably very evil. But at least the cook displayed some initiative, rare among these strange people whose "utter apathy to everything," Lou had written to a friend, was "heartbreaking to an energetic Yankee."

It was not a surplus of servants that drove Lou into the garden, but a sinus infection. Her doctor prescribed rest. How she longed to be back where she belonged, with her husband, roaming the countryside on the back of a Manchurian pony, camping out under the stars on a mattress of plaited grass. Herbert's position entitled him to travel by sedan chair but both he and Lou, an expert horsewoman, preferred a humbler conveyance. Their caravan was elaborate, nonetheless. Whether scouring the Chinese landscape for mine sites or merely sightseeing, the Hoovers always brought along "the necessary multitudes of servants." Bands of thieves were a constant hazard. The servants rode ahead, acting as armed guards.

Lou closed her book—sometimes she wondered if it was Chinese syntax that made her head hurt, not her sinuses at all—and gazed with pleasure at her new home. It was of Western design. A formal raised veranda graced the front entrance, with broad stairways at either end. Huge arched windows upstairs and down filled every room with sunlight. The flat tile roof reminded Lou of the old Spanish villas in

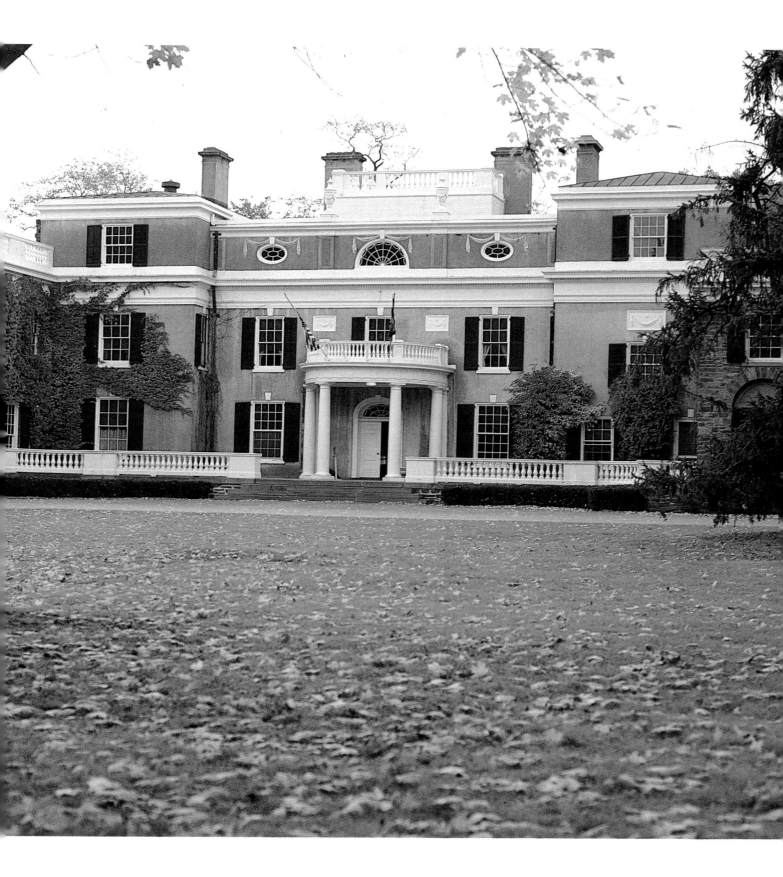

Hoover's birthplace in West Branch, Iowa, measured 20 by 14 feet. Jesse Hoover built his smithy across the alley.

Overleaf: Franklin Roosevelt was born and buried in Hyde Park, New York.

Monterey, California, her home town, and of the wondrous turn her life had taken since Herbert cabled his marriage proposal from a mining camp in Australia.

Both were born in 1874, into peripatetic families who ventured westward over two centuries. The mid-1800s found the Hoovers and the Henrys at about the midpoint in their odyssey. A Quaker newspaper called the immigration into Iowa "astonishing. For miles and miles, day after day, the prairies of Illinois are lined with cattle and wagons, pushing on towards this prosperous state." Charles Henry settled in Waterloo, a Quaker farm town, but his wife's poor health forced him to move the family to California when Lou was ten. Herbert's father, Jesse, traveled by riverboat and covered wagon from Ohio to the Quaker village of West Branch.

Fun-loving and ambitious, with a talent for fixing things, Jesse Hoover married a former schoolteacher renowned for her piety. For $90 he and Hulda bought a small lot beside a creek, and built a two-room cottage across the alley from his blacksmith shop. He and his father dug the foundation. It measured fourteen by twenty feet. Jesse nailed up the wagonload of timbers shipped to West Branch on the rail line that went in that same year, 1870. One room was for cooking and socializing; in the other, the Hoovers' bedroom, Hulda gave birth to three children.

West Branch had 502 inhabitants the year Herbert was born. Jesse opened a store and put the cottage and smithy up for sale. He added farm implements to his inventory, a few of his own invention such as barbed wire made "rust-resistant" by a coat of tar—and from the local minister received a stern reminder that in his pursuit of worldly goods he must not neglect his calling to God. Hulda more than made up for Jesse's spiritual shortcomings. Her pupils recalled that she taught the three R's "to the tune of hymns."

The Hoovers' moved to a frame house just down the street from the cottage. It had two stories and four rooms. Maple trees enclosed the front yard, which together with the back added up to a full acre boasting a crab apple tree, a garden, a potato vine, and a barn.

Eighteen months later Jesse was dead. He left his wife a $1,000 life insurance policy and a mountain of debts. She worked as a seamstress to pay them off, and for the next four years Herbert and his older brother enjoyed all the amenities of a wholesome childhood. They climbed trees, swam and fished in the creek that ran by the house. They also learned "at the earliest and most impressionable age...the meaning of poverty from actual experience," Herbert later wrote. In 1884 Hulda Hoover died of typhoid fever and pneumonia.

Herbert seldom spoke of the lonely years after the children were separated. "When I was 7 I was removed by relatives on my mother's side to Oregon," he wrote in his

Memoir, though he had been eleven at the time. By age sixteen he had his mother's air of detached sobriety, her righteousness and practicality, her grim resolve.

Jesse's second born had some of his father in him, too. The pioneers who settled in the Middle West had dreamed of rich soil and bountiful harvests; Herbert observed that those who pushed on to the Coast brought richer visions—of gold and silver. He had learned early how to earn his keep. Now he planned to make a fortune. He bought a train ticket to Palo Alto, intent on studying engineering at the new university there. A high score on the math exam (he flunked the rest) won him acceptance on a conditional basis. By his senior year Herbert had proven himself academically and in other ways. Most of his education he paid for himself, holding down odd jobs and operating a laundry.

In his sophomore year, the Stanford campus was invaded by Greek-letter social clubs. Hoover's Quaker principles rebelled. The poorest students on campus were unable even to afford a room in the dormitory much less the plush fraternity housing. They lived in unheated wooden shacks and cooked their meals over kerosene stoves. Herbert became their champion, delivering "The Camp" vote to a rabble-rouser nicknamed "Sosh," short for Socialist, in his successful bid for student body president.

At Stanford Hoover embraced the self-styled doctrine of social progressivism that would serve him throughout his life. Even in the depths of the Depression, when critics on all sides were demanding from their president some revolutionary government action to force the economy back on its feet, Hoover held firm to his belief that individual enterprise is the engine of economic prosperity, with social harmony the inevitable end product. It was an engineer's progressivism, born of a Quaker's unwavering dutifulness and unshakable faith.

The Hoovers were supremely well-matched— adventuresome, industrious, practical, steadfast. They lived in dozens of countries, hundreds of "homes."

Jolted from her reverie by the sound of bullets ricochetting off the garden wall, Lou rushed indoors and nearly collided with Herbert, who brought shocking news. Most of the Chinese army had taken up arms against foreigners. As the shells whistled overhead, Herbert touched her hand. "See what I brought you to," he said. "You shouldn't have come." Lou replied him that she was not the least bit frightened, though she might be persuaded to haul their bedding over to her friend Lucy Drew's house, a fortresslike structure surrounded by an immense wall.

The Boxer Rebellion ended Herbert's Tientsin assignment, but not his travels. By 1907 he had circled the globe five times, and Lou had given birth to two sons. She toted the pair from country to country in a wicker basket cushioned with an air mattress, bragging that the boys never missed a meal or night's sleep except in Burma, where the whole family came down with malaria. When a particularly formi-

dable assignment advised against togetherness, Lou and the children remained in London, living at first in hotels, later in a cozy flat in Kensington, and finally in the Red House, a rambling brick mansion whose seventy-five-year-old lease strictly prohibited tenants from letting their cows wander out onto the street.

With its huge windows and wood-panelled walls, its several fireplaces and steam heating system, the Red House was a warm and comfortable home base. The children had yearned for a pet; now Rags, a lively Airedale, joined the family, along with several parakeets, Javanese seed birds, assorted pigeons and hens, and two cats, a silver Persian and a yellow Siamese. The Hoovers filled the leaded-glass bookcases in the library with books on geology and mining, economics and political science. Travel souvenirs shared crowded table tops with toys and games—only Lou's rare Chinese porcelains were stored under lock and key. A raised dais in the dining room showcased the Hoovers' theatrical talents. French doors opened onto a garden, with its own fish pond. The tangled limbs of an ancient mulberry tree enticed agile young climbers and soon embraced a tree house.

Like the blue house at Tientsin, the Red House became a beacon for Americans passing through town, especially Stanford graduates. Again immersed in Stanford politics, Hoover was rumored to be angling for its presidency. He had once said "If a man hasn't made a fortune by age 40 he is not worth much." Hoover turned forty in 1914. He had made in the neighborhood of five million dollars and was looking for something else to do.

World War I ended the Kensington idyll. One dark night in 1915, as German bombs rained down on London, the Hoovers became engrossed in a discussion of Herbert's daring plan to ship American food supplies to Belgium, where tens of thousands faced starvation. Suddenly, Lou noticed that the boys had quietly disappeared. After a frantic search, "we found them calmly observing the streaming searchlights and the fighting planes," Herbert remembered. "For reasons like this, plus the fact that I had to be on the continent two-thirds of the time and also that the boys should wear off their Oxford accent and soak in the American way of life, Mrs. H. decided to return with them to California."

Between 1914 and 1920, the Hoovers rented seven different houses in Palo Alto and Stanford, four in Washington, D.C., one in New York City. There were more than a dozen apartments, hotel rooms, and summer places. The time had come to put down roots. Lou and Herbert had always dreamed of making California their home. In London they spent hours tinkering with the scale model of a house they hoped to build in San Francisco. Its entrance was at the foot of a precipitous hill; visitors would ride an elevator, whose shaft was embedded in the hill, several hundred

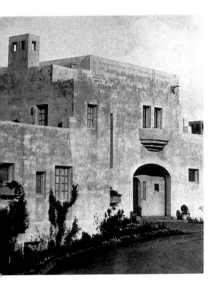

Architectural critics weren't sure how to categorize the Hoover house in Palo Alto, and that was just how Lou had wanted it.

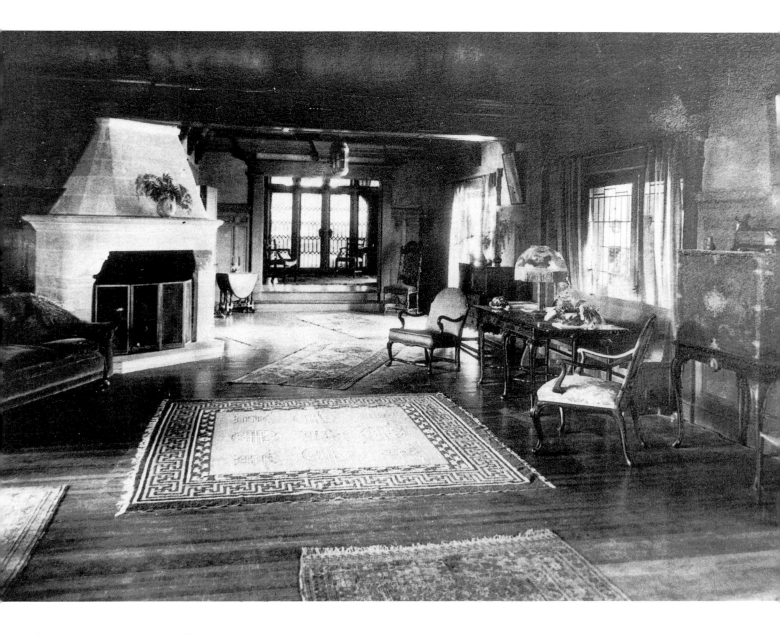

feet up to the house itself. In the end, the Hoovers chose a gentle slope in Palo Alto instead, and hired a California architect, Arthur Clark, and his son Birge, to design their dream house.

"Though Mr. Hoover paid no attention, Mrs. Hoover paid a great deal of attention, far more than the average client ever would," Arthur Clark recalled. "She had excellent taste, with complete confidence in her taste. Neither of them wanted the house to be a French Provincial, or an English manor, early California, or any historical style. They just wanted it to be a house."

The February 1929 issue of *Western Homes and Gardens* labeled it Algerian with a

Oriental rugs, European antiques, and many other treasures from around the world were displayed in the Hoovers' huge living room. After Lou's death the house served as the official residence of Stanford University presidents.

Pueblo-influenced exterior. It was a unique and arresting composition of vine-covered adobe cubes, each opening on to a terrace—which was really an outdoor room—with fireplaces in every room and on every terrace. Outdoor staircases connected the cubes, which themselves resembled steps mounting the slope. One staircase, particularly steep and winding, led from Lou's dressing room to her private study, whose three tiny windows allowed her to screen callers. If she did not personally greet them at the door, her servant knew Mrs. Hoover was "out."

Hoover had this to say about the house as it was going up: "[We] all think we can build a better house than anybody ever built before, and every American family is entitled to this experience once in a lifetime. I offer this intimate disclosure of private affairs in order that no further inquiry on this subject will be needed and so that it may be seen that I contemplate no mischief against this commonwealth...."

The next fifteen years afforded him little opportunity to develop a fuller appreciation for Lou's handiwork. After serving two administrations as commerce secretary, he accepted his party's nomination for president. Hoover's superb management of U.S. relief programs in Europe had earned him respect as a man of action, a true humanitarian—and another nickname, "The Great Engineer." As commerce secretary, he had shown courage and prescience by repeatedly calling for a halt to frenzied stock speculation. Chief Justice Taft called him "a dreamer" with "rather grandiose views...much under the Progressive influence."

The stock market crashed seven months after Hoover took office. The president believed at first that the economy would right itself. But as the Depression deepened, he responded with farm-price stabilization measures and public works programs. "We didn't want to admit it at the time," one of Franklin Roosevelt's top advisors said in 1974, "but practically the whole New Deal was extrapolated from programs that Hoover started."

By mid-1931 four million Americans were out of work. Hoover pressured all going concerns to hold wages steady, but resisted direct government relief even when confronted with reports that some Americans were starving. For this he was vilified in the press. His hostility to criticism further eroded public confidence. Wholly lacking the more conspicuous leadership qualities of more effective presidents—the dramatic flair of Theodore Roosevelt, the imagination of Lincoln, or the warmth of FDR—Hoover lost every state but six in the election of 1932.

A Quaker friend once asked Hoover what single tenet of his religion was most important to him. Hoover replied, "individual faithfulness." In place of eloquent phrases, The Great Engineer offered his own life as an inspiration to Americans. If the orphaned son of a poor blacksmith could become a millionaire and then president,

surely the same opportunity existed for anyone. Yet, in seeing himself as Everyman, Hoover failed to acknowledge his exceptional gifts, or to recognize that intuition, another foundation stone of the Quaker philosophy, was not one of them. Herbert Hoover left office humiliated and hated, caricatured in the press and even in his own party as an unbending capitalist with a heart of stone.

He never did put down roots; nor did he ever get used to dining alone. Lou died shortly after they moved to the Waldorf-Astoria Hotel in New York. If none of his friends could come for dinner, Hoover's oldest son would drive in from Connecticut. Hoover occupied the same suite at the Waldorf for forty-eight years and died there at the age of ninety.

Leland Stanford made his fortune in railroads and spent it lavishly on a variety of passions. Horse racing was one, education another. In 1891 he laid before Stanford University's pioneer class a Promethean vision that blended the ideals and ambitions of turn-of-the-century America. "The Beneficence of the Creator towards Man on Earth, and the Possibilities of Humanity are one and the same," he said. Darwin's theory of natural selection had revealed the elegant justice of God's plan—and exonerated capitalism. To Herbert Hoover, with his "individual faithfulness" and engineer's intelligence, his humble pedigree and empty pockets, Stanford's words were a call to greatness. In the coming millennium a tidal wave of scientific revelations would elevate the common man to power and prosperity, ushering in true social democracy.

To those born into more privileged circumstances, true social democracy must have been an alarming prospect. A nineteenth-century historian, finding the habits of American country squires whose estates decorated the banks of New York's Hudson River remarkably like those of their American counterparts, made this observation: "I doubt if ever there was so high a standard of morality which has such means of self-indulgence at its command . . . and which secures so much deference."

The Knickerbockers, wealthy families of Dutch-English descent, ruled New York society for two centuries. Duty and decorum ruled the Knickerbockers. "The good old fathers and their Madames were great sticklers for form and ceremony," noted a member of that esteemed set. "Their full ruffles and cuffs were starched, and unwittingly imparted to the wearer an air of dignified composure that would check the merest approach to familiarity."

Franklin Delano Roosevelt's father, James, was a Knickerbocker, as proud of his own bloodlines as those of the magnificent trotters he bred at Springwood, his home in the Hudson Valley village of Hyde Park. Claes Van Rosenvelt had sailed from

Holland to New Amsterdam in 1650, married an Englishwoman, and established a successful farm near what is now Manhattan's garment district. By the time Isaac "the Patriot" Roosevelt, James's great grandfather, was born, the family had parlayed that land into a sizable dry goods fortune.

The lucrative West Indian sugar trade made a patriot of Isaac. Enraged by onerous taxes, he reluctantly voted for independence, fled to Duchess County for the duration of the war, and, when the dust settled, joined the Federalist cause. In his third term as president, Franklin Roosevelt scoured the Library of Congress for evidence that his illustrious ancestor had some sympathy for the egalitarian views of FDR's hero, Thomas Jefferson. He found the two names linked only once—when Jefferson noted in his account book for 1790, "pd. Roosevelt 3 feather fans."

James's father, another Isaac, was a reclusive hypochondriac. At his Hyde Park estate, which he called Mount Hope, Isaac bred cattle and tended vast gardens. Two years after he died, leaving most of his fortune to James, the house burned to the ground. From the rubble James managed to retrieve some bedding and a pair of stone gate posts. These he judged meager compensation for the loss of 400 fine cigars.

The gate posts were hauled down the road to Springwood, an Italianate mansion with tall arched windows, a deep veranda dripping with ivy vines, and a three-storied tower. It looks like nothing so much as a steam locomotive pulling a train, James mused to himself as he walked over the hundred-acre grounds in 1867. The house was small, with just seventeen rooms, but then, the Roosevelts were a small family. James, and his wife, Rebecca, had only one child, a thirteen-year-old boy.

In 1873, James's prize trotter shattered the world record for the mile. Leland Stanford boarded a train for New York and offered Roosevelt $15,000 for the fleet-footed gelding. The two men shared many interests, but they were as different as the nineteenth and the twentieth centuries. Stanford had been governor of California; Roosevelt, a lifelong Democrat, found the rough-and-tumble of politics a shade undignified. The rough-and-tumble of business he could not resist, but his speculating failed to bring him stupendous wealth.

Shortly before the dynamic Californian appeared on James's doorstep, Roosevelt's scheme to gain control of all rail lines south of the Potomac had collapsed. His spirits plummeted along with the value of his holdings. With heavy heart, he took Stanford's money and said good-bye to his champion. The horse never raced again. He perished in a train wreck en route to California.

Rebecca died three years later. This loss James could not accept. Springwood was a dreary prison without her; incessant travel failed to divert him. Finally, after two

lonely, nomadic years, he decided to find another wife. When Theodore Roosevelt's sister Bamie gently rebuffed his proposal, James rebounded into the arms of his neighbor Warren Delano's daughter Sara. She was twenty-seven. He was fifty-two.

A woman of weaker character might have been cowed by the prospect of marriage to a man twice her age. Sara Delano Roosevelt was not easily cowed. Her father, Warren, shrewd and indomitable, had made his fortune in the China trade, lost it in the Panic of 1857, returned to China at age fifty and made it all over again. "There was never anyone like my father," she often said. Sara Delano Roosevelt was like her father.

James took his bride on a ten-month European tour, and though he would have preferred to leave Springwood just as it was when Rebecca was alive, he consented to Sara's purchase of a massive Dutch sideboard made up of carved medieval panels. She rewarded him with his second child. Her father pronounced Franklin "a beautiful little fellow—strong and well-behaved, with a good-shaped head of the Delano type." Sara concurred, and never altered her opinion that her first and only child, the center of her life until she died, was more Delano than Roosevelt.

Perhaps she overstated the case. Warren Delano was a man of character, but no remarkable compassion. Franklin's father, on the other hand, was far from indifferent to the suffering of those less fortunate. Toward the end of his life he gave an extraordinary address to his congregation at the tiny St. James Church in Hyde Park. It began as a routine paean to toil and thrift, then detoured sharply as James took his listeners on a tour of London slums. He described how he had himself climbed down a ladder to a cellar beneath the streets of St. Giles and found "several feet below the gas pipes half a dozen nearly nude and hideously dirty children, a man toiling by the flame of a candle, a woman lying ill abed, all in this pestiferous and dingy den." James exhorted his audience to "Help all who are suffering...for that single cause that we have, all of us, one human heart."

Seated in the family pew toward the front of the church, young Franklin Roosevelt listened attentively.

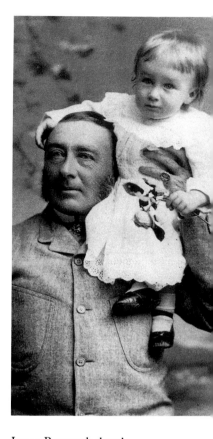

James Roosevelt doted on his son; Franklin worshipped his father.

"Mama had a very wonderful end," Eleanor Roosevelt wrote to a close friend upon Sara's death at age eighty-seven. "I think Franklin will forget all the irritations & remember only pleasant things which is just as well." While her husband, now in his third term as president, prepared the nation for war, Eleanor braced herself for a task that seemed almost as awesome. "The endless details, clothes to go through, check books, paper...."

Sorting and storing away the remnants of Sara's life was indeed an immense under-

taking, and, like so many that Eleanor performed for both mother and son during her remarkable marriage, a thankless one. Sara's "strongest trait was her loyalty to her family," Eleanor wrote. "[She] was not just sweetness and light, for there was a streak of jealousy and possessiveness in her where her own were concerned."

Perhaps, with Sara gone, Franklin would allow his wife to make some changes in the Big House. With great delicacy, Eleanor broached the matter. Franklin was evasive, and finally sent a message by way of Anna, their oldest daughter—he would not have so much as a slipcover replaced. Only after two years' silence did Eleanor again raise the subject of redecorating the Big House, this time in a letter. "I want to buy some little upholstered chairs & some few little things to make the servants' rooms more livable. I won't spend much & I think there is enough room in the House account to do it. May I? Also, if I make a diagram of Mama's room so everything could be put back in place could I arrange it as a sitting room with a day bed in case someone had to sleep there?"

Franklin Roosevelt seldom reflected—at least not out loud—on the complex forces that shaped him. He was a man of action, especially brilliant in a crisis. The deeper

Sara Delano Roosevelt was a strong influence— and a constant presence.

190

the crisis, the stronger the dose of government action he prescribed. When he took office in 1932, banks were closing, breadlines forming, factories shutting down. He called an emergency session of Congress, proposing a mass of legislation unprecedented in scope. Roosevelt called his patchwork panaceas the New Deal. Business and banking interests called them socialism. Herbert Hoover was especially scathing, branding FDR a "chameleon on plaid."

FDR ignored his critics and pushed on. Re-elected in a landslide in 1934, he lead the nation as if by divine right. The people revered and respected their benevolent monarch. Here was a man who daily triumphed over a handicap that even his immense fortune could not heal nor his heavy braces disguise, a handicap worse than bankruptcy or temporary unemployment. At thirty-eight, Franklin had been stricken with polio and paralyzed from the waist down.

This imperial president who shattered tradition by serving an unprecedented twelve years, refusing to abandon his subjects on the brink of war or in the heat of it, this "dangerous radical" was a rock-ribbed, cradle-to-grave conservative where Springwood was concerned. Not only could FDR not bear to have his mother's slipcovers replaced, he also forbade the removal of any tree that was not diseased or damaged. On breezy summer days, the emerald expanse of lawn that surrounded the Big House on three sides, dropping off sharply where it met the densely forested river bluff, seemed alive with the dancing shadows of majestic oaks, maples, and poplars.

For Franklin, the trees were alive with memories. As a child, he was his father's constant companion. James taught him how to climb trees and trap woodchucks. He gave him a sailboat and a pony, and when Franklin was eleven a gun. Springwood's oaks and maples teemed with birds of a dozen or more species. At these the boy took aim, dressing and stuffing the finest specimens and arranging them in a trophy case, just as his cousin Theodore had done when he was a boy.

Sara would not become pregnant again, having barely survived Franklin's birth. She clung to the child in him. At age five Franklin still wore shoulder-length curls. By eight he had yet to take a bath alone. He was tutored in his lessons until he was fourteen, and entered boarding school two years later than his classmates. Never accepted by them, Franklin sent home giddy reports of fantasy friendships and grossly exaggerated his few triumphs on the playing fields of Groton. The "outsider" stigma followed him to Harvard. So did his mother.

From her Cambridge apartment Sara closely monitored Franklin's busy schedule of extracurricular activities, never suspecting his growing fondness for his Oyster Bay cousin, Eleanor Roosevelt. When he finally told her that he wished to marry Uncle Theodore's favorite niece, Sara took the news badly. She had just lost her

husband, and did not intend to lose her son so soon. She felt betrayed and disarmed, for to fault the match would have risked alienating her illustrious, and notoriously loose-tongued, relations. Besides, she liked Eleanor, who though rather shy seemed appealingly malleable. Sara persuaded Franklin to postpone the engagement—Eleanor, after all, was just eighteen—then agreed to invite his sweetheart to the Roosevelt's summer house on Campobello, a tiny island in New Brunswick, off the Maine coast.

Franklin's father made his first visit to Campobello in 1883, lured by the island's reputation as a sailing paradise. He was not disappointed, and with several other families of agreeably aged vintage set out to fashion a rustic retreat free of the vulgar pretensions that had ruined more accessible resorts. Campo offered few amenities. There were no butlers or beach clubs. Meals were cooked over coal stoves.

Eleanor arrived at nightfall, and awoke the next morning to find the island enveloped in thick fog. The sun rose, the shroud receded until at about noon the waters of the bay sparkled under a cloudless sky. Every day on Campo unfolded in precisely this fashion, Franklin told her. Eleanor was enchanted by James Roosevelt's "beloved isle," where even the wild cattle were allowed to roam the pine-scented landscape undisturbed, and Franklin was enchanted by Eleanor. Mrs. Hartman Kuhn, who lived next door, found both young Roosevelts charming. When she died, the wealthy Boston matron left her cottage on Campobello to Sara, for the token sum of $5,000, with secret instructions that it be given to Franklin and Eleanor as a belated wedding present.

By the time the details of Mrs. Kuhn's will were disclosed, Eleanor and Franklin had long since overcome Sara's opposition and revealed their own secret to the world. They were married in 1905. Uncle Theodore gave the bride away.

Franklin idolized his Oyster Bay cousin. When James died, in 1900, Franklin was an impressionable eighteen-year-old, and Eleanor's uncle a national hero on his way to the White House. Teddy replaced James as Franklin's role model. When he ran for a second term, Franklin switched parties to campaign for him, then took up politics himself, adopting the Rough Rider's progressive ideas as well as his personal style, including the trademark pince-nez and ubiquitous grin.

Even Franklin's fascination for the sea recalled his cousin. FDR came by it naturally, having amassed an impressive collection of model ships as a boy. His command of arcane seafaring terms helped qualify him for his cousin's old job as assistant navy secretary. (Ironically, it was Teddy's loss to Woodrow Wilson in 1912 that secured the post for Franklin, who by then had served two terms in the state senate as a Democrat.) Teddy's resume had become the blueprint for FDR's career, as Franklin rounded out his training for the presidency as governor of New York.

Franklin and Eleanor on the beach at Campo.

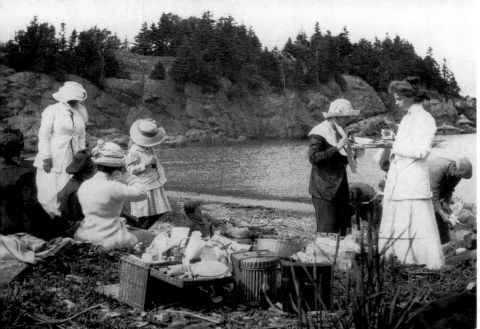

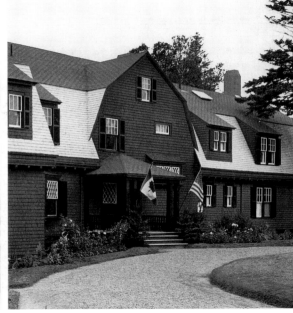

Eleanor loved elaborate picnics. Her house on Campobello Island was a wedding gift from an admiring neighbor, and the only house she ever thought of as her own until Franklin built Val-Kill, her cottage near the Big House.

When Eleanor and Franklin returned from their wedding trip, a charming but tiny townhouse on East 36th Street in Manhattan was waiting for them, fully furnished and staffed by Sara. Eleanor dutifully declared herself "jubilant" and "looking forward so much to getting it in order with you to help us." She declined Sara's offer to install electricity, pointing out that they would not be in their "14-ft. mansion," as Franklin called it, for long. Apparently Sara took this as a hint. On Christmas Day she handed Eleanor the rough sketch of a house. "Number and street not yet decided" was scrawled across the bottom. This crude illustration was not the whole picture. The house next door would be Sara's.

Every spring Eleanor flew to Campobello before the robins. Mrs. Kuhn's cottage was the first house she ever thought of as her own. Like most of Campo's summer establishments, it was a cottage in every respect but size. Charming and cozy, with deep red shingles and green shutters, sturdy furniture made of wicker and wood, and a wide veranda devoid of ornament, the house was nevertheless undeniably vast. "I have moved every room in the house around," a euphoric Eleanor wrote to Franklin in the summer of 1909. He must have been impressed—altogether there were thirty-four rooms.

After Franklin contracted polio on Campobello in 1921, Eleanor made the annual pilgrimage alone. Her husband complained that it was "too much trouble getting around." Franklin Jr. knew the truth: "He just couldn't bear to go back to the place where he had hiked and run and ridden horseback and climbed cliffs, and realize that he could never do those things again."

By 1927 Eleanor was desperate for a place of her own at Hyde Park, where she could pursue her own interests, free of her mother-in-law's interference and the sniping of Franklin's step-brother about her "Parlour Socialist" friends. "My Missus

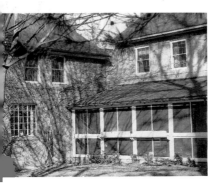

and some of her female political friends want to build a shack on a stream in the back woods and want, instead of a beautiful marble bath, to have the stream dug up so as to form an old-fashioned swimming hole." Thus Franklin described the project to a former associate whom he had asked to supervise construction. An architectural purist, Franklin insisted that Eleanor's cottage be built of gray fieldstone to match the village post office.

Val-Kill was to serve another purpose, as well. Eleanor sometimes remarked wistfully that she would have made a good farmer's wife. As her children grew older, she yearned for some sort of useful, consuming work. Her true calling, she knew, was teaching, and with a friend she had founded a girls' school in New York City. That same friend helped her launch a hand-crafted furniture business, Val-Kill Industries.

At the stone cottage Eleanor slept on a screen porch enclosed by trees and overlooking a pond. Traffic between the cottage and the Big House was heavy. Franklin often brought steaks for the grill and a new acquaintance for Eleanor to meet, or came alone just to talk. During his presidency there were annual baseball games with White House staff, and every fall Eleanor organized a clambake, climaxed by a raucous Virginia reel, for members of the press. Over the years the cottage acquired several wings, to accommodate the expanding ranks of "Parlour Socialists" and others who came to visit Eleanor. She pampered them all.

Eleanor's twenty-room sanctuary was a hovel by comparison to the Big House, which in 1915 had gained two new wings, a third floor, and a stylishly stuccoed neoclassical facade, complete with pillared portico and balustraded terrace. The choicest corners of the south wing were reserved for spacious bedrooms with huge bay windows. Franklin occupied one, Sara the other, with Eleanor (after her husband contracted polio) taking the poorly lit corridor in between.

As a boy FDR had staked out as his own bedroom opening onto the main staircase, in the heart of the house, ideally situated for eavesdropping on his parents' dinner parties. When he had sons of his own—four of them—it became the scene of an important rite of passage. Upon arriving at maturity (whenever the previous occupant moved out), each of Franklin's sons was ceremoniously moved from the children's quarters on the third floor into their father's old room.

An immense, sunken living room-library filled the first floor of the north wing. Here Franklin's ancestors, Isaac the Patriot and great-grandfather James, gazed down upon the president-elect as he composed his inaugural address in 1932. In later years FDR preferred to work out of the small free-standing library he had built to house his books and papers (now the Franklin D. Roosevelt Presidential Library). An avid collector all his life, Franklin credited this passion for lifting him from despair—

indeed, for saving his life—as he battled polio. He would pore for hours over coins, maps, and children's books; his stamp collection was one of the finest in the world. He also loved Dutch tiles and chose his favorites for the library's handsome fireplace border.

There were times when even the library was not seclusion enough. Then Franklin retreated to his Top Cottage, built on a hillside behind Val-Kill in 1938. Eleanor described it as "a little refuge he can work in, where no one can come unless he invites them."

Two months after Sara's death in 1941, the Japanese attacked Pearl Harbor. The Axis powers instantly supplanted the Depression as public enemy number one—as mobilization cured most of the nation's lingering economic ills. On the president's ills, the war had no such rehabilitative effect. He spent more and more time at Warm Springs, the Georgia resort he began frequenting in 1924 when he found the rushing waters excellent therapy for his legs. Eager to share his discovery with other polio victims, he plowed most of his personal fortune into the development of an attractive resort. He called his tiny white-pillared home at Warm Springs "The Little White House."

In 1944, with a fourth term looming before him and peace within his grasp, FDR began to complain of crushing fatigue. His doctors suspected congestive heart failure, but the president rejected as preposterous the notion that he take a break from his important work. He died at Warm Springs in April of 1945, three weeks before Germany surrendered. Eleanor traveled with her husband's body to Washington. All night she lay awake in her berth, the gentle rhythm of the train bringing to mind some lines from a poem she had always loved.

> *A lonesome train on a lonesome track*
> *Seven coaches painted black*
> *A slow train, a quiet train*
> *Carrying Lincoln home again...*

Franklin wished to be buried in the rose garden at Springwood. A simple graveside service was performed by the aged rector of the Church of St. James—the same village church where Franklin had served diligently as senior warden, and where his father had spoken so eloquently of toil and suffering long ago.

His own toil done, his suffering ended, Franklin Delano Roosevelt would never leave home again.

Opposite page: Eleanor and Franklin's marriage became more like a partnership, albeit a fond and practical one, as time went on. She moved from the Big House to Val-Kill in 1927. When he wasn't in Washington or Warm Springs, he shared the Big House with Sara, whose bedroom was down the hall from his (opposite page, bottom) in the south wing.

In Warm Springs, Georgia, Roosevelt found some relief from near constant pain. He died at his "Little White House" in 1945.

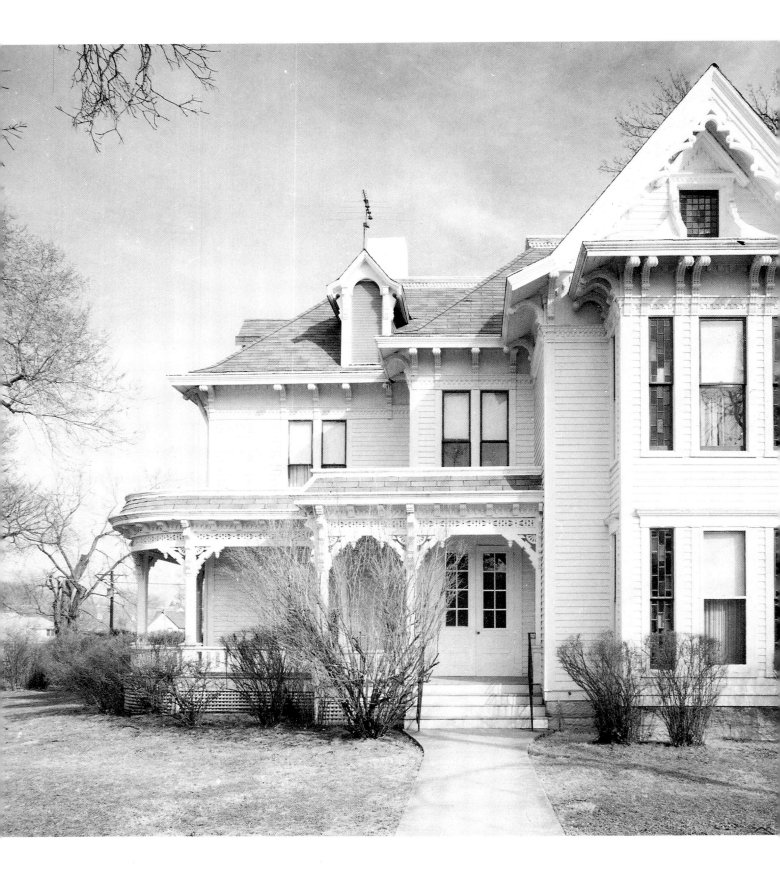

Harry S. Truman, Dwight D. Eisenhower

HARRY TRUMAN WAS OFTEN TAKEN FOR a country boy with common sense going for him if nothing else, a typical politician, kind of small-minded and mean-spirited, lacking in erudition, an embarrassment in the White House.

There was one prominent feature that belied that no-nothing image. He wore it on his nose.

Mattie Truman first suspected that there was something wrong with Harry's eyes in the spring of 1889. Her son couldn't seem to make out the cows across the pasture, or a buggy coming up the road. On Independence Day she knew. The other children screamed with delight as rockets streaked over their heads and—boom!—splattered color across the sky like a thousand paint cans being upended in the heavens. Harry quietly drew circles in the dirt. The next morning Mattie woke him early and hitched up the wagon. They drove to Kansas City, where an eye specialist fitted the boy with a pair of glasses a quarter-inch thick, warning him to avoid "rough and tumble play" or his eyes "would get knocked out." At least that's how Truman remembered it in his memoirs. He had been five years old at the time.

The Trumans lived with Mattie's parents on the family farm in Grandview, Missouri, until Harry was six. The boy helped his father, John, plant wheat, corn, oats, and clover. "Later, after the fall freeze, came the hog-killing time, with sausages, souse, pickled pigs' feet, and the rendering of lard in a big iron kettle in the smokehouse." The farm supported the three generations comfortably.

Harry wore his expensive new glasses with pride, protected them fiercely, and delighted in the new world they opened up. He recruited his younger brother, Vivian, for a daring half-mile expedition to the south pasture. For the first time he was able to pick out "birds' nests in the tall prairie grass,...daisies, prairie wildflowers, and wild strawberries." A more important discovery was the fine print in the family Bible. Harry memorized most of it and moved on.

By his senior year in high school Harry could recite passages from Mark Twain and an author more popular in Missouri than the home-grown talent, Sir Walter

Scott. After the ravages of the Civil War, as reconstruction degenerated into a melee of power-grabbing and graft, many Southerners saw the Old South mirrored in Scott's tales of chivalry and honor.

Before the war, Harry's grandfather, Solomon Young, had owned five thousand acres of prime farmland in Jackson County, Missouri, tens of thousands more in California. To please his bride, Louisa, a young lady of good breeding who had come all the way from Kentucky to the Missouri hinterlands, Solomon sold off his holdings in California and built a pillared mansion with a grand piano in the parlor and fireplaces in every room. A stunning niagara of a staircase spilled into the front hall from the second floor.

Solomon's slaves, about two dozen, lived in shacks behind the mansion. The women wet-nursed Louisa's babies, cooked and served the meals, and in the summer months, waved fans to keep insects off the fine linen tablecloth. By 1887, Solomon's holdings had been reduced to 600 acres, his slaves replaced by hired help. A year after his death in 1892, the transformation from antebellum plantation to midwestern farm was complete when the big house burned to the ground.

By this time John and Mattie had moved to Independence for Harry's schooling (they would later return to Grandview). In the homely structure thrown up where the mansion had stood, Louisa would sit alone for hours, wrapped in a shawl by the fireplace, smoking a pipe and staring into the flames. Solomon's empire had been built on the blood and sweat of slaves, but to Harry's grandmother slavery was never the real issue dividing North and South. The real issue was honor.

Grandma Young was still alive in June 1905 when Harry enlisted in the National Guard and was given a full-dress uniform, a "beautiful blue with red stripes down the trouser leg and red piping on the cuffs and a red fourragere over the shoulder." Always a bit of a dandy, he drove out to Grandview at the first opportunity to parade his military plumage before his grandmother. It was the kind of tactical error Harry Truman seldom committed. Louisa drove him out of the house, but not before delivering a scorching history lesson.

In May of 1861, she told her cowering grandson, a general in a blue uniform ordered his men to seize Solomon's mules and horses, to butcher his prize Hampshire hogs and laying hens, and to put the torch to his hay and stock barns. An elderly slave was forced at gunpoint to show him to the family silver, hidden in the well. Louisa made biscuits for his men until her fingers were blistered. The theft and carnage were repeated on more than four occasions, each more ruinous than the last. One marauding band of blue-coats hung Louisa's son Harrison as a spy—she cut him down alive as they rode off with 30,000 nails, seven wagons, 1,200 pounds of

bacon. Finally, in 1864 the Youngs (like their neighbors the Trumans and Wallaces) were ordered to vacate the farm, even though Solomon had signed a loyalty pledge in Kansas City.

Harry Truman was a deliberate man, as his family was fond of saying, but hardly a simple one. His political code of honor might have been lifted from the pages of *Ivanhoe*. Champion of the New Deal, he was also a practical politician, a Southern Democrat as stubbornly loyal to the party boss who got him his first government job as he was to FDR. When Roosevelt sought to clean up Democratic politics in Missouri, Truman defended T.J. ("Boss Tom") Pendergast as "an honest man who would never go back on his word." The same, he felt, could not be said for the president.

Truman dismissed fiction as "romantic adventure." For "honest instruction and wise teaching" he turned to history, carefully plucking out the subjective judgments of historians and tossing them aside like so many seeds in a watermelon. He would take his lessons directly from the facts. "Make no little plans. Make the biggest one you can think of, and spend the rest of your life carrying it out." That was lesson number one. "In the picture of the great in the United States, most were honorable, hard-working men who were ready when opportunity knocked. Most had training on the farm, in finance, or in the military." Harry tried his hand at all three before following opportunity into the men's clothing business in the Twenties and losing his shirt. Harry's mother had put up the family farm as collateral on the store lease. For the next twenty years he would battle banks and county bureaucrats to hold onto his ancestral home.

Harry's passion for politics probably came from his father. Emotions ran high in the Truman household around election time; John Truman would come home from work bleeding as often as not. He fought "like a buzzsaw" for his beliefs, said a childhood friend. "He always rode a horse and carried the stub of a buggy whip.... One day Rube Shrout, a high-tempered, high-strung fellow, came in to the barn to get his horse and buggy. He had a knot bleeding on his face and he was about to cry. My father asked him, 'Rube, what's the matter?' And Rube replied, 'I got in an argument with John Truman and he hit me with a whip.' "

Harry ascribed his father's colossal temper to "sentimentality" and fierce Southern pride where friends and family were concerned. Women especially were "set on a pedestal.... No one could make remarks about my aunts or my mother in my father's presence without getting into serious trouble." Maybe out of necessity, Harry learned the art of compromise. When fights broke out at home or on the playground at

The Wallace house (overleaf) in Independence, Missouri, became Harry Truman's official residence when he married Bess Wallace. She couldn't bear to live anywhere else, but 219 Delaware Street wasn't really home to Harry until his retirement.

school, the bespectacled bookworm was called on to mediate. His teachers marveled at Harry's maturity. "I used to watch my father and mother closely to learn what I could do to please them," he said. He did the same with teachers and playmates. "I was usually able to get what I wanted. It was successful on the farm, in school, in the Army, and particularly in the Senate."

John Truman had started out as a livestock trader, taking his bride across the state to the tiny town of Lamar, where Harry was born in a white frame house for which his father paid $685. It measured twenty by twenty-eight feet, had four rooms on the first floor and two on the second that even a small man had to stoop to stand in. The toilet and smokehouse were outside. The family went to live on the farm at Grandview when Harry was five. Never an avid farmer, John hastily agreed to Mattie's suggestion that they move to Independence.

A town of about 6,000 in 1890, Independence was a Democratic stronghold. Its white frame houses had generous porches trimmed in Victorian bric-a-brac—the bigger the house the more the trimmings—fine shade trees, and sprawling yards. The Trumans' first home in Independence was, naturally, a small white frame house. The yard spanned several lots, a sturdy wire fence enclosing mules, cattle, hogs, sheep and as many as 500 goats. There was no shortage of playmates, either. "With our barns, chicken house, and a grand yard to play in, all the boys and girls in the neighborhood for blocks around congregated at our house."

Ardent defender of the family honor, John Truman was not destined to recover its wealth. He made a small fortune speculating in commodities, but promptly lost a sizable one, $40,000 in a single trade. His reverses cost his son a college education— "You miss it when you sit at this desk," Harry Truman wrote from the Oval Office— and forced another move, this time into enemy territory.

In Kansas City, Harry went to work as a railroad timekeeper, then a bank clerk. In desperation John Truman resorted to farming, asking Harry to join him. Ever mindful of his life plan—"In the picture of the great...most had training on the farm, in finance, or in the military..."—Harry moved back to Grandview in 1906, and for the next ten years made his living off the land. "Riding one of these plows all day, day after day, gives one time to think. I've settled all the ills of mankind in one way or another while riding along seeing that each animal pulled his part of the load."

World War I ended both his farming career and his courtship of Bess Wallace. Harry claimed to have been in love with Bess since kindergarten. They began dating after high school and the relationship had dragged on for fourteen years. Apparently sobered by his imminent departure for the front, Harry popped the question in 1914.

Young Bess Wallace swings on her front porch.

He served with distinction in France, was mustered out as a major, and married Bess in her living room in 1919.

The Wallace house on Delaware Street was a three-story, seventeen-room white frame Greek Revival mansion. Harry would call it home until his death. It had been built in 1887 for Bess's great grandfather, who added the Eastlake ornamental brackets and a new wing, facing the street, in 1897. Bess and Harry (or more accurately, Bess and her mother) made no changes of any kind, except to add such twentieth-century essentials as central heating, electricity, and a telephone. When Harry became president the government added a fence.

Truman hated the fence, but heeded the advice of another ex-president that he leave it up. Herbert Hoover had been forced to raise a fence around his house at Palo Alto when curiosity seekers made off with everything that wasn't nailed down, and a few things that were. "It was said in the first World War that the French fought for their country, the British fought for the freedom of the seas, and the Americans fought for souvenirs," Truman told a reporter who asked about the fence. One day, as his daughter, Margaret, fumed over the appearance of another gawking face in the window, Harry told her to remember her history. All ex-presidents were treated as freaks of nature by the populace. Even Thomas Jefferson had been plagued by tourists after his retirement at Monticello. "Well, it's disgraceful!" Margaret shouted. Marching out of the house, she ordered the uninvited guest off the property.

The Wallace house was more than a home to Bess; it was a womb. After politics sent her husband to Washington, Bess and Harry lived mostly apart, he in bleak Washington apartments and hotel rooms, she at 219 Delaware Street. Their letters are a poignant chronicle of loneliness and obstinacy on both sides. Harry chided Bess for failing to kiss him good-bye at the conclusion of one of his whirlwind swings through Independence, and hinted that Bess should behave more supportively of her important husband; Bess reminded her important husband that she disliked public displays of affection, and complained that they were too poor even to buy a $10,000 house in the nation's capital.

"I am somewhat disappointed that you don't look with favor on coming back....," Harry wrote from Washington in 1935. "I couldn't go to sleep until 1:30 thinking about you and home."

Harry had done a favor for T. J. Pendergast's nephew during the war. Boss Tom repaid the debt with interest in 1922, when he backed Truman for eastern Jackson County judge. Thus began the balancing act Harry Truman would perform for most of his political career. As a Pendergast man, he doled out favors with fairness and

finesse, while at the same time earning a reputation as a crusader for clean government.

In the Twenties clean government did not mean democratic government. No one with real power questioned the practice of stuffing ballot boxes; rather, the delicate issues of how, where, why, and by whom they would be stuffed were furiously debated. The same was true of patronage and government contracts. Truman opposed any scheme that would cost the taxpayers, even if it meant taking on the Boss. Honor among thieves, except that Harry Truman never stole a penny.

Charges that Harry Truman was Boss Tom's stooge were the drum roll accompaniment to his campaign for a second Senate term. As usual, his best defense was his bank account. By 1935 his clothing store debts were paid off, but the financial pressure did not abate. He was now supporting his mother in Grandview, his mother-in-law in Independence. When Bess took a clerical job to help pay the bills, Harry fantasized privately about striking it rich. "Maybe I can make a gamble next fall and hit a pot of gold."

Publicly he stuck by his conviction that money and decency don't mix. "The reason for my lack of worldly goods [is] I just can't cheat in a trade or browbeat a worker. Maybe I'm crazy, but so is the Sermon on the Mount if I am."

His "poverty" proved a priceless asset as he built a national reputation for exposing financial hanky-panky in high places. He had dealt with Boss Tom on his own terms, and so he would deal with FDR. By now a pro at reading fine print, Truman exposed a massive railroad stock scheme that linked many of the nation's rich and powerful, including members of the Roosevelt administration. During World War II, as vice president, he focused his attention on the war industry, again and again turning up dramatic evidence that the "corporate interests" would conspire with the enemy and undermine the safety of the American fighting man to make a buck. FDR cringed but did not call Truman off.

In 1940 Harry was embroiled in his Senate reelection campaign when he learned that the Jackson County court had foreclosed on the Grandview farm. Pendergast rivals engineered its sale to the county for $36,500, let it languish during a soft real estate market, then sold it for a handsome profit. "No matter how much front [Mattie] puts on she hates to leave the farm even if it has been nothing but a source of worry and trouble to us for about 50 years," Harry wrote to Bess from Washington. "The place has brought bad luck and financial disaster to everyone connected with it since my grandfather died in 1892. If we'd been smart and sold it right after the World War...we could have been no worse off if we'd spent all the money in riotous living. Well it's gone anyway, and may the jinx go with it."

It wasn't gone for good. A few months after Harry became president, a wealthy

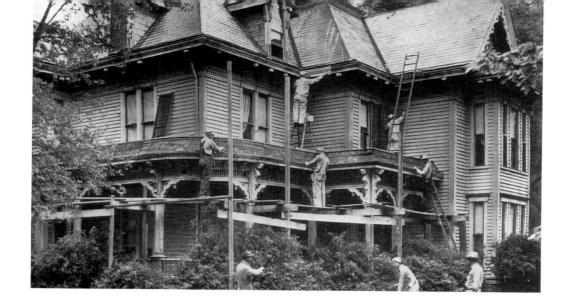

Bess's great grandfather added a new wing to the Wallace house in 1897. Bess made no changes other than to add electricity, central heating, and a telephone—and from time to time a fresh coat of paint.

admirer arranged for him to repurchase the old farmhouse and twenty acres of land. After World War II every medium-sized city in America was sprouting suburbs at a frantic rate. Independence was no exception. Those twenty acres began to look more and more like Harry's pot of gold. The land was eventually cleared to make way for Truman Corners shopping mall, and the president's peaceful retirement at 219 Delaware Street was assured.

Harry Truman was elected president "in his own right" in 1948, after almost every newspaper in America had predicted a Republican landslide. "Mr. President, we are ready to eat crow whenever you are ready to serve it," announced the Washington *Post* in huge letters on the front of its building.

For the next four years Truman wrestled with Stalin in East Berlin, Mao Tse-tung in Korea, General Douglas MacArthur in the Phillipines (Truman finally fired him when MacArthur publicly defied the president's Cold War diplomacy), the Democratic Party at home. Ironically, the machine politician par excellence could not find a presidential hopeful eager for his endorsement. Disappointed when Dwight Eisenhower switched parties, Harry finally threw his unsolicited support behind the Democratic nominee, Adlai Stevenson, though he thought him too intellectual ("a man who couldn't decide whether he had to go to the bathroom or not").

In retirement, Truman wrestled with greatness. There were three presidents especially dear to him—Andrew Jackson, James K. Polk, and Andrew Johnson. They all "lived through the days when reason was overcome by emotion," and because of this "their acts were misunderstood and misinterpreted. ...A President may dismiss the abuse of scoundrels, but to be denounced by honest men, honestly outraged, is a test of greatness that none but the strongest men survive."

He never really doubted how Harry Truman's presidency would come out. "Do your duty," he always said, "and history will do you justice."

Truman respected history's first commandment to great American war heroes, that they resist the temptation to run for president. The case of Dwight David Eisenhower had Harry perplexed. By 1950 the general's presidential aspirations were clear. Truman was grateful for Ike's support during the post-war negotiations, the Korean conflict, and the messy business with MacArthur. But would he make a good president?

He "has the Lincoln touch," the New York *Herald Tribune* gushed in 1944 after Eisenhower delivered the most famous speech of his career—"another Gettysburg Address"—in London. Though he came from Abilene, Kansas, "the heart of America," Ike said, the love of liberty he and his countrymen shared with the British had forged a mighty alliance. For freedom, equality, liberty, "the Londoner will fight. So will the citizen of Abilene. When we consider these things then the valley of the Thames draws closer to the farms of Kansas and the plains of Texas."

Ike was born one year after Harry Truman, in 1890, and a few hundred miles further south. His father, David Dwight, had fled to Denison, Texas, following the failure of his general store. The business owed its brief existence to the generosity of David's father, Jacob, whose wedding gift to his son had consisted chiefly of a farm, sixty acres of prime Kansas real estate. These David sold, against Jacob's wishes, moving his family from Abilene across the state to the town of Hope. He went into partnership with a man named Good, and for two years the business thrived. David seemed vindicated. Then a severe recession hit, wiping out many of the farms that supported the general store, and finally the store itself. Unscrupulous attorneys claimed most of the store's assets; David's partner stole the rest.

In Denison Eisenhower found work as a railroad machinist, earning $40 a month. His wife, Ida, struggled to feed and clothe her three sons on whatever was left after the landlord came by for the rent. They lived in a gabled frame house beside the railroad tracks. Bales of cotton awaiting shipment shared the dusty front yard with grazing goats. A quiet man under the best of circumstances, David Eisenhower sank into a miasma of self-pity and gloom, all his confidence and enthusiasm exhausted at the age of twenty-two.

Ike's grandfather was made of sterner stuff. Leader of a religious sect called the River Brethren, Jacob Eisenhower had moved his flock from Pennsylvania to Abilene in the 1870s. Severed end to end by a railroad track, the town had two personalities. On the south side, murderers, thieves, and prostitutes stalked saloon-lined streets. The main drag, Texas Street, "led straight from the open range to the delights of hell," the locals said. According to the Topeka *Record* of August 5, 1871, the other

Abilene, to the north, was "literary, religious, and commercial....When you are on the north side of the tracks you are in Kansas, and hear sober and profitable conversation;...when you cross to the south side you are in Texas."

In 1891, Jacob called David home. Old and infirm, the father needed the son. He put David to work in a creamery owned by the River Brethren. It paid about the same as the railroad, and for the next seven years the family lived in a one-story shack on South East Second Street. The neighborhood had two nicknames: "Hell's Half-Acre" and "the Devil's Addition." The saloons and brothels were gone, replaced by the cramped and dreary dwellings of the poor.

Ike always remembered his mother's cheerfulness as a blessed contrast to David's taciturnity, describing his father as "breadwinner, Supreme Court, and Lord High Executioner." But after Jacob moved in with the family, the crowded quarters were more even than she could bear. The Eisenhower sons now numbered six. "I spend all my time keeping the boys out of other people's yards," Ida grumbled.

When Jacob's son Abraham moved West and offered to rent them his house on South East Fourth Street, she rejoiced. Abraham's house was hardly a mansion but it seemed to have two of everything—two stories, two bedrooms upstairs and two down. It even had two parlors. These Ida furnished with a few mismatched upholstered pieces, wooden tables and chairs, and an ebony piano she had acquired during David's flirtation with happiness in Hope. It was the single possession she would not part with. Over the years she became just as stubborn about the house, refusing to move even after each of her sons had made his fortune.

To Ike and his brother Edgar, the best thing about their new home was the three-acre yard. An orchard with row upon row of cherry, pear, and apple trees, and a vegetable garden kept the family well-nourished. In the huge Dutch barn the boys reenacted the adventures of Wild Bill Hickok. At Abilene's nadir, Wild Bill had been imported by a group of upstanding citizens to tame their town. Legend credited him with the feat long afterwards, even though it was more likely the westward shift of the cattle business that drove the brothels and bars out of business. Filled with awe of Hickok and the outlaws he alone could intimidate, Ike began flexing his own muscles. At age thirteen he fought the leader of the north side gang, and became, as he later put it, the "president of the roughnecks."

That was in 1903. By then, of course, all traces of wanton adventurism had been banished from the Kansas landscape, now bleached the colors of corn and wheat. The Wild West was no more—in its place, the proper and parochial Midwest. As Carl Becker has observed, "the fundamental characteristic of Kansas individualism is the tendency to conform." Discipline and self-denial were the qualities admired

Ike and Mamie on their wedding day (above). The Eisenhower clan gathered in Abilene to welcome Ike home. The war hero is seated on the steps, his parents directly behind him.

above all others. Spoon fed these simple values, Ike grew up strong, healthy, fair-minded, and hard-working—but he had a sweet-tooth craving for adventure.

The army was an obvious career choice. In this most regimented of worlds there was opportunity for the individual to shine. All it took was courage, and a war. After passing the entrance exam for West Point, Ike left home in June of 1911. One simple value David and Ida had failed to pass on. Pacifism was a cornerstone of the River Brethren philosophy. After kissing her son good-bye, Ida Eisenhower went to her room and wept.

As president of the United States from 1952 to 1960, Dwight Eisenhower was the living symbol of the ideals he grew up with "in the heart of America," just as the Fifties would become their historical shrine. Ike came to represent all that was good about postwar America—opportunity, prosperity, wholesome family life, peace—and everything that was bad—McCarthyism, racism, complacency. His penchant for compromise and cautious problem-solving, which had served him so well in the military, too often had about it the smell of procrastination. Like his Republican predecessors Taft and Coolidge, Ike was accused of caring more for golf than greatness. The game had come a long way since Teddy Roosevelt cautioned Taft never to play in public. After all, Ike liked golf, and, whatever his failings as president, everybody liked Ike.

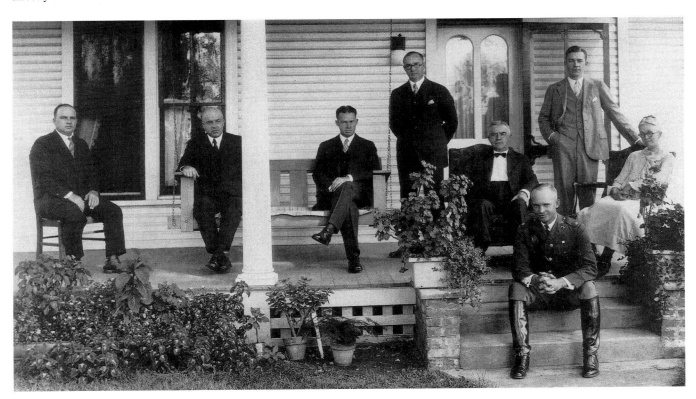

In 1950, before the war hero fell in with the millionaires and metamorphosed as a Republican, even the vituperative Harry Truman liked Ike. That year Truman finally decided to add another coat of varnish to Eisenhower's lustrous image. Ike was named Supreme Commander of the twelve-nation North Atlantic Treaty Organization force in Europe. Thrilled with the appointment, he promptly sent his old Army uniform to the tailor for alterations. His first job outside the military, as president of Columbia University, had proved as ill-fitting as his uniform. Eisenhower's colleagues seemed to regard him as an undereducated, hypocritical fool.

In France, however, he received a hero's welcome—but within days Ike was in trouble again. Without consulting his wife, he had accepted the government's offer of a treasured landmark as his temporary residence in Paris. Set among fountains, statues, sculpted hedges, and vast lawns, the Villa Trianon had once been the home of Marie Antoinette. The magnificent structure was furnished with Louis XIV antiques—enormous ceremonial chests and tables, huge gilt mirrors and crystal chandeliers, priceless rugs, exquisite chairs with straight, high backs upholstered in damask, velvet, and tapestry. Mamie Eisenhower, accustomed to spending her mornings in bed, couldn't imagine sitting for five minutes in one of those chairs.

"MRS. EISENHOWER VETOES GENERAL'S CHOICE...BECAUSE OF FURNITURE," screamed the New York *Herald Tribune*. The page one story, instantly picked up by the French press, drove Mamie into seclusion—but not to the Trianon. She stood her ground and the Eisenhowers moved into a two-story chateau on six landscaped acres in a Paris suburb. Shielded from the road by tall hedges and encircled by a twelve-foot-high iron fence, the Villa St. Pierre, though tastefully appointed, was no monument to art. Mamie could do what she liked with it. She called in the U.S. Army Corps of Engineers.

The fireplace was large and clumsy looking, she thought. The Corps built her a new one, then enlarged the dining room and installed a downstairs kitchen for Ike, who, unlike his wife, enjoyed preparing an occasional meal. Also for Ike, the Corps put in a putting green, and a small cornfield was planted outside the kitchen window, a reminder of home. Fourteen interior decorators collaborated on the decor. Though not banned outright, decorative period pieces were far outnumbered by simple overstuffed sofas and chairs. "I know what you're thinking," Mamie said as she showed a friend her bedroom, its walls freshly painted bright yellow and green and covered with with family photos. "We might as well be in the States."

Having occupied thirty-seven different "homes" in the course of her husband's career, from a rat-infested villa in the Tropics to a cavernous fraternity house at Gettysburg College in Pennsylvania, Mamie Eisenhower knew how she wished to

Having lived as nomads since their marriage, the president and his wife were perfectly content to stay at home.

live. The oldest daughter of John Doud, a prominent Denver businessman, she had grown up in a three-story brick house full of servants and comfortable chairs. Mamie Eisenhower wished to live like Mamie Doud.

She was a pampered, party-loving child of eighteen when she met Ike in San Antonio, Texas. Instantly smitten, the genial lieutenant shrewdly discerned that he must first pay court to the genteel Mrs. Doud—Mamie's mother would not likely be thrilled at the prospect of giving up her pretty daughter to a penniless soldier from Abilene. His deft maneuvering foreshadowed conquests in more challenging arenas. Elivera Doud was enchanted with Ike. After the wedding, in the Doud's living room, she whispered to a guest her only qualm: "Mamie will never have a home of her own."

Their love nest at Fort Sam Houston was hardly more than a corridor on the second floor of a long gray barracks called Infantry Row. Furnished with a bureau and a sagging couch, equipped with gas lighting and a two-burner cooking range, the apartment had no closet space (Mamie's trousseau alone filled a trunk), no electricity, not even a bed. The Eisenhowers had been married a month when Ike received orders to travel to the Mexican border, where Pancho Villa's revolutionaries had attacked U.S. settlements. Mamie was undone. "You're not going to leave me so soon?" she wailed. "Mamie, there's one thing you must always understand," her husband declared. "My country comes first and always will. You come second."

By 1952, as Ike's NATO tour ended and Mamie said good-bye to her French chateau, she was convinced that her mother's prophesy would come true. The Eisenhowers had scoured the Hudson Valley, Connecticut, and northern New Jersey for a summer home, but Mamie found everything "too estate-y." They had given up the hunt and were about to launch Ike's campaign for four years at 1600 Pennsylvania Avenue, when they ran into an old friend who had just bought a house in Gettysburg.

Both Ike and Mamie loved the Pennsylvania countryside. At their friend's suggestion they drove to Gettysburg to inspect a charming property that, unfortunately, wasn't for sale. It took three months and $40,000 to convince dairy farmer Allen Redding to part with his century-old brick home with views of the picturesque valley where Union and Confederate soldiers had clashed in the decisive battle of the Civil War.

Work on "Mamie's Dream House," as the press christened the Gettysburg farm, was delayed while the Eisenhowers campaigned from the rear platform of the train they called "Look Ahead, Neighbor," and delayed again when Mamie took on the White House. A meticulous housekeeper, she was appalled at the grim cubicle where Eleanor Roosevelt and Bess Truman had slept, and on Inauguration Day ordered the twin bed removed to the basement and shelves put up for a dressing room. The

sitting room next door, which adjoined the president's suite, would become Mamie's bedroom. She had it painted pink and a kingsize bed moved in.

As First Lady, Mamie's leisurely routine blended well with the comfortable surroundings she preferred. Ike's routine blended well with Mamie's. The White House staff was keenly disappointed when America's most celebrated couple turned out to be homebodies. The president loved going to movies, which he did faithfully one night a week. The other six, unless some affair of state interfered, the Eisenhowers spent in front of their new color TV. "At last I've got a job where I can stay home nights, "Ike told his friends, "and, by golly, I'm going to stay home."

In the spring of 1953, the First Lady turned her attention to Gettysburg, hiring contractors to make a few minor alterations. The project escalated into a full-scale overhaul when it was discovered that a decaying two-hundred-year-old log cabin formed the core of the house. Mamie hired an architect to draw up plans for a two-story Georgian farmhouse with large wings off the small center brick section.

Finally finished in 1953, Mamie's "Dream House" had a thirty-seven-by-twenty-one-foot living room, an oak-beamed study, a butler's pantry, a small "general's room" for Ike's afternoon naps, four guest bedrooms, and eight baths. The decor was vintage Mamie—"no decorator's dream," as she admitted, but a mix of cozy pieces collected over the years and housewarming gifts that poured in from around the world. From the American people came some $40,000 worth, including several cows and a tractor. As always, Mrs. Eisenhower brooked no professional opinions in the matter of her bedroom. Light green walls set off an orgy of pink—bedspreads, draperies, even the telephone were pink.

During Ike's retirement, the Gettysburg farm overflowed with grandchildren. David Eisenhower was Ike's favorite until his Arabian horse got loose and demolished the putting green. If that episode temporarily soured the relationship, David's marriage to Richard Nixon's daughter Julie nearly killed it. Dwight Eisenhower never much cared for his slippery second-in-command, and may have cost Richard Nixon the presidency in 1960 by withholding his support until Nixon's candidacy was assured. Harry Truman, for one, must have enjoyed the spectacle, having himself been pricked by the fickle finger of Ike a decade before.

Mamie's health was never robust, one reason why she seldom strayed far from her bed. She managed to outlive her husband by ten years, however, and was at his side when, just a few days before he died, he took stock of his affections: "I have always loved my wife. I've always loved my children. I've always loved my grandchildren. And I have always loved my country." It must have been a comfort to know that at long last she came first.

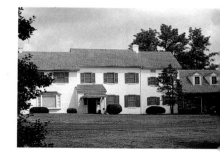

Only the midsection of the original structure could be preserved during renovation of the Gettysburg farm.

The formal dining room and living room at the farm in Gettysburg. "No decorator's dream," as Mamie said, but cozy and comfortable.

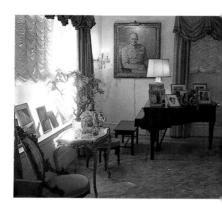

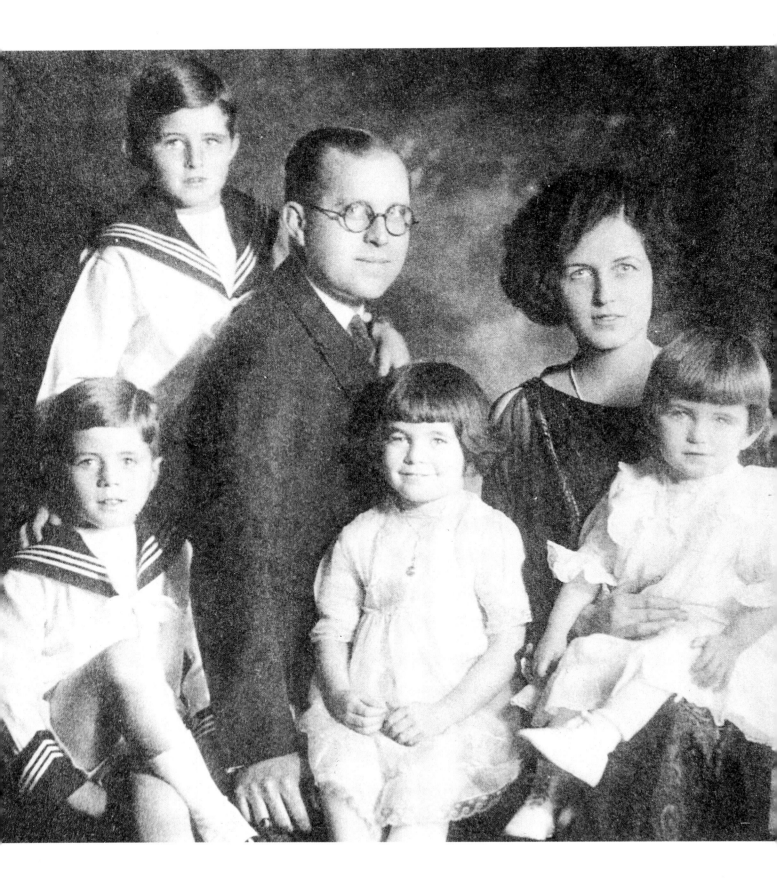

John F. Kennedy, Lyndon B. Johnson

JOE KENNEDY WAS ACCUSTOMED TO LONG separations from his family. Under normal circumstances, he would have relished his independence and the enormous prestige accorded the U.S. ambassador to Britain. Circumstances were far from normal in the fall of 1940. Rose had taken the children home to the States when German tanks rolled into Poland. Now he was alone, abandoned by his family and awash in dread of the coming cataclysm, the war that he believed Britain could not win, that he begged Roosevelt not to join. Isolated by his own isolationism, the ambassador consoled himself with thoughts of the white frame house at Hyannis Port, with its profusion of chimneys and cheerful, green-shuttered windows, its sprawling porches, its breathtaking views of Nantucket Bay.

Joseph P. Kennedy was thirty-eight years old, a millionaire many times over, when he first rented the house on Cape Cod in the summer of 1926. It was a cottage then; Kennedy bought it three years later and over time added bedrooms, bathrooms, pantries, utility rooms, servants quarters, a finished attic, a four-car garage, a sauna and movie theater in the basement, and on the grounds a swimming pool and tennis courts. The enlargements never altered the home's essentially unassuming nature. Inside as well as out it was a friendly house but reserved; well-groomed but never fastidious. Like an indispensable butler, it served its occupants with reassuring civility, constancy, and poise.

Hyannis Port in 1926 was a trove of such houses, shingled or clapboard, comfortable and rambling, rich in character, reeking of class. A quiet village crisscrossed by low stone walls, gnarled hedges, and tidy country lanes, it resembled nearby Cohasset with none of the pretensions. Joe had rented a place in Cohasset the summer before. Even his chauffeured, plum-colored Rolls failed to arouse the admiration of the town's WASP establishment. When Joe applied for membership at the local golf club he was blackballed. "Those narrow-minded bigoted sons of bitches barred me because I was an Irish Catholic and son of a barkeep," he fumed years later. "You can go to Harvard and it doesn't mean a damn thing."

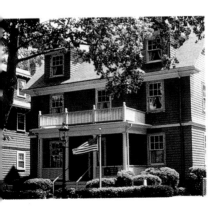

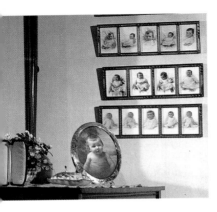

John F. Kennedy's birthplace in Brookline, Massachusetts. The family swiftly outgrew the small gabled house on Beals Street, which had three bedrooms including the master bedroom (above) and one bath.

Overleaf: Joseph P. and Rose Kennedy with five of their nine children: Joseph Jr. (standing behind his father), John, Rosemary, Eunice, and Kathleen.

That same year he pulled up stakes in Brookline. The Boston suburb had been his winter address since 1914 when he married the daughter of Boston mayor John F. Fitzgerald. In 1917 Rose gave birth to her second son, her father's namesake, at 83 Beals Street, a charming but small, gabled house with three bedrooms and one bath. When the Kennedys moved to a larger house on nearby Naples Road, she set up partitions on the front porch, separating the children (now there were six) so they wouldn't "knock each other down or gouge each other in the eyes with toys."

Joe liked to romanticize his own childhood as a triumph of desire over destitution. His father was in fact a shrewd businessman and respected member of the Irish mafia that dominated Boston politics. Yet Joe had felt like an outsider ever since, as a Harvard undergraduate, his characteristically dogged attempt to scale the fortress that was Brahmin society ended in a bruising tumble. "Boston is no place to raise Catholic children," he concluded seventeen years later, his social position having changed not a wit in spite of his millions.

"What is it you *really* want?" a Boston acquaintance asked him as Joe was packing up. Without a pause, Kennedy answered, "Everything." Obsessively ambitious for his children, he loaded them into his private railroad car and shipped the family to New York. Absence proved a tonic for the Kennedy image. When Jack, at age twenty-nine, returned to Boston to run for Congress, he campaigned from a room at the Bellevue Hotel. His opponents called him a carpetbagger, but he won anyway, serving two terms, then staged a spectacular palace coup, upsetting his aristocratic fellow Democrat, Senator Henry Cabot Lodge, and going on to win election handily. A political ally observed, "Jack is the first Irish Catholic Brahmin."

In 1926 he was a skinny, trouble-making nine-year-old. Rose set up temporary housekeeping in a manor beside the Hudson while real estate agents scoured Westchester County for a permanent winter residence. "Joe Kennedy can't use a residence," grumbled one exasperated realtor. "He wants a hotel." Kennedy did spend a lot of time in hotels. He traveled constantly, often to Hollywood, where he soon acquired a motion picture studio, a mansion on Rodeo Drive, and a mistress, the actress Gloria Swanson. He also owned a six-bedroom house in Palm Beach, with its red-tile roof and white stucco walls, a tropical version of Hyannis. Family photos crowded walls and bookshelves in the living room. An adobe cubicle beside the pool was Joe's private sanctuary; the children had to phone him on an inside line to request permission to enter the "Bullpen," where their father conducted his business dealings over an outside line, usually in the nude. Jack delighted in bribing unwary house guests to dial the number, sing a song, and hang up.

Joe Kennedy finally settled in Bronxville, seventeen miles north of New York.

Originally built for Anheuser Busch, the twenty-room, red-brick colonial was encircled by magnificent gardens and manicured lawns sloping to a thickly forested perimeter. There was a cottage for the gardener, another for the chauffeur. A fleet of limousines met Rose and the children at the Bronxville station. A small squadron of nurses, governesses, cooks, maids, and assorted other family retainers filed out of the train, attending to the boisterous clan as bags were transferred from luggage compartment to limos. Shopkeepers watched, fascinated, until the caravan had wended its way to the outskirts of the village and disappeared.

Rose now had twice the family she'd had at Beals Street and four times the staff. Her passion for order had become more pronounced with each birth; it seemed the best offense in a constant war on dirty laundry, broken toys, bloody noses, unacceptable table manners, and dozens of other ills associated with a teeming household. From her father she borrowed the habit of pinning scrawled "reminders" to her clothing. Closets were remodeled to maximize space, and toothbrushes, shoelaces, and other personal items stored in boxes on the topmost shelf until they could be passed on to the next in line. Rose's economies were all the more remarkable in view of her husband's mushrooming net worth. She would not tolerate extravagance, irreverence, or indifference to the family schedule. To ensure prompt attendance at meals, clocks were installed in every room.

Nine Kennedy children called it home, yet a school chum of Jack's remembered that the house in Bronxville seemed always to be empty. "I'd say, 'Where is everybody?' They had either gone to Palm Beach or I don't know where they were. It was creepy. It wasn't homey." "They really didn't have a real home, with their own rooms where they had pictures on the walls or memorabilia on their shelves," said Jack's best friend Lem Billings, "but would rather come home for holidays from their boarding schools and find whatever room was available." Summers at Hyannis Port were no different. A young woman whom Jack entertained at the Cape when his parents were away remembered him stalking the house like a cat burglar, wandering silently from room to room, poking about in his parents' drawers and closets, then, out in the the garage, slipping behind the wheel of his father's Cadillac.

Just as Joe's extravagance brought out the penny-pincher in Rose, so did her husband's infidelities seem to summon the saint. She was determined to "form the habit of making God and religion a part of [the children's] daily lives," she said. Close friends claimed that Rose maintained her air of curiously disinterested composure by stealing away to her private beachhouse to read scripture and meditate. Rose was the disciplinarian, Joe the taskmaster. "My husband likes the boys to win at sports and everything they try," Rose said. "If they don't win, he will discuss their failure

with them, but he doesn't have much patience with the loser." Before a swimming race, Joe would drop onto his knees beside the pool and whisper a warning to whomever was competing that day: "Come in a winner; second place is no good."

Mr. Swinnerton, the family athletic instructor, began morning calisthenics at Hyannis at seven sharp. The wake-up drills were followed by lessons—swimming, sailing, golf, tennis—then lunch, then violently competitive games—tag, kick-the-can, touch football—that raged until dusk. One frequent house guest composed a list of "rules" for touch as played by the Kennedys. "Run madly on every play, and make a lot of noise. Don't appear to have too much fun, though. They'll accuse you of not taking the game seriously enough....Don't criticize the other team, either. It's bound to be full of Kennedys too, and the Kennedys don't like that sort of thing....To show raw guts, fall on your face now and then. Smash into the house once in a while going after a pass. Laugh off a twisted ankle or a big hole torn in your best suit. They like this."

The competition wasn't limited to the playing fields. The Kennedys loved party games, especially charades and anything having to do with politics. Current affairs were *the* topic of conversation at the "big" table, where the older children, Joe, Jr., Jack, Kathleen, and sometimes Eunice, sat with their parents while Bobby, Jean, Pat, and Teddy, exiled to the "little" table with the governess, sulked. Joe, Sr., quizzed and lectured the children endlessly, and on weekends would lead them in reenactment of some famous historic event. Everyone—guests included—was assigned a part, and every performance savagely critiqued.

Of all the children, Jack probably had the most grueling childhood, and the most to gain from its hard lessons. Plagued by chronic illness and constantly bullied by his older brother, Jack learned early to settle his own scores, compensating for his frail physique by building reserves of stoicism and wit. When a mysterious blood disease landed him in the hospital, Kennedy dashed off a note to a friend: "They haven't found anything yet except that I have leukemia and agianalecucytosis. Took a peek at my chart yesterday and could see that they were mentally measuring me for a coffin. Eat, drink, and make love as tomorrow or next week we attend my funeral."

In the Thirties Joe had purchased a powerful friendship; in return for his generous financial support FDR named him chairman of the newly established Securities and Exchange Commission. "Mr. Kennedy, former speculator and pool operator, will now curb speculation and prohibit pools," wrote a cynic on the staff of *Newsweek*. In 1938 Roosevelt sent Kennedy to London as ambassador to the Court of St. James,

and three years later ordered him home. Kennedy was denounced in the press as a Nazi sympathizer and a coward— but his sons talked of nothing but joining the fight.

His own presidential ambitions ruined by war, Joe was more determined than ever to put a Kennedy in the White House. He had brought his children up to be winners; his first born son had never let him down. In 1944, when young Joe was shot down over England and killed, Jack unquestioningly donned the mantle of his father's dreams, astonishing everyone with his persistance and political astuteness. By 1953 the senator from Massachusetts was a presidential hopeful; soon he would be a contender. He needed a wife.

Jack is said to have fallen in love with Jackie over a word game at which he particularly excelled. She won. "Jackie always gave him a good match," Lem Billings recalled. "That's one of the things Jack liked best." At the time, Washington's most eligible bachelor was living in a Georgetown townhouse with his sister Eunice, who had been dispatched by Rose to run the household, at any rate to see that Jack changed his clothes. Tidiness was never part of the Kennedy ethos; her boys had more important things to learn than how to make a bed, Rose always said. Unused to managing a closet, Jack tossed his wrinkled shirts and food-stained ties over chairs, his underwear and socks under them. The columnist Joseph Alsop claimed to have once discovered a half-eaten hamburger behind some books on the mantel.

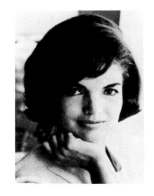

"I brought a certain amount of order to his life," Jackie said. "We had good food in our house—not merely the bare staples that he used to have. He no longer went out in the morning with one brown shoe and one black shoe on. His clothes got pressed and he got to the airport without a mad rush because I packed for him." There was something poignant, even pathetic, in such declarations of purpose. Politics bored her, so the senator's wife compensated by bringing "order" to his domestic life.

A few months after their marriage in 1953, Jack presented his wife with a three-story, white brick mansion called Hickory Hill. Situated just across the Potomac River from McLean, Virginia, the Georgian estate had for a time served as General George McClellan's Civil War headquarters. A passionate preservationist, Jackie plunged into an ambitious restoration project, buying antiques by the lot, changing the kitchen wallpaper three times in one month. Jack complained that he felt like "a transient."

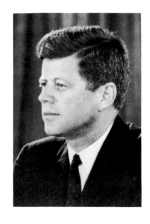

Jack Kennedy is said to have fallen in love with Jackie over a word game. She won.

Jackie complained that she felt like a widow. Politics was "the enemy," she said. "We had no home life whatsoever." She spent months decorating the nursery, and when her baby daughter was born dead, Jackie blamed her husband. He had left

her, seven months pregnant, to join Joe at his rented villa on the Riviera. Fresh from a rare defeat, for the vice presidential nomination, Jack arrived in a foul humor which swiftly dissipated as the trip degenerated into a bacchanale. Three days after he received word of the miscarriage, Jack managed to pry himself away. Jackie refused to speak to him until Joe intervened to save the marriage.

If it weren't for her devotion to her father-in-law, Jackie might have named him the enemy instead of politics. Jack's affection for his wife and children never superseded his loyalty to "the clan." Jack and Bobby bought homes on either side of Joe's at Hyannis Port, architectural clones of the Big House. Linked by the expanse of lawn that served as the athletic field, the three houses became known as the Kennedy Compound. Jack's sisters, Eunice, Pat, and Jean, and brother Ted also lived in the neighborhood. Hyannis was to Jack Kennedy what Hyde Park was to FDR. It was home.

Jackie despaired of ever having children, and bitterly announced that the huge house in Virginia more properly belonged to her fecund sister-in-law, Ethel. Bobby bought Hickory Hill in 1957. Jackie directed her decorators to 3307 North N Street in Georgetown, a lovely townhouse with a double drawing room and extensive gardens in back. A friend who visited her in Georgetown marveled at the "rows and rows of beige shoes" in her closets. Jackie had "at least 25 lipsticks in a gold lipstick holder on her dresser. She could spend a whole afternoon in front of the mirror with a lipstick brush and make-up. She had a drawer for short gloves, and a drawer for long gloves and special lingerie bags for nylons, and catalogues and scrapbooks for everything.... With all that household help to do the big things for her, Jackie

Kennedys gather at family headquarters, Joe's sprawling home at Hyannis Port (right).

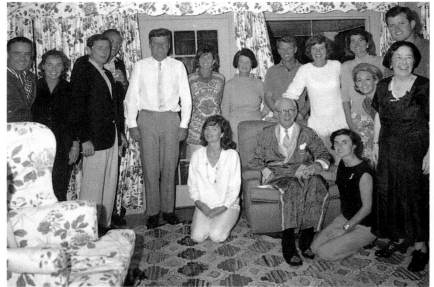
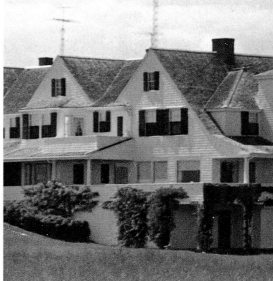

concentrated on niggling little details like picking out the right shade of off-white paint for her dining room walls, painting stencils on the floor, selecting frames for her paintings, and rearranging furniture, which she seemed to do constantly."

The Kennedys sold the house when Jack became president in 1960. It changed hands again shortly after his assassination. "God, that enrages me," Jackie said when she heard the sale price. "They're going to make $120,000 on the deal because it was our house."

The oldest daughter of a dashing French rogue nicknamed "Black Jack" Bouvier, Jackie was an American Marie Antoinette. At the White House she served French food and wines. When she was honored as First Lady of Fashion, her husband exploded. "I can see it now," he said. "The New Frontier is going to be sabotaged by a bunch of goddamned French couturiers." Sister Parish was summoned from New York to redo the White House family quarters. "Let's have lots of chintz and gay up this old dump," Jackie instructed her. Stephan Boudin, head of a prestigious French design firm, was called in from Paris to redo everything else. The new, improved White House was opened to the public—for one hour on CBS. Forty-six million Americans tuned in.

Liberal intellectuals were enthralled with the new regime. The youngest and most stylish president in history succeeded the oldest and stodgiest. When Jack described the challenging landscape of his New Frontier, calling for action on festering domestic issues such as civil rights, and a coherent foreign policy, Harvard academics responded as though the rhetoric were divinely inspired. When Jackie blasted her new home's "seasick green curtains" and "Pullman car ashtrays," the "eyesore ornamentation" and "Mamie's ghastly pink," the establishment press snickered its approval. As the myth of Camelot took hold in the public imagination, Joe Kennedy reveled in the inevitable comparisons to British royalty.

Conspicuous in the charmed circle of Kennedy advisors—the Sorensons, MacNamaras, Bundys, Kennedys, Shrivers, Salingers, and Rusks—was a knight errant with more political experience than any of them. Vice President Lyndon Johnson was Kennedy's concession to the hard realities of the legislative process. Like Kennedy, Johnson was a political hybrid, a man of hard-boiled conservative means justifying heartfelt liberal ends. Unlike Kennedy he was vulgar, oafish, outspoken, cruel. He was also the most ambitious man in Washington.

Lyndon Johnson was an extreme personality, and a paradoxical one. Few people ever claimed to understand him. Even his old, old friends, the ones who remember how he used to chafe and scheme against the grinding poverty they all endured

growing up in the central Texas hills, even they were puzzled as to what was "always eatin' Lyndon." Their memories of the gangly, floppy-eared youth are as vivid as the blue sky for which the hill country is famous. But while some recall a brilliantly clever boy, always the youngest on the team and the smartest in the class, others remember Lyndon Johnson as a malevolent clod, forever barking out orders to his mother and anyone else who let him.

They felt sorry for him, but they couldn't help teasing him either, the way he strutted and preened himself, tucking his pants in at the knee to show off the fancy boots he wore, parting his hair in the middle and slicking it back with Sta-comb hair pomade; the way he carried on when his father, Sam, brought out the razor strop (there were precious few red marks to show for all that wailing and moaning—Sam wasn't nearly as tough as Lyndon made him out); and the way Lyndon Johnson bragged.

Lyndon was so full of it, in college they called him Bull. He attended Southwest Teachers College, a few hundred miles south of Johnson City. The nickname stuck even after he'd single-handedly upended the campus political hierarchy, putting his enemies on the bottom and himself on top. Politics was in the Johnson blood. Both his father and grandfather had served in the Texas legislature and he was still an infant when Big Sam, his grandfather, started referring to him as "the future U.S. senator." Lyndon's teaching career was brief but memorable; he loved his students and pushed them hard, even as he plotted his escape. "I was raised down there at the legislature, playing around my daddy's desk," Lyndon told fellow teachers in Pearsall, Texas. It was only natural, he said, that he should entertain presidential aspirations. It was only natural, too, that his colleagues might judge him "kind of off," as one of them put it, and tend to look the other way when they saw him coming.

One who believed in Lyndon was his college sweetheart, Carol Davis, a wealthy banker's daughter who planned to marry the campus radical until her ultra-conservative father intervened. Her mistake was inviting Lyndon home for dinner. Lyndon devoured three helpings of everything, got drunk, and delivered his unabridged autobiography. Then he got onto politics. Carol's father "hated everything about me," Lyndon said afterwards.

Later that night Carol appeared at Lyndon's door, her face red and swollen from crying, to tell him that her heart was true; she still intended to be his wife. But Lyndon's ardor had been savagely uprooted by the banker's contempt. Where love once bloomed, bitter resentment had taken root. "I wouldn't marry you or anyone else in your whole damned family," Lyndon declared, "...and you can tell your daddy that someday I'll be president of this country."

Lyndon Johnson grew up poor, but then so did most everyone else in the hill country. What set the Johnsons apart, at least in their own minds, was their heritage. Lyndon's mother, Rebekah Baines Johnson, traced her family back to Kentucky aristocracy, preachers and planters lured westward by the promise of virgin soil. Rebekah's father arrived in 1900, setting up a law practice in the town of Blanco and investing his earnings in farmland. His brother blamed "over-kindness" to tenant farmers and "overconfidence in men" generally for Joe Baines's reversals, which in just four years' time ruined his health and forced him to sell his house in Blanco. He died in nearby Fredericksburg in 1906.

A generous nature may have sped the decline, but Baines's true nemesis was his adopted home. With its waist-high grass and dense forests, the hill country seemed like paradise to those who braved the fierce Commanches to establish the first white settlements. All that vegetation turned out to be a gorgeous ruse. The Indians had lived off the wildlife, not the land. After farmers and cattle ranchers replaced the hunters, stripping the soil of its protective cover, the truth about the Texas hills slowly came to light: underneath those abundant grasses was a thick layer of limestone. Nature had labored a thousand years to create the shimmering mirage. It vanished in a matter of decades.

The boom-to-bust syndrome was Lyndon Johnson's birthright on both sides. For nearly ten years, the decade after the Civil War, Lyndon's grandfather had been a very wealthy man; bankers branded Big Sam a rustler only after he couldn't pay back their loans financing expansion of the biggest cattle operation in the region. He and his brother, Tom, had bought the ranch on the Pedernales River in 1867, when longhorns were cheap and the grass was high. Given to extravagance and the grandiose gesture (another durable Johnson trait), Tom presented Sam's bride, Eliza, with a silver-trimmed carriage and a pair of matched Kentucky thoroughbreds as a wedding gift. By 1870 the Johnson pens extended for miles along the riverbank.

"The year 1871 set in cold, sleety, and disagreeable," a local historian wrote. Spring brought a severe drought. The Johnsons' cattle were thin and sickly when they started out on the long drive north, half-starved when they arrived to find the pens at Abilene overflowing, and prices at a record low. Forced to sell at the bottom of the market, the brothers lost everything.

Lyndon got his big dreams from the Johnsons, but he had his grandmother's big ears and dark eyes, and the Bunton nose for a bargain. Stripped of their vast fortune, Sam and Eliza accepted a loan from her father to buy a small farm on the plains. After a few good years, Sam started selling off pieces of it. Finally he put the farm and Tom's wedding present up for sale and moved to a 433-acre farm on the Peder-

The Johnson settlement
in the Texas hill country.

nales. In 1888 the worst drought in hill country history welcomed them home.

Sam Johnson, Jr., was the fifth of their nine children. He brought Rebekah Baines from Fredericksburg to the banks of the Pedernales in August 1907. Rebekah had known only "gracious hospitality...and beautiful ideals" as a girl. "I love to think of our home, a two-story rock house with a fruitful orchard of perfectly spaced trees...."

This she traded for a ramshackle structure consisting of two twelve-foot-square rooms on either side of a breezeway. The walls, formed by vertical boards that Sam had painted bright yellow for the homecoming, were full of holes. Hill country folks called this style of architecture the "dog-run," on account of the breezeway. The roof sagged under the weight of a lean-to style porch tacked onto one of the rooms; propped up against the other was a makeshift kitchen that housed the enemy: Sam's monster cooking stove. (Rebekah was a good cook, but there was no call for gourmet cuisine in the hill country, and she never seemed to come away unscathed from a bout with that stove.) The Pedernales River, filthy and unpicturesque, meandered like a drunk through the yard, which was mostly dirt with a few clumps of grass growing here and there. There was a crude shelter for animals in back, not far from the "two-holer" toilet.

A single strand of barbed wire mounted to wooden posts ringed the premises. As Sam pushed open the gate, Rebekah must have wondered how she would survive a night here, let alone a life. From Sam's desolate hilltop she could not make out another structure on the horizon; as dusk settled, it was as though a heavy shawl had been draped over the little house.

Her neighbors accused her of putting on airs when she served meals on table linen, instead of the customary oilcloth. Rebekah didn't deny it. Lyndon was born August 27, 1908. In the big bed beside the fireplace, Rebekah labored all through the night as a fierce storm whipped the Pedernales into a frenzy and almost tore the sycamore trees from its banks.

Grandfather Sam lived just up the road. He and his son worked the 433 acres together. "I remember walking along the banks of the Pedernales when I was four, five years of age," Lyndon said, "hearing my grandfather talk about the plight of the tenant farmer, the necessity for the worker to have protection for bargaining, the need for improvement of our transportation to get the farmer out of the mud with blacktop roads."

Lyndon had a habit of "wandering off" as a toddler, sometimes to his grandfather's, other times toward his cousins' who lived upriver about a mile, near the tiny town of Stonewall. Sam's sister had married well. Clarence Martin, a rancher

and judge, had once defeated Big Sam in a run for the legislature. Most years the Johnsons went to the Martins' house for Christmas. It seemed to Lyndon that every year the house grew by another couple of rooms; Uncle Clarence and Aunt Frank were forever fussing with it, adding fancy stonework or a new fireplace. "This was *the* big house on the river," Lyndon told reporters when he bought the place in 1951 and named it the LBJ Ranch.

Lyndon may have inherited his wanderlust from Sam, Jr., who hated farming and looked for any excuse to hit the road. Politics offered an excellent excuse. As a state legislator Sam spent more and more time in Austin, sometimes bringing Lyndon along. When the boy was five Sam moved the family to Johnson City and set up a real estate office. These were happy years. They lived in a cozy, white frame house with two bedrooms, a living-dining room with a big fireplace, a kitchen, and a screened-in back porch.

Every afternoon Lyndon climbed onto the porch swing and listened to his father talk politics. Every evening Lyndon crouched beneath his bedroom window and listened to his father talk politics some more. The topic never got stale for Sam, or any Johnson. Political discussions were their favorite form of entertainment, political campaigns their favorite form of exercise, political strategies their favorite form of art. "If you can't go into a room and tell at once who is for you and who isn't," Sam told Lyndon, "you should stay out of politics."

Unfortunately, for Sam Johnson politics didn't pay. "Straight as a shingle," his colleagues in the legislature always called him. Some praised his integrity, others thought him a fool. The more Lyndon learned about politics, the more he tended to take the latter view. He would hold public office for thirty years and die a multimillionaire, having amassed fortunes in real estate, ranching, broadcasting, and oil.

In 1918 the Johnsons were considered one of the "big three " families in town. Then Big Sam died and his son took over the family farm. In 1919 the *Blanco County Record* declared it "one of the largest and best farms" in the region. Three years later it was gone. "We had dropped to the bottom of the heap," Lyndon said. "As a boy...I saw my own home place sold because cotton dropped from forty cents to six."

Confused, humiliated, and bitter, young Lyndon turned against his father. Sam turned to drink. Rebekah, more frail than ever yet too poor to hire household help, turned to her mother. "That boy Lyndon is going to wind up in the penitentiary— just mark my words" was the refrain that always accompanied Grandmother Baines on her frequent visits to Johnson City in the 1920s. Lyndon seemed hell bent on proving her right. Rebekah believed there was one clear alternative to prison—

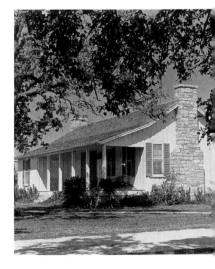

Lyndon was proud of his humble beginnings, so proud he had his boyhood home moved from Johnson City to the LBJ Ranch.

As gentle and soft-spoken as her husband was flamboyant and bombastic, Lady Bird knew that life with LBJ would never be dull.

college. Finally her arguments wore him down. In 1927, Lyndon thumbed a ride to San Marcos, Texas, and entered Southwest State Teachers' freshman class.

To Lela Martin growing up, Lyndon Johnson was just another "poor relation" who visited on holidays. In 1948 he was a rich and powerful U.S. senator, plotting to snatch away her family home.

Lela and her husband, Tom, had an agreement with her parents dating back to 1934. The Martins would leave them the house if Tom and Lela would care for them until they died. When Clarence passed away and then Tom, Lela took a job in Austin to help support her mother. In 1948 she learned that Mrs. Martin (Lyndon's Aunt Frank) had paid her own taxes that year, on the advice of a lawyer who, mysteriously, had offered his services free of charge. The lawyer also counseled Mrs. Martin to sue her daughter to regain sole possession of the house. Baffled by the turn of events, Lela countersued. The jury sided with her, but the appeals judge overturned their decision on a technicality, whereupon Mrs. Martin sold the 350-acre ranch to Lyndon.

Lyndon had been commuting between Austin and Washington since 1932. After eight years of marriage and four miscarriages, Lady Bird (Lyndon always called her Bird), longed for "the security of a real home." The home she had in mind was a two-story colonial just off Connecticut Avenue. Lyndon put in an absurdly low offer. As her husband haggled, Bird fumed. "I want that house!" she cried, storming into his office one day. "Every woman wants a home of her own. I've lived out of a suitcase since we've been married. I have no home to look forward to. I have no children to look forward to. I have nothing to look forward to but another election." Stunned, Lyndon turned to his aide, "What should I do?" he asked. "I'd buy that house," the aide replied.

With the help of Bird's aunt, the Johnsons bought the house for $18,000. It seemed to bring them luck. In 1944 they had their first child, Lynda. Luci arrived three years later. Bird's defenses were down when Lyndon started talking about his dream of planting roots back home in the hill country.

"I almost should have foreseen it,...[but] I wasn't intuitive enough," she said after Lyndon took her to see the old Martin place for the first time. He had told her only that were going on a pleasure trip. It started out pleasurably enough; after visiting several luxury ranches in the area they took a detour, crossing the Pedernales and passing by a crater-sized erosion ditch. Just beyond the ditch sat a stone house— "*the* big house on the river."

For once Lyndon's elaborate scheming backfired. "How could you *possibly* do this to me?" his wife cried. To Lady Bird the house wasn't big at all; it was cramped,

dark, and deteriorating almost before her eyes. "It reminded me of the Addams cartoons....There were even actually bats up under close to the chimney up there....I was aghast!" But there was no arguing with Lyndon once his mind was taken over by a vision. And the vision of "*the* big house" had haunted him since his youth. Where Lady Bird saw bats and cobwebs, Lyndon saw vats of egg eggnog and a giant Christmas tree, Uncle Clarence handing out candy apples, and a tiny, dark-eyed boy in a ruffled collar leaning against his mother's outstretched arm, reciting poetry on the raised apron of the stone fireplace.

"He would get so enthusiastic when he talked about it...and my goodness, you really couldn't squelch that kind of enthusiasm," Lady Bird said. He still owned his parents' house in Johnson City. Mrs. Martin moved in there, and Lyndon sent her a check every month to cover her expenses. He also bought the tiny cottage he was born in, and years later moved both boyhood homes to the ranch as part of the Lyndon Baines Johnson National Historic Site.

He paid $20,000 for the Martin ranch. The banker who loaned him the down payment cautioned Lyndon not to expect the ranch to pay for itself, but "if you're going to play cowboy and stomp in boots around the post office on Saturday, I'm not going to interfere." Lyndon played cowboy to the hilt. The spirit of Uncle Clarence was removed from the house just as Aunt Frank had been removed in the flesh. It became "the house my granddaddy built."

Lyndon stocked the LBJ Ranch with sheep and cattle, and had 200 acres planted with winter oats. "You couldn't see the river," Lyndon said. "It had grown up in underbrush and shin-oaks and old weeds, sunflowers." What was needed was a dam. Lyndon called in mining engineers to make him a swimming hole. When some farmers downriver complained that the dam had reduced their water supply, Johnson replied that his "beautiful little lake" was partly fed by wells he had dug, so those farmers were actually getting more water then before. While tree surgeons pruned back the ailing shade trees, architects drew up plans for an addition. The eighteen-inch-thick limestone walls remained intact. The house sprouted five rooms, including a first-floor master bedroom that opened onto a swimming pool. Famous people who came to visit scratched their names in the concrete steps.

"You would be staggered if I told you how little it cost," Lady Bird told a biographer after Lyndon died. "But it enabled us to have a big comfortable house that meant a lot to him, to his spirit and his heart."

John F. Kennedy came to visit in 1960.
Lyndon drove out to his private airstrip in an open white convertible to meet the

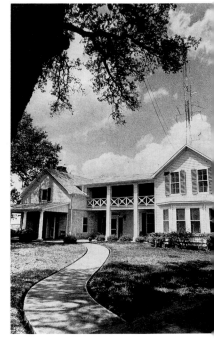

Lyndon thought of the LBJ Ranch as his ancestral home, and in a way it was.

man who had robbed him of the presidency. Determined to set aside his jealousy, he planned to show the young senator from Massachusetts some real Texas hospitality. Just as he always did when company came, Lyndon started with a tour of the grounds. "We're down here by Grandpap's house, near the old graveyard," he yelled into the car radiophone as a light rain began to fall. In the shelter of by his wide-rimmed Stetson, Lyndon didn't seem to notice.

Back at the house there was a party going on. Lady Bird greeted Senator Kennedy with a plate piled high with barbecued ribs, and a slew of gifts: ashtrays decorated with a map of Texas, cookies cut in the shape of Texas, dishes with the state's image baked into the finish. Lyndon's steady stream of instructions to the staff, mixed with Muzak piped in from his Austin radio station, blared over loudspeakers placed in the old oak tree, beside the swimming pool, by the guest house, at the foreman's house, and out in the corrals.

The next morning Kennedy awoke at dawn to the strains of Lyndon's voice booming out orders for the deer hunt. After a breakfast of venison sausage, Kennedy was

The living room of the LBJ Ranch.

piled into the front seat of the white convertible and a rifle shoved in his hands. All morning the hunting party—a caravan of Cadillacs and Lincoln Continentals—roared through the foothills and by noon Kennedy had himself a deer. "Ya got him, ya got him," someone yelled. Jack was mystified. "If I got him," he recalled, "I certainly didn't aim. But there on the ground lay that dead deer."

While the candidates tracked their quarry, reporters were rounded up and herded onto a bus. Bird had planned a tour of her own. As the bus rumbled along the dirt roads, she stood up front with a microphone, pointing with pride to the prize Herefords and the Johnson gravestones in the cemetery; the schoolhouse and the boyhood homes; and in Johnson City, Furr's Cafe, home of the Furrburger, the potlicker, cracklin' bread, and the best fried jack rabbit in all of Texas.

That evening a battered presidential candidate read a brief statement to a bewildered press corps: "It is my belief that Senator Johnson's great talents and experience equip him to be the most effective Vice President in our history."

Four years later they were calling the old Martin place the Texas White House.

Richard Nixon paid a visit shortly after his election in 1968.

Richard M. Nixon, Gerald R. Ford

I have never thought much of the notion that the presidency makes a man presidential. What has given the presidency its vitality is that each man remains distinctive. His abilities become more obvious, and his faults become more glaring....

—The Memoirs of Richard Nixon

THE FORMER PRESIDENT WAS THREE YEARS out of office and a few hundred pages from completing his monumental life history when he wrote this passage. Had the solitude of San Clemente forged a truce among his own abilities and strengths, the several Richard Nixons competing for his soul? Was "the divided man," as more than one biographer has described him, at last becoming whole? Was he about to confess to the crime that had cost him the White House, and the place that mattered even more to him, his place "among the giants" of American history? Was he going to ask forgiveness? He was not. "The presidency is a magnifying glass," Nixon went on. "I thought that Jerry Ford would measure up well under that magnification."

It seems that Richard Nixon truly believed he was innocent of obstructing justice in the Watergate affair. When General Vernon Walters came to visit him at San Clemente, the former president asked his old friend a question he had been afraid to put to anyone else. "General," he said, "What did I do wrong?" Nixon's family had implored him to fight on through impeachment, but that, he knew, would forever obscure the triumphs of his presidency—renewal of relations with Red China, the end of the Vietnam War. Though his heart was broken, his political instincts remained keen and agile. When the timing was right, when the politicians had moved on to more pressing issues and the media to more powerful victims, he would take his case before the people. In televised interviews, in personal appearances, and in books, he would rebuild the reputation so painstakingly crafted over thirty years of public service, and so swiftly shattered by a band of bungling second-story men.

Politics is war, Nixon told a reporter in 1954, after his nationally televised defense against charges that he had been improperly dipping into a campaign slush fund.

The Nixons were hardly big spenders then. During his vice presidency their Washington home was furnished with a secondhand circular couch and draperies "borrowed" from their house in Whittier, California. Over time, though, the political warrior learned to savor the spoils of victory. As president he jetted among nine personal offices across the country and ordered $17 million worth of improvements for his retreats in California and Florida.

At San Clemente Nixon liked to turn up the air conditioner and lounge before a crackling fire. Perched high atop a cliff overlooking the Pacific Ocean, the white stucco villa had been built by a Los Angeles land baron in the Twenties. The single-story structure had towers at the corners and a courtyard at the center, high, beamed ceilings, ceramic tile floors, and massive furniture. Its tall arched windows offered views so breathtaking that the president found it impossible to concentrate unless he turned his back to them. Nixon bought the house for $1.5 million in 1969 in a complicated transaction. His friend Robert Abplanalp loaned him the $625,000 down payment; Nixon kept 5.9 acres for himself, and sold an adjoining parcel to Abplanalp and Nixon's best friend, Charles "Bebe" Rebozo, for $1.2 million.

(After the resignation Nixon shrewdly parlayed his notoriety into millions in real estate profits. In 1979 he sold La Casa Pacifica for $2 million and moved to a four-story townhouse in Manhattan, for which he paid $750,000. Dismayed to discover a marijuana cigarette on the steps, he promptly sold the townhouse to the Syrian government, which installed its United Nations ambassador there. Sale price: $2.6 million. The Nixons then purchased a four-acre estate in Saddle River, New Jersey. Nixon paid $1 million for the seven-bedroom home. When it went on the market briefly in 1985 the asking price was $2 million. The modern brick house has a mansard-style roof and seven bedrooms, a swimming pool, tennis courts, and a vast wine cellar. Nixon loved good wine; at White House functions the staff served $6 bottles to guests, while the presidential glass was always filled with $30-a-bottle vintages concealed in an unmarked carafe.)

During the early months of Nixon's exile, thousands of tourists arrived in San Clemente each day, their cars backed up for miles along the Avenida del Presidente. Most were content to stare at the tall iron gate, flanked by giant cypress and palm trees, that swung open in a remote-controlled arc, slow and soundless, revealing nothing. But there were always a few "kooks," as Nixon called them, who required a closer view and had to be removed. One who made it inside brought surgical tools. He wanted the president's permission to castrate himself, he said.

Nixon passed through the iron gates two or three times a week. The former First Lady never emerged. La Casa Pacifica, "the peaceful house," had become her prison.

Overleaf: Richard and Pat Nixon in the huge living room of La Casa Pacifica in San Clemente. After the resignation the former First Lady lived in the enormous house as though it were a prison.

Pat Nixon entertained no illusions about her place in history. It was she who installed the crisply uniformed honor guard, the Marine band that struck up "Hail to the Chief" on Nixon's every public entrance. Her greatest achievement, she believed, was the restoration of the White House to the classical ideal that had inspired its architects and earliest occupants. "Mrs. Nixon knew precisely what she wanted," said then White House Curator Clement Conger, "and every change…was the right one." All that had been forgotten in the final days.

Pat and Richard Nixon were much alike: hard-working and reticent, even reclusive. "The silent patriot," Henry Kissinger called her, "…speaking only when spoken to, and not sullying the cigar smoke with her personal opinions." In the first few months after the resignation, as Pat wrestled with despair and a crippling resentment, relations between the Nixons were strained and communication confined to perfunctory notes shuttled from her bedroom to his by Richard's personal secretary.

Still, she loved him. Just before leaving the White House Pat had gathered a few of the president's favorite possessions and packed them in a crate. As Nixon prepared for bed on his first night in San Clemente, he noticed that his things had been carefully arranged about the room. In his study, the presidential "hot line" to other world leaders had been removed; now, on the same shelf in the corner, there stood an eight-by-ten-inch frame containing a poem written on ruled paper in a childish hand.

Helping others to live,
Willing to give, his life,
For his beloved country.
That's my dad.
　　　　　Love, Julie

On election day, 1960, Nixon voted in his hometown of Whittier, California, but he unpacked his suitcase that night in the Royal Suite of the Ambassador Hotel in Los Angeles. "His campaign had been based on home talk," Theodore H. White wrote in *The Making of the President 1960*. "But he had no real home except wherever his wife was; he was a stranger, even here in California, seeking home and friendship." While the vice president brooded in a garish hotel boudoir, amidst bronze furniture "said to be of Siamese motif,…ending his campaign as he had begun—as a guest," his opponent tossed a football and frolicked on the beach, warmly ensconced in the womb of Hyannis Port, at once the symbol of America's Yankee heritage and the reality of a happy home.

It wasn't a fair comparison. Kennedy was born into wealth, power, and privilege. Nixon was born in a house his father built. There were two main rooms downstairs, a truncated second story where the younger boys slept, and a lean-to addition off to one side. Two of his brothers died in that first floor bedroom.

Nixon's mother, Hannah, was a Quaker and a college graduate. Frank Nixon, who never got beyond grade school, moved in with Hannah's family after their marriage. His father-in-law helped Frank buy land for a lemon grove. Richard arrived in 1913, the first citizen of the newly incorporated village of Yorba Linda. Diligent and proud, Frank struggled to wring a living out of his ten-acre plot. The young trees clung to a crumbly, barren slope where only weeds and desert plants had grown before. Rainfall was unpredictable and ran off the hill into a yawning irrigation ditch. Finally, in 1918, Frank surrendered to the forces of nature and the laws of gravity. He built a gas station on the road from Whittier to La Habra and later a grocery store.

Everyone who knew her said Hannah Nixon had the disposition of a saint. Frank had a temper. Sales at the Nixon Market fell off sharply when he ran the cash register, so leery were the neighbors of getting snarled up in a ferocious argument. Frank and Hannah struck a deal: he would butcher the meat and buy the merchandise, she would run the store. Every day at closing time Hannah scooped all the overripe fruit out of the storage bins, mixing it with sugar and cornstarch for pies; the next morning she would be up before the sun to bake them fresh for her customers. She worked six days a week and so did her boys. Richard ran the produce counter, rising even before his mother to drive the twelve miles to the Los Angeles market. On Sundays the family went to church, twice in the morning, once in the afternoon, and again at night.

Frank never got out from under his reputation as a man who had married above himself. Richard respected his father, but he was determined not to take after him. Just as he fought to suppress the violent temper he knew was his birthright, muzzling frustration in a soft-spoken reserve and cloying courteousness, he also avoided the menial tasks at which his father excelled. He practiced piano for hours each day and stayed up late reading. Even in grade school Richard made a lasting impression on his teachers; he was the unsmiling child, solitary and competitive, with a "mind like a blotter." His brother Harold was as fun-loving as Richard was intense. Harold couldn't resist teasing his grim little playmate. "I was the biggest cry baby in Yorba Linda," Nixon admitted. "My dad could hear me even with the tractor running."

Fate seemed set on flattening Frank Nixon's defiant spirit. "We have a picture in our home which money could not buy," Richard wrote at seventeen, just after his younger brother died of an undiagnosed sleeping disorder. "The first thing we notice,

perhaps, is that this particular boy has unusually beautiful eyes, black eyes which seem to sparkle with hidden fire....Money could not buy that picture, for it was the last one ever taken of my brother Arthur."

Arthur's illness and the tuberculosis Harold battled for five years almost bankrupted the family. Frank sold off half his land and Hannah set up a home for tubercular children. Richard got part-time work in an oil field. As the country slid into the Depression, Frank refused to let loyal customers, now destitute, go without the most basic necessities. He knew they would pay him back when they could. But for the vagrants who passed through town he had no sympathy. All his life he would rail against any government program, beginning with the New Deal, that smacked of socialism.

Harold died on his mother's birthday. "From that time on it seemed that [Richard] was trying to be three sons in one," Hannah remembered, "striving even harder than ever before to make up to his father and me for our loss."

Somehow the Nixons scraped together enough to send Richard to Whittier College. He became "a big man on campus" without really making close friends, cramming his schedule with extracurricular activities—student government, glee club, debate team, drama club, football. Nixon served four years as a human tackling dummy for the team, but never made varsity; his teammates called him "the punching bag." "Oh my gosh, did he take it," one recalled. "Why he went out for four years is beyond me." Nixon's football coach knew why. Coach Newman was a lot like Frank Nixon, Richard later wrote. "There were no excuses for failure...He said, You know what a good loser it? It's somebody who hates to lose and who gets up and comes back and fights again...there are a great deal of similarities between the game of football and the game of politics."

Richard Nixon first proposed marriage to Pat on the day they met.

The campus paper observed that Nixon was "a quiet chap about campus, but get him on a platform with a pitcher of water and a table to pound on and he will orate for hours." It was his drama coach who taught Nixon how to cry. Thirteen years later, seeing a picture of the vice president weeping after the "Checkers" speech, he cried, "That's my boy! That's my actor!"

Hannah always claimed that Richard's yen for politics had been sparked by indignation over the Teapot Dome scandal. "One evening Richard was lying on the floor," she recalled, "the newspaper spread out around him, reading about the corrupt officials and attorneys who had been dominating the headlines. Suddenly he looked up and solemnly announced, 'Mother, I just made up my mind: I'm going to be a lawyer—a lawyer who can't be bought by crooks.' "

He won a scholarship to Duke University Law School, where for the first few

weeks he inhabited an abandoned toolshed in the woods off campus. Nixon lined the eight-by-twelve-foot shed with corrugated cardboard for warmth and stored his razor and toothbrush in his athletic locker. Eventually he and three other scholarship students rented "a one-room clapboard shack without heat and inside plumbing, in which the four of us shared two large brass beds…We called the place Whippoorwill Manor, and we had a great time there."

Rejected by the top East Coast firms, he resumed his job search in California, ending up a junior partner in a firm back home in Whittier, where he was introduced to his future wife. He proposed that very day, renewing the offer on a regular basis for two years, sometimes while driving Pat to meet her Saturday night date. Finally she succumbed. They were married in 1939. Pat worked full-time as a schoolteacher. She also shopped, cleaned, cooked, did the laundry, pressed her husband's pants, sewed all her own clothes and the curtains and slipcovers in the four-room stucco bungalow they had rented on East Beverly Boulevard.

World War II brought the Nixons to Washington. For two years Richard languished in the bowels of a bloated military bureaucracy, then he shelved his Quaker principles and enlisted in the Navy. His connections in Washington and his military record made him a plausible congressional candidate in 1946. The "fighting Quaker" was put up against the popular incumbent, Jerry Voorhis, as more or less a tackling dummy. But Nixon waged a hard-hitting campaign and astonished his supporters by winning.

In 1950 the Nixons purchased a two-story white brick house with blue-green shutters on Tilden Street, in northwest Washington. It had a screened porch in front, a postage-stamp square of lawn in back. Pat shopped, cooked, cleaned, did the laundry, pressed her husband's pants, sewed all the curtains, the slipcovers, and a blue quilt for the double bed. In the heyday of the housewife, photographs like the one of Julie and Tricia dressed in spotless matching pinafores, crisp white anklets, and patent leather pumps, helping Mom mix up a batch of fudge "for the church social," made excellent political capital.

"We're moving up," the vice president crowed as he closed on the Nixon's next home, a $75,000 fieldstone English Tudor house at 4308 Forest Lane in fashionable Wesley Heights. The house had eleven rooms, including a bedroom and private bath for each of the girls, a hideaway study between the first and second floors for Richard, and formal living and dining rooms ideal for entertaining visiting heads of state. To Pat the home's best feature was its seclusion—it was the last house on a dead end street and surrounded by woods. The second best feature was the all-electric kitchen. She hired a live-in couple who, like her Swedish housekeeper at Tilden Street, were

never to be photographed with Pat—lest the voters get the idea that someone else was doing all the shopping, cooking, sewing, and scrubbing. Mrs. Nixon still pressed her husband's pants, an activity that attracted much favorable comment in the press, but her draperies and slipcovers were custom made.

Richard Nixon was an obsessive man, addicted to clean white shirts, eighteen-hour days, and politics. Garry Wills's brilliant study of the president, *Nixon Agonistes*, published in 1969, opens with a line from *The Runner*: "All I knew was you had to run, run, run, without knowing why you were running....and the winning post was no end to it...." Nixon himself recalled in his memoirs: "My first conscious memory is of running. I was three years old."

After losing the race against Kennedy, he took a disastrous detour. "The main problem was that I had no great desire to be governor of California," Nixon admitted. At one campaign appearance he referred to his ambition to be "governor of the United States." He chastised reporters for publicizing the slip, then indulged in another old habit: he said he was through with politics.

He had said the same thing to Pat in 1946, after the bruising bout with Voorhis. And again in 1950, after extinguishing the career of Helen Douglas in a flood of anti-communist rhetoric, on his way to the U.S. Senate. And again in 1952, after the infamous "Checkers" speech. And again in 1956, after President Eisenhower threatened for the second time to dump him from the ticket. And again in 1960, when he lost to Kennedy.

But this time Pat believed him, especially when he told her they were moving to New York, three thousand miles away from his political power base. She was ecstatic even though the move meant giving up her brand new home in Trousdale Estates, an exclusive housing development near Bel-Air. The Nixons had planned it together and plowed most of their savings into a down payment on the $100,000 purchase price. Streamlined and ultramodern, designed in the suburban "ranch" style popular in the Fifties, the house had three fireplaces and seven bathrooms. "Every night for a full week he can bathe in a different bathroom," quipped one of his friends who knew of Nixon's fanatical cleanliness.

"New York," Nixon said, "...is a place where you can't slow down." He joined the law firm of Mudge, Stern, Baldwin & Todd in 1963. The Nixons' twelve-room apartment (two fireplaces, four baths) at 810 Fifth Avenue, for which he paid $135,000 plus $10,000 annually in maintenance fees, sprawled over an entire floor. Governor Nelson Rockefeller had arranged for the Nixons to be accepted into the cooperative. Nixon revelled in the company of socially prominent neighbors and especially loved

to point out that there was not a Democrat among them.

In November of 1967, his younger daughter, Julie, married David Eisenhower. It was a lavish wedding, which the father of the bride could well afford. His net worth had soared to over half-million dollars, much of it invested in the Fisher Island development at Key Biscayne, Florida. (When he became president Nixon made a $180,000 windfall on the sale of Fisher Island stock.) The newspapers were full of speculation about the coming campaign. Pat was full of dread. Her husband had lately become moody and irritable. How well she knew the symptoms of his peculiar malaise, his political hunger.

One morning, sensing Pat's distress, he assured her that he had no intention of dragging her through another campaign. That night Nixon slipped into his study

La Casa Pacifica viewed from the air. The three arched windows look out onto the ocean. A stone wall encloses the estate.

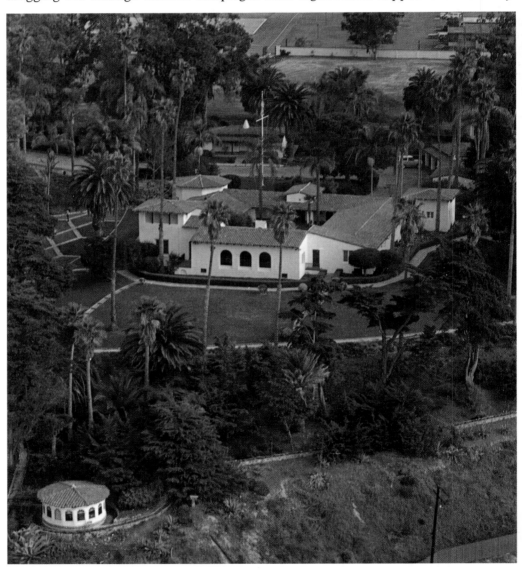

and threw a log on the fire. With his feet propped on an ottoman, a yellow legal pad on in his knees, Nixon began composing for Pat a list of reasons why he would not run. His pen failed to change his heart. He put it down and stared into the flames. "I *did* want to run," he later wrote. "Every instinct said yes."

The happy hiatus was over. Richard Nixon would not be a three-time loser.

Nixon and his successor did have one thing in common: as a handyman, each was hopelessly inept. Pat Nixon not only pressed her husband's pants, she also replaced washers on leaky faucets, took the mower into the shop when it broke down, and changed the oil in the Oldsmobile. Betty Ford, her husband confessed, gave up on him as a "household maintenance man…when I managed to hang a screen door upside down."

Gerald R. Ford grew up in Grand Rapids, Michigan. But he was born Leslie L. King, Jr., in Omaha, Nebraska. His mother divorced her first husband, Leslie L. King, Sr., when Jerry was two. Her second husband adopted the boy and gave him his name. The middle initial stands for Rudolph.

Gerald, Sr., was a paint salesman. At the turn of the century, a furniture industry had taken root in the vast forests bordering Lake Michigan. Companies like Herman Miller formed the solid core of Grand Rapids' economy, and companies like the Grand Rapids Wood-finishing Company, Gerald, Sr.'s employer, revolved around them. A sign on the edge of town greeted newcomers with the message: "Welcome to Grand Rapids—a Good Place to Live." No purple prose for the good citizens of Grand Rapids. Clean streets make clean minds. Every spring the town's mostly Dutch Protestant housewives made a symbolic ritual of hauling out buckets and scrubbing them down. As a congressman Gerald R. Ford came home from Washington to lend a hand.

In 1916, when Jerry was three, the Fords moved into a duplex in the heart of town. By the third grade Jerry had acquired the grace and physique of a natural athlete, and a new set of friends in fashionable East Grand Rapids. Times were good. Gerald, Sr., had quit school at thirteen to support his mother and three sisters. Now he was supporting a wife and four boys (Tom, Dick, Jerry, and Jim), driving around town in an open touring car, and living in a house with columns running all across the front.

In the Twenties he collided head-on with recession. The bank foreclosed on the house in East Grand Rapids and the Fords moved to a rented frame house on Union Avenue, with a barnlike garage in back where Jerry defied his parents' strait-laced sensibilities by playing penny ante poker. It was about as defiant as Ford ever got.

"The house was large and clean and I had chores to do," Jerry recalled. He banked the furnace every morning, made his bed, mowed the lawn, and did the dinner dishes. Furthermore, "my parents didn't drink and never kept liquor in the house." It wasn't until his sophomore year in college that Jerry lit up his first cigar and downed his first shot of alcohol, and his second, and his third.... Scheduled for knee surgery the following morning, he woke up so hung over that the doctor sent him home.

Though Gerald, Sr., was of English descent and Episcopalian faith, his values were those of the community, steeped in Calvinist theology, *Dutch* Calvinist, the strictest kind. "He and my mother had three rules: tell the truth, work hard, and come to dinner on time—and woe unto any of us who violated those rules," Jerry said. There was a fourth: "finish your plate." Failure to comply meant sitting at the oval mahogany dinner table until bedtime.

Gerald, Sr., loved Jerry just as much as he loved Tom, Dick, and Jim. Jerry worshipped his stepfather. "At six feet one, he was a handsome man with jet-black hair parted in the middle. He kept himself in excellent shape and had the straightest shoulders I have ever seen." His real father appeared only once, in 1930, the same year Jerry found out he was adopted.

It had been a hard year on several counts. Still reeling from a second round of financial reverses, Gerald, Sr., had nevertheless managed to buy a house in East Grand Rapids. The Fords were thrilled to be back in the "best" section of town. Their oldest boy was not. "The place was in terrible shape, and all of us spent nights and weekends trying to refurbish it," Jerry said. Worse, he had just been elected captain of the football team at South High, now four miles distant. By September he was the proud owner of a 1924 Ford coupe, complete with rumble seat.

Mercifully, the car waited until the end of football season to die. Ford didn't know much about cars and when winter came and the car began acting like it was going to blow up, he parked it in the garage and looked under the hood. "I saw that the motor was a fiery red.... Some old blankets were lying in the garage. I laid them on top of the engine and went inside to eat. Just as we finished the family meal, we heard fire engine sirens loud and close...." He had to borrow his stepfather's car to get to a track meet thirty-five miles away. "Leaving the parking area, I backed the car into a tree." The impact snapped the clamp that held the spare tire onto the car. "No problem, I thought; I'll simply tie the tire on the back." The heat from the exhaust pipe burned a hole through it.

A friend of his stepfather's gave him work at a restaurant to pay for the repairs on the family car. "One day at noon I was behind the counter in my regular spot near

the register, when I noticed a man standing by the candy display case. He'd been standing there fifteen or twenty minutes without saying a word and he was staring at me. Finally, he came over. 'I'm Leslie King, your father,' he said. 'Can I take you to lunch?' "

From the look of his clothing and the fancy car he drove, Jerry concluded that Leslie L. King was a rich man. Over lunch they made small talk, most of it centering on Jerry's football career. He had just made the All-City squad. Jerry was too polite, or too intimidated, or maybe just too stunned to ask his father why he had stopped sending the monthly check for child support. But three years later, when he was $600 short in making his college tuition, Jerry wrote King asking for a loan. King did not write back.

Why had his father bothered to come to Grand Rapids? Long afterward Jerry decided that had simply wanted to be able to brag about his son the football player. He never knew if Leslie King lived to see his son sworn in as president.

His senior year at the University of Michigan, Ford was named most valuable player. Like Richard Nixon, Jerry Ford saw football as a metaphor for life, especially political life. But football taught him something the benchwarmer never learned. "As a football player, you have critics in the stands and critics in the press. Few of them have ever centered a ball, kicked a punt, or thrown a touchdown pass with 100,000 people looking on, yet they assume they know all the answers. Their comments helped me to develop a thick hide, and in later years whenever the critics assailed me, I just let their jibes roll off my back."

Ford landed a coaching job at Yale after graduation and used it as a wedge to gain admittance to the law school. In 1941 the "big jock" from Grand Rapids graduated with the likes of Cyrus Vance, Potter Stewart, and Sargent Shriver, in the top fourth his class. He started his own firm and moved into his parents' new, two-story colonial home on Santa Cruz Drive in East Grand Rapids. If not for his mother Jerry might still be living there. When he turned thirty-four she decided to get him married and on his own. Wouldn't it be nice, she said to him one day, if he gave that attractive Betty Bloomer a call? Betty Bloomer was actually Betty Warren at the time, and in the process of extricating herself from a six-year marriage. She and Jerry dated for a year, keeping their relationship (notably her marital status) secret until he was safely elected to Congress. Then they bought a stucco duplex in Grand Rapids and moved into a two-bedroom apartment on Q Street in Washington.

"We loved Grand Rapids," Betty later wrote. "It's such a beautiful city.... Percentage-wise, it had more home ownership than any other city in the country, and that automatically meant that people took pride in their homes, their yards, and their

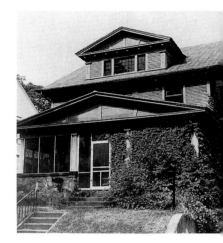

Jerry Ford's stepfather moved the family to Union Avenue after business reverses cost him his home in more fashionable East Grand Rapids.

neighborhoods." But compared to Washington, Grand Rapids was about as glamorous as a used car lot. Vivacious and freewheeling, she quickly overcame her homesickness.

So did Jerry. When Ford settled into his congressional seat, he settled like an anchor lodged between boulders. Rejecting the Republican endorsement for U.S. senator and later for governor, he ended up serving eleven terms in the House. Not that Jerry Ford lacked ambition. Politics enthralled him. But with every election his job seemed more secure, and he simply wasn't willing to risk losing it in an unsuccessful bid for a bigger salary and more prestige. Instead he set his course for House Speaker. In his methodical and cautious way he secured the position of minority leader and needed only a Republican landslide to achieve his heart's desire. But in 1973 charges of graft forced Spiro Agnew to resign the vice presidency and Richard Nixon abruptly took command of Ford's career.

He and Nixon had been born six months apart in 1913. Both had served with distinction in the Navy, both belonged to the Republican Chowder and Marching Club. They had been elected to Congress the same year. They were friends. Their wives were friends. Would Jerry Ford serve as vice president? Of course. Would Jerry Ford go out on the road on the president's behalf, proclaiming Nixon's innocence at every VFW convention and Chamber of Commerce banquet that would have him? Naturally.

Would Jerry Ford be angry when he learned the truth about Watergate? "Throughout my political life, I have always believed what I was told," he later wrote. "I was truthful to others; I expected others to be truthful to me."

For the first five years of their marriage, the Fords had commuted between furnished apartments in Washington and the stucco duplex in East Grand Rapids, their political base. Betty began "militating," as she put it, for a house in Washington in 1952. The Fords had one child, another on the way. Jerry finally relented. It was time to build some equity. With the help of a contractor they designed a simple, four-bedroom brick house on the five-hundred block of Crown View Drive, a typical suburban street in a typical post-war housing development in Alexandria, Virginia.

"If I'd known we were going to have two more babies, I'd have built more bedrooms and more bathrooms," Betty said. "And if I'd even considered the possibility that my little boys [Michael was five and John three at the time] might grow up to be six-foot-something apiece, I'd have asked for thicker walls and higher ceilings." But the immediate concern was decor. "I suddenly realized I didn't want to move all my old furniture into those brand new rooms." The landscaping, too, seemed threadbare. "It was nothing compared to what I wanted.... I shoveled every pile of dirt through

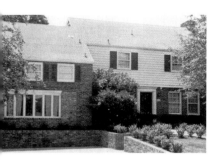

The Fords raised four children at 514 Crown View Drive, a modest home in a typical suburban development.

a screen to cull crabgrass, which doesn't speak highly of the dirt I had. But in Virginia, if you don't have crab grass, you don't have grass."

Apart from the garden and the swimming pool in the back yard, the Fords made no major changes at 514 Crown View Drive until Jerry became vice president and the Secret Service moved in. A huge trailer was parked in the driveway, and telephone wires snaked across the front lawn. Men with walkie-talkies bustled back and forth between the house and the van. The house had been cramped with four children; now it was brimming over with reporters and photographers and electricians and Navy stewards who ran errands for the family. Finally Betty called a halt to "Operation Improvise." The garage was bricked over and the security agents were parked inside. The Fords themselves footed the bill for a privacy fence. "I don't want my neighbors' property values to go down because of us," Betty explained.

In 1974 the Fords sold 514 Crown View Drive for $137,000, and moved into the White House. "After we...put the house up for sale, I never went over there again," Betty later wrote. "I knew it would upset me. I wanted to think of my new life, to look forward." There were no lavish, privately owned retreats while Ford was president. Ford "escaped" to his condominium at Vail for a week of skiing over Christmas, to his condominium in Palm Springs during the Easter holidays. In 1976, after his close but unsuccessful race with former Georgia governor Jimmy Carter, the stucco duplex in Grand Rapids went on the market, making it official: Jerry Ford's political career was over.

The move from 1600 Pennsylvania Avenue to Palm Springs, California, was hardly a tragic event. The Fords had begun planning their retirement home while Jerry was still in Congress. Since the birth of their fourth child, they had not had a guest bedroom in Alexandria. The split-level rambler in exclusive Thunderbird Estates would have enough bedrooms for the whole family, spouses and grandchildren included, a room-sized closet for Betty's wardrobe, a swimming pool for Jerry, and a tennis court they would share with the neighbors.

During construction they rented a place in the same development but high up in the hills and "very secluded, with a spectacular view of the mountains." Betty admitted that she "couldn't wait to get away from all that privacy." She happily traded the mountain view for the thirteenth fairway of the Thunderbird Country Club, which rolled by a few yards from her front door. "I want Jerry to play lots of golf and enjoy life," she said.

Ever the dutiful spouse, Jerry played lots of golf and enjoyed life. He had held up very well under "the magnifying glass," just as Nixon had predicted. Even in defeat the football star was a hero, even in retirement a stunning contrast to his predecessor.

Jerry Ford leaves 514 Crown Drive for work on Capitol Hill. The Ford residence was overrun with reporters and Secret Service men when Nixon appointed Jerry vice president. Betty fretted over what it would do to property values.

Jimmy Carter, Ronald Reagan

Ronald Reagan's Rancho del Cielo (ranch in the sky), high in the Santa Ynez Mountains of California. Opposite page: Bookshelves line the walls of the cozy combination porch and family room. Reagan did much of the remodeling himself.

ALTON CARTER, JIMMY'S UNCLE, MOVED to Plains, Georgia, in 1904 after his father, William Archibald Carter, was killed in a dispute over a desk. Like most of the Carters descended from James, Jesse, and Kindred, the three brothers who settled the clan in Georgia in the mid 1780s, Alton and his father were farmers—farmers with a flair for business and a streak of orneriness when their possessions or their reputations seemed at risk. In 1851 Jimmy's great grandfather, Wiley Carter, had barely escaped the gallows after killing a man who made off with one of his slaves. His son wasn't so fortunate; Littleberry Carter was shot dead during a quarrel with a business partner over a homemade merry-go-round.

Alton was fifteen years old at the time of his father's murder, an act he witnessed and would have prevented had he succeeded in retrieving the desk when William sent him over to Rowena to fetch it. "I went after the blamed thing," Alton remembered in the spring of 1876, "but this fellow said he'd bought it from my daddy. Well, Daddy said he'd just go over there and get it himself, since I hadn't done the job. It was a mighty rough scene. They got into a terrible argument—screaming and shouting at each other—and then they got to scuffling and wrestling around and there were some blows exchanged and they were both bleeding by then and all of a sudden that fellow came up with a gun, a little pistol. It wasn't there one minute and then, all of a sudden, there it was. I wasn't no more than fifteen feet away when he shot Daddy. Shot Daddy in the head, the back of the head."

In the Carter family everyone had a nickname. Alton's responsibilities as head of household kept him so busy that his friends called him Swift; later on, he was known as Buddy. His little brother James Earl was just Earl to most people until his friend Joe Bacon remarked that Earl reminded him of a turtle, "kind of low-slung." Then some people started calling him Turtle, and that got shortened to Turk. Buddy's son Hugh, who owns the World's Largest Worm Farm as well as Hugh Carter's Antiques and the Carter Mercantile in downtown Plains, got the name Beedie, short for "beddie-

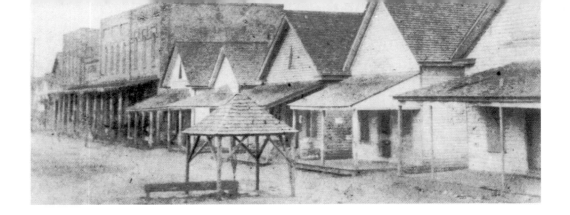

Plains, Georgia, as it looked around the time Alton Carter moved the family there.

bye," from his nurse. Earl sometimes called his firstborn son (the future president) Hot, as in Hot Shot.

Plains was originally a sort of nickname too. Its first settlers had christened their village Plain of Dura. By 1904, when Alton came to town and bought the general store (Carter's Mercantile), the name had become an embarrassment and the town fathers shortened it to Plains. From then on, as Ruth Carter Stapleton recalled, "Plains was Plains was Plains." It was a town of a few hundred people in 1904, in 1944, and in 1974. There was a brief boom in the Twenties when a rail line was laid to Plains, and a post office, a hospital, a two-story hotel, and a depot were added to the skyline. But the population never got close to four figures. In the mid-Seventies, when Jimmy was president, on weekends tourists outnumbered locals by two to one.

"Jimmy has done a lot for Plains, though some people tend to forget it," Hugh Carter said in his book, *Cousin Beedie, Cousin Hot*, published while Jimmy was still in office. Land values quadrupled. Hugh himself made a small fortune selling family memorabilia at the Carter Mercantile and at his antique store downtown. Hugh admitted that he was sometimes jealous of Jimmy's quick rise to power, but added that he and his cousin were still close. "Jimmy always stops into the store when he's in town." A Carter to the core, Hugh wasn't about to let pride stand between him and a dollar.

Especially in the beginning, residents understandably were concerned over what kind of havoc the presidency might unleash on their town. When Larry Flynt, publisher of *Hustler* magazine, purchased *The Plains Georgia Monitor* shortly after the election, the town fathers met to discuss it. Hugh accepted Flynt as part of the price you pay for glory. "It's hard to keep Plains a sleepy little town when a high-pressure entrepreneur like Larry Flynt comes down and buys its newspaper. But I think [longtime editor] Sam Simpson will continue to do a good job.... We just don't want Plains to become a town of chrome and plastic like Johnson City, near LBJ's ranch, became." Four years later it was clear that Jimmy Carter's home town would be spared that dismal fate.

With its clapboard store fronts and steep shingled roofs, the town bears a remarkable

resemblance to Dodge City when Marshall Dillon was keeping order there and dallying with Miss Kitty on his off hours. But behind the frontier-town facade, Plains has always been a God-fearing community. The Carters worshipped at the Plains Baptist Church. Earl and Hugh served as deacons, as did Jimmy until a dispute over blacks forced his resignation. While most of the family passionately opposed integrating the church, Jimmy held out in favor.

Hugh Carter was plainly stupified by Jimmy's liberalism, but Lillian Carter, Jimmy's mother, understood her first-born perfectly. "Jimmy isn't mysterious," she would say later on to critics who insisted on describing the president as an enigma. "I would say that he's original and stubborn." Like mother, like son. Hugh Carter remembers Lillian as "fiercely kind" to the blacks who worked in the Carter peanut fields, bringing them food and nursing them when they were ill, and on one occasion going so far as to invite the son of their preacher to tea in her parlor, an event that would have been front page news had Larry Flynt been publishing the *Weekly Monitor* in 1933.

Of all the Carters, Jimmy's father was the most financially astute. Earl knew how to make a buck—and then some. "You see folks that work all their lives," Alton said, "I mean, just work from sunup to sundown, and never seem to have a thing to show for it. Then, you see folks like Earl. I think he was some sort of a wizard, maybe a genius or something like that. Now, he was as honest as the day is long, but he sure could find out where the dollars in town were, and he sure knew how to get his hands on them."

Earl was barely out of high school when he started buying up real estate in Plains. He opened a laundry called The Pressing Club, an insurance office, and a grocery store the year he and Lillian were married. "He asked me if I thought the grocery store was a good idea and I said fine just as long as he didn't expect me to work in it," Lillian recalled. "I had no intention of becoming Earl Carter's clerk."

He moved Lillian and the children to the peanut farm, which he'd inherited from his father, in 1928. Jimmy was four years old. "We weren't rich," said Lillian. "But we weren't poor. You take the radio, for instance, and the car. They cost a lot of money in those days but Earl thought they were important for us to have and so he just bought them." On cool summer evenings the Carters would set up the radio on the front porch and tune in their favorite music station. Sometimes Earl and Lillian would step into the parlor, pull down the shades, and dance, an activity some people thought undignified for a church deacon.

Not that anyone was likely to have caught them at it—Earl's big clapboard house stood well off the dirt road from Plains to Preston, in a grove of pecan, fig, magnolia,

and chinaberry trees. It had high ceilings and spacious rooms, a pump in the front yard and a privy in back. "Newspapers or a Sears catalog was the accessory," remembered cousin Hugh. "I don't know that rolls of toilet paper were necessary." Chickens scratched up dust in the bald front yard, which was swept smooth with a broom. Fires in every room roared in vain against the chill of winter nights when the thermometer dipped below freezing. Jimmy often slept with his feet curled around a heated brick.

The farm technically belonged to the municipality of Archery, which consisted of Earl's place plus a dozen or so tumble-down dwellings filled to overflowing with the black families who worked for him. Earl bought the town (he let his hands live rent-free), opened a general store, and set about creating a community that was a replica of the antebellum South with one key difference: while the slaves had received nothing for their labors but food, clothing, and the roof over their heads, Carter paid as much as one dollar for a fourteen-hour day. Women got seventy-five cents and children fifty cents; domestics (including Annie Mae Hollis, who cared for the children when Lillian was away, which was most of the time) made a dollar a week. By 1940 Earl

was raising cotton, corn, sugar cane, and several other commodities in addition to the staple item, peanuts. His employees remembered him as a fair-minded, even benevolent boss, but on the question of civil rights Jimmy's father was a rock-hard reactionary.

Of all the Carters, Lillian was by far the most radical in her views, the most flamboyant in person, and the least devout, after Billy, that is. If Billy Carter lived in fear of the Lord he didn't let on. Jimmy didn't scare him either, even though his brother was several years older and liked to have his way. Lillian spoiled Billy terribly, according to cousin Hugh, while Jimmy had been driven hard by both his parents.

One of the more peculiar family habits was reading at the dinner table. Herself a voracious reader, Lillian couldn't bear to put her book away just because it was time to eat. So when the meal was served she went on reading and insisted that everybody else do the same. Thus she raised a brood of bookworms, Billy included until his wife threatened to leave him if he didn't break the habit. Jimmy was reading by the age of four and never stopped, collecting more stars on the Plains High School reading chart than any student before or since.

Jimmy Carter's house in Plains (opposite page), one of the very nicest in town. After retiring from politics Carter was able to spend more time in his workshop (lower left) and with his wife, Rosalynn, and his daughter Amy (below).

245

Over the years he developed quite a store of knowledge, as well as a deep-seated conviction that he was never wrong. One of his closest aides remarked during his presidency, "There are two things Jimmy Carter hates. He hates making a mistake, and he hates admitting it." His bedroom in the rear of the house was always immaculate and had "no trespassing" written all over it. His prized possession was the scale model of a frigate. From the age of six Jimmy dreamed of going to the Naval Academy, which Earl finally arranged two years after Jimmy graduated at the top of his high school class.

Jimmy's naval career was cut short by Earl's death, in 1953. Jimmy and his wife, Rosalynn, returned to Plains for the funeral to find Lillian distraught, the family business in disarray. Lillian begged Jimmy to move back home and take over the peanut operation. Ever the achiever, he threw himself into the business, working fourteen-hour days, with Rosalynn in full partnership as treasurer. Jimmy had educated himself on the fundamentals of business at a tender age. He was six when Earl first sent off to town to sell ice cream and nickel bags of peanuts. At thirteen he'd saved enough to make a down payment on five houses. "He was tight with his money, all right," said Lillian. "He saw money as what he got for work. A sort of fair exchange, I think is the way he saw it—and that's about the way he looked at everything else."

By 1956 Jimmy and Rosalynn were able to move out of their $30-a-month apartment in a housing project, into a home of their own just outside of town. Constructed of wide, heart-pine boards, the house dated back to the 1880s. Spacious rooms opened onto a wide front hall leading to the kitchen. There were porches front and back, and chimneys resembling medieval fortresses on the roof. "I personally went up to the attic room one day and felt relieved to come down," Hugh Carter remembered. "The old chimneys gave it an atmosphere and I told myself that the noises had probably been birds or bats that had been trapped in the chimneys and were trying to get out."

The Carters lived there just four years. They moved into a brand new house on Woodland Drive in 1962. By this time Billy was running the family business and Jimmy was a state senator with his eye on the governor's mansion. Jimmy's four-bedroom, one-story rambler, with its attached garage and brick facade, looked to most Plains residents like a mansion. Cousin Hugh had built his own house in town a couple of years before. One detects a note of competition in Hugh's description of the two homes' similarities. He figured his was worth around $100,000, the same as Jimmy's. Hugh had hired Ralph and Charlie Wiggins as his contractors; Jimmy did the same.

"My house is located on a thirty-acre lot of woods about two miles from Jimmy's

house. Some distance behind my home is the World's Largest Worm Farm—about three acres of worm beds—plus parking and storage sheds. I also have bluegill and bass fish ponds on the property....[Jimmy's] living room is medium sized with formal wallpaper. He has turqoise and white provincial furniture and a gold rug. On a table sits a Grecian bust, and on the walls are a pair of landscapes and a massive portrait of Amy which is hung over the couch. The dining room has a medium-sized table with straight-backed chairs. Crystal and silver adorn the sideboard and at the far end of the room a Chinese screen is hung on the wall. When he's home in Plains, Jimmy spends most of his time in the high-ceilinged family room which is behind the living room. This spacious room is paneled and contains hundreds of books and family photos. There are more paintings of Amy and the other children. It contains comfortable furniture for relaxing. The family room opens onto a large patio. The small back lawn is where Amy's trampoline is located. Jimmy does not have a swimming pool as yet. I have a figure-eight pool and a greenhouse."

In 1977, late in the campaign, Jimmy Carter said that the hardest thing about running was being away from home so much. "People don't believe me when I say that. They don't believe me because they don't know how much I love that place and those people, and maybe they don't believe me because they don't have a place to love like I do. I know it's probably foolish but I'd like to see everybody in the country get to know their family tree, to study it, to find out about their own people—who they were, where they came from, how they lived, when they died, where they're buried. I think that might make a lot of difference in the way people think about themselves and other people around them."

Elected with a mandate to restore honesty and openness to government, Jimmy Carter plunged headlong into a morass of domestic and foreign troubles that no amount of candor could illuminate a way out of—inflation, recession, a growing Soviet menace, and a hostage crisis, to name a few. Sadly, the most insidious of these was a crisis of confidence caused in part by the president.

To stabilize economic conditions, he recommended fiscal restraint in government and in the home. Americans, as it turned out, relish the accoutrements of success as much as they admire ambition and industry, and they resent being preached at by their elected officials. From his symbolic walk to his inaugural to the cardigan sweater he wore while scolding the nation for wasting energy, Carter's plebeian pretensions left the nation uninspired and unrepentant. Not since Woodrow Wilson had a president so badly misread Americans' devotion to God, Home, and Country.

Enter Ronald Reagan, elected by a comfortable margin in 1980, reelected in a

landslide four years later. Not since Franklin Roosevelt had a president gotten it so right.

Reagan, too, cherished his roots and the old-fashioned values he grew up with, but his was a fundamentalist's faith, an all-consuming passion uncluttered by intellectual analysis or doubt. Trained as a sports announcer, he made his fortune as an actor, but his special gift was not so much a knack for assuming other identities as the ability to project his own immensely likable one. In Hollywood he complained that he wasn't given juicy parts, but Reagan typecast himself—he was the irrepressible, incorruptible all-American boy. A born salesman, he managed to prolong his career by taking jobs in television, first as spokesman for General Electric and host of its weekly television series, "The GE Theater," and later as host of Borax's "Death Valley Days."

It was his producer for "The GE Theater" who set the stage for Reagan's metamorphosis from television pitchman to standardbearer of the Republican right. The producer (a liberal) suggested that some sort of upbeat political message might add muscle to the GE pitch. Reagan went to work, hewing an ideology out of his idealism. He discovered that his convictions placed him not in the tradition of FDR, a boyhood hero, but in the party of Hoover.

By 1960 Reagan was in demand all across the country as a speaker. Rotararians, chambers of commerce, and the VFW couldn't get enough of the glamorous movie star turned flag-waving free enterpriser. He had one stock speech but it was a rouser, electrifying not only audiences but also GE's marketing department. When Ronald and his wife, Nancy, built their new house in Pacific Palisades, California, the company donated all the latest conveniences. Billing it as "the GE all-electric home," GE created a sparkling showcase of American ingenuity.

Reagan's producer, meanwhile, wondered if he had created a monster. Exhausted after eight years of ceaseless political debate with his opinionated pitchman, he recommended that "The GE Theater" be cancelled in 1962. But by then Reagan had embraced his destiny; within five years he was governor of California and running for president.

Ronald's father sold shoes for a living. Driving ambition and a weakness for alcohol kept Jack Reagan on the move—from Tampico, Illinois, where he worked in a dry goods store downstairs from the five-room apartment that was Ronald's birthplace; to Galesburg, where Ronald learned to play football in the huge back yard of the grandest home his father ever provided; to Monmouth, where the next-door-neighbors' home, a trove of Victoriana, instilled in Ronald romantic notions of an elegant past;

and finally to Dixon, whose proudest monument was a huge beaverboard arch built in 1919 to welcome home the soldiers back from the Great War. The Reagan family arrived the following year, 1920. Ronald was nine.

"Everyone has to have a place they come home to," he used to say. "Dixon is that place for me." In Dixon, Illinois, he achieved his lifelong dream of playing on the high school football team, and Jack Reagan achieved his dream of self-employment. With the financial backing of a former boss, Jack opened the Fashion Boot Shop and poured his energy into making it the finest women's shoe store in town.

The Reagans rented a pleasant two-story frame house with a bay window in the living room and a big front porch. One afternoon Ronald came home from school and found his father sprawled on the porch steps, dead drunk. "It wasn't a case of bad times bringing on the drinking," Ronald's mother, Nelle, remembered. "It was the drinking bringing on the bad times." Ronald dragged his father into the house and put him to bed, then banished the incident from his mind. Even as a boy Ronald denied unpleasantness. His father's melancholia remained a mystery to him all his life, a mystery best left alone. Reagan was his mother's son; he inherited Nelle's gentle disposition, embraced her ever-hopeful, God-fearing faith, and worshipped her as a saint.

In 1930 the Depression forced Jack to close the Fashion Boot Shop. He sold shoes on the road for awhile, then took a job managing a rundown chain store 200 miles away. Nelle went to work in a dress shop and moved the family into an apartment. That same year Ronald and his older brother, Neil, came home from college to spend Christmas Eve with their parents. Jack was saying grace before supper when the doorbell rang. It was a message from his boss; the chain store had let him go.

Ronald was determined to finish college. He won a football scholarship and earned extra money washing dishes. Poverty didn't frighten him. He could still remember, as a small child in Tampico, Nelle sending him to the butcher shop to beg a liver bone for the stockpot that would feed the Reagans for a week.

He and Neil attended a Christian school in Eureka, Illinois, "A City on the Go with Young Men on the Go." At Eureka College, young men and women pursued their studies in an atmosphere so oppressively Puritanical that even the mild-mannered Ronald Reagan rebelled in his freshman year, delivering a speech that helped instigate the ouster of the president. The cheers and applause, he remembered, were "like heady wine."

After graduation Ronald examined his prospects for gainful employment. His father's experience left him leery of business. What he wanted was to figure out a way to make money doing what he loved best. What he loved best was talking before

Ronald Reagan's birthplace in Tampico, Illinois. Jack Reagan worked for a time in a dry goods store downstairs.

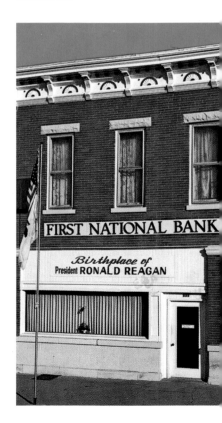

a crowd. Ignoring the advice of friends that he stay home and learn a trade, Reagan looked for work in broadcasting. As a play-by-play man he was a natural, his gift for gab landing him a job after his first audition.

A screen test in Des Moines, Iowa, sent him to Hollywood as a contract star with MGM. A prodigious memory helped immeasurably to compensate for Reagan's limited dramatic gifts. He soon became known as a hard-working professional. In a world of tender egos and hot tempers, Reagan was refreshingly uncomplicated. His lines always seemed to come out sounding like Dudley Doright, but at least they always came out. In his off hours, Reagan took to the podium. As president of the Screen Actors Guild, he sprinkled his speeches with stories that had a lesson to them. Some people thought he was becoming a righteous bore, and indeed it was precisely that quality—his loquaciousness harnessed to a growing passion for politics—that finally drove his first wife, the actress Jane Wyman, to divorce.

No screenwriter could have timed an entrance more brilliantly than that of Nancy Davis into the life of Ronald Reagan. Still in love with Jane when they met, Ronald was a reluctant suitor. It took Nancy more than a year of devoted attention to convince him that they were meant for each other. The trouble may have been that they were so alike. But that deficiency eventually proved to be the glue in a pairing as durable as any dreamed up by Hollywood.

Stable and self-possessed, Nancy Davis carved out a role for Mrs. Ronald Reagan that pleased her every bit as much as it pleased her husband. To Nancy, being domestic meant running a well-organized household. Servants actually performed the chores. The house Jane and Ronald had shared in Hollywood Hills, with its hunting prints and rustic furniture, had been a masculine domain. Nancy and Ronald lived at first in her apartment, then moved to a modest ranch-style house in conventional Pacific Palisades. This house was unmistakably Nancy's.

Founded as a Methodist settlement in the Twenties, Pacific Palisades struck many of the Reagans' friends as old-fashioned even though most of the houses were new. It was essentially a suburban tract for conservative, upper-middle class Californians. In 1956 the Reagans moved up to a more prestigious section of Pacific Palisades called the Riviera, a windswept plateau bordered on the west by the Pacific Ocean, on the north and south by canyons. Not content with mere privacy, they achieved isolation by situating the house in a grove of trees at the end of a long hedge-lined driveway. A pair of stone gates at the main entrance wore a delicate veil of white azaleas.

Bright red bouganvilleas softened the stone facade of the house. Ultramodern on the outside (designed by architect Bill Stephensen), the Reagan's "GE home" was

ultrafeminine within, decorated in a style that one frequent guest labeled "conservative Chicago—everything must be the best and match." In the living room, a pair of yellow sofas complemented floral chintzes in a palette of pastels and corals. The scheme was anchored by a sleek ebony coffee table of Oriental motif and a stone fireplace. Floor-to-ceiling windows looked out onto the pool and patio.

Immense and immaculate, with few books, original artworks, or knickknacks to gather dust, the 4,764-square-foot house felt to many visitors more like a hotel than a home—but to Nancy it was perfection. Guests noted only one design flaw. In its enthusiasm to equip the house with every modern convenience, a task made possible with a basement switch box that weighed more than 3,000 pounds, GE had neglected a few of the basics, such as light switches in the living room. Still, if a house becomes a home when it captures the essence of its occupants, then Nancy Reagan's sprawling fortress on the Pacific was as homey as any suburban bungalow.

No sooner had the Reagans settled into their all-electric home than Ronald was elected governor of California. By now Nancy had, in her demurely determined way, exchanged one set of friends, the movie crowd, for another, mostly self-made business tycoons and their wives. Pampered without being decadent, these unpedigreed aristocrats of southern California society would come to symbolize the Reagan presidency just as Billy Beer and peanuts had seemed to capture the Carter ethos.

Nancy was chagrined at the prospect of four and possibly more years in Sacramento. "No one in Sacramento can do hair," she replied when reporters questioned her habit of hightailing it to Los Angeles on weekends. Nor could any shopping mall in Sacramento compare to Rodeo Drive, any shop to Gucci, any restaurant to the Beverly Hills bistro where Nancy enjoyed three-hour lunches with Betsy Bloomingdale.

After her first visit to the governor's mansion, a gleaming white Victorian confection in the heart of Sacramento, Nancy emerged wreathed in smiles, seemingly entranced with the whimsical old place when in fact she was as overwrought as the architecture. It was filthy and practically falling down, she told the governor-elect. Nothing seemed to work. The paint was peeling, the plaster cracking, the furniture junk. No public official, least of all the governor of California, should be housed in such squalor. No, she would not launch a renovation. The house was beyond renovation, a candidate for the wrecking ball.

With her husband's approval, Nancy announced her decision to rent a house more suitable—a twelve-room, two-story Tudor-style mansion in one of the city's better neighborhoods—then hosted a tea for key Republican women that began with a tour of the governor's mansion. Nancy scrupulously noted every clanking radiator and running toilet.

Ronald doing what he loves best.

Both Reagans grew up in the Midwest—Nancy in Chicago, a city full of substantial homes and matched chintzes; Ronald in a small town with shady streets and frame houses furnished for comfort with this and that handed down or picked up cheap at an auction. Pacific Palisades was the closest thing to her roots Nancy Reagan was likely to find in Southern California. Ronald too had "a place to go home to." His beloved Rancho del Cielo, "the ranch in the sky," made him feel like a kid again, as if he'd never left Dixon.

Reagan already owned land in Riverside County when a rancher friend suggested they drive up into the Santa Ynez mountains to inspect 688 acres that seemed a steal at $527,000. Since the rancher friend was also a rich real estate developer, Reagan respected his opinion and put down the $90,000 even though his financial future was uncertain. (Governors aren't paid as well as TV stars, and Reagan's other ranch was losing money.) Rancho del Cielo had everything—water, power, and a gorgeous hilltop setting that on a clear day afforded panamoric views of mountain ranges and the ocean beyond.

Another tempting feature was that the ranch qualified as an agricultural preserve, meaning that Reagan would be taxed at a fraction of the normal rate, thanks to a new piece of legislation aimed at protecting arable land from real estate developers. In 1979, for example, Reagan would pay $862 in taxes on Rancho del Cielo; the same property without the loophole would have cost him in the neighborhood of $40,000. (By that time Reagan's land holdings had made him more money than films, television shows, and political office combined.)

But it wasn't the tax shelter that won Rancho del Cielo its special place in Ronald Reagan's heart. It was the physical life he led there and the rugged beauty of the terrain. He bought the ranch in November of 1974 and right away got into the habit of spending weekends in the Santa Ynez mountains, taking his chauffeur and bodyguard, a former patrolman named William Barnett, along for company. Chopping wood and clearing away brush, the two would talk all day (Barnett mostly listened) about how they were going to tear down the walls in the small stucco ranch house so as to make room for a kitchen, how they might even take off the old porch and add on a family room.

Together they eventually accomplished all that and tore off the old corrugated roof, too, replacing it with fiberglass tiles. Nancy had a say in the interior decorating, but not the final say. Ronald wanted bold colors—reds, blacks, deep browns. With its huge stone fireplace, the house was cozy, and even cluttered. Big cushions and cowhide rugs were scattered over the floor. Western art hung on the walls and shelves were crammed with photographs, souvenirs, and dozens of books.

Because she never much enjoyed the outdoor exertions her husband craved, Nancy usually found herself a bit at sea when she visited the ranch. She spent a lot of time on the telephone. Her husband, meanwhile, "would have been perfectly content by himself," said a former aide. "I've never really seen him need people."

It was true even back home in Illinois. Always moving from one set of friends to the next, Ronald Reagan learned that his finest companion was his own imagination. He fashioned a view of the world as an intensely pleasurable place and he stuck with that view even when it seemed to blatantly defy reality.

In high school he once put his philosophy into verse.

> *I wonder what it's all about, and why*
> *We suffer so, when little things go wrong?*
> *We make our life a struggle,*
> *When life should be a song...*
> *Millions have gone before us,*
> *And millions will come behind.*
> *So why do we curse and fight*
> *At a fate both wise and kind?*

Like his predecessor, Reagan offered himself as an example of how all men should live. But for Jimmy Carter life was a struggle, especially the four years he served as president of the Unites States.

For Ronald Reagan, life would always be a song.

Nancy and Ronald Reagan at Rancho del Cielo.

PHOTOGRAPH AND ILLUSTRATION CREDITS

D.J. Tice, pps. 20, 24, 31, 34, 47, 63, 69, 76, 80, 92, 101, 104, 109, 130, 153, 157, 168, 180; Mount Vernon Ladies Association: pps. 4, 13, 16, 17; Library of Congress, pps. 9, 29, 43, 49, 107, 108, 125, 126, 127, 129, 136, 137, 171, 196; National Park Service, pps. 10, 26, 40, 85, 100, 142, 149, 150, 151, 166, 167, 182, 193, 209, 212, 223, 249; Bettmann Archive, p. 10; Dover Publications, Inc., pps. 15, 22, 23, 27, 32, 44, 46, 48, 83, 86, 90, 96, 99, 106, 112, 121, 123, 128, 146, 148, 151, 158, 161, 166, 175, 183, 194, 208, 215, 222, 231; C. Harrison Conroy, cover, pps. 30, 34; Millard Fillmore House Museum, p. 84; Illinois Historical Society, p. 103; Ohio Historical Society, pps. 2, 111, 115, 144, 145; Historical Society of Wisconsin, p. 113; Spiegel Grove Presidential Center, pps. 118, 120; Benjamin Harrison Home, p. 141; Forbes Library, pps. 174, 177, 178; Hoover Institution, pps. 185, 185; Franklin D. Roosevelt Presidential Library, pps. 189, 190, 192, 193, 196; Warm Springs Association, p. 195; Harry Truman Presidential Library, pps. 200, 203; Dwight D. Eisenhower Presidential Library, p. 206; John F. Kennedy Presidential Library, pps. 210, 216; Lyndon B. Johnson Presidential Library, pps. 221, 224, 225; National Archive, the Nixon Project, pps. 226, 234; Gerald R. Ford Presidential Library, pps. 237, 238, 239; Michael Evans, Sygma, p. 241; the White House, pps. 240, 252, 253; Hugh Carter, p. 242; Charles Plant, p. 245.